# World Art Trends 1982

# World Art Trends 1982

**Edited by Jean-Louis Pradel**

Preface by Hilton Kramer

**Harry N. Abrams, Inc., Publishers, New York**

# World Art Trends 1982

## Authors, contributors and correspondents

The English-language edition of this book was created by VNU Books International, New York, London, Paris, Amsterdam
Project director: Jean-Louis Pradel
Editor-in-chief: Lynn Sonberg
Managing editor: Paula Litzky
Assistant: Claire Forgeot
Art director : Marcel Pijpers
Editorial advisor: Flor Bex
Editorial secretary: Catherine Lanson, Dianne Cullinane
Production: Danièle Hellouin

ISBN 0-8109-1780-7

### Australia

John C.N. Gooch
Visual Arts Board,
Australia Council, Sydney

Bernice Murphy
Art Gallery of New South
Wales, Sydney

Leon Paroissien
Sydney Biennale
Visual Arts Board,
Australia Council, Sydney

### Japan

Shigeo Chiba
National Museum of Modern
Art, Tokyo

Ichiro Hariu
Art critic, Tokyo

Jungi Ito
Art critic, Paris, Tokyo

Alain Jouffroy
Writer, Paris, Tokyo

Takeshi Kanazawa
Hara Museum, Tokyo

Ito Masahiro
Art critic, Tokyo

Yusuke Nakahara
Art critic, Tokyo

Hideki Nakamura
Art critic, Nagoia

Keiji Nakamura
Art critic, Kyoto

Kenjiro Okamoto
President AICA Japan

Bertrand Raison
Art critic, Tokyo

Yoshiaki Tono
Art critic, Tokyo

Katsuhiro Yamaguchı
Artist

### Korea

Cho Choung-Kwon
Art critic, Seoul

Marie-José Parra-Aledo
Art critic,
Paris, Tokyo, Seoul

Philippe Sergeant
Writer,
Paris, Tokyo, Seoul

Kim Yoon-Soo
Art critic, Seoul

### China

Philippe Briet
President of New Colors
Association

### Finland

Marja-Liisa Bell

Helsingin Kaupungin
taidemuseo, Helsinki

### Sweden

Jacques Adelin Brutaru
Art critic, Paris

Olle Granath
Moderna Museet, Stockholm

Marianne Nanne-Bråhammar
Lunds Konsthall, Lund

Cecilia Nelson
Lunds Konsthall, Lund

### Norway

Karin Hellandsjø
Henie-Onstad Kunstsenter,
Høvikodden

Per Hovdenakk
Henie-Onstad Kunstsenter,
Høvikodden

Ole Henrik Moe
Henrie-Onstad Kunstsenter,
Høvikodden

### Denmark

Anneli Fuchs
Louisiana, Humlebæk

Knud W. Jensen
Louisiana, Humlebæk

Steingrim Laursen
Louisiana, Humlebæk

Hans Erik Wallin
Louisiana, Humlebæk

### Holland

Wim Beeren
Museum Boymans-van
Beuningen, Rotterdam

Jan Debbaut
Stedelijk Van Abbemuseum,
Eindhoven

Rudi Fuchs
Stedelijk Van Abbemuseum,
Eindhoven
Documenta, Kassel

Karel Schampers
Stedelijk Museum, Amsterdam

Lon Schröder
Museum
Boymans-van Beuningen,
Rotterdam

Gijs van Tuyl
BBKB (Head Visual Arts Office
for Abroad), Amsterdam

Edy de Wilde
Stedelijk Museum, Amsterdam

### Germany

Tina Anjesky
Zeitgeistbureau, Berlin

Hamdi el Attar
Gesamthochschule, Kassel

Wolfgang Becker
Neue Galerie, Aachen

Johannes Cladders
Städtisches Museum
Abteiberg, Mönchengladbach

Thomas Deecke
Westfälischer Kunstverein,
Münster

Karl Manfred Fischer
Städtische Galerie, Erlangen

Helmut Friedel
Städtische Galerie in
Lenbachhaus, Münich

Siegmar Holsten
Staatliche Kunsthalle Baden-
Baden

Christos M. Joachimides
Art critic, Berlin

Ulrich Krempel
Kunsthalle Düsseldorf

Annelie Pohlen
Art critic, Bonn, Erlangen

Ursula Prinz
Art critic, Berlin

Lisa Puyplat
Städtisches Galerie, Erlangen

Marc Scheps
Museum Tel Aviv, Israel

Katharina Schmidt
Staatliche Kunsthalle Baden-
Baden

Felix Zdenek
Museum Folkwang, Essen

### Austria

Monika Faber
Museum Moderner Kunst,
Vienna

Patrick Frey
Art critic, Zürich

### Switzerland

Jean-Christophe Amman
Kunsthalle Basel

René Berger
President AIVAC
Art critic, Lausanne

Rinaldo Bianda
President Video Art, Locarno

Richard Calvocoressi
Tate Gallery, London

Jean-Hubert Martin
Kunsthalle Berne

Harold Szeeman
Art critic

### Belgium

Florent Bex
Art critic, Antwerp

Karel Geivlandt
Palais des Beaux-Arts,
Brussels

Jan Hoet
Museum van Hedendaagse
Kunst, Gent

Wim Van Mulders
Art critic, Antwerp

J.P. Van Tieghem
Art critic, Brussels

## France

Daniel Abadie
Centre National d'Art et de
Culture Georges-Pompidou,
Paris

Jean-Max Albert
Artist

Henri-Alexis Baatch
Writer, Paris

Georges Boudaille
Biennale Paris

Maïten Bouisset
Art critic, Paris

Dominique Bozo
Centre National d'Art et de
Culture Georges-Pompidou,
Paris

Gilles de Bure
ADEA, Paris

Jean Clair
Art critic, Paris

Jacques Dupin
Writer, Paris

Don Foresta
Biennale de Paris

Jean-Louis Froment
CAPC, Bordeaux

Gerald Gassiot-Talabot
Art critic

Gérard Guyot
Artistic advisor, Bordeaux

Marc Le Bot
Writer

Jean de Loisy
Art critic, Paris

Yves Mabin
Association française d'action
artistique, Paris

Catherine Millet
Art critic, Paris

Alfred Pacquement
Centre National d'Art et de
Culture Georges-Pompidou,
Paris

Suzanne Pagé
Musée d'art moderne de la
Ville de Paris
General secretary, CIMAM

Yann Pavie
Art critic
Groupe régional d'intervention
pour l'art contemporain,
Rhône-Alpes

Marie-Noël Rio
Playwright,
Atelier Lyrique du
Rhin, Colmar

Marc Sanchez
Musée de Nice

Christian Schlatter
Art critic, Paris

Anne Tronche
Art critic, Paris

Monique Veauté
France-Culture, Paris

## Italy

Amnon Barzel
Art critic
Fattoria di Celle, Pistoia

Achille Bonito Oliva
Art critic, Rome

Michele Bonuomo
Art critic, Naples

Cesare Brandi
Professor, Rome

Sisto Dalla Palma
Venice Biennale

Antonio Del Guercio
Art critic, Rome

Vittorio Fagone
Art critic, Milan

Giuliano Gori
Fattoria di Celle, Pistoia

Giovanni Joppolo
Art critic, Paris

Bruno Mantura
Galleria Nazionale d'Arte
Moderna, Rome

Goffredo Parise
Art critic, Milan

Elisabeth Vedrenne
Art critic, Paris

## Spain

Francis Calvo Serraller
Art critic, Madrid

Alexandre Cirici
Art critic, Barcelona

Fernando Vijande
Galeria Fernando Vijande,
Madrid

## Great Britain

Robert Ayers
Art critic, London

Fenella Crichton
Art critic, London

Catherine Ferbos
British Council, Paris

Sue Grayson
Arts Council of Great Britain,
London

Timothy Hyman
Art critic, London

Jeremy Lewison
Art critic, Cambridge

Marco Livingstone
Museum of Modern Art,
Oxford

Sandy Nairne
ICA, London

Sir Herbert Read
Art historian

Anthony Reynolds
Arts Council of Great Britain,
London

Nicholas Serota
Whitechapel Art Gallery,
London

Caroline Tisdall
Art critic, London

Marina Vaizey
Art critic, London

## Argentina

Jorge Glusberg
CAYC, Buenos Aires

Abraham Haber
Art critic, Buenos Aires

Julio Le Parc
Artist, Paris

## Brazil

Roberto Pontual
Art critic,
Paris, Rio de Janeiro

Walter Zanini
São Paulo Biennale

## Venezuela

Sofia Imber
Museo de Arte
Contemporáneo, Caracas

## Mexico

Helen Escobedo
Instituto Nacional de Bellas
Artes, Museo de Arte
Moderno, Mexico

Mercedes Iturbe
Mexican Cultural Center, Paris

## Canada

Nicole Dubreuil-Blondin
Art critic

Jeanne Gagnon
Musée des Beaux-Arts,
Montreal

Diane Guay
Art critic

André Ménard
Musée d'art contemporain,
Montréal

Yves Pépin
Canadian Cultural Center, Paris

Gilles Toupin
Art critic, Montréal

## USA

Judith Aminoff
Art critic, New York

Michèle Cone
Art critic, New York

Jack Cowart
Saint Louis Art Museum,
Saint Louis

Claude Gintz
Art critic, Paris, New York

John G Hanhart
Whitney Museum of American
Art, New York

Louise Katzman
San Francisco Museum of
Modern Art, San Francisco

Hilton Kramer
Art critic, New York

Susan C. Larsen
Art historian, Los Angeles

Ruth La Ferla
Art critic, New York

Lucy Lippard
Art critic, New York

Jane Livingston
Corcoran Gallery,
Washington D.C.

Thomas MacEvilley
Art critic

Sarah MacFadden
Art critic, New York

Gabrielle Maubry
Artistic director

Craig Owens
Art critic, New York

Margit Rowell
Guggenheim Museum,
New York

John Russell
Art critic, New York

Peter Schjeldahl
Art critic, New York

Jeanne Siegel
Art critic, New York

Roberta Smith
Art critic, New York

Diane Waldman
Guggenheim Museum,
New York

Robert Whyte
San Francisco Museum of
Modern Art, San Francisco

**under the direction
of Jean-Louis Pradel**

# World's Art Trends'82

# Contents

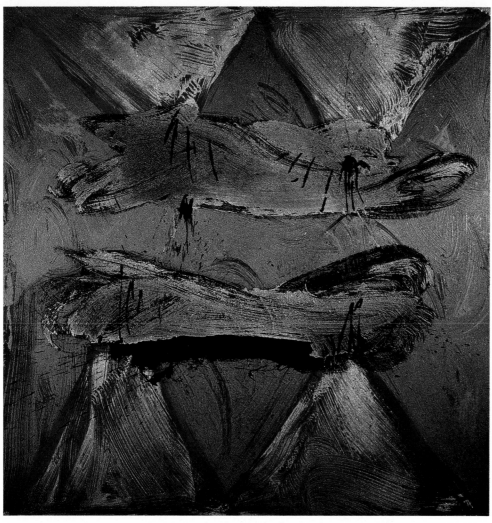

Robert Malaval (1937-1980), *Untitled*, 1980, acrylic and sequins on canvas, $76\frac{3}{4} \times 76\frac{3}{4}''$ (195 × 195 cm).

## Foreword

Artists and art lovers have always met on the highways and byways, at the boundaries between the real and the imaginary. ART 82, therefore, invites you on a tour of the world, a journey that would take about a day of Greenwich time to cover the multitudinous and sometimes baffling contemporary art scene. In each country included, data had to be collected and contacts established; art and travel were again combined.

Without prejudging the future, without hastily apportioning creativity and setting up categories, or bringing judgments to bear, ART 82 leaves its readers the freedom to trace the configurations of their own taste. It will be a leisurely ramble and one that we have tried our best to make agreeable and informative.

The aim of ART 82 is to offer the means to become familiar with art that is in the process of being made, and to add the participation of new onlookers to the international scene woven from the immense diversity of artists in all countries.

But, of course, only a small portion of their creative activity is visible here. Without taking into consideration the nationality of the artists, ART 82 has only retained, for each country, whatever made news there, whatever was placed in the limelight either by the numerous

specialists we consulted or by the various institutions and media connected with contemporary art.

As an echo of this tumultuous artistic scene, ART 82 lets old forms stand side by side with new ones and allows some rebellious youngsters to jostle the "masters" of the twentieth century, at a moment when a gigantic redistribution in the role of the centers of artistic creation is underway throughout the world.

What we have, therefore, is a book in the making, a reflection of the tendencies brought to light by the news of the day, as fleeting as the ideal annual documentary exhibition, as invaluable as certified evidence of the taste of our time.

My warmest thanks go to all those who have willingly taken part in this publishing adventure by contributing, with patience and enthusiasm, the piece of the jigsaw puzzle without which there would have been irremediable gaps. I especially thank Willem Sandberg and his decisive enterprise and action in bringing contemporary art before the eyes of a steadily growing public as a major cultural phenomenon of our time.

Jean-Louis Pradel

# Preface

The habit of looking for trends in art is nowadays frequently maligned. It is said to represent the interests of commerce rather than the interests of art or the imagination. And it is certainly true that many people without a genuine interest in art—people in the market, in the media, and in the academy—find it far easier to attach themselves to something that can be considered "new" and different than to pay close attention to the immense variety of expression that is likely to characterize contemporary art at any particular moment of its development. Yet even when we take full account of the vulgarity and opportunism and sheer stupidity that often govern an excessive attention to new trends in art, we are left with the obligation to explain what actually occurs when artists of genuine talent, imagination, and ambition turn away from the established modes and attempt to give us something unexpected.

This is an obligation that we are likely to feel especially keenly at the present time. It seems only the other day that aesthetic orthodoxy required artists to limit their work—and indeed, limit their emotions—to a highly constricted austerity. The minimalist mode in painting and sculpture ruled with an unquestioned authority, and formalist criticism kept up a vigilant campaign to ensure that any deviations from the austere aesthetic it favored would be promptly consigned to oblivion. The minimalist mode was never, of course, the only art claiming our attention even when its fortunes were prospering. But it had the appearance of speaking with the authority of the historical moment, and this gave it a power and influence that few other styles could rival.

From our perspective in the early 1980s, this power and influence now looks much diminished. Clearly the taste for the minimal and the austere, for simplified forms and an immaculate technique, has receded, and styles answering to very different imperatives have now come forward to speak, if not exactly in the name of the historical moment, at least in the name of some wider spectrum of feeling that we know art to be capable of accommodating.

How, then, are we to account for this trend? For a trend—like the word or not—it surely is , and it looks just now to be the dominant and most fertile trend. It is not, however, a trend to be identified with a single style. It embraces many styles, from the wildest reaches of neoexpressionism to the most equable modes of realism. Its most persistent characteristic is a vivid interest in some form of representational imagery, either naturalistic or symbolic, but even this interest does not quite account for everything that can be legitimately included in this shift of outlook. For there are modes of abstraction and semi-abstraction that must be included as well. It is, perhaps, a yearning for—and a belief in the legitimacy of—certain kinds of feeling in art that most nearly explains what has happened. Emotions that for too long had been denied entry into art were at last to be given their due. And as often happens when shifts of this kind occur in art, we may feel that these emotions are sometimes given more than their due. Minimalism is by no means the only artistic impulse that has been carried to extremes.

In attempting to come to terms with this development, it is essential, I think, to see it in a perspective that goes beyond considerations of fashion. Something more profound would seem to be involved. In following this recoil against the minimal mode, for example, I am reminded of an observation made by Baudelaire in *L'Art Romantique.* "The puerile utopia of art for art's sake, by excluding morality and often even passion," Baudelaire wrote, "was inevitably sterile." (« *La puérile utopie de l'école de l'art pour l'art, en excluant la morale, et souvent même la passion, était nécessairement stérile.* ») Whether the utopian vision of minimalism must ultimately be judged to be either "puerile" or "sterile" is not quite the question, of course. Opinions will naturally vary on this point. What must be understood, however, is that many of the artists who have now come forward to transform the scene saw the minimalist heritage in terms very much akin to Baudelaire's in the line I have quoted. Something important and essential to experience was felt to be missing in the art of our time, and it suddenly was felt to be imperative that this void—an emotional void that is also a spiritual void—be filled.

Baudelaire's reference to "art for art's sake" also has a relevance here. For the great hunger in art today—the spiritual yearning that accounts for many of the changes we have recently observed—derives from an impatience with the notion that art is incapable of expressing anything but itself. Whether we describe this hunger as the search for a new "content" in art, or as a desire for a new "subject matter," a "new image," or a new figuration, we can recognize it as a quest for something that lies beyond the art-about-art notion that acquired such currency in recent decades. Fundamentally, it is a quest to make art more capacious than it was recently thought to be—to restore to it some of the strengths and resources that it so conspicuously enjoyed in the past.

This search has not, I hasten to add, involved any wholesale revolt against modern art itself. (Even the artists who declare their disenchantment with modernism very often smuggle its conventions into work without acknowledgment.) But it has altered our view of what modern art encompassed. It has reversed the idea that the vitality of modernism was to be found exclusively in the rejection of representation or symbolic expression. It has altered the assumption that modernism must be identified with abstraction and purism. The trends that are now upon us have reawakened us to the fact that the modern movement was born in the effort of the nineteenth-century realists to come to terms with the world they could actually observe with their own eyes. In this revisionist view of modernism, expressionism is fully as important as cubism, and representation plays a role equal to that of formalist purity. Thus, the trends that we observe in 1982 have not only brought us new and ampler styles in contemporary art than any we have had in many years, but they have also enlarged our sense of the tradition—the modernist tradition—that has so long nourished us.

Hilton Kramer

# Australia

## Survey
## by Leon Paroissien

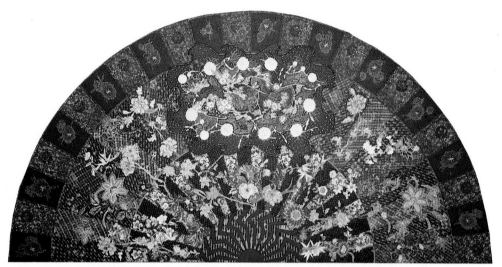

Miriam Schapiro, *Black Bolero*, 1980, fabric, glitter and acrylic on canvas, 6' × 17'⅞', Biennale of Sydney 1982

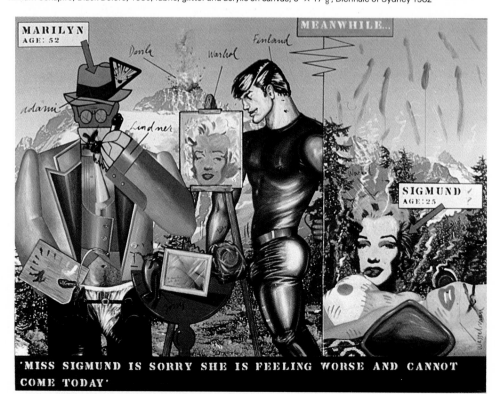

'MISS SIGMUND IS SORRY SHE IS FEELING WORSE AND CANNOT COME TODAY'

Juan Davila, *Miss Sigmund*, 1981, acrylic on photographic panel, 6½' × 9'9½" (2 × 3 m), Popism Exhibition

The Australian continent inspired strong Aboriginal visual cultures, some of which remain vital after nearly two centuries of European settlement. The unique nature of the country has also been a major inspiration to immigrant and Australian-born white artists from the time of European settlement to the present, producing a strong visual arts tradition.

On October 13, 1982 the new Australian National Gallery opened to the public, showing historical and modern collections, the most important acquisitions of which have been made during the last decade.

In Sydney, the first major survey of contemporary Australian art since 1973 was held in 1981 at the Art Gallery of New South Wales (May 29-June 21). Selected by Bernice Murphy and titled *Australian Perspecta 1981,* this exhibition was the first of a series of biennial exhibitions of Australian art to be held in years alternating with the Biennale of Sydney. *Perspecta* pointed up the diversity and energy that had emerged among artists who sought an informed but distinctly regional identity, rejecting the general deference to international styles that had marked the 1960s.

The Fourth Biennale of Sydney was directed by William Wright and titled *Vision in Disbelief* (Art Gallery of New South Wales and other venues, Sydney, April 7-May 23 1982). It represented 45 Australian artists and 162 artists from 16 other countries. Half the works were temporal—video, film, performance and sound works (the latter formed a major section, with 32 artists represented). A dominant theme was the search by Western artists for new expressive modes of signification. However, one of the most memorable works in the exhibition was a huge Aboriginal sand painting and performance, which translated ancient ritual into a Western art museum context—a precarious process but nevertheless producing a work of dense cultural symbolism.

Two small thematic exhibitions of contemporary Australian art were held simultaneously in Melbourne during 1982: *Art in the Age of Mechanical Reproduction* (selected by Judy Annear and shown at the George Paton Gallery July 7-28) and *Popism* (selected by Paul Taylor and shown at the National Gallery of Victoria June 16-July 25). These exhibitions presented a counter-thrust to the return to expressionist painting strongly evident in the Fourth Biennale of Sydney, although the majority of artists in the two shows had either been in *Perspecta* or the Biennale. The first of the two Melbourne exhibitions focused on a range of work employing reproductive technology, such as xerox, photography, video, and computer techniques. The second also had an emphasis on photographic or mechanical reproduction but presented the thesis that the most important contemporary artists were primarily concerned with the anti-modernist activity of "quoting" from popular, amateur, or mechanically reproduced images, giving new meanings to existing images.

The debate triggered by these and other exhibitions continues in several recently established art journals and is generating a sharpened critical consciousness surrounding and mediating art in Australia.

*Original text*

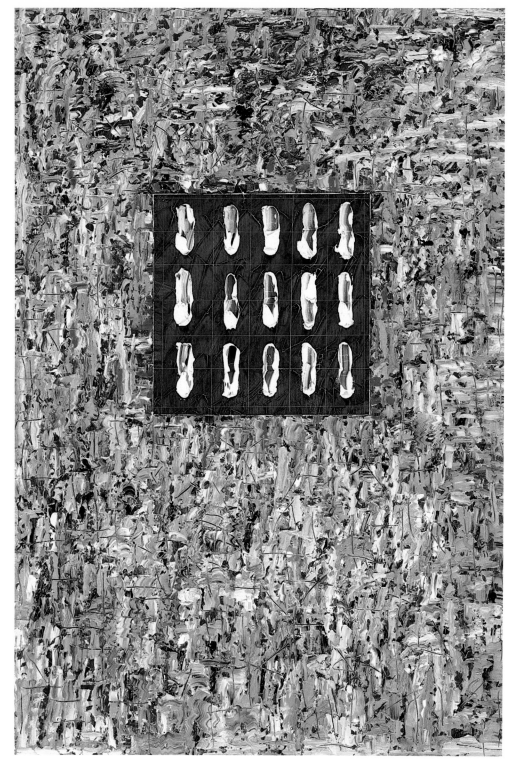

Paul Partos, *Untitled*, 1980, oil and pencil on canvas, 78 × 59⅞ (197.5 × 152 cm), Australian Perspecta 1981, Art Gallery of New South Wales, Sydney

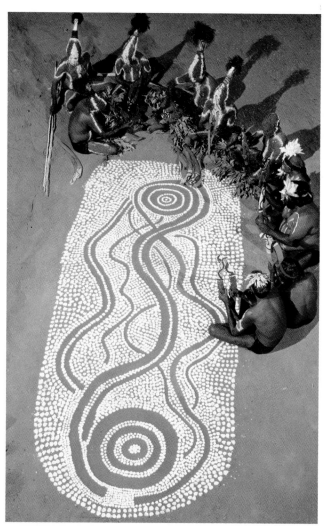

Aborigines of the Walpiri tribe, *Snake Dreaming Centre at Jundu*, Biennale

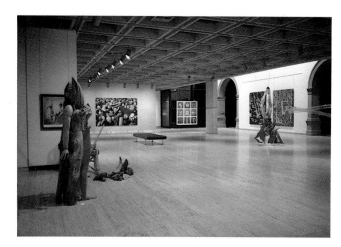

View of installations, Australian Perspecta 1981

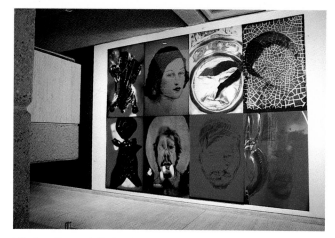

Mike Parr, *Parapraxis III: Cold Photography*, 1982, mixed media, Biennale

# Japan
## Nantenshi Gallery
## Tokyo
横尾忠則展

Tadanori Yokoö
born in 1936 in Hyōgo, Japan
lives in Tokyo

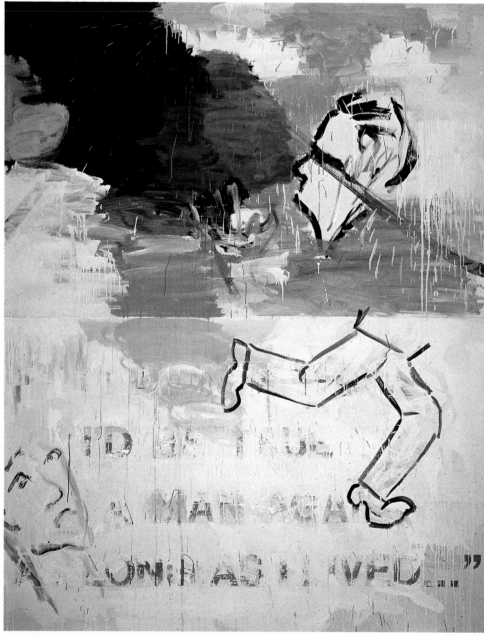

*A Made Up Story*, 1982, oil, acrylic, gesso, and collage on canvas, 89⅜ × 16'8⅜ (227.3 × 509.1 cm), three panels

Once, having spent considerable time carving a woodcut of his experimental work in his Milan studio, artist Li Man Kan took it to a printer who damaged the work with a paint spatula. The printer didn't seem to care. Li was angry with the printer who then told him that it didn't matter and that he should be more concerned with other things. When the print was made, it did not retain the original image because of the damage, but Li was surprised to find such strong expression in his work.

The fact that Li Man Kan could find unexpected importance in such a small matter gives the impression of someone with a sensitive, artistic mind. Works by Japanese artists suggest that their surroundings should be clean and sterile (something which Li sees as a typically Japanese way of thinking). Works by Europeans are dirty and materialistic, yet they make one aware of their strong presence. This contrast set Li to thinking.

Li did not see the so-called "bad" paintings which have spread in Europe and America like overgrown weeds as just a trend in the art world. It seems that he felt a deep despair and finality from which there was no way out except by perfecting dirtiness. Li even saw something psychoanalytical in those dirty, germ-infested paintings—the existence of someone who has been pushed to the limit. Ironically, he felt that Japanese artists had to choose one way or another: Go to Europe to spray disinfectant or sit and wait for foreign germs to invade Japan...

Now let's talk about Tadanori Yokoö's recent works. They're dirty, germ-infested paintings. Li, who is critical of his colleagues, might say that Yokoö's filth simply represents the other side of Japanese cleanliness, although he does not seem to think that either the germless cleanliness or dirtiness of paintings is inevitable or should result from a predetermined, rigid formula...

In his paintings, sweet sadness is combined with violence, without compromise. You could say that they represent a violent outburst of an immature child or an indiscreet disguise. Just as a hoe held in rough, unskilled hands might destroy ancient artifacts buried in underground ruins, his paint brush, which some say he uses carelessly, digs up personal memories and images after the artist seemingly has mixed up and damaged everything. He seems to say that one must now possess a disgraceful, fragmented, irresponsible, indiscreet disguise in order to express "self."

Yoshiaki Tono
*from the catalogue*

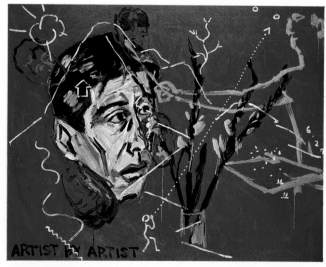

*Artist by Artist*, 1982, acrylic and gesso on canvas, 71¼ × 89⅜ (181.8 × 227.3 cm)

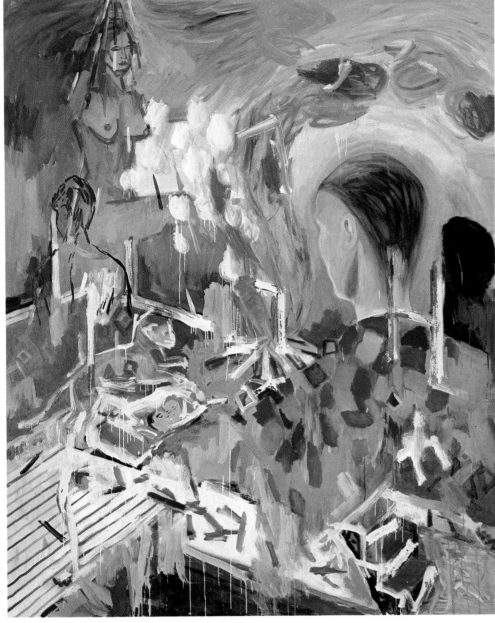

*A Postcard from My Son*, 1982, oil, acrylic and gesso on canvas, 8'6⅞" × 7'5⅝"

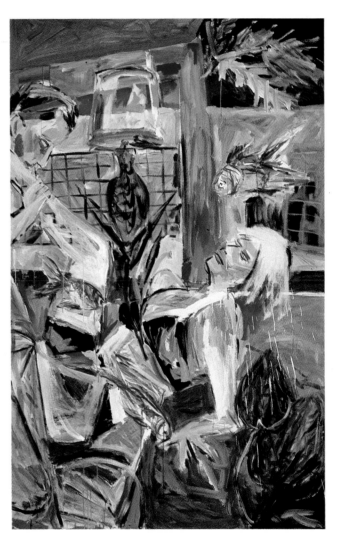

*Gift of L.A.*, 1982, oil, acrylic and gesso on canvas, 7'5⅝" × 9'6⅛" (227.3 × 290 cm), two panels

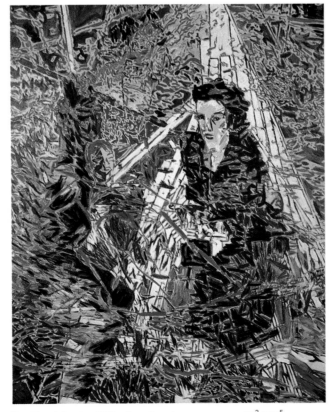

*Four Days in London*, 1982, oil acrylic and gesso on canvas, 89⅜ × 71⅝"

# Japan
## Galerie 16
## Osaka

野村仁展

**Hitoshi Nomura**
born in 1945 in Tatsuno, Hyōgo Prefecture
lives in Takatsuki, Osaka Prefecture

Nomura's serial photographic work entitled *A Spin in Curved Space* records the sun's movement from sunrise to sunset. Using two cameras with fish-eye lenses and handmade pin-hole filters to diminish the light, he leaves the shutters open all day. One camera is held horizontally on a tripod, another is tilted, depending on the north latitude of the camera's location. On the days of the spring and autumn equinox the orbit of the sun photographed by the tilted camera shows a straight line and a slightly curved one intersected by a horizontal line. The tilt of the earth's axis is thus visualized, as is the relation between space and time.

The concept of this series, he explains, originally came from his interest in non-Euclidian geometry and relativity theory as well as his interest in another space, in a world of the fourth dimension. But it is neither purely scientific interest nor a free fantasy of outer space as in the space operas. His interest is to show, to visualize, the anticipation of fourth-dimensional space, and so he does not use the rigorous methods of astronomy or mathematics but only simple photography. Because of this direct and simple method, he does not increase our knowledge but stimulates our perceptions, and he extends them easily into something beyond this world. In a sense, we might say that the scientific appearance of his works does not come directly from theoretical physics but originates in and is an extention of the study of space in visual art; he was, after all, a student of sculpture in college.

Even though his works have some reference to contemporary scientific thought, they remind us that in ancient times people decided the time of seeding and harvest and made calendars by consulting the movement of the heavenly bodies. His works reconcile science to us.

Keiji Nakamura
*Original text*

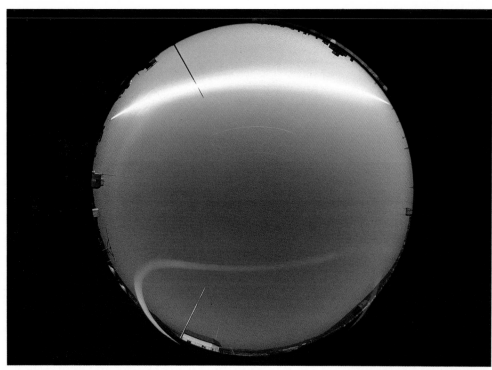

Jan. 11, 1982, 7:06 (sunrise)-17:06 (sunset), *A Spin in Curved Air*

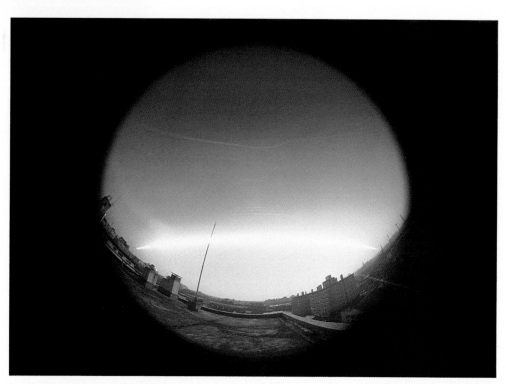

Jan. 11, 1982, 34° 51', 7:06 (sunrise)-17:06 (sunset), *A Spin in Curved Air*

Kusama once declared that the intention of her work is to obliterate everything in the world including herself.

I prefer the word "annihilation" to "obliteration" to illustrate her intention. Kusama annihilates the world through painting a net or a polka dot, or making a phalluslike object. But, doing that, she creates a new world just like a positron created by the annihilation of a photon, a phenomenon that was explained by the physicist Paul Dirac long ago.

The essential quality of Kusama's work is here, in creation through the annihilation. Needless to say, we can find in her motifs an analogue of life and death.

Another word that she likes to use is "obsession," and she herself calls her work "obsessive art." But I think her obsession belongs not only to her but to the world itself. Her obsessive art comes from the world—the universe and the cosmos.

Nakahara
*from the catalogue*

I discovered Kusama's art in Washington, several years ago, and at once felt that I was in the presence of an original talent. Those early paintings, without beginning, without end, without form, without definition, seemed to actualize the infinity of space. Now with perfect consistency she creates forms that proliferate like mycelium and seal the consciousness in their white integument. It is an autonomous art, the most authentic type of super reality. This image of strange beauty presses on our organs of perception with terrifying persistence.

Sir Herbert Reed
*from the catalogue*

"... to repeat one touch by another a thousand or a million times in the unlimited world of time seems unimportant to the purpose of painting and the idea of art. However, the accumulation of this "meaninglessness" is merely an uninterrupted continuous action against the infinite."

Kusama
*Geijutsu Shincho*, May 1961

### Yayoi Kusama
born in 1929 in Matsumoto City, Nagano
lives in Tokyo

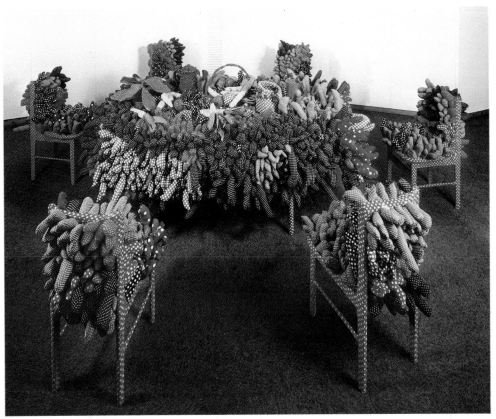

*Farewell Supper*, 1981, table and six armchairs, mixed media, 45½" × 11'2⅜" × 8'6⅜" (115 × 340 × 260 cm)

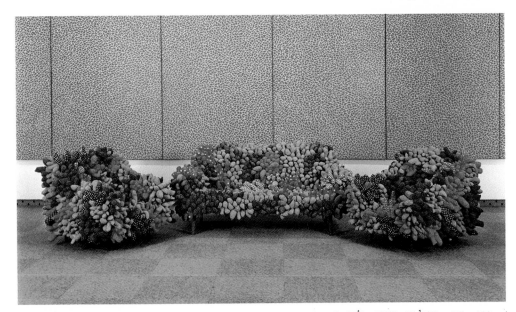

*Spring Festival* (multicolor polka dots), 1981, sofa and two armchairs, mixed media, 33½" × 13'6" × 51⅛" (85 × 410 × 130 cm)

# Japan
## Fuji Television Gallery
## Tokyo

## 清水九兵衛展

Kyubei Kiyomizu
born in 1922 in Aichi, Japan
lives in Kyoto City

I place importance on the interrelationship of one form to another in my work. In the case of my "Mask" and "Wig" series, this is between square shapes and curving flat shapes. I like flat forms and am interested in Chinese gems and traditional Japanese masks and wigs. I like the flat form and feel of gems and am especially attracted by their flowing and swelling richness. Masks and wigs have good forms of their own but take on an added breadth and depth of expression when worn by someone.

The composition of my works also focuses not only on the relationship between forms within the work but, for works placed on the floor, on the relationship between the work and the floor, and for works placed along the wall, on the relationship between the work and the wall. Among my outdoor sculptures, at first I largely made works to be placed on the surface of the earth, but gradually they came to be erected as I became more conscious of their background of trees or buildings. Then, using stainless steel pipes or rocks, I shifted my focus to the relationship between the work and its environment, between the work and the surface of the earth.

Therefore the location where an outdoor work is to be placed is a large factor in its composition. However, in the case of works to be placed in a room inside a building, only the flat planes below and behind the work become elements in the composition. Then I think of where the work should be placed only after it is completed, in a way similar to visualizing how a mask or wig could be used.

Remarks by the artist,
*from the catalogue*
*Translated by Hiroko Hoshii*

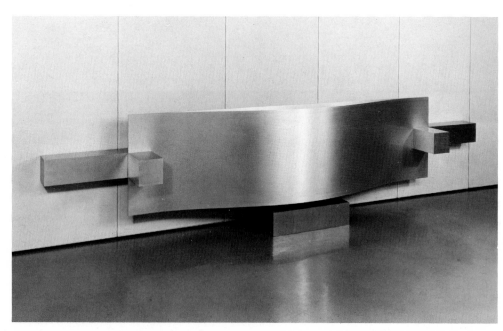

*Traverse-G*, 1982, aluminum, 48" × 17'1½" × 23⅝" (122 × 522 × 60 cm)

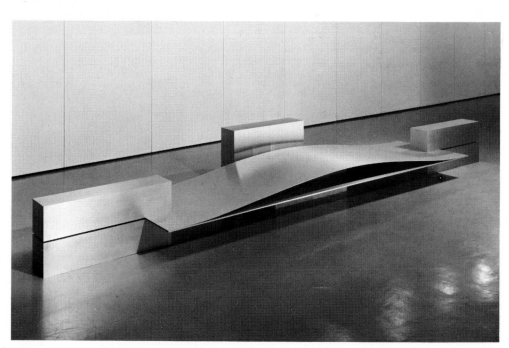

*Traverse-H*, 1982, aluminum, 23⅝" × 17'1½" 52⅜" (60 × 522 × 133 cm)

Kazuo Yuhara is the most outstanding abstract sculptor in Japan, primarily because of his extremely clear and fundamental concept of seeking only the essential in his works, without lyricism or literary elements, but also because of his profound social criticism.

Yuhara spent three years in Paris, returning to Japan in 1966. Upon his return he began using various materials produced by modern technology: stainless steel, cast aluminum, enameled iron, brass, glass and artificial fur. His use of these materials strengthened rather than altered his concept of form, which was based strictly on his own body. Therefore, while the shapes of his works have developed in various aspects, they never lose their direct substantial character. An example of this can be seen where, out of the combination of cylinders and cubes, appear the forms of an arch and a gate, the curved surfaces of the cylinders arranged in a row forming a wall and the door of the gate.

More than 50 of his representative sculptures, including his recent works, and 70 collage-dessins were shown at this exhibition organized by the Kanagawa Prefectural Modern Art Museum.

I found that, in his recent work, main subject matter moves from shapes to space and light.

This sculptor, who has spent much time in Europe looking at ancient, medieval and modern art in order to understand the occidental tradition of rationalism confronting irrationality, has now turned towards penetrating into the chaos of oriental irrationality, in search of a new rationality. As a result, his works have taken on an increasingly ironical attitude towards modern civilization and society.

Ichiro Hariu
*Original text*

**Kazuo Yuhara**
born in 1930 in Tokyo
lives in Tokyo

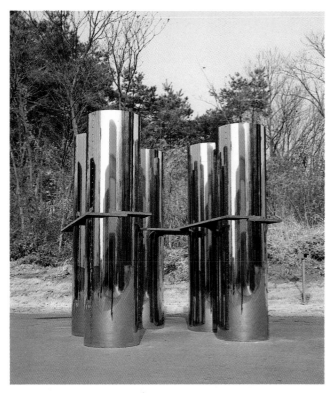

*Untitled*, 1982, stainless and coated steel, $73\frac{1}{2} \times 73\frac{1}{2} \times 78\frac{3}{4}''$ (1.85 × 1.85 × 2 m)

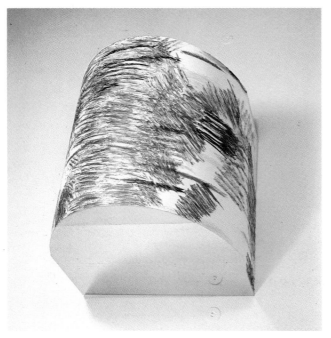

*Untitled*, 1981, acrylic, oil pastel, copper, and stainless steel, $24 \times 23\frac{5}{8} \times 23\frac{5}{8}''$

*Untitled*, 1982, cast aluminum, zinc-plated steel, and glass, $13'11'' \times 8'9'' \times 5'9\frac{5}{8}''$ (423 × 268 × 176,5 cm)

<現代美術の動向>1950年代

**The 1950 s**

There are two factors which should be recognized as having played an important role in promoting Japanese art of the 1950 s. The first is the organization of various experimental shows of prewar and contemporary artists (the latter chosen from the Yomiuri Independent Exhibition), by the poet and art critic Shuzo Takiguchi. The second is the appearance of articles in the little magazine *Art Critic* by young critics—Yoshiaki Tono, Yusuke Nakahara, and myself.

At the beginning of this decade, many avant-garde artists were still under the influence of prewar surrealism, although some of them had turned towards geometric abstraction. However, the Salon de Mai Tokyo exhibition influenced this generation in a variety of ways, and together with the successors of fauvism and the Ecole de Paris, they formed the main current. At the same time, younger artists, such as On Kawara, Shigeo Ishii, and the "Gutai" group, formed by Jiro Yoshihara, were exploiting new directions in the areas of happenings and various events.

The visit to Japan, in 1957, by Michel Tapié, Georges Mathieu, Sam Francis, and Toshimitsu Imai, and their demonstrations of the "Signifiant de l'Informel" and abstract expressionism, was to have its impact on Japanese art as well. There were, however, those artists, such as Shusaku Arakawa, Tetsumi Kudo, Tomio Miki, and Jiro Takamatsu, who were influenced by neo-dadaism and began seeking more radical directions of performance and object, in opposition to "l'Informel".

Ichiro Hariu
*Original text*

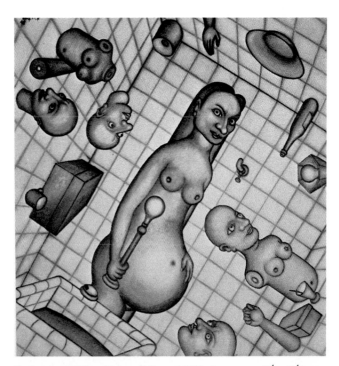

On Kawara, *Bathroom (Pregnant Woman)*, 1953, oil on canvas, $55\frac{1}{8} \times 53\frac{1}{8}''$

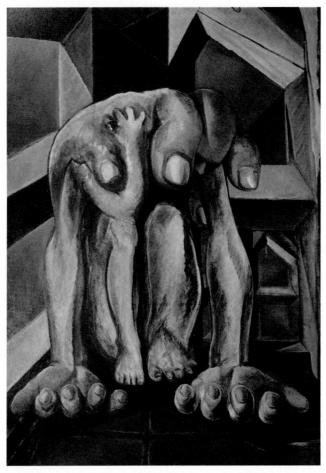

Masao Tsuruoka, *Heavy Hands*, 1949, oil on canvas, $51\frac{1}{8} \times 38\frac{1}{8}''$ (130 × 97 cm)

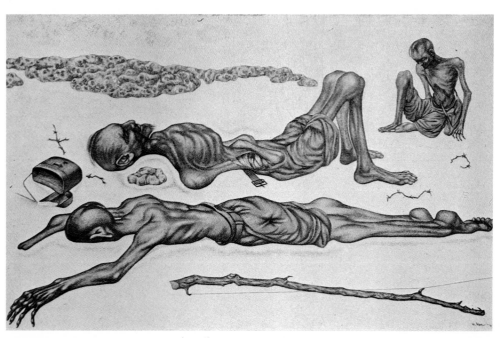

Nobuya Abe, *Hunger*, 1949, oil on canvas, $31\frac{1}{2} \times 51\frac{1}{8}''$ (80 × 130 cm)

The 1960 s was an age of great economic and industrial development in Japan. It was also the era of the Vietnamese War and the growth of third-world liberation movements. In the world of the arts, it marked the emergence of many international avant-garde trends—assemblage, op art, pop art, primary stucture, kenetic and minimal art, earth work, conceptual art and hyperrealism—all of which were successively and directly reflected in our arts, under the slogan of anti-art. By the end of this decade, most of these movements had been integrated and manipulated into the higher social and industrial structure by means of the Osaka Expo of 1970. At this time, one of my colleagues criticized this result by saying that all of this anti-art couldn't change art as a social system, but rather only demonstrated the impossibility of being non-art.

This exhibition, which was shown in our modern art museums, should have started from the point of view of looking for new meanings and possibilities for today's art, in that of the Sixties, but instead, it only succeeded in drawing a line of superficial conclusions. However, if we draw an analogy between this exhibition and the ages of man, the Sixties seem more like the Thirties, whereas the Fifties appear more like the Twenties. Thus the Sixties appear very strong and mature, especially as seen in the works of artists now living abroad, for example, Shusaku Arakawa, On Kawara, Ushio Shinohara, Tetsumi Kudo, Tomonori Toyofuku, Kenjiro Azuma and Minoru Niizuma.

I hope that the lack of a large audience doesn't discourage the national art museums from showing contemporary art.

Ichiro Hariu
*Original text*

### The 1960 s
A Decade of Change in Contemporary Japanese Art

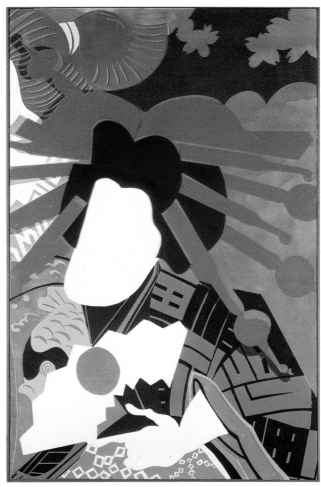

Ushio Shinohara, *Doll Festival*, 1966, oil on canvas, $76\frac{3}{8} \times 51\frac{1}{8}''$ (194 × 130 cm)

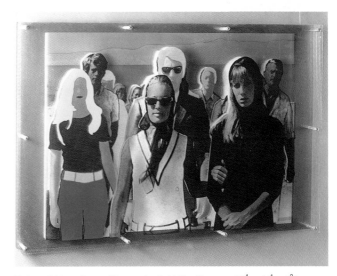

Tadanori Yokoö, *Funeral Procession II*, 1969, silkscreen, $29\frac{1}{2} \times 44\frac{1}{2} \times 4\frac{3}{4}''$

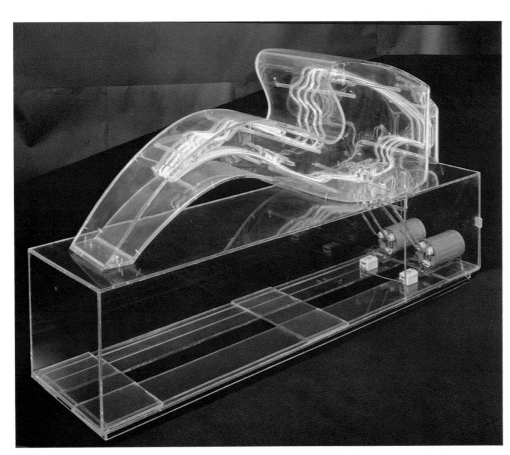

Masunobu Yoshimura, *Queen Semiramis II*, 1967, neon tubes, acrylic

# Japan
## K Gallery
## Tokyo
## 保科豊巳展

**Toyomi Hoshina**
born in 1953 in Nagano
lives in Tokyo

Toyomi Hoshina at the Paris Biennale

The visible aspect always represents only half of the whole meaning of my works. They are supported by the universe. The various materials used are not autonomous, and when self is mingled with their qualities, the result is a dynamism of will among these three elements (based on my own body scale and on all the senses).

The same weight is given to the materials, space, and the artist. I am not confined by the materials, and I do not depend overly on the situation. Nor do I impose my own image. My presence is neither external or internal but rather between the two, and signifies a surface on which my body and nature come into contact. The instant of linguistic utterance and the instant of sensory perception. I think of the apprehension and fear that ancient man felt toward his universe when encountering the primal source. I am concerned with dynamic life in itself.

Toyomi Hoshina
*from the catalogue, Paris Biennale*

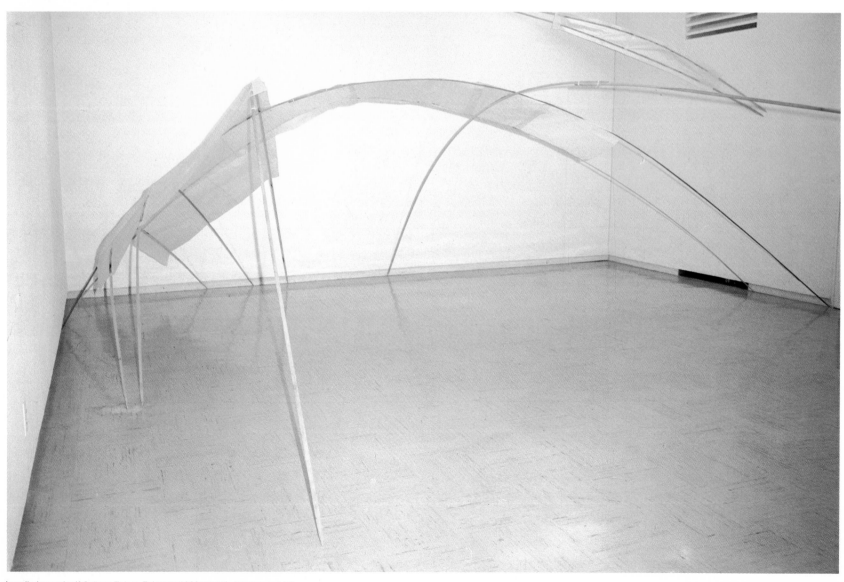

Installation at the K Gallery, Tokyo, February 1982; wood, Japan paper, ink

*Tono:* At the entrance to this exhibition there's a Cézanne still life in three dimensions, which gives everybody a shock. It's like a waterfall flowing off the table.
*Segal:* That work is a reaction against all the public sculptures that I've had to do these last years. When I did public sculptures, I suddenly had the impression of being thrown in among people who were strangers to me. And I'd had enough of listening to ignorant people making comments. So I decided to do what I like personally... This produced the Cézanne series. I'd never ceased to admire Cézanne. I chose a Cézanne reproduction, which I very rigorously translated into three dimensions. Due to the calculations in perspective, the table became a mountain and the apples glaciers. It was a very amusing game.

From an interview with Segal by Tono, *Geijutsu Shincho,* July 1982

When I applied the colors to the plaster, I discovered that it was an excellent support that absorbs color very well. Colors have always fascinated me. Before I started doing sculpture, I was a painter. At first my colors were red, yellow, blue, and white. Those are the ones that I'm now applying to my plaster works...

From an interview with Segal by Ito Masahiro, *Bijutsu Techo,* July 1982

**Japan**
**Seibu Museum of Art**
**Tokyo**
ジョージ・シーガル展

21

**George Segal**
born in 1924 in New York
lives in New Jersey

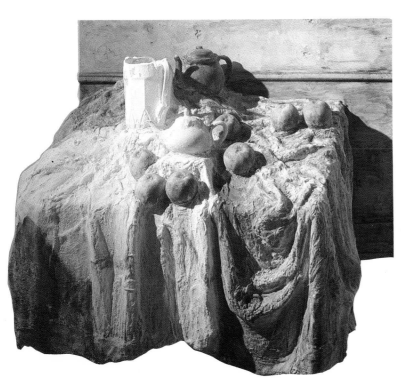

*Cézanne Still Life No. 2,* 1981, painted plaster, wood, and metal

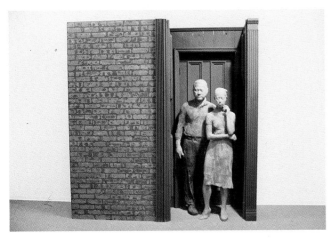

*Japanese Couple Against Brick Wall,* 1982, painted plaster and wood

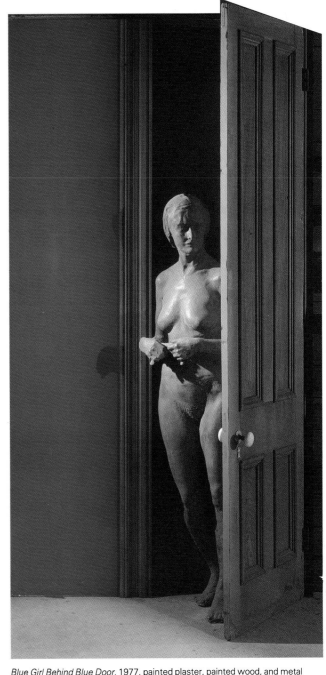

*Blue Girl Behind Blue Door,* 1977, painted plaster, painted wood, and metal

具象絵画の革命——セザンヌから今日まで

Revolutionary Figurations: From Cézanne to the Present

G. Fromanger, *Hommage à François Topino-Lebrun: la vie et la mort du peuple*, 1975-77

Jacques Monory, *Homage to Caspar David Friedrich No. 1*, oil on canvas, 5'3¾" × 8'6⅜" (162 × 260 cm), artist's collection

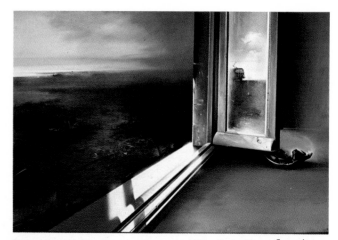

Christian Bouillé, *Les choses nous pensent*, 1980, oil on canvas, 44⅞ × 57⅛"

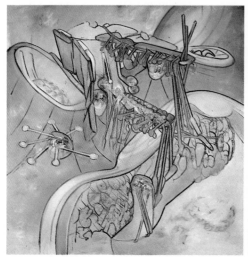
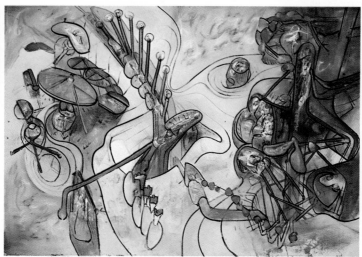
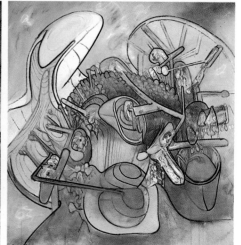

Roberto Matta, *La nature unie (United Nature)*, 1965, triptych, paint on canvas 6'6¾" × 6'6¾", 6'6¾" × 9'10⅛", 6'6¾" × 6'6¾" (200 × 200, 200 × 300, 200 × 200 cm)

Over half a century has passed since D.H. Lawrence said, "Ours is essentially a tragic age..."

In an age when plural values coexist in confusion, in an age, so to speak, of catastrophe, or in a situation where the whole of the world cannot be caught by a net of diverse relations such as cause and effect, resemblance, affinity or adjacency, in order to avoid being swept away by the waves of illusions and fashions that rise one after another and rush towards us, we need the help of the compass and luck...

It is probably easy to understand at once the individual phenomena shown in a work of art and the world they represent clearly. But today's artists know they should see in a work of art that there is a different world outside of it, or, in other words, that another world exists outside conventional understandings...

The idea that all men are equal leads eventually to the idea that all things are equal. There is no particular individual, object or colour that is central, but anything can become a centre anywhere.

A work of art is created by man the artist and there is no mistake about it, but that work also lives its own life and makes its own growth.

A good work of art betrays the original intention of its artist and reveals the depth he was not aware of. In other words, the deeply buried element which is a constituent of the structure of the society in which the artist lives and for which he is responsible to some extent as its member is revealed unintentionally. We can say that the structure which the artist makes up together with others whom he may not know personally or directly is revealed in some other form...

Kenjiro Okamoto
*from the catalogue*
*Translated by Mie Kakigahara*

Aspects of British Art Today

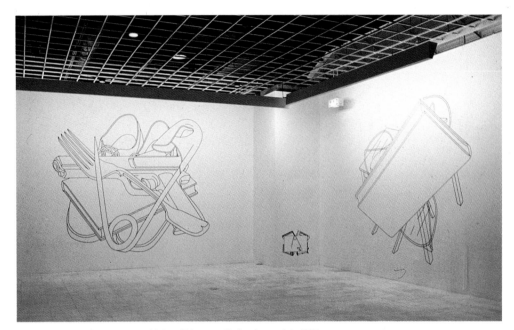

Michael Craig-Martin, installation, National Museum, Osaka, Japan, July 1982

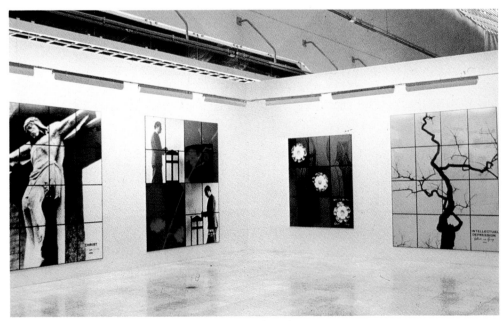

Gilbert & George, *Intellectual Depression*, 1980, photograph, 94½ × 78¾" (240 × 200 cm)

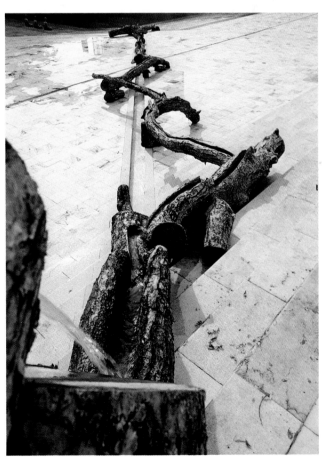

David Nash, *Waterfall Sculpture*, 1982, installation, Tochigi Museum of Fine Arts

# Japan
## Tanagi Gallery
## Nagoya
## 工藤哲巳展

Kudo
born in 1935 in Aomori
lives in Paris

Tetsumi Kudo

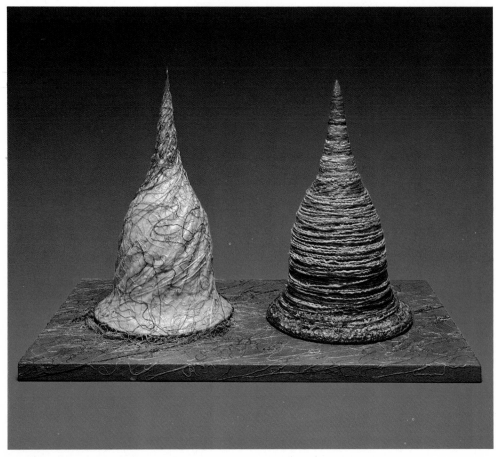

*The Void and the Chitterling*, 1980-81, wood, plastic and thread, 13 × 20⅛ × 12¼" (33 × 53 × 31 cm)

There used to be a saying in Japan: "The *manju*\* scares me, and since I hate sake, if I don't like a monk, I'll go so far as to hate his habit. If I hate his habit, the same goes for the monk!"

Ah, the wine of Paris! Ah, the Paris of wine! Here in my gloomy room in Sakuragaoka, I weep endlessly while remembering the excessive attachment of that woman... Ah, the tranquilizer is beginning to work! I'm sleepy...

I'm losing my grip. The dream carries me away across the desert plains...

Excuse me, Basho!

Staggering in the direction of Paris...

Here with the dream is Charles de Gaulle Airport. Quick, a glass of beer at the café counter! Next a taxi. Saint-Germain-des-Prés. A Pernod at the Deux-Magots. To the Saints Pères. Calves' brains, washed down with Bordeaux. And then that pear liqueur whose name I forget...

I'm like a wandering chimera in this woman's fleece... The future in my memory. I tug at the thread of memory, without knowing where I am. Edo, Tsugaru, and Paris intermingle like the thousand earthworms in my paintings.

In the labyrinth of hereditary chromosomes. That's what A.J. calls prison.

That's all nonsense! In fact, it's rather like a tangled magnetic tape 1/1000th of a millimeter in width that never stops, like a play of threads, like the space of an infinite whole. But if you want to talk about a prison, can you then tell me which is bigger, its inside or its outside? Of course, it's the inside that's bigger! And that's something that neither Alain nor François understands! So we're going to explain it to them. That the prison is too large. We're going to brainwash them with great Edo sake when they come to Japan this spring. We're going to clasp them in the arms, overflowing with affection, of great Edo and revolutionize their concept of freedom. It's your turn, gentlemen. Today I truly speak a decadent language. But I'm sure you'll love it.

Kudo, Tokyo, January 1982
*from the catalogue*

Titles like *The Unlost Light in the Labyrinth of the Hereditary Chromosome, The Independence of Memory* are not baubles taken from scientific vocabulary to add emphasis or humor to a sculptural work. They are an essential element of the work, and the work expresses a knowledge, with the ambiguity of the status of knowledge, at a time when only general philosophy existed and before experimental science was invented.

Henri-Alexis Batch
from "Aesthetic and Its Authors" *catalogue for the exhibition "Où" [Where], Galerie Paul Ambroise, Paris*

\**manju:* a soft, moist Japanese pastry. The word is often used for the female sex organ.

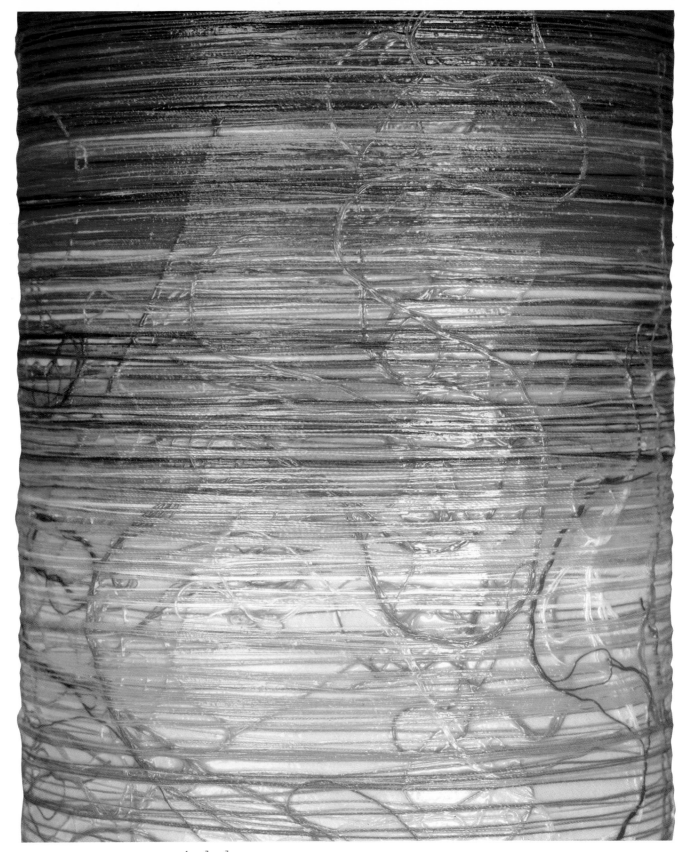

*Casket of Life,* 1981, plastic and thread, $23\frac{1}{4} \times 3\frac{7}{8} \times 3\frac{7}{8}''$ (59 × 10 × 10 cm)

# Korea
## Gallery of Seoul
## Seoul
## 日本現代美術展

Japan '70

For a long time now, academicism has been gone not just from the fine arts, but also from music and architecture. Multiple trends coexist; some have been around a while, others are quite recent. Hence, it is much more difficult today to predict the evolution of the fine arts. I am not all that familiar with the present-day world of the fine arts in Korea. However, it seems to me that the situation is more or less the same as we find in Japan. The chief trait of this exhibition, which is the first large-scale Korean showing of Japanese modern art, is the diversity of styles represented. Most of these works were done during the Seventies, and, aside from Takeo Yamaguchi and Yoshishige Saito, all these artists began their careers after World War II. Although regarded as the forerunners of Japanese abstract art, the works of these two artists are included because they are still representative of Japanese art.

Most of the other artists showing oil paintings debuted in the Fifties and Sixties. Among them, Jiro Takamatsu and Natsuyuki Nakanishi use not only oil but also acrylics. The artists who started out in the late Sixties and in the Seventies are distinguished by a wider variety of styles. Good examples of this are the works of Kohi Enokura and U-Fan Ri.

With Jiro Takamatsu, painting appears not as a means of transmitting an image, but as an end in itself. The works of Koji Enokura, who uses textiles, planks of engraved wood, and splotches of oil, are virtually paintings in relief.

In the domain of sculpture, the works of Yoshikuni Iida create a mirror effect by slanting steel against acrylic in order to reflect outside images. The works of Mogami and Koshimizu are representative of contemporary wood sculpture. Makio Yamaguchi works stone; some of his pieces recall the existence of the beings who came before us.

Nakahara
*from* "Reflections on the Exhibition," *the preface to the catalogue*
*Translated by Joachim Neugröschel*

Takeo Yamaguchi, *Encounters*, 1975, oil and plywood, 72 × 72"

Left to right: works by Koji Enokura, Hisayuki Mogami and Susumu Koshimizu

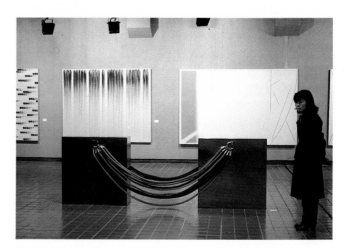

Yoskikuni Iida, *Hexahedron*, 1977-78, lead, stainless steel and nylon cables

At the initiative of an art critic, former aesthetics professor at the State University of Seoul, and former editor of the magazine *Criticism and Creation* (closed down after 20 years of literary activity by the 1979 censorship), a group exhibition bringing together 11 artists chosen by 11 art critics, was held at the Gallery of Seoul, which had opened in October 1981.

The show attested to a new wish to authenticate and test the most recent—and if not the most unexpected in the Korean context, at least the most outstanding—artistic achievements.

Thus from January 16 to February 12, 1982, 20 works—oils, watercolors, and sculptures—were displayed on the spacious premises of the Gallery of Seoul (given the scarcity and inadequacy of places in which to show contemporary art, this gallery is a remarkable site).

This exhibition duly reflected its organizers' desire for impartiality...

For a foreign spectator, most of the works in the exhibition evade established, identifiable categories, and the motivations governing the creative endeavors characteristic of these Korean artists are far from being clear to the eyes of a foreign public.

For example, Kim Yong-Min's *Landscapes,* mythographies inspired by sociological reflections very particular to South Korea, are not the sort of painting that easily accords with the aesthetic rules laid down by contemporary art in America or Europe.

On another level, the fact that some of the artists chosen belong to the Reality and Communication group has nothing to do with what a foreigner might spontaneously suppose as to their objectives or their common creative drive.

This preliminary exhibition, offering to the Korean public a group of works representative of various artistic endeavors, has made it possible to measure to what extent it has lost interest in the younger generation. Certain artists, such as Lim Ok-Sang or Kim Yong-Min, have acquired abroad a renown that does not seem to have helped them to be better understood in their own country. The exhibition has likewise produced a tangible reconciliation among art critics. One of them, Chang Biang Kwan, had long been interested in Surrealism in France and had presented Picasso and Miró in Korea but had disregarded those few Korean artists who were occasionally shown.

Let us also add that if the work of a Kim Jang-Sup or a Lim Ok-Sang lies outside the analyses that art historians have formulated and tested in Europe and the United States, it is because in Korea there is the absolute need to take into account the socio-cultural environment and the political facts to which creative mechanisms have adapted themselves.

*Based on remarks by Mr Kim Yoon Soo*
*Translated by John Shepley*

Kim Kyung-In, *Women,* 1981, acrylic on canvas, 44½ × 57½″ (112 × 145.5 cm)

11 Artists, 11 Critics

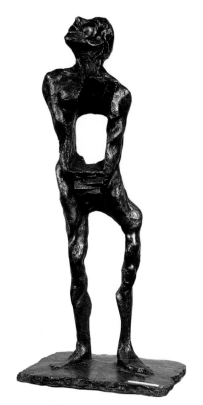

Shim Jung Soo, *Man with Gaping Chest,* 1981, bronze

Kim Jang-Sup, *The Matter,* 1980, cement block, wood and carbon pigment

Kim Yong-Min, *Landscape 1,* detail, 1981, watercolors, pencil and ink, pasted on paper, 45½ × 31⅛″ (115 × 79 cm)

# Korea
## Kwan Hun Gallery
## Seoul
李升澤展

born in 1932 in Go Won Ham Nam, Korea
lives in Seoul

*Cho:* When people speak of the sculptor Lee Seung-taek, they think first of all of the man who from the beginning of his career has refused to participate in the National Exhibition, a fact that has given your work a particular character. In characterizing your works, you have often spoken of "anti-sculpture"...

*Lee:* At the beginning of my career, I tried to follow the current of modern Korean sculpture. It was, however, inevitable that at a certain moment I would separate myself from that current—I was determined to build my own world. For me, the term "anti-sculpture" means that I work against the current of modern Korean sculpture...

*Cho:* It seems to me that you always try to show your works in the open air or even in natural surroundings.

*Lee:* The external environment possesses a very strong character beyond our imagination, while an interior one limits our view, leading us to concentrate on the works themselves. In the open, the trees, forests, and hilltops are actually volumes that cause a stereoscopic effect. It is very hard for works to get the better of nature. So I hung some of my works from trees, which gave the illusion of large flower buds...

Then I began to "tie up" my works, thus symbolizing the body of woman. Nobody at that time had yet treated the woman's body from the conceptual angle. In fact, the usual thing is to treat it solely on an anatomical basis. Well, I saw an effect of contrast between the constricted part and the swollen part of the supple skin of a woman's nude body, making it emanate a sensual beauty...

I've been fighting myself for more than twenty years. You can see the repercussions of it in my work. Once I've finished a work, I always try to free myself from it. In other words, I keep striving to destroy and change myself. To me, the process of self-destruction is inherent in the nature of the artist. When someone appreciates one of my works, I immediately try to escape from that work—the sympathy or praise of a third party are warnings that should put you on guard against an excessive materialization or vulgarization.

*Excerpts from an interview with Lee Seung-taek by Cho Choung-kwon from the catalogue*
*Translated by John Shepley*

*Untitled*, 1980, tree, cloth, cord, h. 13' (4 m)

*Untitled*, 1981, tree, cloth, cord.

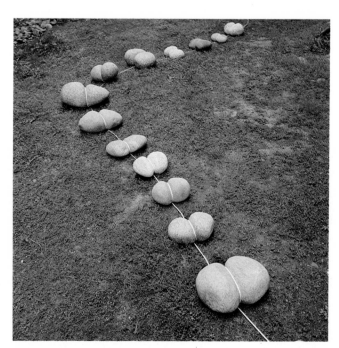

*Untitled*, 1975, cord, stone, 36'5" × 2" (11.1 m × 5 cm)

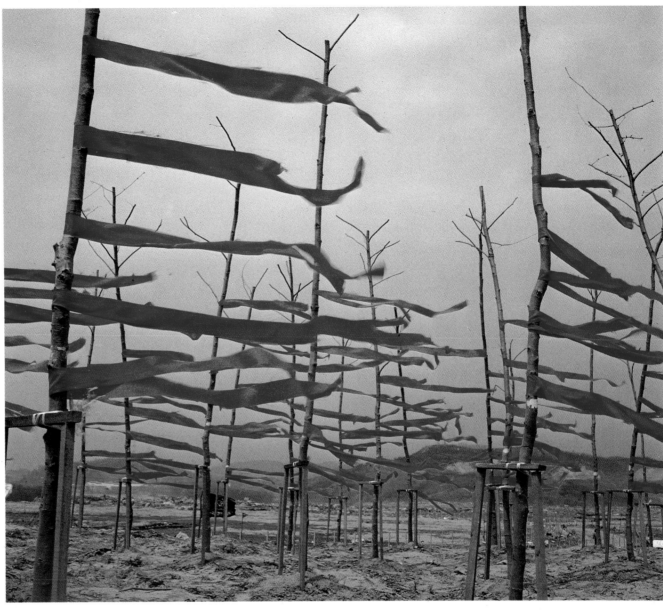

*Wind,* 1972, cloth and tree, 16 × 12 × 2″ (40 × 30 × 5 cm

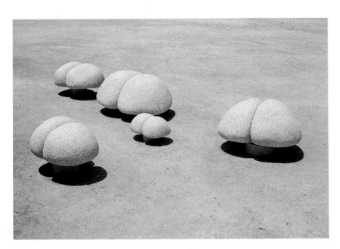

*Untitled,* 1978, stones, 96′ × 32′ (30 × 10 m)

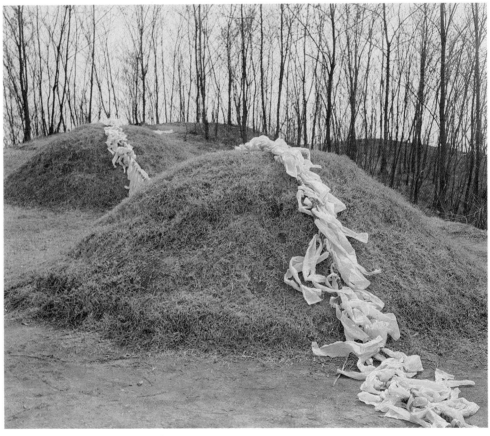

*Untitled,* 1973, cloth and tomb, 128′ × 6½′ (40 × 2 m)

Philippe Briet was invited to Beijing, Hang-Zhou, and Canton by the Chinese Exhibitions Agency in March 1982 in preparation for the arrival in France of an exhibition of young Chinese painters aged 20 to 35. M. Briet has brought back a number of photographs taken in the course of the numerous visits he paid to artists' studios during his visit.

*Editor's note*

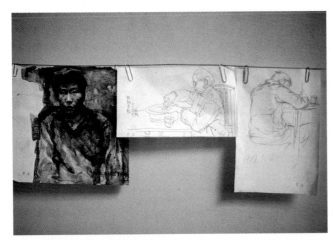

Drawings depicting scenes of daily life, School of Fine Arts, Peking

Western influence reflected in the vibrant colors of a traditional painting

Painting studio, School of Fine Arts, Peking

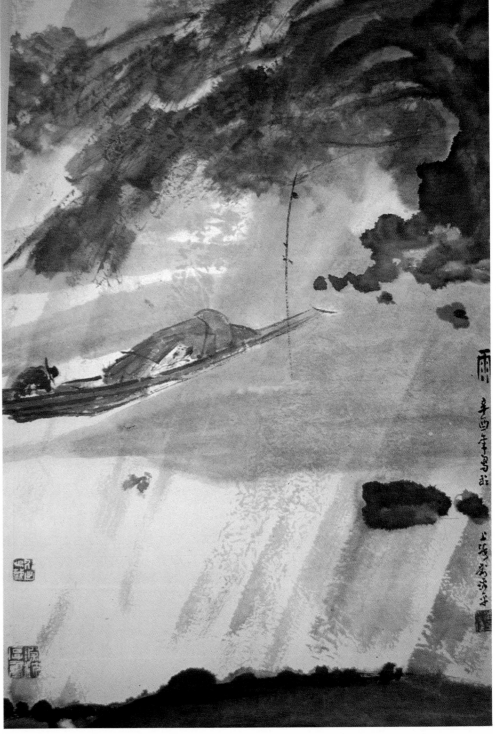

Chinese ink sketch  School of Fine Arts, Peking

Oil painting class, Institute of Fine Arts, Peking

Exhibition of regional artists from Zhejang Province, Hang-Zhou

Painting studio, Institute of Fine Arts, Peking

Traditional Chinese painting

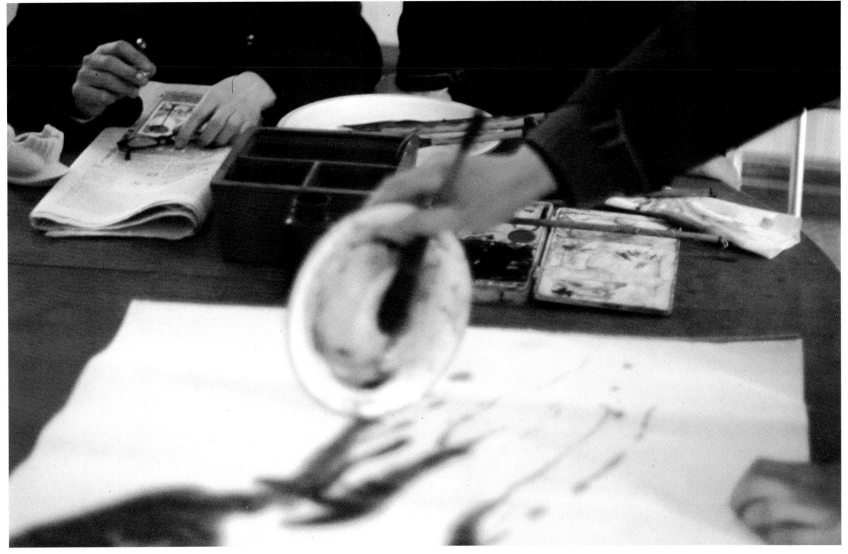

Traditional techniques presented for the westerner

## Finland

### Helsingin kaupungin taidemuseo
### Helsinki

### Helsinki Summer
### Dale Eldred

born in 1934 in Minneapolis, Minnesota, USA
lives in Kansas City, Missouri

Dale Eldred is one of the most prominent sculptors in contemporary American art. Since the end of the 1970s, he has devoted himself entirely to large-scale light sculptures. In rapid succession he has "conquered" the cities of Houston and Corpus Christi in Texas; St. Petersburg, Florida; Phoenix, Arizona; Kansas City, Missouri; and Boston, Massachusetts; now he is working on Helsinki, Finland.

Dale Eldred actually takes over a city when he works. He utilizes its geographical location and architectural profile; spatially alters its buildings, its parks and its horizons; and exposes his audience to some of the basic elements of life—energy, rhythm, pulse and interrelationship.

With the varying reds, yellows, greens, and blues of the spectrum, Dale Eldred succeeds in emphasizing certain basic interdependencies: there is no light without shadow; the sun and the earth rotate around each other, and this rotation is controlled by two forces, velocity and gravity. Reflection is the second generation of light; reflection continues its path at a given angle, and it can be bent around—downwards to the inner corridors of pyramids, for instance.

Eldred's work entails the creation of controversy. His works contain every level of meaning: a celebration of everyday life; a seed growing into a flower; or the concept he has chosen to be the main theme of his Helsinki exhibition—spring turning into summer, the zenith of the sun, and earth turning again towards autumn after the summer solstice.

*from the catalogue*

The human life cycle used to be intimately related to light. Men got up and went to sleep by the sun. They measured time by the shadows their own bodies cast on the earth in the sun's light. Light and shadow were equally immediate influences in their lives.

In my work, I return to this concept of light and shadow as entities directly related to the human condition. The work deals with the cycles of relationships between man, the earth, and the sun.

Dale Eldred
*from "The Vital Element" in the catalogue*

*Esplanade Diffraction Panels:* detail of one panel around noon, $9\frac{3}{4}' \times 96'$ (3 × 30 m)

*Esplanade Diffraction Panels:* reflection in shop window

*Esplanade Diffraction Panels:* panel around 3 p.m.

*Space Defined by Light:* installation in Jugendsali Museum

*Projects Drawings:* drawing of installation in Töölönlahti (Gulf of Finland), showing sun's line of incidence, Mylar, 32 × 42″ (82 × 107 cm)

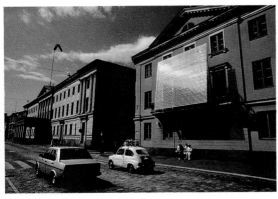

*Senate Square Diffraction Panels:* around 2 p.m., $16\frac{1}{2}$′ × $19\frac{1}{2}$′ (5 × 6 m)

*Töölönlahti Water Diffraction Units:* 100 units, 16 × 16″ (40 × 40 cm)

*Harbor/Market Diffraction Panel:* around 2 p.m., $16\frac{1}{2}$ × $19\frac{1}{2}$′ (5 × 6)

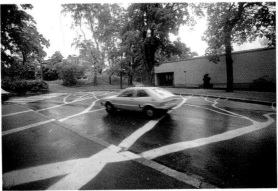

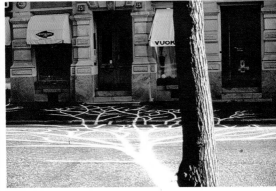

*Helsinki City Art Museum Painted Shadows:* entrance to museum

*Esplanade Painted Shadows:* shadows of trees, May 30 at noon

*Trams an Painted Shadows*

# Sweden
## Moderna Museet
## Stockholm

## EKO
## Englund, Kirschenbaum, Ohlin

Call it a coincidence that the initial letters of the three artists' surnames form an EKO, echoing, as it were, the ecological approach. But coincidences of this kind can be supremely meaningful...

One factor common to all three artists is that they allow themselves a diversity of materials, structures, and forms, without any confusion or failure of vision. All three produce an art that is full of surprises, but never for an instant deviating from its purpose, its "inner necessity," as Kandinsky would have called it. Even so, their aesthetic approach proves that it can operate beyond the narrow boundaries that its detractors are accustomed to lay down for it.

They create forms whose ethic is the freedom *to* rather than the freedom *from*...

Thus, together, these artists expand the space they fill with their works, not only physically but also metaphysically. As we stand there, we can—if only we will—realize that through our creative acts we are able to reconcile ourselves to the world and to nature, and to do so with the same energy that we have devoted to separating ourselves from them. This we can do without changing in any respect our nature as human beings. The question is simply whether we are to create ourselves for life or for death.

Olle Granath, *Moderna Museet,* No. 1, 1982

Bernard Kirschenbaum, *Kättingvalv,* 1981, chain

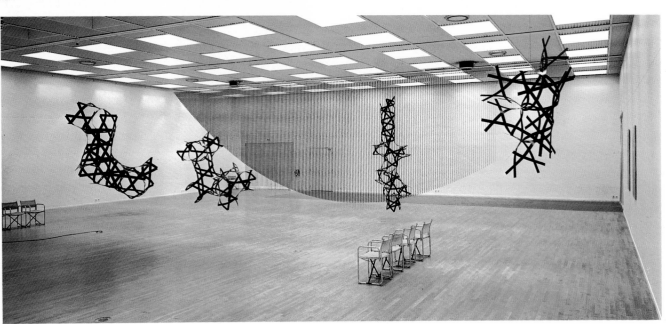

Group of sculptures: Lars Englund, *Untitled,* charcoal fibers; rear, Bernard Kirschenbaum, *Blue Steel Parabola,* 1981, steel

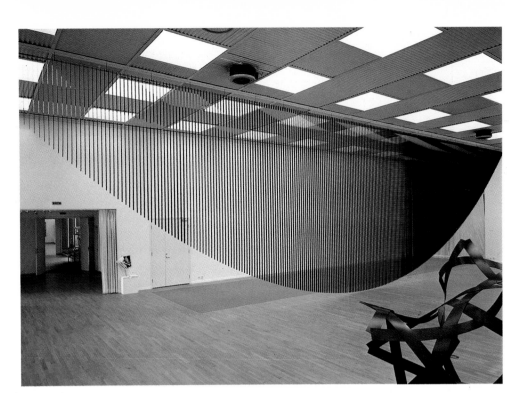

Bernard Kirschenbaum, general view with sculptures: *Blue Steel Parabola,* 1981, steel

Kjell Ohlin, Partitura (score), program for the *Anadyomene* installation, 1982

Kjell Ohlin, *Anadyomene,* 1982: view of installation and detail (a computer projects light through water onto a canvas), mixed media, 11'2⅛" × 11'2⅛" (340 × 340 cm)

# Sweden
## Lunds Konsthalle
## Lund

## Materia/Minne
## Breivik, Håfström, Knutsson

Matter and Memory

"Matter and Memory" is a project that has grown out of a continuous dialogue between three artists—Bård Breivik, Jan Håfström, and Anders Knutsson—and three art critics—Douglas Feuk, Bo Nilsson, and Lars Nittve. The project has taken concrete form as an exhibition at Lunds Konsthall.

We wished to abandon the usual procedure of arranging exhibitions, which ordains that the artist should prepare the show independently or in collaboration with the staff of the museum. "Matter and Memory" is the result of close cooperation between artists, museum staff and critics, a process which has involved constant and enriching interplay of creative ideas and practical considerations. The texts of the catalogue and the exhibited items constitute a vital unity.

Cecilia Nelson
*from the catalogue*

Anders Knutsson, *Regatta*, 1975, wax and oil on primed linen, 74¾ × 68⅞" (190 × 175 cm)

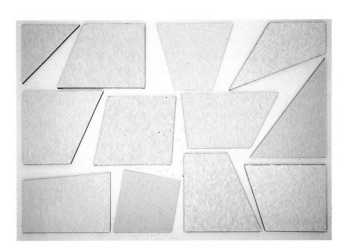

Anders Knutsson, *Lärjungara (The Disciples)*, 1981, wax and oil/linen, 8'⅛" × 12"

Jan Håfström, *Double Rose Ladder,* 1981, acrylic/wood, $39\frac{3}{8} \times 63''$ (1 × 1.6 m)

Jan Håfström, *Fönster I (Window I),* 1981, acrylic on wood, $50 \times 37\frac{3}{8}''$ (127 × 95 cm)

Bård Breivik, "Fiber" installation at Sonja Henie-Niels Onstad Foundation in 1981, wood and fibers, h.$82\frac{5}{8}''$ (210 cm)

# Norway
## Henie-Onstad Kunstsenter
## Høvikodden

## Fiber
## Bård Breivik

born in 1948 in Bergen, Norway
lives in Stockholm, Sweden

The works in this series are the result of several months' work at Jordan's brush factory in Oslo...
A brush has a primary construction, like structures in insects, with organic but also mathematical/geometrical principles of construction. This requires a really organic way of thinking, since it has to do with living material that has grown, either on animals or in plants...
After walking round Jordan's, I realized that the factory contained craftsmanship, material and a technology that opened up undreamt of visual possibilities, I got in touch with the management and was given permission to work at the factory for four months. What a marvelous feeling...

There my wish to realize quite new objects and take part in solving the purely material problems yielded purely professional respect: Feeling that one's profession has not only an abstract value but also a concrete one; feeling communication grow and that the attitudes (the values one works with) spread. Not because of the completed picture but how the process they take part in opens up ideas and understanding about one's own situation, profession, time, place in people who prefer to keep to imagery at a distance, and who may perhaps be quite at a loss when confronted with the finished work. Suddenly, through being in touch with the work process per se, they perhaps understand what pictorial art is all about.

Bård Breivik
from "Fiber" Kalejdoskop Förlag, 1981, *published in connection with Bård Breivik exhibition*
*Translated by Muriel Lansson*

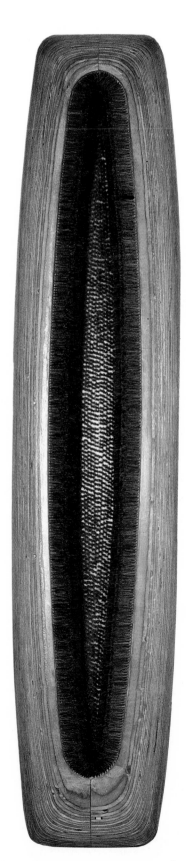

A work from the *Fiber* series, 1981, wood and fibers, h.82⅝" (210 cm)

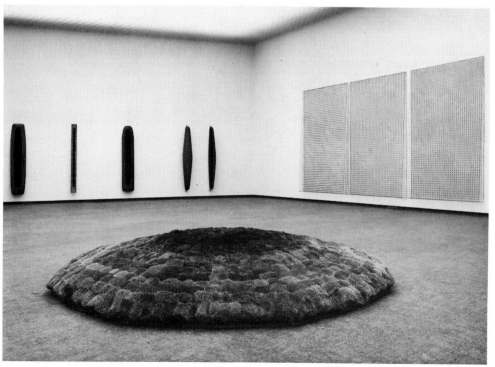

View of "Fiber" installation, 1981

The exhibition gives an impressive outlook on the communicative aspect of Joseph Beuys's work. He has worked in a wide range of print media, from etchings to photos, postcards and newspaper cutouts. The multiplied objects are mostly "found objects," slightly manipulated or just signed and inscribed by the artist. Also the ideas/contents cover a vast area from German mythology to personal experience of death and violence.

There is hardly any artist who has more intensely taken part in his own time than has Joseph Beuys, and hardly any who has more precisely and without mercy formulated central problems of our time...

He has placed himself in the center of fight and discussion, and by entering situations of this kind, contributed to formulating issues and problems, bringing out into the daylight connections hidden or forgotten, and thereby made it possible for us to see them and make up our minds about them.

By doing so, Beuys has contributed to changing the role of the artist itself—one of the most sacred cows in Western culture.

Beuys is not an ivory tower artist, neither a cool observer, nor a rebellious provocateur. He is *in* the situation, *taking* part, creating new situations, new movement. In this sense, Beuys becomes part of a strong tradition in modern art, started by the dadaist (if not even before), and very strongly formulated by the abstract artists of the Forties and Fifties. But they were never able to bring their ideas into reality. On the contrary: they disappeared from the streets into the cosy comfort of the Establishment. Most of them at least. The same thing happened to the pop artists.

Beuys has never let himself be captured by established temptations. He has, with great strategy and maximum alertness, always fought for—and been able to keep—his freedom.

Per Hovdenakk
*from an article in* Prismanytt, *N°. 1, 1982, on the occasion of the exhibition*

born in 1921 in Kleve, West Germany
lives in Düsseldorf

Showcase, 1982, assorted objects

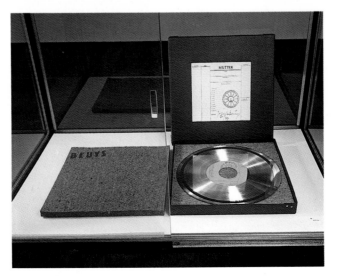

Showcase, 1982, assorted objects

Joseph Beuys at the Oslo Art Academy September 1982

# Denmark
## Louisiana, Museum of Modern Art
## Humlebæk

### Sydfløjen abner

Opening of the New South Wing and Robert Irwin exhibition
born in 1928 in Long Beach, California
lives in Los Angeles

Our aim is that a walk round the museum and park should be somewhat like a journey. A sense of expectation is continuously stimulated and maintained. The attention is held fast because the rooms are never alike, each one is different from the next—narrow, wide, low or high, and with different lighting. This, I believe, is experienced by the visitor as something positive. The works of art also benefit by this diversity, as their special characteristics can be emphasized more easily than if they were displayed in uniform surroundings. What appear to be different considerations—the landscape, the work of art, the museum visitors—are actually coincident in many ways...

The new wing is located on ground that rises steeply, and as the buildings follow the slope but maintain the same floor level inside, the height from the floor to ceiling gradually increases. By building into the terrain the architects have to some extent reduced the exterior of the buildings, and at the same time achieved high, closed spaces, creating a tranquil setting with optimal daylight, which brings out the qualities of each work of art. Here again the aim has been to create a balanced interplay between architecture and art, while from the outside the buildings' surfaces and their mass engage in a kind of dialogue with the rich wooded scenery surrounding them.

Knud W. Jensen, *from the introduction to the catalogue*
*Translated by Jean Olsen*

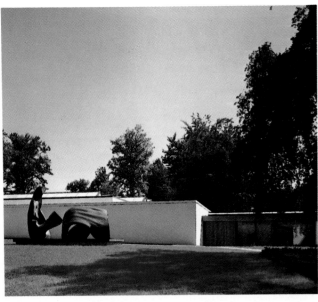

View of south wing, 1982, with sculpture by Henry Moore, 1974-75

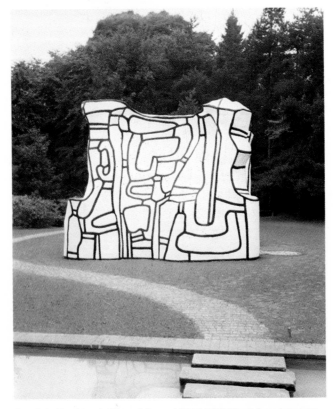

Jean Dubuffet, *Manoir d'Essor (Manor of Flight)*, 1969-82, reinforced concrete

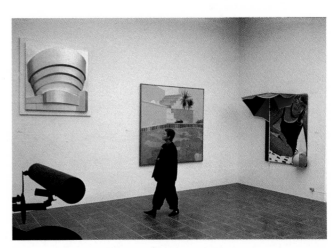

Left to right: works by Richard Hamilton, David Hockney and Martial Raysse

This work is about presence. It is not a metaphor for anything else. It is not about social commentary, political rhetoric or intellectual "meaning games."

It is about form, relation, space, light and order.

It is a particular social bias to cast the meaning of art to be in the present. But the meaning of art's presence as we experience it, is in what we call the future and reveals itself only in time.

In short, this is a work about seeing.

These three rooms are a tactile response to the passage, geometry, space and light that existed before I came.

Robert Irwin
*from the catalogue*

View of installation: screens of silk suspended from ceiling

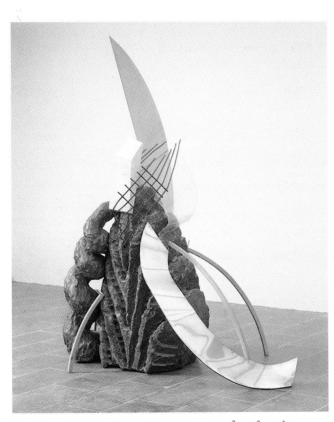

Bjørn Nørgaard, *Spiralen (Spiral)*, 1980, mixed media, 79⅞ × 65¾ × 45¼″

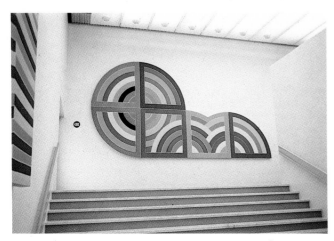

Frank Stella, *Ctesiphon II*, 1967, fluorescent paint on canvas, 10′2⅜″ × 20′

View of installation: painted wooden boxes and screen of silk

View of installation: screens of silk suspended from ceiling

# The Netherlands

## Stedelijk Museum
## Amsterdam

'60'80
attitudes/concepts/images

The purpose of the exhibit 60'80' is to portray the renewal and change which has taken place in the period 1960-1980—two decades marked by an exceptional vitality which broke through established trends and norms, placing in question existing concepts about the nature and function of art. One of the most important features of contemporary art is that it breaks down barriers and makes new propositions—propositions which go against the accepted aesthetic and which confront the public with the unknown and the yet unseen. The fundamental function of art within culture/society, which by nature attempts to prevent change, is to become an element of continual movement and freedom. It is the duty of a museum to give ample attention to new forms although they may draw negative reactions. Only through gradual exposure shall the new vision be accepted and absorbed into the general cultural framework. Altered conceptions about the nature and function of art have cleared the way for a much freer use of materials.

Meanwhile, art products in the form of film, photographs and video have made their appearance not only as media for recording or communicating, but also as autonomous image-projecting materials. Many artists used these new forms in other disciplines such as music, dance and theater, producing results which broke through the barriers of fine arts in a previously unforeseen way. Also, there was a growing desire to come into direct contact with the public, by means of happenings, performances, installations, environments and activities where participation from the public was expected, for example. In conclusion, one can say that in those twenty years, the doors of the fine arts have been thrown completely open and art has become more a question of attitude for the artist as well as for the public.

The exhibit was assembled without historical perspective, styles or movements in mind. A representation of the artist's meaningful works was chosen; those which have, to an important degree, determined the overall image of the fine arts in those twenty years.

Karel Schampers
*from the catalogue*

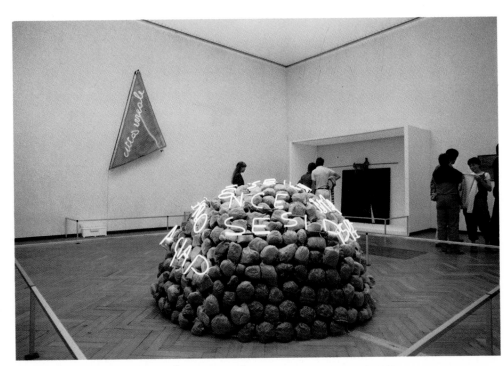

Mario Merz, *Iglo di Giap*, 1968, diam, 6'6¾" (200 cm), h. 47¼" (120 cm) ; on wall : *Città Irreale*, 1968

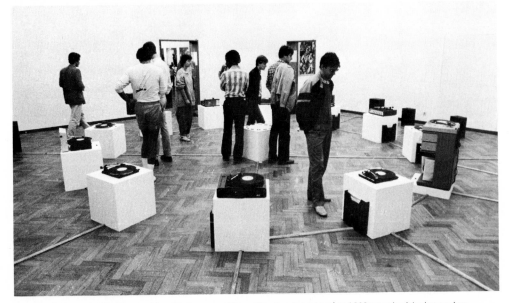

John Cage, *33-1/3*, 1969, 12 turntables, 12 stereo amplifiers, 12 pairs of speakers, and 300 records picked at random

Richard Serra, *Untitled*, 1966, variable height × 6'1¼" (186 cm)

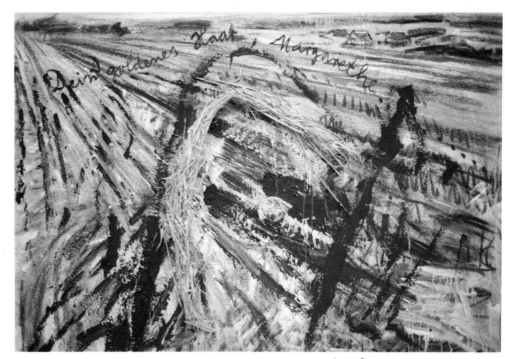

Anselm Kiefer, *Dein goldenes Haar, Margarete,* 1981, oil and straw on canvas, 51⅛″ × 66⅞″ (130 × 170 cm)

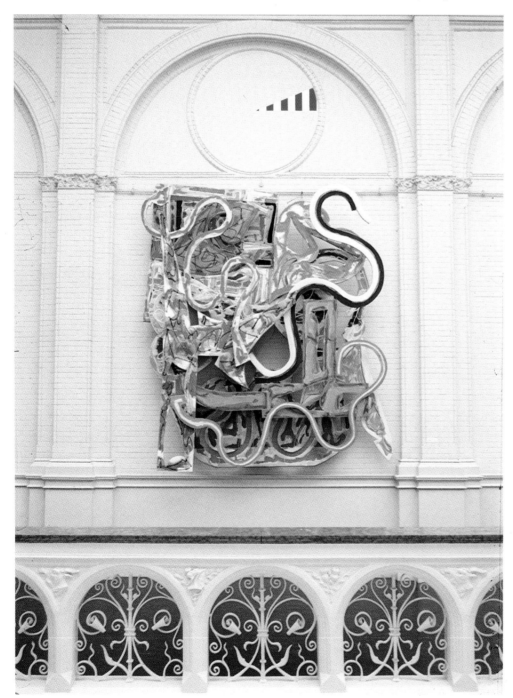

Frank Stella, *Pau,* 1981, mixed media on aluminium, 10′8″ × 9′6½″ (325 × 290 cm)

Sigurdur Gudmundsson, *Het grote gedicht,* 1980-81, mixed media, 1⅛″ × 49¼″ × 49¼″

Roger Raveel, *De stilte na het schot,* 1978, oil on canvas, 6′4¾″ × 4′9⅛″

# The Netherlands
## Museum Boymans-van Beuningen
## Rotterdam

44

## Werkers
## Jonathan Borofsky

Workers
born in 1942 in Boston, Massachusetts
lives in Venice, California

The rose heart, detail of the *Business Man*

The American, Jonathan Borofsky, designed this installation especially for the Boymans-van Beuningen Museum. He worked here for a number of weeks, the rooms serving as his atelier. In one room stand five giant-like, black silhouettes of men with motorized arms who endlessly hammer upon an undefined object. Seen against the ceiling in the other room is a silhouette of a man with overcoat, brief case and fedora, painted onto 90 transparent, numbered plexiglass panels. These numbers have a connection with a project, "Counting," which Borofsky started in 1969. By writing numbers continuously on pieces of paper, beginning with "I," he restricted his thought processes to one activity, to keep him focused. After some years, numbered sketches began to appear which also developed into [numbered] drawings and paintings. The projected drawings, enlarged on the walls as well as the floors and ceilings, gave rise to installations which encompassed the entire space. Although he currently devotes less time to counting, it remains an important activity for him. His methodical system, from which all else originates, is the expression of his conceptual interest. Each work is given a number which is bound to its inception...

Borofsky's installations are precipitated by his own dreams, sketches, personal graffiti, self portraits, observations, photographs, blown up on a large scale...

Besides the personal, the universal plays a large role. According to him there exists a relationship between him, the very personal and the archetypal—the primitive experience which is recognizable by everyone.

Lon Schröder
*from the catalogue*

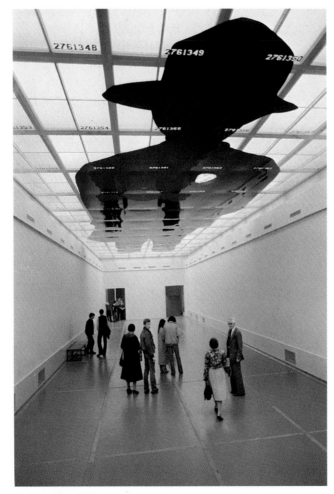

*Business Man*, 1982

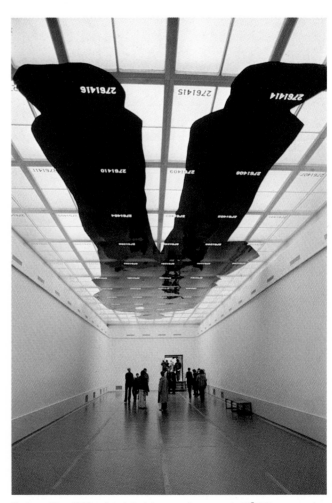

*Business Man*, 1982, painted plexiglass panels, approx. L. 98⁵" (30 m approx.)

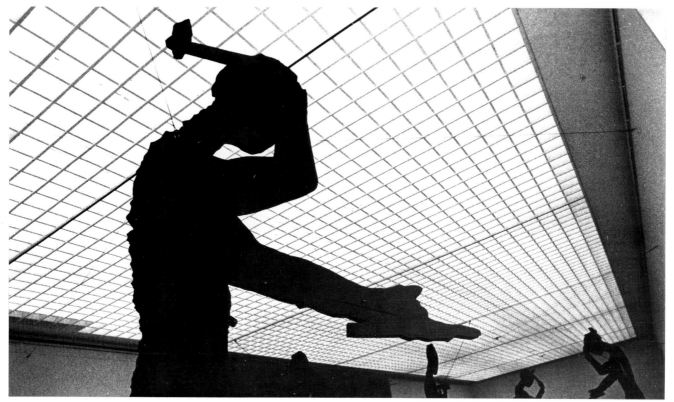

*Hammering Man*, 1982, detail, composition board reinforced with aluminum braces

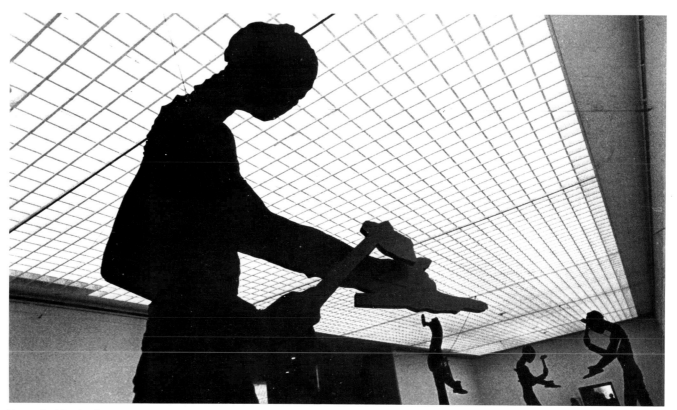

*Hammering Man*, detail

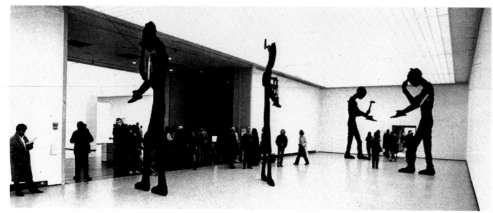

General view of gallery containing one of the installations of Borofsky's "Workers"

# The Netherlands
## Stedelijk Van Abbemuseum
## Eindhoven

## Jannis Kounellis

born in 1936 in Piraeus, Greece
lives in Rome, Italy

*Untitled*, 1975, pedestal, plaster head, and bottled gas

Human beings are, dangerously maybe, attracted to the unknown: to the *fabulous* unknown. You once remarked, I remember, that the most beautiful, the perfect interview would be to talk with Christopher Columbus aboard the *Santa Maria* on his way to America. The unknown is our destiny—our fate, really. The desire to *know* takes us beyond our fear. Do you remember how we once, during a lunch in the sun, had a long conversation about nomads? It started with the observation that art, in the present culture (which is, in many ways extremely brutal although physical life is much more secure: that is the contradiction which endangers us)—that art had become homeless: a refugee. Your art, too, gives that impression. It is characterized by an incredible distance: a deep, dark space *inside,* like in music, or like the ever moving sea of which one does not know where she begins or where she ends. (Was not that the fear of the early navigators: where does the sea end, beyond which horizon?)—What I mean to say, Jannis, is that the actual center in your works, if there is one, cannot be located. That, I suspect, is your attraction to Christopher Columbus who did not really know where he was going. The distance lured him into the great unknown of the ocean. But he knew that he was going somewhere. Art had become homeless, we observed, at lunch. This makes the artist into a nomad, back at the beginning of time, setting out once more to discover Paradise. You sit there, the mask covering your face, overlooking the broken remnants of ancient culture, shattered Apollo—and you sing your slow *lamentos.* You look and you look, Kounellis, at those fragments; you wait for the Delphic oracle; you watch for a small sign that might point the way to Paradise...

Rudi Fuchs, *"Letter" (fragment)*
*from the catalogue*

*Untitled,* 1978, ship model on pile of burlap bags

*Untitled,* 1976, chimney

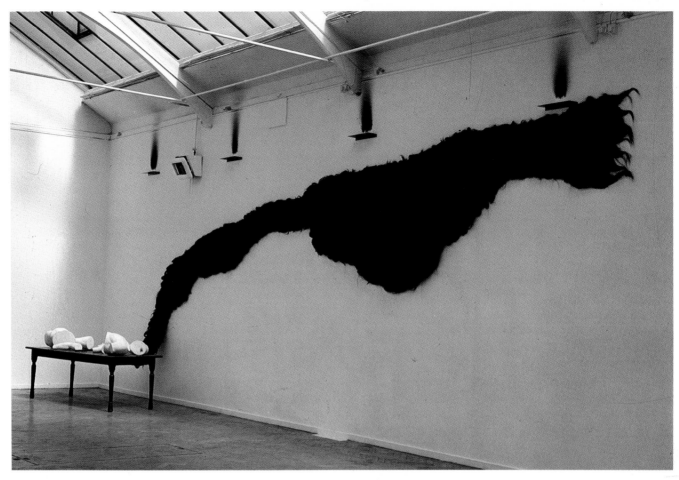

*Appollo Notorno,* 1975, casts of anatomical parts on table, horsehair in the shape of a cloud of smoke on wall

*Libertà o Morte, W Marat, W Robespierre,* 1969, blackboard and bottled gas

*Untitled,* 1971, bottled gas series

# The Netherlands
## Stedelijk Museum
## Amsterdam

## Julian Schnabel

born in 1951 in New York
lives in New York

*Untitled*, 1980, plates, putty, oil paint, wax and epoxy on wood, 95⅝ × 83⅞ × 7⅞″

Julian Schnabel in his New York studio, February 1982

Schnabel has defined a generation in terms of himself. He is the measure of his contemporaries. In this sense he is not American. One's contemporaries are no longer American. America needed American art, and America never felt it had it. The wars that destroyed the continent of Europe left America to pick up the torch and run mightily with it as the traditions of European painting were bombed out, first in Russia by censorship, then on through the cultural incineration of the Third Reich to the ultimate rape of the entire youth of Europe: the death of young men who would have probably become painters if their brains hadn't been blown out at nineteen. America produced great painters because some place had to. You can't kill painting. There is a curious historical need to have great painting going on someplace at all times. Nor can you forcibly kill a viable tradition in painting. Painting is stronger than war, or government or taste. You can burn it or build a city over it, but like grass pushing up through concrete, it will flourish. They couldn't kill constructivism, it just popped up somewhere else. The importance of German expressionism is proved by the fact that when Germany was ready to paint again, as if there had been no war, is if an entire generation hadn't been lost, it started up again right where it had left off. Julian was the first American to locate himself firmly with other artists all over the world, spread the news that there was new art in the old world, create an interest in European painting and eliminate the fantastic notion that European painting was dead... He is an international artist: the young American artist of international calibre, but always in a class by himself.

Rene Ricard
*from the catalogue*

The painter's New York studio

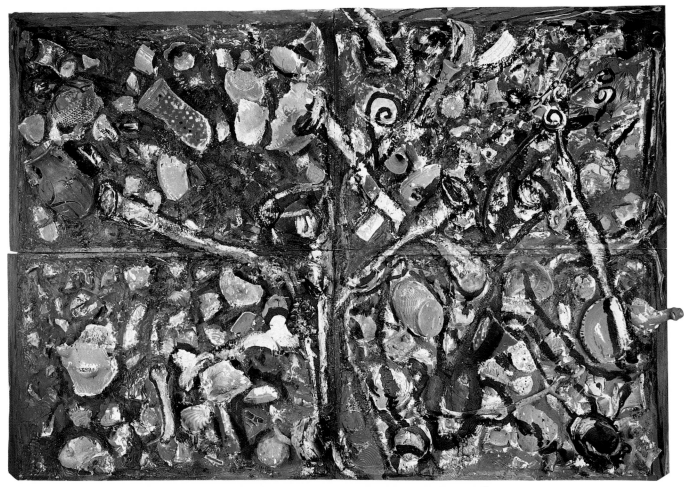

*Bones and Trumpets Rubbing Together Towards Infinity*, 1981, oil paint, Mexican pots, deer's antlers, bondo on wood, 9'5¾" × 14' (289 × 426 cm)

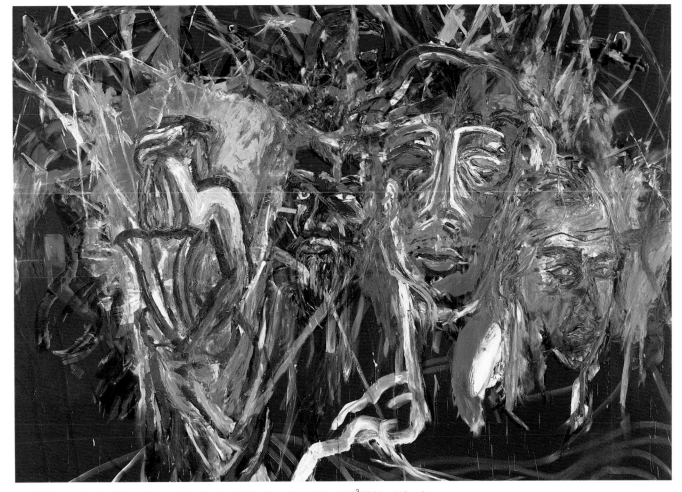

*The Unexpected Death of Blinky Palermo in the Tropics*, 1981, oil on velvet, 9'8" × 13'8⅜" (294 × 416 cm)

# West Germany
## Kunsthalle
## Düsseldorf

## Café Deutschland Adlerhälfte
## Jörg Immendorff

born in 1945 in Bleckede, near Lüneburg, West Germany
lives in Düsseldorf

Immendorff at the Galerie Daniel Templon, Paris, 1982

"If you do work that is honest and committed, then the notion of beauty overlaps with the notion of truth. So don't try to pull the wool over our eyes with some phony harmony. I try to reach people who are looking for truth, for identity. Even though these notions are incredibly hackneyed, we must try to get back to these simple ideas."[1]

Since 1978, Jörg Immendorff has been working intensely and obsessively on his "Café Deutschland" series. Ultimately the artist has been striving to make a statement on his own situation within the reality of our time, not only in hundreds of drawings, gouaches, drawings on paper, and paintings, but also in 19 large-format oil canvases.

"Café Deutschland" is not only a pictorial invention in variations, not only a fictitious site of cognitive knowledge. It is more. As a setting it is a world animated by the artist, with its own laws; it is both the culmination of extra-pictorial reality and the concrete utopia of a new reality. People and objects act by their own lights here or in terms of given patterns. Individual scenes reflect political conflicts and personal behavior. The different levels of reality, which we experience as separate entities in everyday life, encounter one another here. The personal experience of the individual or the relations between two people occur next to the cleerly depicted relations between governments. The artist is present in all this exemplary conduct of his characters: He is reflected in images and speaking characters, he is a knowledgeable seeker with a moral demand, and in the course of the artistic process, he names his alternatives. "If I were to give the reason why I keep painting, (I would have to say that) for me painting is a highly complex possibility of exploring myself in form, that is, reflecting on the things that happen all around me. At the same time, however, it enables me to formulate an anti-world by means of ideas."[2]

Ulrich Krempel
*from the catalogue Die Wirklichkeit der Bilder, in Jörg Immendorff's series, "Cafe Deutschland"*
*Translated by Joachim Neugröschel*

Notes: 1. Quoted from an interview with Immendorff in *Überblick,* Düsseldorf, December 1978, p. 24.
2. Quoted from an interview conducted by Hans Peter Riegel with Immendorff in *OETZ,* magazine published by the Design Department of the Fachhochschule Düsseldorf, May 1982, p. 42.

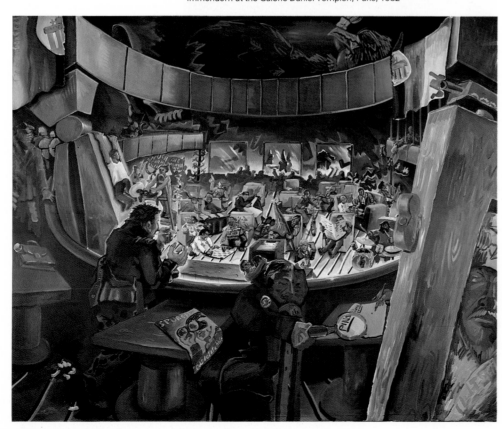

*Parlament I (Parliament I),* 1981, acrylic on canvas, 9'2¼" × 11'6" (280 × 350 cm)

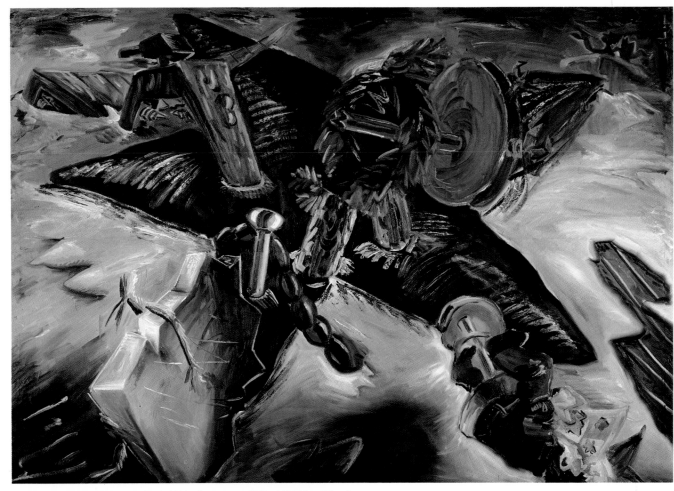

*Café Deutschland XV-Schwarzer Stern*, 1982, oil on canvas, 9'3" × 14' (282 × 400 cm)

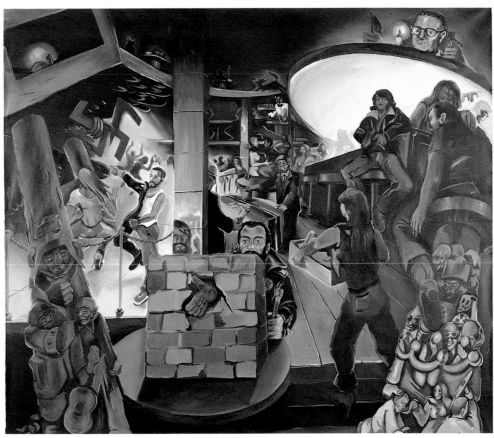

*Café Deutschland I*, 1977-78, acrylic on canvas, 9'3" × 10'½" (282 × 320 cm)

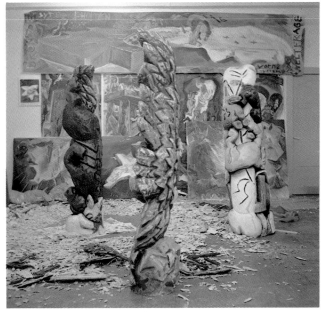

The painter's studio, 1981

# West Germany

## Städtisches Museum Abteiberg Mönchengladbach

Opening of the new museum

The museum realizes that its primary duty is to serve the needs of artworks...

This applies particularly to works of contemporary art. More and more twentieth-century painters have been leaving off the frames, and sculptors no longer demand the traditional base. The function of the frame and the base has been assumed by the surrounding space.

Hollein's architecture takes these factors into account. It avoids any irksome frills in the exhibition rooms. Simple, clean, white walls, a white marble floor or carpeting in restrained tones create a mood of relaxation and "neutrality," which helps the atwork develop a life of its own. After all, it is this specific and individual life that the visitor wishes to become familiar with. There are no doors in this museum, the rooms open crosswise into one another; this arrangement prevents any interference in the layout of the walls.

Despite all these features, the architecture does not have to forgo self-articulation. Quite the contrary: Hollein created an extremely self-willed architectural body that teems with ideas, variety, and surprises, both in the internal space structure and in the external appearance. On the inside, the space ranges from the tiniest units, measuring only a few square yards, to huge series of vast rooms, from square shapes to circular, polygonal, and amorphous ones, and from straight walls to curving ones. The art collection does not compel any chronological structure. Thus, the various types of rooms can unfold like a labyrinth, while never losing a sense of order...

Hollein's architecture aims at communication. It pays as much heed to the urban situation of the historical center of the town, with its cathedral and abbey, as it does to the activity zone of the main commercial thoroughfare...

Nevertheless, his architecture guarantees that an art viewer will experience the intimacy vital to dealing with spiritual goods. Hollein enables us to have an experience that harmonizes art, space, and architecture.

Johannes Cladders
*from the catalogue*
*Translated by Joachim Neugröschel*

Exterior view of Museum, 1982, Hans Hollein, architect

Interior gallery

For its opening, the museum of Mönchengladbach presented, along with its own collections, works from the Marx Collection. This collection of several hundred works is unusual in that it is devoted exclusively to four artists: Beuys, Rauschenberg, Twombly, and Warhol.

*Editor's note*

Round Gallery with work by George Segal

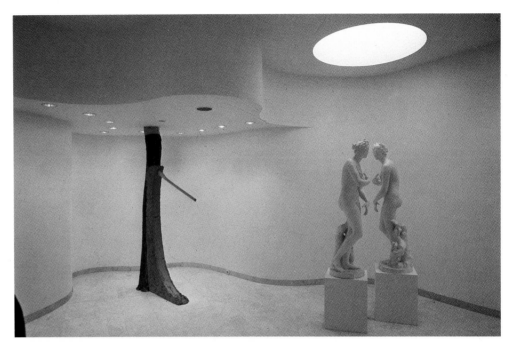

Penone, *Zappa di terra* (Hoe in earth), 1980 ; Paolini, *Mimesis,* 1978

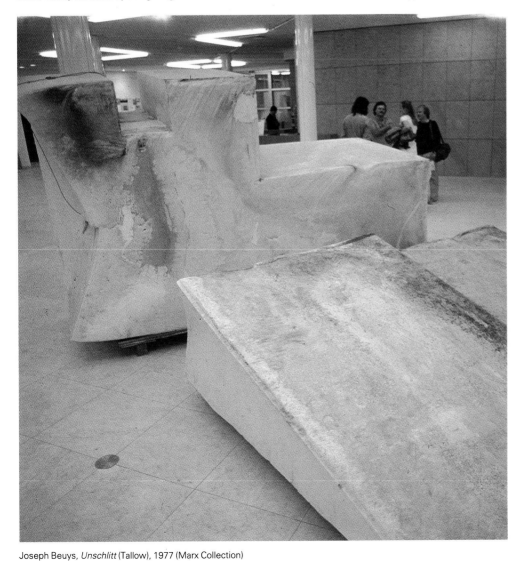

Joseph Beuys, *Unschlitt* (Tallow), 1977 (Marx Collection)

Interior with work by Yves Klein

# West Germany
## Kassel

Museum Fridericianum, Orangerie, Neue Galerie, Karlsaue

We practice this wonderful craft: We construct an exhibition after first having made the rooms for this exhibition. In the meantime the artists attempt to do their best, as it should be. Exhibitions must be made, somehow and somewhere (also in Kassel), because artworks appear there in their concrete form. The exhibition is a reality. It is important to stress this again and again because our culture suffers from an illusion of the media (we see more reproductions than pictures). The feeling for the essential gets lost. We are aware of that in the ugly details of everyday life. There is a great lack of care.

The artists—and not only those in this exhibition—sometimes achieve a great deal; but only a few people are really conscious of what art has to offer. One must seriously question whether there is still a culture out there in the world that is capable of taking up art and supporting it—in other words, really making something of it above and beyond its mere exhibition. That is the decisive question today: Should we place more trust in the artists or should we leave them in this isolation in which they are free but simultaneously in captivity, like Indians on a reservation.

In that way art is only useful to us as decoration. But this kind of usefulness must be prevented. For art also reflects a certain knowledge, certain experiences gathered in the world, thoughts about the world and about its culture as a whole. This is why this exhibition, even though it can unfortunately only be an exhibition, should be the place where such things must be discussed with the artists and among ourselves—so that we can reconsider what we really want of art and how far we can still go. The river is gradually freezing over; it is time for a new departure.

R. H. Fuchs
*from the catalogue*

View of Fridericianum with works by Beuys and Buren

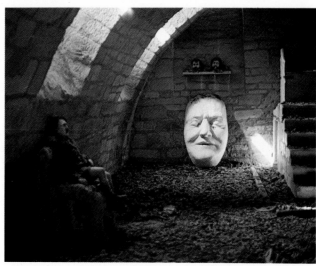

Pieces of scenery from Syberberg's film *Parsifal*, Fridericianum

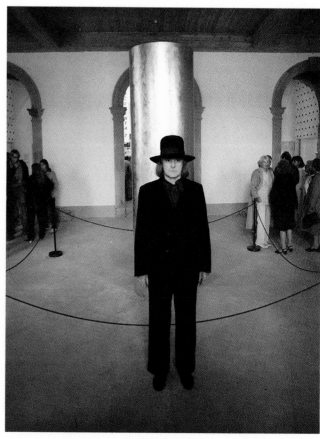

J.L. Byars in front of *The world's tallest golden tower with changing tops*, 1982

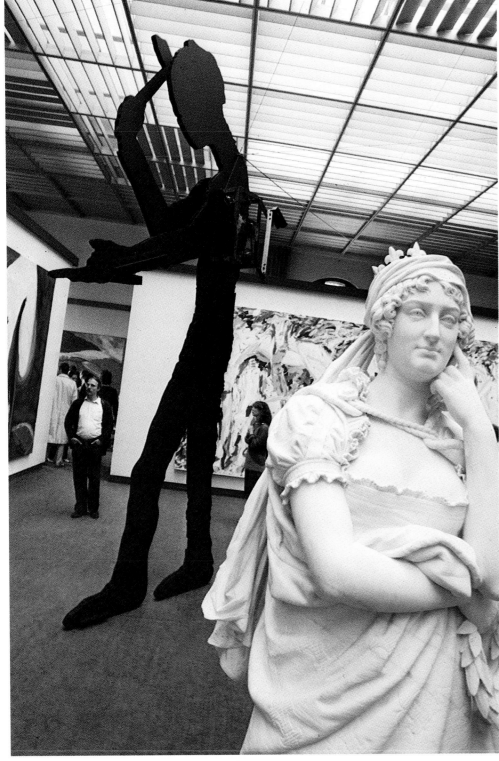

Jonathan Borofsky, *Hammering Man*, 1981-82, wood, Neue Galerie

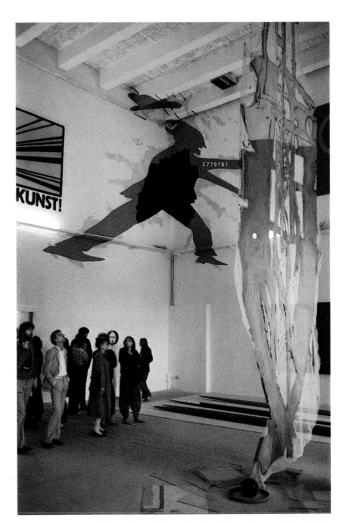

Works by *left to right* Klaus Staeck, Jonathan Borofsky and Remo Salvadori

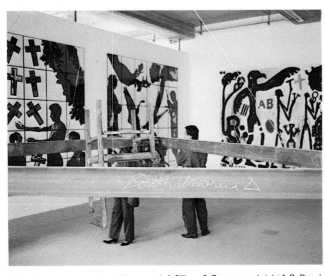

Works by *foreground* Bruce Nauman, *left* Gilbert & George, and *right* A.R. Penck

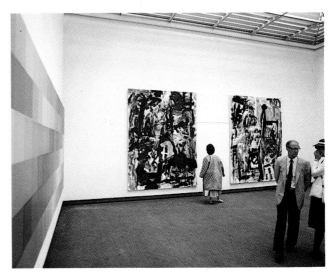

Works by *left to right* Richard-Paul Lohse and Emilio Vedova, Neue Galerie

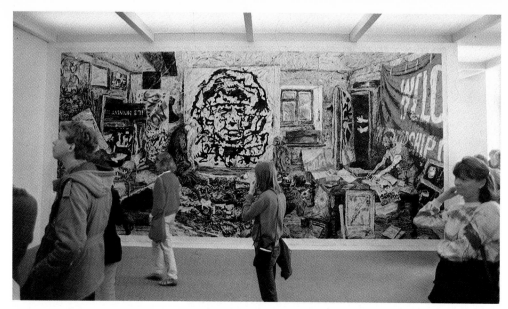

Art and Language, *Index: Studio at 3 Wesley Place Painted by Mouth,* 1982, ink and pencil on paper, 11′ × 21′5″

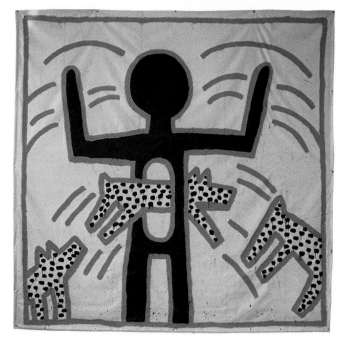

Keith Haring, *Untitled,* 1982, mixed media, 12 × 12′ (366 × 366 cm)

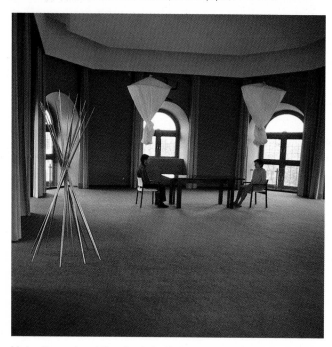

Marina Abramovic and Ulay, *Durch das Nachtmeer,* performance

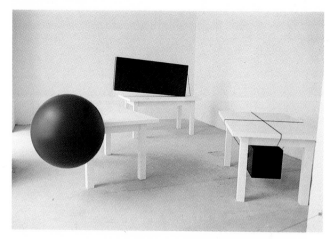

R. Ruthenbeck, Tables with sphere, slanting box and block, 1981-82

Bertrand Lavier, Acrylic painting on balustrade, 1982, Fridericianum

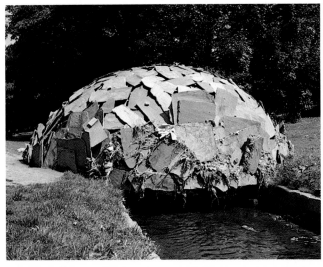

Mario Merz, *Igloo über die kleine Fulda* (Igloo on the Little Fulda), 1982, Karlsaue

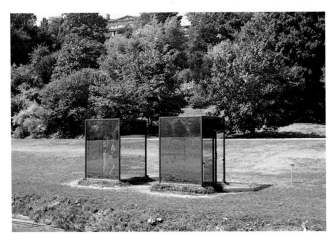

Dan Graham, *Pavilion Sculpture,* 1978-81, 96 × 96 × 96″ (244 × 244 × 244 cm)

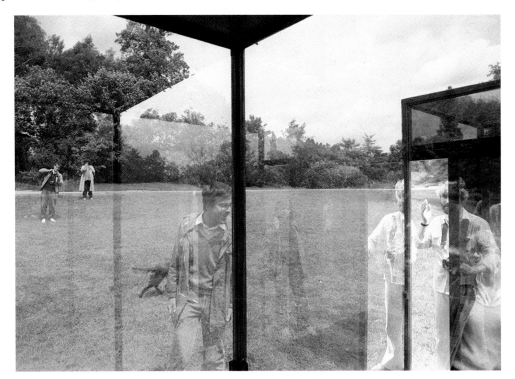

Dam Graham, *Pavilion Sculpture,* 1978-81, mirror, glass and wood, detail, Karlsaue

Ulrich Rückriem, Granite block split in three sections, 1982

Claes Oldenburg, *Pick-Ax*, 1982, h. 39′5″ (12 m)

# West Germany
## International Art Exhibition
## Kassel

## K18-Stoffwechsel

K18-Textile Metabolism

Initially we had chosen the title "Textiles in Art" for this exhibition, but we found that this failed to express the artists' intentions. The artists we were interested in tend to use textile in a purely intuitive, coincidental or offhand fashion. They do not use textiles in their artwork for the sake of the material itself.

This exhibition is concerned not primarily with "textiles," but more broadly with "material" and "materiality." "Metabolism" implies process and transformation. The artist (or the organ, the catalyst) effects a change in the "materiality," the substance of his medium. The transformation of matter—metabolism—turns objects into artworks.

The project, lacking financial support, was in a desperate situation. We decided to look for a factory hall for the exhibition. The Gesamthochschule Kassel allowed us free use of factory hall K 18, which had been abandoned and was about to be demolished. This large industrial building was indescribably filthy, damp, and smelly, but its architectural possibilities were fascinating. Today we are certain that no gallery, museum, or school could have been more suitable.

H. el Attar
*from the catalogue*

The exhibition presents some 70 artists from 15 countries with several artworks each, and furthermore offers 10 performances, 20 videotapes, and slide shows about the work of 180 artists from 20 countries.

*Editors' note*

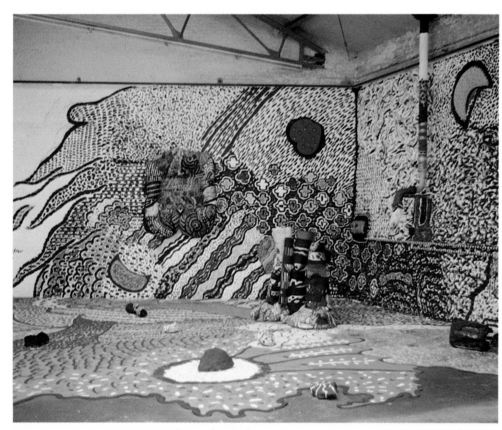

Hamdi El Attar, *Osterei*, 1982, cloth, 32′9½″ × 32′9½″ × 19′8¼″ (10 × 10 × 6 m)

K18: exterior of hangar

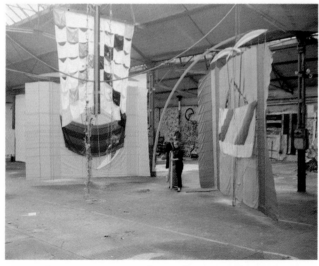

John Newton, *Cockerel I*, cloth, 16′8⅝″ × 13′5¾″ (5.1 × 4.1 m)

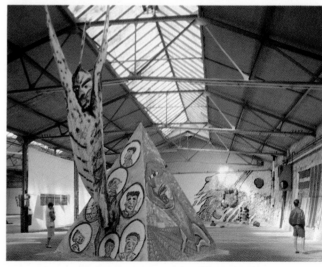

En avant comme avant, *La Pyramide*, 13′1½″ × 13′1½″ × 22′11⅝″ (4 × 4 × 7 m)

All at once, it exists, and it is desired and celebrated. It is also mocked, attacked, and rejected. Yet its existence provides the stuff for creating myths, which—readily taken up and evolved by the media, popular magazines, and even television—are kindled by the appearance, the very fact of something unexpectedly and confusingly new. Young art—for this is what we are talking about—is perplexing, last but not least because it generally employs the traditional means of expression, chiefly painting, and it formulates its statements in a pictorial language that seems unburdened by thought, a language that is subjective and often provocative. Characteristically, and unfortunately, the sensational reports on this art usually ignore the substance of what truly motivates it; these reports focus on quantity, the simply unlimited growth connected with the change of generations that has been taking place for the past two years. The art of the younger generation is thus in a paradoxical situation. It confuses us with its pronounced individualism and its lack of style, yet it is judged as an overall phenomenon, a tendency—promptly labeled with various names and terms.

Furthermore, the young painters from Germany are concerned not so much with painting, that is, the medium, as with the personal and hard-to-define expression concealed in their "pictures." One has to distinguish between *picture,* a painting on canvas, and *image,* a tiding from the inner world of the painter, emerging unexpectedly and enigmatically and thus resembling the invention of a picture rather than its creation. "Painting" and the "painterly" are actually only a conveyance for these artists, a specific "form of content." Nevertheless, we experience painting today as an extremely tension-fraught, almost infinite field of "pictures," which are erotic and self-loving, open and aggressive, libidinous and cunning, and always proclaiming the new adventure of art.

Felix Zdenek
*from the catalogue, "A King Does not Fall from the Blue."*

**West Germany**
**Museum Folkwang**
**Essen**

**10 Junge Künstler aus Deutschland**

Ten Young German Artists

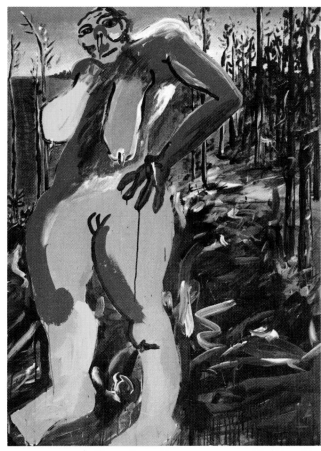

Gerard Kever, *Weiblicher Akt,* 1981, gouache on cotton, 63 × 43¼"

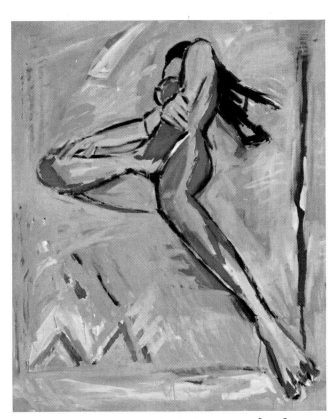

Helmut Middendorf, *Beate II,* 1981, oil and resin on canvas, 86⅝ × 70⅞"

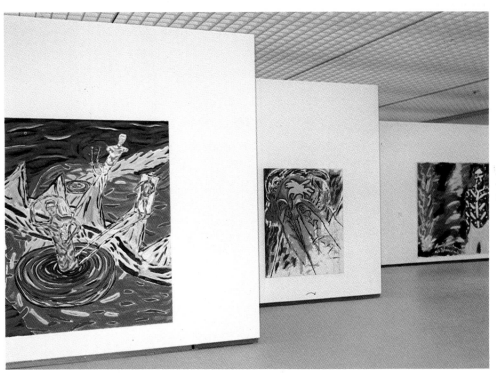

Peter Bömmels, *Traversale,* 1980, dispersion on cotton; Gerhard Naschberger, *Der Reichsadler,* 1981, casein on cotton

## West Germany

### Kunst- und Museumsverein
### Wuppertal

### Bilder und Zeichnungen 1981-1982
### Mimmo Paladino

Paintings and Drawings 1981-1982
born in 1948 in Paduli, Benevento. Italy
lives in Milan and in Southern Italy

Paladino pays homage to abysmal depths and darkness as well as to the merriment of dance. If his pictures are cheerful, then a slap is lurking in ambush. And if dull grief seems to predominate, then these paintings become tender, enigmatic. They are indecipherable for the analytical mind. But intuition, drawing from the never ending synthesis of human imagery, briefly drops anchor here and there. The images and signs, blazing like meteorites from the primal mud of human consciousness, are acquaintances from a dream that unites the many scattered human selves. They derive from the primal yearning for animal "vulgarity" and cultic sublimity, for unabashed merriment and mystical absorption. They vanish the moment we awaken. And this too, I feel, is part of Paladino's creative contradiction: the intensity of the alternation between dreaming and waking, between the dissoluteness of the senses and the skepticism of a world removed from the primordial state of human development after millennia of intellectual achievement. However, the contradiction does not so much paralyze as nourish the intensity of an ecstatic and vulnerable testing of an exemplary self. "For I want [art] to arouse the most disparate and most contradictory reactions not just from me."

Annelie Pohlen
*from the catalogue*
*Translated by Joachim Neugröschel*

*L'isola (The Island)*, 1981,
oil on canvas,
9'10⅞" × 31½" (300 × 80 cm)

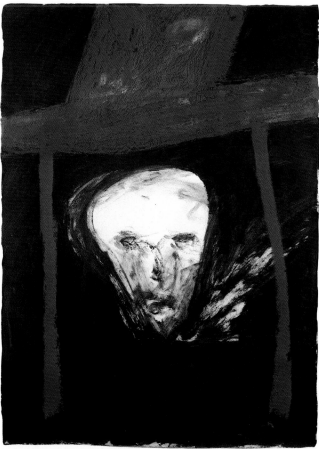

From a series of 16 gouaches, 1982, 31⅛ × 76¾" (79 × 58 cm)

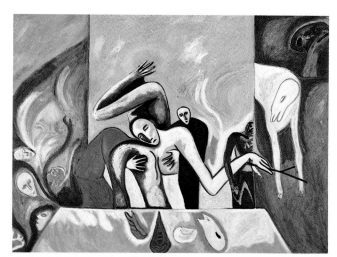

*Untitled*, 1982, oil on canvas, 57½ × 76¾" (146 × 195 cm)

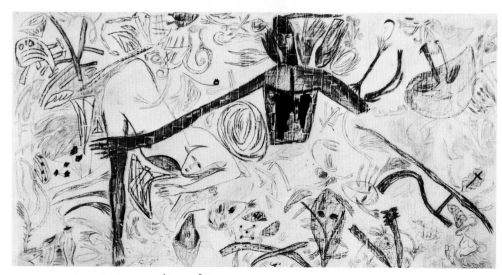

*Untitled*, 1981, charcoal on paper, 8'10¼" × 17'8⅜" (270 × 540 cm)

James Lee Byars collects questions as Diogenes collected people. "Which questions have disappeared?" Meanwhile there are already hundreds and there will be more and more. With the help of futurologist Herman Kahn in his Hudson Institute near New York, Byars began to collect the one hundred most interesting questions in America at this time. He went to CERN, the European Center for Nuclear Research near Geneva to ask the astrophysicists working there for their questions. He was frequently offered answers, but he was not interested in them. Later on he gathered the questions and had them printed on tissue paper in golden letters, so tiny that they can hardly be deciphered with the naked eye, for what cannot be read cannot be answered. The practical application lies in the invitation to question oneself. Just as Werner Heisenberg meant by the so-called "world formula" that he developed and wanted to be considered as a question and not as an answer, the question is the answer. The world is determined by questions, not by their answers; if they do not raise new questions, they are useless, because they mean stagnation. "I can repeat the question but am I bright enough to ask it?" is the answer that Byars gives. It is not the world that is reflected in Byars's art works but the ego. His works, whether they are phrases or the questions or the objects that are produced according to his instructions, are self-sufficient. Because they are, first of all, directed to the creator himself, the artist, and they render the recipient, if he ventures into them a creator and artist, too. They demand nothing but total concentration for a moment, the moment of cognition—"know thyself" as a thinking being. They ask to be conceived because they are unmistakable. In their presence there is no misunderstanding but only nonunderstanding. James Lee Byars's works are humane because they mean man's mind, man's soul; they are anarchistic because they concern man alone; they are optimistic because they aim at man's perfection.

Thomas Deecke
*from the catalogue*

# West Germany
## Westfälischer Kunstverein Münster

### James Lee Byars

61

born in 1932 in Detroit, Michigan
lives in New York and Europe

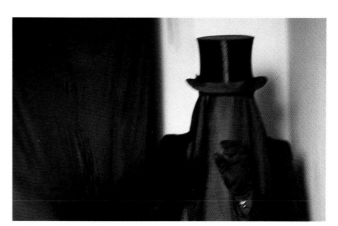

The artist presenting his work: "Hear the first totally...", 1978

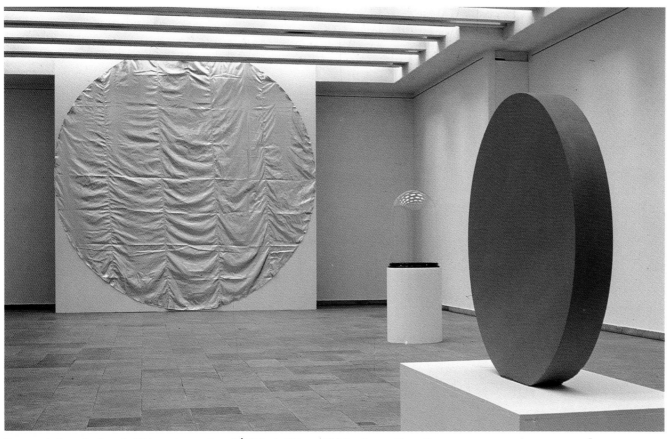

Foreground: *Stone for Speech,* 1981, sandstone, diam. $47\frac{1}{4}''$ (1.2 m), thickness 5" (14 cm); rear: *Planet Sign,* 1981, gold cloth, diam. approx. $16'4\frac{7}{8}''$ (5 m)

# West Germany

## Staatliche Kunsthalle Baden-Baden

## Makom
## Dani Karavan

born in 1930 in Tel Aviv, Israel
lives in Florence and Paris

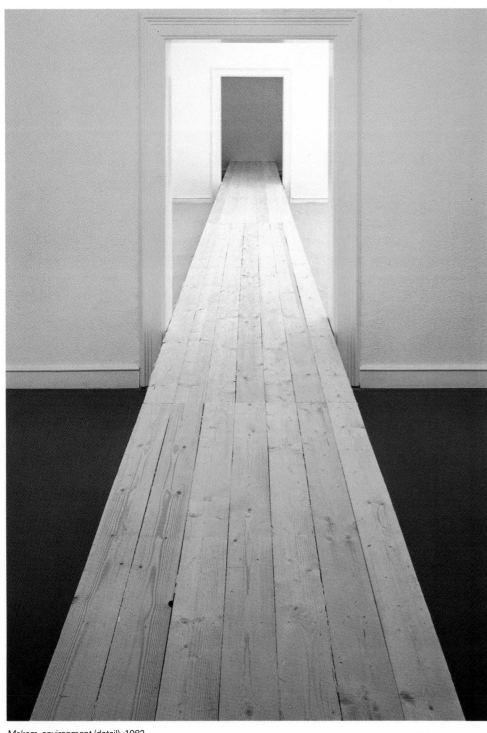

*Makom,* environment (detail), 1982

Dani Karavan's exhibit in the Tel Aviv Museum and the Staatliche Kunsthalle, Baden-Baden, comes after twenty years of artistic activity. His work ranges from an impressive monument in the Negev (Beer Shebah, 1963-68) to the current large-scale project of the central axis in Cergy-Pontoise, a new townscape near the outskirts of Paris (begun in 1980). This project is developing into a model for a new type of artistic activity, which combines the talent of an artist with that of an architect and city planner. In his work, Dani Karavan has pursued and developed two distinct kinds of sculptural creation. On the one hand, a number of permanent sculptures were created in Israel, Europe, and the United States. On the other hand, he created many nonpermanent environments, the first in 1976 for the Israeli pavilion of the Thirty-Eighth Venice Biennale. His environments take in both external and internal spaces, frequently creating a connection between them.

The Hebrew word *makom* means "place." The environments both created under this title in 1982 in Tel Aviv and Baden-Baden are a new attempt by Karavan to produce an ambiance encompassing both external and internal space. This complex ambiance operates with various means and methods as a reaction to existing architecture. The normal functions of this existing architecture are modified by additional, but temporary constructions, formal developments such as focused daylight, as well as the inclusion of sounds and noises made by sand, water or olive trees, for example. The overall complex conveys a self-contained integral message.

From the expressive design for the Negev monument, carried out in concrete, to the harmony of the Makom wooden constructions, executed more simply, Karavan's works have been going through a process of refinement.

Marc Sheps
Katharina Schmidt
*from the catalogue*
*Translated by Joachim Neugröschel*

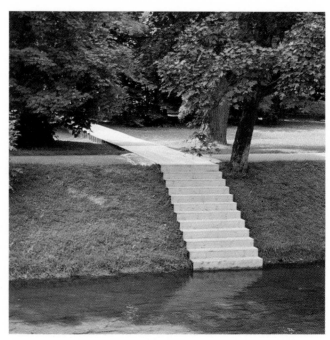

*Makom,* Staircase from the river Oos, 1982

*Makom,* Bridge through the Thermal Park with tree-trunk of Christ's Crown, 1982

*Makom,* environment (detail), 1982

*Makom,* environment (detail), 1982

*Makom,* environment (detail), 1982

# West Germany
## Kölnischen Stadmuseum/Cologne
## Sammlung Ludwig/Aachen

## Aspekte sowjetischer Kunst der Gegenwart

Aspects of Soviet Art Today

In summer 1982, the Ludwig museums of Cologne and Aachen showed 120 paintings, a dozen sculptures, and 400 engravings under the title "Aspects of Present-Day Soviet Art." This double exhibition triggered a passionate debate in the German press: Was this a presentation of necessary information about an unknown continent or a political act within a worldwide constellation?

In 1979, when the Neue Galerie offered a collection of artworks from the German Democratic Republic, Ludwig revealed his interest in Soviet art. This was a logical move, given the encyclopedic character of Ludwig's dream: to create a "world museum" gathering the artistic output of his era.

In 1979, the Soviet ambassador to the Federal Republic of Germany, a renowned collector of Soviet art, invited Herr and Frau Ludwig to make a general survey of the situation in Moscow and Leningrad. By May 1982, the Ludwigs had visited all the large national and regional exhibits as well as hundreds of artists' studios. Their way of purchasing the artworks placed their Soviet partners in a difficult situation; and it was only after long diplomatic negotiations that the overall purchase was carried through. The present-day Soviet art in this collection shows conservative work imbued with the artistic traditions of the Thirties. It demonstrates solid craftsmanship as well as great timidity about openness to new experiences. And it also falteringly traces the rhythms of artistic evolution in Eastern Europe. We find pop art here as well as hyper-realism and new fauvism.

Dr. Wolfgang Becker
*Translated by Joachim Neugröschel*

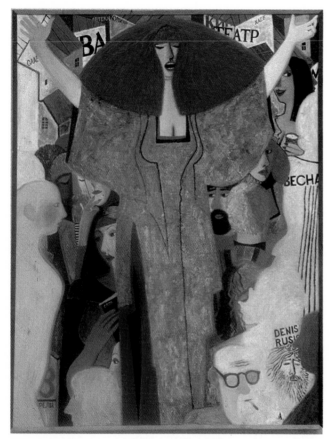

I. Lubennikov, *The Pop Singer*, 1981, oil on canvas, 64⅛" × 48⅜" (163 × 123 cm).

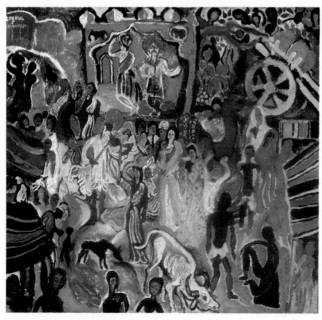

T. Narimanbekov, *Market at Schantiniketa*, 1971, oil on canvas, 47⅝" × 51′⅝"

L. Baranov, *Monument to Pushkin*, 1981, plaster, 12′3⅝" × 26′3" × 13′1½" (375 × 800 × 400 cm)

When the first ideas on developing this exhibition blossomed in people's minds, scarcely anyone could suspect that just two years later, the young Berlin art, and especially the new, so-called *Heftige Malerei* (Intense Painting), would be the focal point of interest in both Europe and America. The art of these young people is no longer so unknown, and their worldwide reputation is being promoted not only by art dealers and exhibition organizers, but also by internationally known art journals and book publications.

The above was written in late 1981, for the first version of this exhibition in Stockholm's Kulturhuset. But what it said holds true today, the year of the Venice Biennale, the Kassel Documenta, and the Berlin Zeitgeist exhibition. There is hardly a topic in the area of plastic art that is as intensely discussed here as so-called *Heftige Malerei*. This discussion naturally includes some vehement controversy, which has a positive effect on general interest and conversation. Opponents and advocates are no less passionate than the object of their fight.

It is fortunate that, after Stockholm, Munich can now offer us a fairly wide spectrum of young art from Berlin. It is an opportunity to present Berlin and its intellectual atmosphere, which is always political, always dynamic, and is now in a process of fermentation. The most important result of this fermentation is to be observed in the plastic arts. Feeling and hardness are participating in this arena. They determine one another and create the lively mood of the scene.

Ursula Prinz
*from the catalogue*
*Translated by Joachim Neugröschel*

Feeling and Hardness

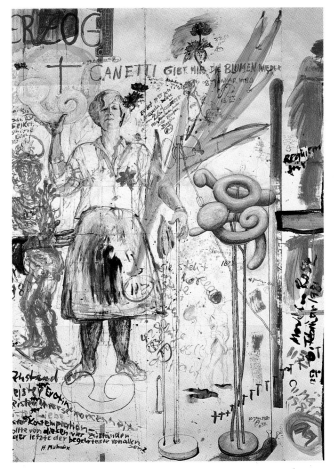

Martin Rosz, *Werner Herzog Piece,* detail, 1981, acrylic, casein and pencil

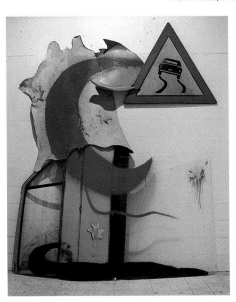

Ter Hell, *Ich bin's (I'm the One),* 1980, mixed media

Gerd Rohling, *Untitled,* 1982, mixed media, 94½ × 70⅞″ (240 × 180 cm)

A passionate dispute is invading all discussions on art today, in the early 1980s. Some people say they see a Janus head; they feel confused, disoriented, deprived of a tedious but familiar order. They are terrified by an impetuous change that is smashing all dams of aesthetic decency. Others feel liberated, freed of the chains of a strict aesthetic diet—they are emitting a euphoric hosanna. They are almost delirious because of the uninhibited subjectivity of these paintings, their immediate sensuality, the enigmatic stories they tell.

Neither argument has always been articulated fully. The pros easily let out a fanfare, a jubilation; the cons are not without envy, arrogance, and frustration.

Should we not really understand the history of art as the history of *dialectical mutations,* and not just within a historical epoch, but also within the development of an artist's individual work? The exciting development of art throughout our century shows the explosions, the dreams, the utopias, and the setbacks that keep recurring from generation to generation, from decade to decade: A titanic battle, seething with contradictions, before the walls of Troy, and no matter how often these walls have been torn down by history, they still engird our minds...

*Zeitgeist* is an *exhibition* of 45 artists—painters and sculptors. Painting and sculpture, the oldest of the artistic disciplines, are now once again conveying the most important creative notions of artists. And *Zeitgeist,* the title of this exhibition, is metaphor for all the present-day artistic suggestions that signal a radical change in the plastic arts. An immediate sensual relationship to the art works is sought. The subjective, the visionary, the mythical, as well as suffering and gracefulness have been brought back from exile. Often, an underlying Dionysian feeling characterizes the way these artists see themselves...

The point of departure in this exhibition is *today.* Yet it encompasses three generations of artists. By starting with the middle and younger generation, who, with the conviction of their labors, have taken a clearcut position against academically petrified minimalism, we have suddenly found a new perspective for viewing the works of the previous generation.

Christos M. Joachimides
"Achilles and Hector at the Walls of Troy," *from the catalogue*
*Translated by Joachim Neugröschel*

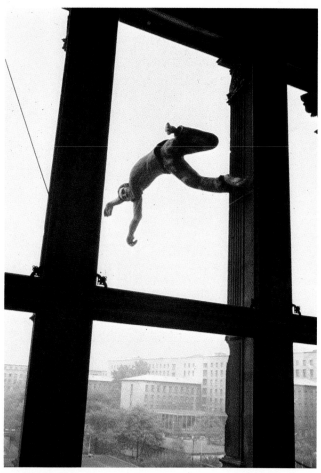

Borofsky, installation created for the exhibition, 1982

Georg Baselitz, left to right: *Adler im Bett, Nacht mit Hund, Adler im Fenster, Franz im Bett,* 1982, each 98⅜ × 98⅜"

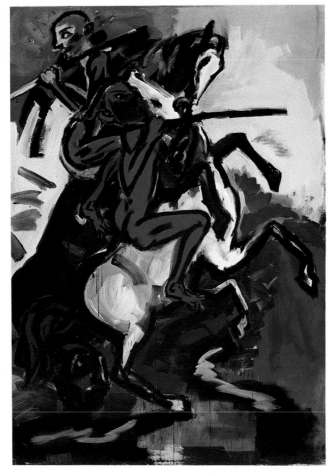

Rainer Fetting, *Die Häscher*, 1982, dispersion and oil on cotton, (400 × 300 cm)

Exterior of Martin-Gropius Bau

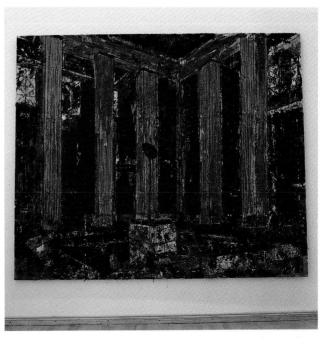

Anselm Kiefer, *Dem unbekannten Maler*, 1982, oil on canvas, 9'2¼" × 11'2⅛"

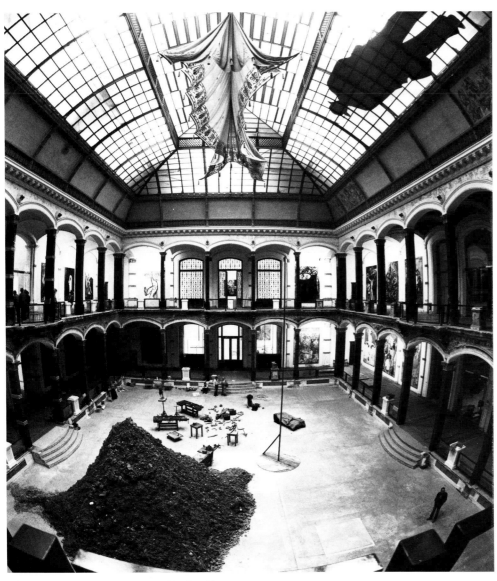

Interior of hall; on the glass ceiling, a work by Borofsky

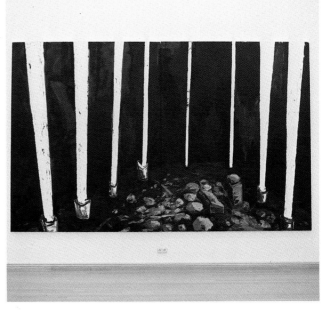

Volker Tannert, *Unsere Wünsche wollen Kathedralen Bauen*, 1982

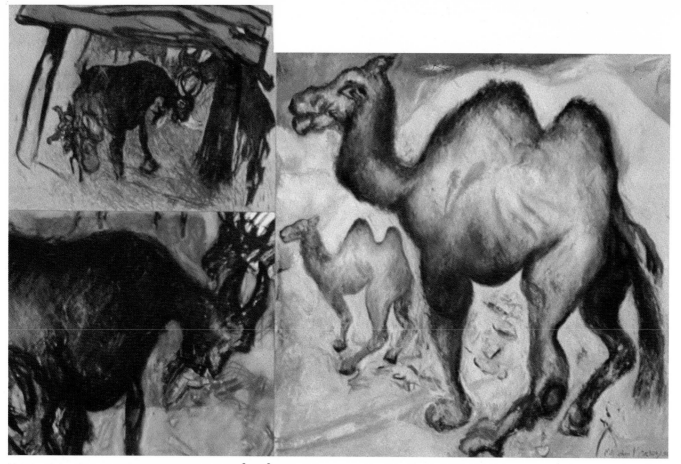

Malcolm Morley, *Camels and Goats,* 1980, oil on canvas, 65⅜ × 98⅜" (166 × 250 cm), collection Doris and Charles Saatchi, London

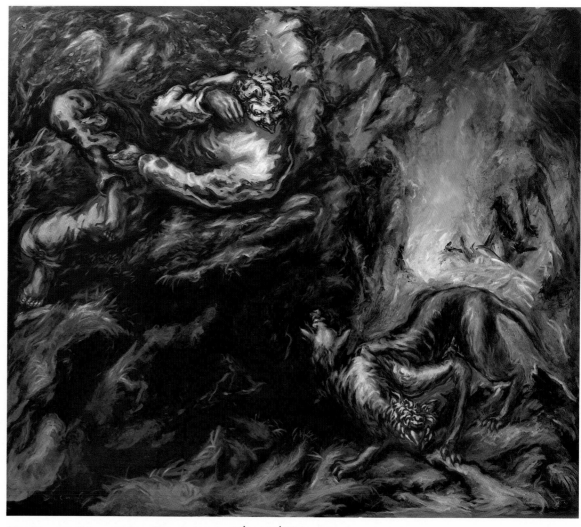

Gérard Garouste, *Orion and Orthros,* 1982, oil on canvas, 9'8⅛" × 13'3⅛" (295 × 405 cm)

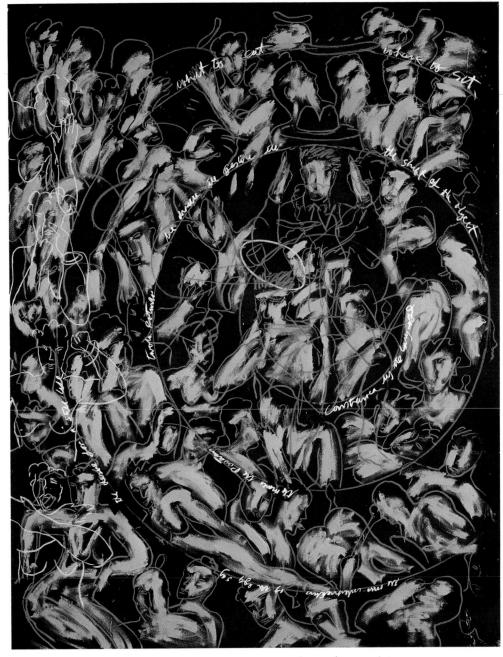

Bruce McLean, *Contained (Historically, Politically, Physically)*, 1982, 13′1½″ × 9′10⅛″ (400 × 300 cm)

Julian Schnabel, *The Sea*, 1981, oil, china, mortar, wood

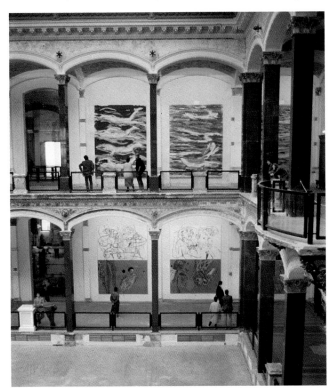

Top: Salomé, *Zeitgeist I* and *III*, 1982; below: David Salle, *Zeitgeist*, 1982

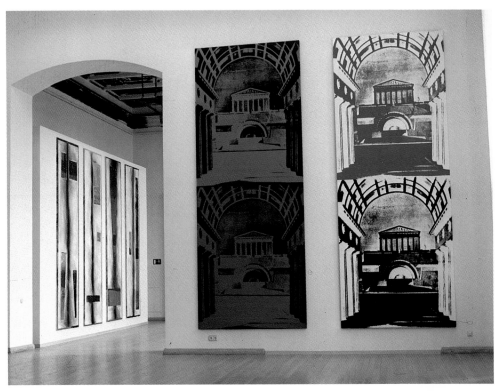

Andy Warhol, *Zeitgeist Painting X* and *XI*, 1982, acrylic and silkscreen on canvas, 14′9″ × 5′9″ (450 × 175 cm)

The three aspects we have previously seen (Hantaï and the Support/Surface group, Concept/Behavior, and Hélion and New Image) participate to a certain extent, despite their particular characteristics, in the broad currents of the international avant-garde, minimalism, conceptualism, and pop art. At the same time a certain number of artists have pursued their own paths, challenging the very idea of an "international" style, and challenging even more the idea of an "avant-garde" as the custodian of artistic truth. Marginal, they rely on an idea of painting that would shun not only fashionable aesthetic positions but political commitments as well.

On the other hand, they uphold the idea of traditional craftsmanship, in which classical quality is rediscovered along with a connection to the culture of the past.

Against the theoretical antihumanism of the avant-garde, nourished in France by the vogue for Marxist structuralism (Althusser) and Freudian structuralism (Lacan), both of which deny the reality of a subject acting for the benefit of obscure productive forces linked to chance, accident, the unconscious, or structure, they proclaim once again the importance of a creative subjectivity operating freely across history.

There, too, their "models" may be two artists whose influence today still continues to grow. One of them is Giacometti, who died in 1967 and whose *œuvre,* inspired at first by Giotto and Tintoretto, was one of those closest to Existentialism and the neo-humanist phenomenology of Sartre and Merleau-Ponty.

Also and especially there is the example of Balthus, whose haughty, singular, spellbinding work has turned its back on all the vagaries of fashion in order to hold a dialogue with a few masters of the past: David, Courbet, Derain, Bonnard...

There will likely be a temptation to compare this latest trend with those that have recently appeared in Italy or Germany, which also go back to painting and representation, but this would be to forget that the phenomenon in France is older and has nothing to do with fluctuations in the international art market.

Jean Clair
*Preface to the catalogue*
*Translated by John Shepley*

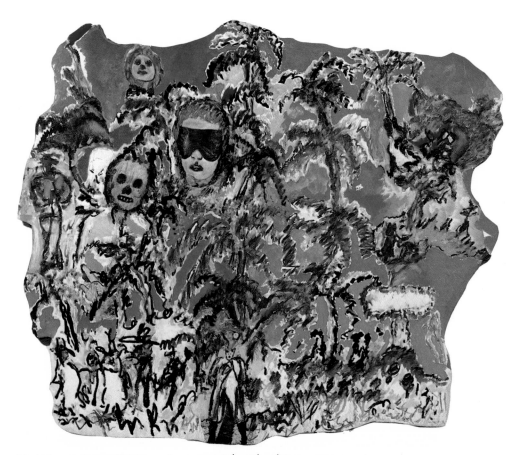

Martial Raysse, *Images,* 1975-76, acrylic on canvas, 44⅛ × 51⅛ × 5⅛" (112 × 130 × 15 cm)

Anne and Patrick Poirier, *Ostia Antica,* 1971-72, Construction Book No. 1

Jean Le Gac, *Les Cahiers: Cahier No. 5,* 1968-71

Since Rodin, the avant-garde of art has been reacting to the acceleration and liquefaction of the concrete world of objects. "Modern" sculpture began to depict movement, followed the streamline, became kinetic itself, turned into light and motion. The homogeneity of the material crumbled, the unity of shape disintegrated; sculpture became soft or fluid. Art became a critical, indifferent, affirmative mirror of the concrete other world, it reproduced, compressed, accumulated consumer goods, like consumers, and counteracted by becoming radically deobjectified, dematerialized; it passed into simple, open, and "empty" structures with no distinction between inside and outside; it became nature, occupying the entire globe, or took refuge in words, thoughts. Eventually, sculpture turned into material metaphors of pure energy, a cybernetic system of capital, production, and society, and, on the other side, it reified the human body, the living body of flesh and blood; it became performance, dance, rock music. Then: the crisis of sculpture—in the mid Seventies, after the energy crisis, came the enormous expansion movement—the expansion of the notion of object and material, which dominated all artistic activity until the current stagnation. Painting, pictures freed themselves from this stagnation. But the new pictorial imaginations which were filled with physical sensuality and ego-energy, contained the possibility of three-dimensional clarifications. The reanimation of creativity in the artist, of pleasurable production and invention of images also suggested the use of three-dimensional material, in which the artist could finally act as the "creator of things."

Patrick Frey
"Making Things", *from the catalogue*
*Translated by Joachim Neugröschel*

New Sculpture

Thomas Stimm, *Badende (Bathers)*, 1981, glazed ceramic

Olivia Etter, installation made for the exhibition, 1982

Erwin Wurm, *Tänzerin (Dancer)*, 1982, painted wood, 66⅛"(170 cm)

born in 1925 in Fribourg, Switzerland
lives in Milly-la-Forêt, Essonne, France

And then there's Tinguely, who has always pointed out that the only secure and stable thing in the world is motion, nonstop movement, change. In other words, there are no solid, absolute values. Equally strange, but by no means contradictory to the above, is Tinguely's interest in the non-material. He breaks with the traditional static quality of image and form by dissolving them in an incessant flow of sound and motion, a flow that has no beginning and no end and that develops in real time. This seems remarkable if we recall that during the past twenty years or so, Tinguely has created his sculptures out of extremely solid, concrete things: scrap metal, old, worn-out machine parts, unusable household items, and other everyday objects. It has frequently been noted that Tinguely's "machines" are built very simply, their movements are not predictable and their functions are useless. This observation is not quite accurate, however. Tinguely has constructed sculptures that devour and spit out soccer balls, spray water, smash bottles or shatter plates, paint abstract pictures, emit pleasant or ominous sounds, emanate fragrances, and even self-destruct. Their true function is irony—they parody both mechanical and human behavior, they satirize production, consumption, and waste.

But at times, they are simply playful, a good joke. Even when his machines toy with the spectator, they can nevertheless free him psychologically from our more and more complicated technology. Tinguely regards cooperation as extremely important: The spectator plays a large part in the functioning of the art work. He acts upon the resting object, not only by switching on the electricity and bringing the object to life; he also is sometimes asked to enter into a relationship with the machine, actively helping it to perform its activity.

Richard Calvocoressi
*Introduction to the catalogue*
*Translated by Joachim Neugröschel*

*Untitled (Baluba)*, 1962, h. 60¼"

*Red Relief*, 1978, metal and wood on steel support, electric motors, 70⅛ × 113⅜ × 44⅛", Galerie Renée Ziegler, Zurich

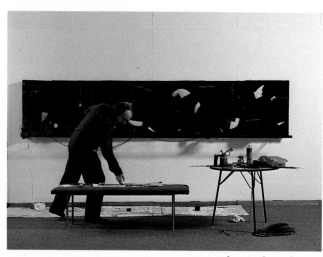

*Metamechanical Sound Relief I*, 1955, mixed media, 28¾" × 11'9¾" × 19⅝"

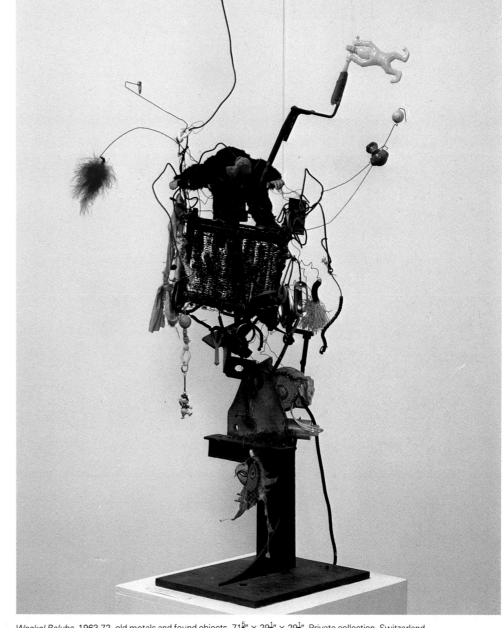

Original drawing for exhibition at Kunsthaus in Zurich, 1982

*Wackel Baluba,* 1963-72, old metals and found objects, $71\frac{5}{8}'' \times 29\frac{1}{2}'' \times 29\frac{1}{2}''$, Private collection, Switzerland

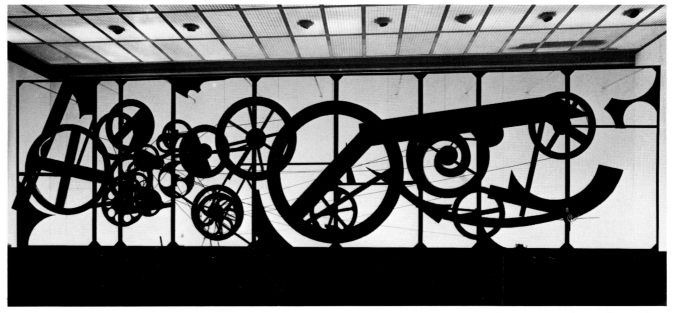

*Requiem pour une feuille morte (Requiem for a Dead Leaf),* 1967, wooden and metal wheels, rubber belts, and electric motor on steel frame, $10'1\frac{1}{8}'' \times 37'8\frac{5}{8}''$

# Switzerland
## Kunsthalle
## Basel

### Carlos Figueira, Federico Winkler, Matthias Aeberli, Josef Felix Müller, Anna Winteler, Jürg Stäuble

The explosive quality in Josef Müller's work is, for me, the demonstration of a radical need for a new understanding of ritual in the guise of radical *metaphors*. A metaphor is always an image-circumlocution. But here it comes about in the creative immediacy of a pictorial mind and sensibility...

Anna Winteler is already just about a complete artist. Yet her work is relatively unknown, because video tapes and performances belong to receptive mechanisms different than paintings. She moves in all directions and always towards places that attract her in the reflective dialogue with herself as an artist and as a woman.

Matthias Aeberli has painted large-format pictures of animals in the prow of a ship. The vessel and the creatures are drawn forward, virtually by an invisible force, as if they were imbued with a yearning that could be fulfilled only by painting.

Jürg Stäuble's construction drawings are like aerial views of skylines that, translated into objects (reliefs) contain the somberness of machine components. His early oval mirror forms rejected or distorted their identities, and now, the skyline, transposed, appears as the refraction of a fascinating image, as the reverse side of illusion.

Carlos Figueira comes from Cape Verde and has been living in Basel for eight years... As emotional and expressive as his paintings appear on the outside, the imagery and calligraphy are utterly precise because they always refer to something specific.

Federico Winkler's work is based on notions as well as concepts of material that cover a wide field of experience and are translated accordingly. His translation destroys the boundaries of ideas, transposes them into other ideas, and transmits them to the emotional and cognitive perceptivity of the human body.

Jean-Christophe Ammann
*from the catalogue*
*Translated by Joachim Neugröschel*

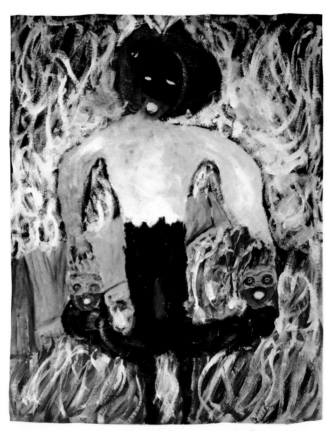

Carlos Figueira, *Untitled*, 1981, dispersion on paper, 100 × 78¾″ (254 × 200 cm)

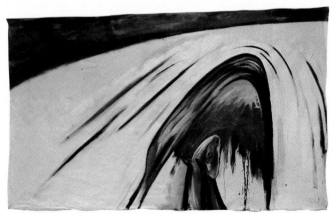

Matthias Aeberli, *Untitled II*, 1981

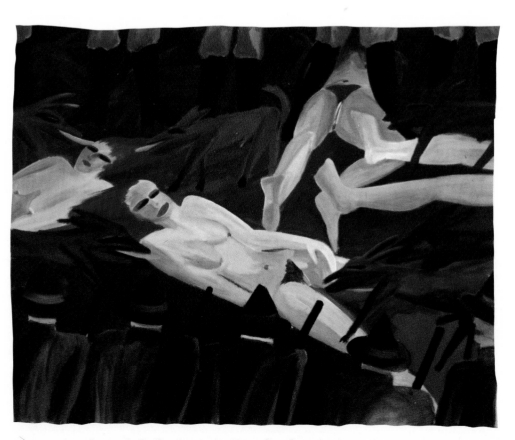

Josef Felix Müller, *Jäger (Hunter)*, 1981, dispersion on cotton, 78¾ × 98⅜″ (200 × 250 cm)

The young and vital art from the Netherlands exhibits a diversity of forms and expressions, all with strongly individual traits. It moves along the line of tension between the two poles of form and expression. These two poles can be seen as two faces. At the one end serenity, enveloped in the stillness of diffuse lighting, the well proportioned classical head. At the other end the expressive face, bathed in direct spotlighting and assuming even more dramatic forms. Rather like a confrontation between Mondrian and Van Gogh...

The pronounced positions occupied by Smits and Dumas at either end of the scale represent the extremities of the panorama of young art from the Netherlands...

If Smits is the protruding nose of the formal face of the young Dutch art, Kees de Goede, Jan Commandeur, and Ansuya Blom are the other features. Their objects, drawings, paintings are also built from abstract elements: forms, colors, lines...

The work of Emo Verkerk attests to a synthesis between painterly form and poetic vision. The classic genres of portraiture and landscape are revived in his work...

René Daniels, John van't Slot, Henk van Woerden, Henk Visch and Marlene Dumas, show a postformalistic mentality that tastes of liberation. Their paintings and sculptures make that impression: they stimulate the imagination directly. The representations are often highly surprising, the contents derive from a very personal contact with the world... They start out from very personal worlds, but they objectify their vision to a high degree, by projecting it in illusory states and apparent forms, just as a novelist or dramatist might do...

The drawings and collages of Dumas and the wooden sculptures of Henk Visch, however dissimilar in form and content, are so subjective in their evocation that they may be seen as forms of pure lyricism.

Gijs van Tuyl
*from the catalogue*

Young Art from the Netherlands

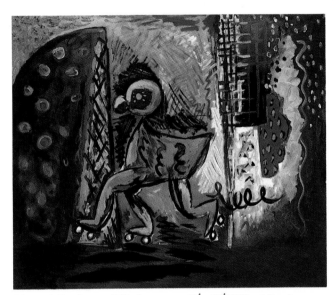

John van't Slot, *Romeo*, 1981, oil on canvas, $47\frac{1}{4} \times 55\frac{1}{8}$" (120 × 140 cm)

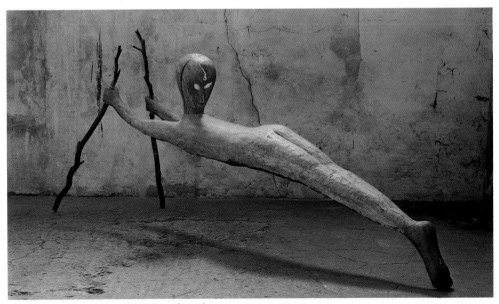

Henk Visch, *Untitled*, 1982, wood, $51\frac{1}{8} \times 98\frac{3}{8} \times 35\frac{3}{8}$" (130 × 250 × 90 cm)

Kees Smits, *Untitled*, 1981-82, acrylic on canvas, $32\frac{5}{8}$" × 10'9$\frac{7}{8}$" (83 × 330 cm)

# Switzerland
## Kunsthalle
## Bern

## Leçons de choses
## Sachkunde

Cragg, Friedman, Gherban, Lavier, Saytour, Vilmouth, Woodrow

The object is the common denominator for the seven artists in this exhibition. This is not a thematic exhibition, nor a question of bringing together all the artists who work with objects. Far from it. Each is exhibited in one of the seven rooms of the Kunsthalle. Of different geographical and aesthetic backgrounds and varying in age, they have all arrived at that crucial point where their work has reached a stage of effective concentration and crystallization. After several years of maturing, they have attained that state of equilibrium where intention finds its formal articulation in the material (things).

Each offers in some way an object lesson, a way of tangibly apprehending our everyday environment and involving an interpretation of reality. These manipulations of the object, very different among themselves, invite comparison: a variety of lessons that go from traditional aesthetics to the theory of art, but always through things.

Jean-Hubert Martin
*from the preface to the catalogue*
*Translated by John Shepley*

Bertrand Lavier, *Nu-Swift,* 1982, fire extinguisher with acrylic paint, h. 25⅝"

Jean-Luc Vilmouth, *Crowd,* 1982, mixed media, ca. 11½' × 6'6¾" (3.50 × 2 m)

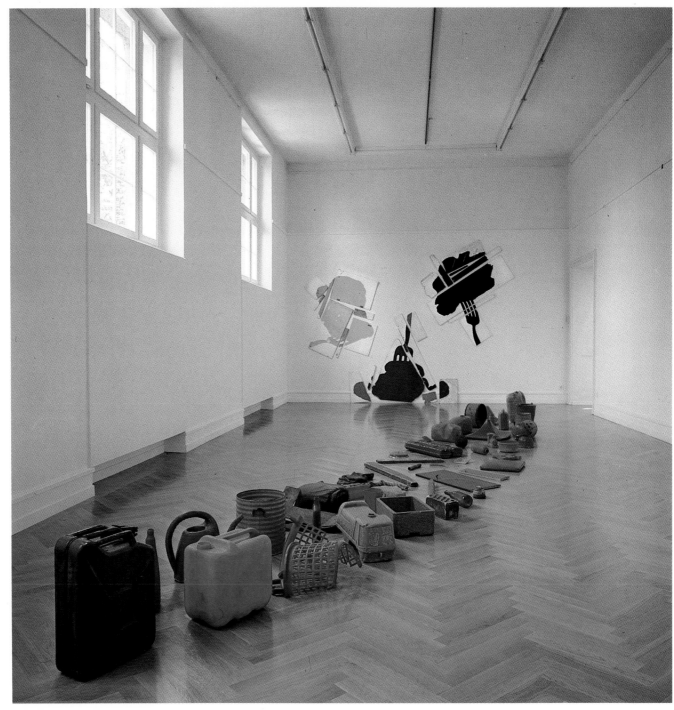

Tony Cragg, *Canoe,* 1982, mixed media, length 25′ (8 m). On wall: *Three Forks,* 1982

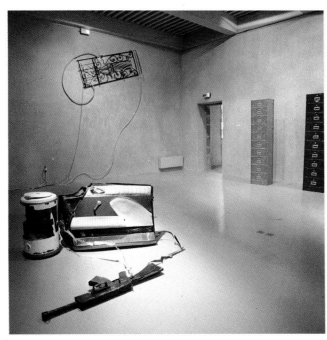

William Woodrow, *Car Door, Stroller, Spindryer, and Incident,* 1982

born in 1941 in Bern
lives in Bern

A work by Markus Raetz is always an integral part and the result of a long series of labors, of a process of work within which a theme develops...

In the many series dealing with the theme of the head, we are obliged to choose separate and exemplary efforts...

Many examples may give rise to the feeling that Markus Raetz was interested in particular physiognomies, that he had ulterior motives of a psychological order. But this was not the case at all. The fact is that by drawing constantly, even with a brush, and while remaining within the framework of a given theme, one brings forth things that nothing would have made it possible to foresee, and which at a certain moment attain such autonomy and seem so to operate on their own that they give the impression that the artist had been seated at his worktable one fine day and, without any preparation, had executed this or that particular work by conforming to the mental representation that had appeared to him. But I should like to say all the same that we cannot speak here of pure contingency. The activity that consists in occupying oneself steadily with a theme, and in particular with a face and the knowledge whose object is the expression and meaning of facial features, ought at a certain stage of research to lead quite naturally to physiognomies that remind us, for example, of strange characters, or which we liken to riddles because we do not know what has produced them, nor by what means they have become incomprehensible...

Raetz is interested not in the reality of objects, but in the reality of the movement and change of which objects and images are examples. As we have seen, it is not a question of just any object or image, but of those that have some relation to Raetz, to his nature. This having been said, have you met Markus Raetz? He is intelligent, friendly, and thoughtful, he possesses a marvelous sense of humor, and his laughter is contagious.

Jean-Christophe Ammann
*from the catalogue*
*Translated by John Shepley*

*Du bois dormant (Sleeping Wood)*, 1981, 94 pieces of wood, $55\frac{1}{8} \times 70\frac{2}{8}$"

*Untitled*, 1981, size color and watercolor on cardboard, $24\frac{3}{8} \times 18\frac{1}{8}$" (62 × 46 cm)

*Untitled*, 1982, watercolor and Erdal Rex on paper, $11\frac{5}{8} \times 8\frac{1}{4}$" (29.7 × 21 cm)

The Third International Festival of Video Art was held in Locarno-Ascona from August 6 to 15, 1982, following the First Festival in 1980, devoted to Swiss artists, and the Second in 1981, devoted to Europeans.

Twenty-six competing groups from eleven countries (Germany, the United States, Belgium, Canada, France, Italy, Japan, the Netherlands, Peru, Switzerland, Yugoslavia) were presented to an international jury by national commissioners headed by a commissioner general...

At the conclusion, AIVAC, anxious to attest its primary interest in video artistic creation, decided to award the AIVAC gold medal to the artist Nam June Paik in recognition of his work as a pioneer and of the international interest aroused by his work...

Denouncing the referential illusion of the media and the reverential collusion of their respective subjects, the power of which is being steadily increased by the market, video artists demystify in advance the "audiovisual happiness" that is promised us and in which, unless we are careful, we will soon be submerged.

In the manner of a Descartes, video artists are trying to establish a new *cogito*. The substance of being does not result solely from conceptual thought; it passes, or can pass today, through the electronic image.

In the wake of Freud, they explore the depths of the unconscious, no longer to derive a theory from them, but to make them simultaneously visible and tangible (many video installations are models of our innermost psychic mechanisms). Breaking with mass production, delivered over to enjoyment, the aesthetic of change that they are inaugurating puts us on the path to the *heart of the subject* that we are. Would philosophy (the love of wisdom), which languishes in the universities, and which the media, mass sophists, claim to reduce to the state of folklore, stand a chance of being reborn when the video artist, like Socrates, sets out to interrogate the world and question us, each of us, with no possible evasions or excuses?

René Berger
*from the exhibition notes*
*Translated by John Shepley*

Third International Festival of Video Art

Marie André, *Galerie de Portraits, (Portrait Gallery)*, 1982 (lst prize)

Magazzini criminali, *Crollo nervoso*, 1981 (honorable mention)

Klaus von Bruch, *Das Alliiertenband (Band of Allies)*, 1982 (honorable mention)

# Belgium

## Galerie Isy Brachot

## Brussels

## Le désir pictural
## Het picturaal verlangen

The Pictorial wish: Results of Current Belgian Painting

An absence of style, called eclecticism, is being born. No response or definitive system is being offered, since it is instead a question of introducing open developments. The crux of the problem posed by this new painting is surely the rediscovery of exuberant pictorialness as realized through a maze of stylistic quotations and ruptures of style within the same painting. Faced with the omnipresent slogans of an economy of restrictions, this painting upholds a pictorial prodigality and lack of moderation. Violent and spontaneous, the execution of the painting is once again decisive for any interpretation. The sanction of a social norm matters little, and even if the artist does not develop any alternative, he aims on the whole at ambiguity and chaos. It is for these reasons that this painting is wild, violent, multicolored, shattered, hateful, adolescent, immature, free, and eclectic. No theme is excluded from it *a priori*. A feeling of omnipotence (to be seen in the pictorial explosions, countless references, and immersion in an a-historical present) is curiously coupled with individual regression and a need for escape. The contradictory character of this painting is shown by the way imitation (i.e., the shameless quotation of other artists and styles) and narcissism culminate in a paradoxical consciousness of being simultaneously free and yet determined by the society and culture. Artists deny the ideology of *pure figuration* and reject any systematic analysis. They transport themselves (and eventually the spectator) by an amalgam of eroticism, violence, movement, marginality, and narcissism. Thus painting is indeed subjected to a goal—that of creating *images* in the artistic sense—while at the same time the need for aesthetic order and consistency is annihilated.

Wim Van Mulders
*from the catalogue*

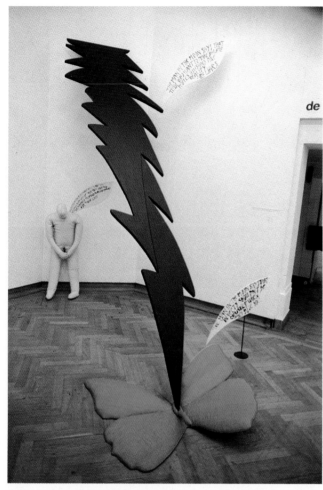

Sigefride Hautman, two works from series *The Man in the Moon Says...* 1981-82

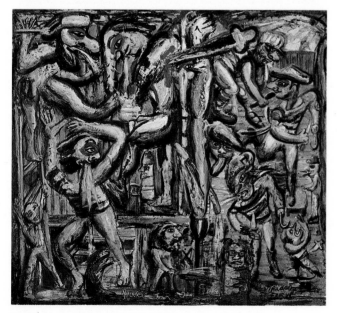

Fred Bervoets, *Ruzie in de Galerij*, 1982, oil on canvas, 6'9" × 8'2"

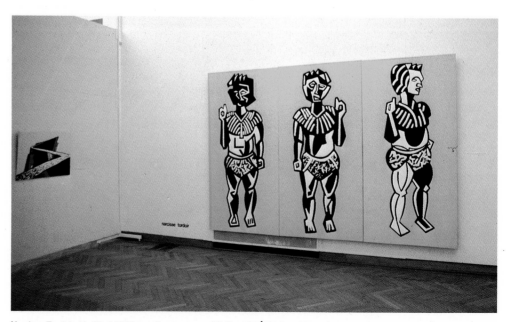

Narcisse Tordoir, *Untitled*, 1982, acrylic on canvas, 11'4" × 12'3½" (345 × 375 cm)

The various approaches, however individual, general, or regional, speak of the *diversity* of ways in which that boundless *freedom* of formulation that characterizes New Image painting is expressed. This diversification, which involves form and content, is the result of a more relative conception of the stylistic conventions, techniques, and positive power of images...

The present quest for spontaneity, sincerity, and immediacy seems, on the contrary, to encourage pure impulse, while at the same time erecting as virtues such aspects as a lack of application, discipline, or craftsmanship. Not that the total genesis of a work is condensed into a shorter time period, but an interval in the process, the moment of final execution, is favored to the point of taking on the appearance of a bolt of lightning. For if truth and authenticity are to come first, it is important that the very act of painting take place rapidly and without excessive technical skill...

Far from being concerned only with living intensely in the present, this painting gives substance to a true passion for the creation of images. Indeed, the fascination of the image, and the affirmative potency it possesses, are present throughout...

Meaning remains most often open, and it is the *intensity of the image* that takes precedence, evoking and suggesting rather than describing.

One could go so far as to speak of a new synthesis in the evolution of painting, to the extent to which simple diachronic development—too often facilely invoked, it would seem—finds itself abandoned in favor of an attempt at assimilation that seeks to reunite all phenomena in a synchronic entity...

Florent Bex
*from the catalogue*
*Translated by John Shepley*

# Belgium
## Palais des Beaux-Arts
## Brussels

## De magie van het beeld
## La magie de l'image

The Magic of the Image

Mark Luyten, *Ruitertje, ruitertje vlucht*, 1982, oil on canvas, 8'2" × 4'11" (250 × 150 cm

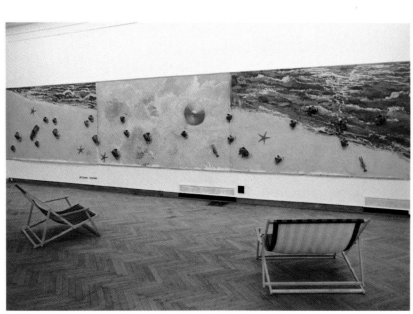

Jacques Charlier, *Untitled*, 1982, acrylic on canvas, 32' × 6'10" (1 × 2.10 m)

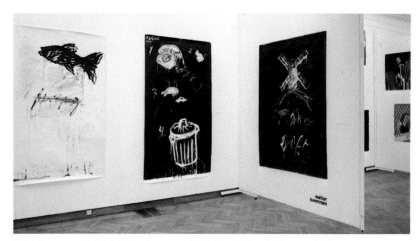

Walter Swennen, *Untitled*, 1981, oil on paper, left & right 7'6" × 4'11", center 8'6" × 4'11"

# Belgium
## Palais des Beaux-Arts
## Brussels

## Verzameling van het museum
## van Hedendaagse Kunst te Gent

Collection of the Museum of Contemporary Art, Ghent

The history of the Musée d'Art Contemporain of the city of Ghent, created on August 1, 1975, is exemplary. In 1957 a private association began making plans for a museum of contemporary art that would have as its goals: an independent museum, the renewal of the spirit and infrastructure of the existing Musée des Beaux-Arts, the purchase of works, information on modern art, the formation of a museum public, and above all a means of helping young people to understand this art. Within a few years, the association included more than a thousand members. Young people joined the group "Jeunesse et Art Plastique," whose membership rapidly rose to five hundred. To encourage the diffusion of art, the association began to publish graphic works. To broaden its scope, the museum has sent its members to visit foreign exhibitions and museums. To educate the public, it organized exhibitions, discussions, informal talks, and lectures with artists and critics. Thanks to these efforts, the association has so far been able to acquire about a hundred works, to which has been added purchases by the museum since 1975, donations, and various loans from the Musée des Beaux-Arts, the state, and private collections—a total of more than five hundred works. While awaiting the construction of new buildings, the collection temporarily occupies a few rooms in the Musée des Beaux-Arts, which is located in the park of the citadel. The space is too small to display the whole collection, and this is the reason for the current exhibition of the most important part of the collection in the Palais des Beaux-Arts in Brussels. The role of art as the museum sees it, is to serve as a "witness" of the national and international trends of our time. The collection contains examples of the Cobra movement, lyrical abstraction, new vision, from pop art to minimal art, *arte povera,* and individual mythology.

*The editors of World Art Trends 82*
*Translated by John Shepley*

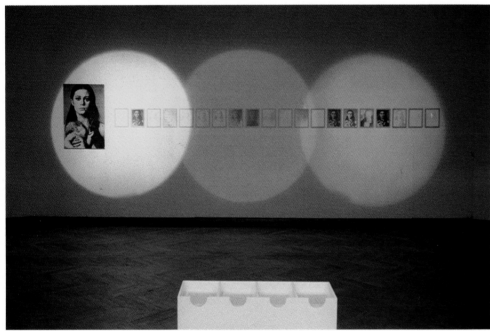

Jef Geys, *Geel, rood, blauw enz... (Yellow, red, blue, etc.),* 1979, installation

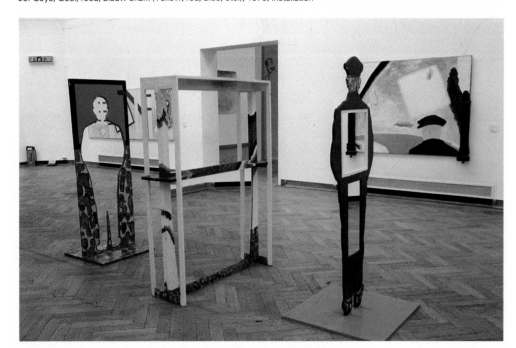

Roger Raveel, *Illusiegroep,* 1965, oil on wood, mirror, 72⅞ × 31½ × 31½" (185 × 80 × 80 cm)

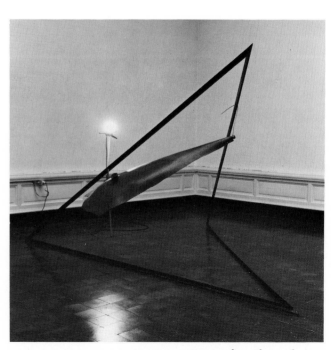

Gilberto Zorio, *Scultura per purificare le parole,* 1979, 6'8¾ × 8'8¾ × 12'1⅜"

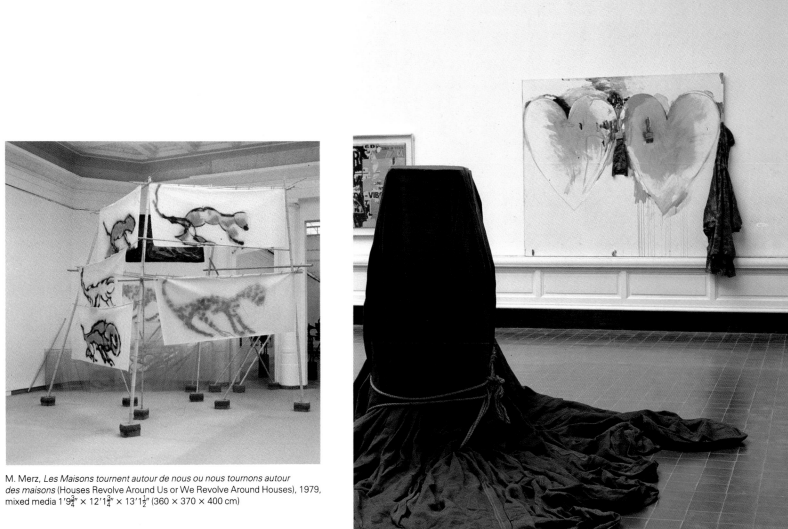

M. Merz, *Les Maisons tournent autour de nous ou nous tournons autour des maisons* (Houses Revolve Around Us or We Revolve Around Houses), 1979, mixed media 1'9¾" × 12'1¾" × 13'1½" (360 × 370 × 400 cm)

Foreground to background: works by Christo, Jim Dine, and Andy Warhol

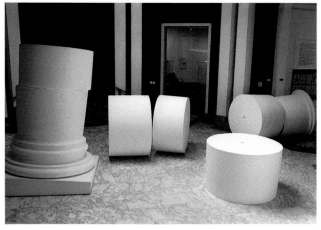

Anne and Patrick Poirier, *La Colonne pour la villa Adriana,* 1979, plaster on wood

Studios 81/82

Let us first note the youth of the participants (some only a little over twenty years of age), the accelerated passage from one "generation" to another (a year and six months sometimes), and the latent and galloping contamination by Show Business of which they are the object.

The diversity of personalities, purposes, results, and means of expression is also quite characteristic of an eclectic, disparate scene, which, as everywhere, has completely abandoned all ideas of line or single reference. Nevertheless, also as everywhere, this exhibition will give convincing proof of the strong current infatuation with painting, which has once again become the favored vehicle for the urge to express and the pleasure of creating. The generation gap can moreover be seen as well in the artists' relations to this painting: the younger ones employ it frantically and insolently, in a combination of fascination and derision, sumptuousness and vulgarity, turning everything into color (an abstract-figurative hybrid of consciously popular, private, rock, punk, pub, comic-strip, and cinema imageries and cultures), with a certain slackness in which a flippancy devoid of "pentimenti" is not uncalculated ("bad painting" affected without affectation). As for the older ones, they assert their mastery in compositions that are likewise very pictorial but more formal, compact, and assured, as well as more distanced and easily verbalized.

In the first: speed, prodigality, spontaneity, skin-deep expression, sometimes not without naïveté. In the others: a time rediscovered (expanded, slowed down), something rare, acute, silent, tense, an economy, an efficiency without approximation, and also an eager persistence, but in the painting rather than on the painting...

It will appear symptomatic that, despite obvious relationships with other scenes (especially Italy, Germany, and the United States), art in France today upholds its singularity in the unavoidable regional/national/international tension. The universal affinities and concerns of the participants certainly prevent their work from coinciding with any ambiguous concept of "French art." Nevertheless, an awareness of its singularity ought to bring it to international attention, an aim that was certainly part of our original purpose

Suzanne Pagé
*from the preface to the catalogue*
*Translated by John Shepley*

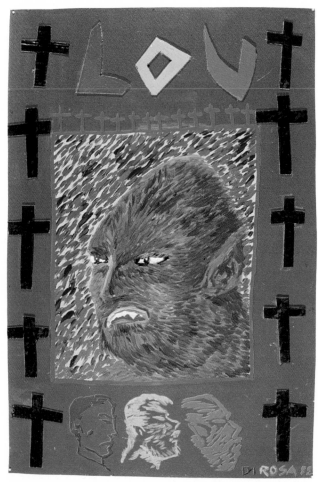

Hervé di Rosa, *Untitled,* 1982, acrylic on cardboard, $47\frac{1}{4}'' \times 31\frac{1}{2}''$ (120 × 80 cm)

Jean-Luc Poivret, *Avion (Airplane),* 1980, stiffened cotton and bright enamel

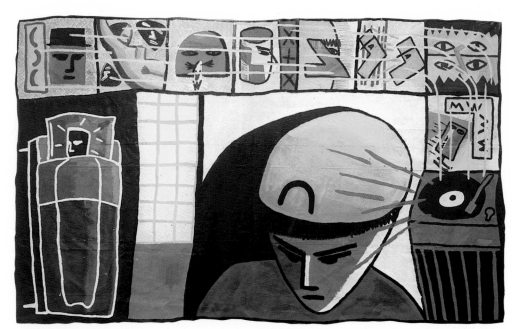

François Boisrond, *Untitled,* 1981, acrylic on canvas, $10'4\frac{7}{8}'' \times 9'10\frac{1}{8}''$ (5 × 3 m)

The year 1981 saw the emergence in France of a number of young artists, all of whom lay claim to a particular approach to figuration. As part of a generation that produced the Punk movement, in which the comic strip has come into its own and aesthetic debate is often marked by a return to former values, these young artists set themselves apart by an individualist attitude, one deliberately cut off from the pictorial avant-gardes of the last decade and emphasizing the personal dimension of their work.

They are considered by some to be the pure product of a method intended to satisfy a part of the middle class that plays at frightening itself. Others perceive them as the beginning of a new avant-garde that is overthrowing established values in favor of a new use of the idea of figuration. Together, these artists have helped to create a situation, new in France, that has produced a certain agitation in artistic circles...

This exhibition, whose title, "L'Air du Temps", indicates the portion granted to the "immediate present" and its possible effects, brings together 15 artists whose different approaches allow us to gauge the diversity of a trend that is interesting in the new beginning it proposes.

The violence of Combas, Blanchard, Blais, or the En Avant Comme Avant group contrasts with the more sensitive perceptions of Lanneau and Castellas or Favier's "minimal" use of space. Likewise the imagery to which the works of Di Rosa, Boisrond, or Denis refer cannot be compared to the classical sources drawn on by Alberola, Laget, Gainon, or Giard. Rousse's work, connected as it is to specific settings, also stands out as individual.

Marc Sanchez
*from the preface to the catalogue*
*Translated by John Shepley*

# France
## Galerie d'Art Contemporain des Musées de Nice

### L'Air du Temps
### Figuration libre en France

85

Free Figuration in France

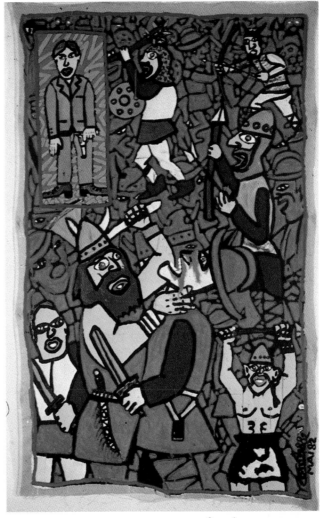

Robert Combas, *The Vikings*, 1982, oil on canvas, 63¾ × 40⅛" (162 × 102 cm)

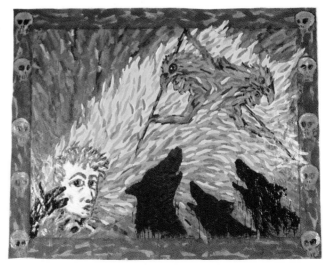

Remi Blanchard, *Self-Portrait*, 1982, oil on canvas, 7'10⅝" × 10'⅝" (240 × 307 cm)

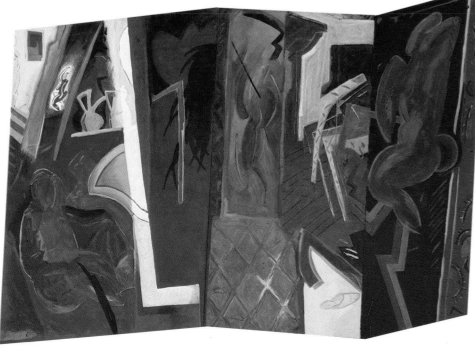

Jean-Michel Alberola, *Aziyadé et le peintre (Aziyadé and the Painter)*, 1981, oil on canvas, 6'4¾" × 9'6⅛" (195 × 290 cm)

# France
## Galerie Eric Fabre
## Paris

## Karel Rösel

born in 1947 in Prague, Czechoslovakia
lives in Cologne, West Germany

Karel Rösel at Beaubourg, carrying a bag, which no one claimed from him

*Je ne veux pas être voulu (I Don't Want To Be Wanted)*, detail, 1982

*Le Jardinier indécis (The Irresolute Gardener)*, 1981, mixed media, 9'6⅛" × 8'6¾"

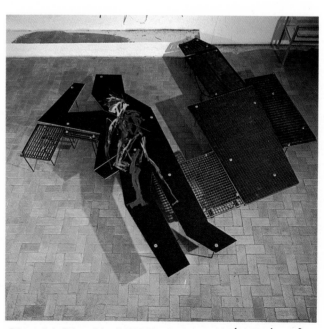

*Prison privée (Private Prison)*, 1981-82, mixed media, 13'1½" × 9'10⅛" × 15¾"

When things can be assigned a beginning and an end, a place, a name, and something to hold them, it is easy to point to them and say, for instance, "sculpture, painting, drawing." Judgment, the great separator, is quite at home with abstract shapes, but not when the tangibly visible comes forward.

Take *The Tunis Player*—a postcard received from Tunis in the form of a tennis racquet. The player himself is outlined with an engraver's tool and then painted; the balls are on a table. *The Tunis Player* is on the ceiling, not a new place for art, since conquest and appropriation are the signs of modern artistic territorial violence: The "this belongs to me" of the violent origin of property in the opening of Rousseau's *Discours sur l'origine de l'inégalité*. This height is only for perception. To the gaze of an onlooker, this could be a nondestructive assemblage in which elements, a technique and its instruments, become interchangeable while continuing their own autonomous existence.

We are then in a generalized artistic system of disturbances. The orders of art begin first to mingle, next to merge, and finally to disappear.

The orders of the artistic visible lose their territory and melt away.

*from the catalogue*
*Translated by John Shepley*

The objects: I am not interested in romanticizing an epoch in the distant past when technology permitted men to make only a few objects, tools, etc. But in contrast to things as they are today, I assume a materialistically simpler situation and a deeper understanding of the processes of production as well as the function and even the metaphysical qualities of the objects produced. The social organizations that have proved to be most successful are productive systems. The rate at which objects are produced increases, and consumption increases accordingly. We consume, populating our environment with more and more objects, but with no chance of fully understanding the processes of production because we specialize in production but not in consumption.

The colors: The choice is from a range of colors that already represent some kind of lowest common denominator. These colors become interesting after they have led a life in which they react to the atmosphere and to light, and in which they are touched by other materials.

The images: Celluloid wildlife, video landscapes, photographic wars, Polaroid families, offset politics. Quick change, something new on all channels. Always a choice of secondhand images. Reality can hardly keep up with its marketing image. The need to know more, both objectively and subjectively, about the subtle and fragile relationships between us, objects, images, and essential natural processes and conditions is becoming critical. It is very important to have first-order experiences—seeing, touching, smelling, hearing—with objects and images, and to let those experiences register.

Tony Cragg
*from "Cahiers du CRIC," No. 4*

**France**
**Galerie Chantal Crousel**
**Paris**

**Tony Cragg**

born in 1949 in Liverpool, England
lives in Wuppertal, West Germany

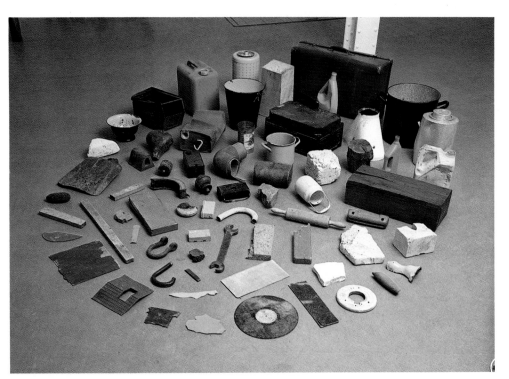

*Oval*, 1982, various materials, 9'6⅛" × 9'3" (290 × 282 cm)

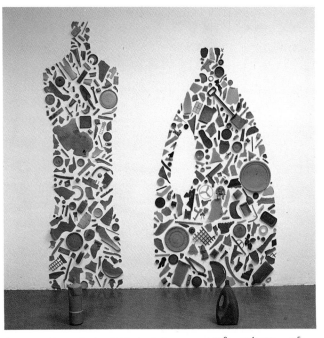

*Orange and Green Bottles*, 1982, plastic fragments, 11'9⅜" × 29½", 91" × 47⅝"

# France
## Galerie Adrien Maeght
## Paris

## L'A.W.K. observée par Gasiorowski

The W.K.A. observed by Gasiorowski
born in 1930 in Paris
lives in Paris

Like the synopsis of a novel, the Worosis-Kiga Academy, conceived by G. Gasiorowski, will allow the artist to experience creation by substituting the *he* for the *I*, his back turned so as no longer to have to meet our gaze. For this purpose, he will invent for himself understudies capable of staging the *neutral*. The understudies will have the status of pupils, a place of residence, the Academy, and a program of creation.

The Worosis-Kiga Academy will see the light of day like the synopsis of a novel.

Errors of pride apparently being, according to Gasiorowski, the compost of artistic desires, a knowledge of the masters will assure future careers for aspiring artists. So as to set at the beginning of the instruction limits that absence of imagination, Gasiorowski will introduce into his academy the principle of the single theme. Pictorial techniques

*Third-year subject, pupil François Morellet*, 1976,
acrylic on paper, 11¾ × 15¾" (30 × 40 cm)

Drawing and original photographic montage for Art 82, ink on paper and black-and-white photo, 12¼ × 21¼" (31 × 53.5 cm)

will thus be acquired on the basis of a single subject: a hat whose appearance will evolve as students acquire a language. The *deus ex machina* of this enterprise will be Professor Arne Hammer, a fanatical autocrat who conceives of teaching only as a system of reward and punishment.

In the present case, fiction will be embodied in a reality itself full of illusions. For over a year, Gasiorowski will collect the works of pupils whose treatment of the hat and background will have developed as a result of his teaching. A total of over 400 drawings will be signed with names referring to the most representative artists of contemporary history.

In Gasiorowski there is a serious irony that takes itself as a subject and object of study. Hence the desire for an indirect action capable of appearing to represent a fictive situation as substantial as the shadow of a shadow. One would say that for him the clear designation of facts and works through the direct principle of a signature prevents the crystallization of transparence—that poetic moment when signs assemble in consciousness as suddenly as the forking of idea and perception.

Anne Tronche
*Opus International,* Summer 1982, No. 85
*Translated by John Shepley*

# France
## CAPC/Entrepôt Lainé
## Bordeaux

## Richard Long
## Bordeaux 1981

born in 1945 in Bristol, England
lives in Bristol

Richard Long is a man who walks... His creative gesture begins there, in paying the closest attention to the ground on which he treads... "Walking," he says, "is one more layer, a mark placed over thousands of other layers of human and geographical history." What he restores to us in an exhibition is in some way an elliptical account of his walks, adapted each time to the structures of the site.

He installs reminders of his journey almost always at ground level in the space. They have an unquestionable emotional power though because of his formal economy —he uses essentially only circles and rectangles—and strict arrangements, they may at first seem severe. With no violence or aggressiveness, in subdued tones—all of which would lead one to place Richard Long's work in a certain tradition of English landscape—the artist works with driftwood or mud collected along the Gironde estuary, and elsewhere with slate from Cornwall...

By offering us the possibility of moving around his pieces, Richard Long elicits our own displacement, bringing in notions of distance and time. Hence, in following the secret paths that he inscribes in the very placement of his materials, one cannot help thinking of the age-old structures of the first human homes and first human rites. Thus, not only do we receive aesthetic pleasure, but we also are made to realize the privileged relationship between man and nature.

Finally, this exhibition, the first of such importance to be devoted in Europe to Richard Long, gives the word "decentralization" a quality and meaning that deserves to be emphasized.

Maïten Bouisset
*Le Matin,* January 26, 1982
*Translated by John Shepley*

*Four Slate Circles,* 1981

*Forêt du Porge Line,* 1981

*Gironde Mud Circle,* 1981

Benni Efrat's approach has many facets and follows diverse paths. However, in trying to redefine space, a task to which any art worthy of the name is devoted, Efrat's work shows a remarkable consistency. It is not so much that it tries to define—as so many artists have attempted—a space in which surface replaces depth. Efrat refuses to be trapped in a radicalism of contraries, something that very quickly reveals its limits. He prefers to manipulate space and distort the image in a quasi-experimental approach that assumes and fully reveals the relativity of any cognitive method. Since it is accompanied by a praise of displacement and what Bachelard would call "a dialectics of the deep and the large (or the infinitely small)," this quest also outlines a space in which it is possible to dream. With the *relevations* made to it, the mind withdraws from this near and yet distant object, venturing out into the terrain of an incommensurable elsewhere. And if it is true that the most recent works tend to echo a certain subjectivity of the artist—simultaneously arousing our subjectivity—they may possibly inaugurate a new course in his *œuvre* without denying its foundations.

Claude Gintz
*from the catalogue*
*Translated by Joachim Neugröschel*

**France**
**Galerie de France**
**Paris**

**Quest for Light**

born in 1938 in Beirut, Lebanon
lives in New York

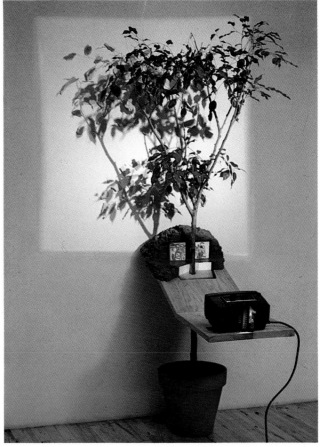

*Quest for Light,* 1982, mixed media, 98⅜ × 29½" (250 × 75 cm)

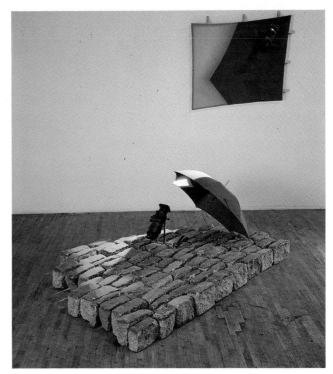

*Remember Beith Mirae,* 1982, mixed media, 8'10¼" × 9'10⅛" × 14'

*At the Edge of the Wheat Field,* 1981-1982, painted wood, film projector, 9'7" × 10'2⅜" (291 × 310 cm)

# France
## Galerie Gillepsie-Laage-Salomon
## Paris

### A.R. Penck

born in 1939 in Dresden, East Germany
lives in Cologne, West Germany

I came to Paris because I was curious to see and find out about the notion of "CLARITY" and the light here that comes from the place and weather. This made me eager to come because I had heard a lot about Paris and because Paris and painting go together. And I had heard this ever since my childhood, when they told me for the first time about all those famous great painters who worked here and made this thing called "painting" advance. To paint "clear" pictures has always been my goal and so Paris was also important to me. But at the same time I have been affected by the city's nakedness and thirst for living which make it seem frightening and monstrous to me.

A.R. Penck
Paris, December 1981
*Translated by John Shepley*

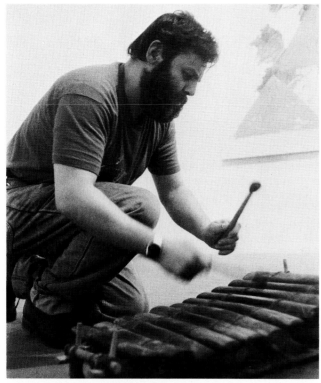

The artist playing the bulaphone the night of the opening

*What Becomes System*, 1981, acrylic on canvas, 78¾ × 118⅛" (200 × 150 cm)

*Separation in Fission*, 1981, acrylic on canvas, 39⅜ × 78¾" (100 × 200 cm)

*Occurrence in the Subway*, 1981, acrylic and oil on canvas, 6'6¾" × 9'10⅛" (200 × 300 cm)

To exhibit is no longer to exhibit oneself; it is to place a particular problem on view, in question, in disequilibrium. The painter is nothing but the organizer of this demonstration. The *subject* is the task; the result, the image of the task. The painter is neither conceiver nor creator, but one individual among others living in his time.

To perform the task in public is not to exhibit a task, but to exhibit someone doing a task—the task being simply the concrete act that produces a physical result.

To exhibit the task, exhibit the image of one's task, exhibit oneself, means anyway to give a different image of an act—the one that remains, as evidence of that act, as memory or document or result, thus distorted and falsified with respect to the impulses that provoked it.

To give a reason (explanation) for one's task, for one's acts, is to falsify them again, amputate them, clarify them in part, fake them, because the things that determine them are many and complex, and cannot be defined in number (those that yield themselves are the ones that are not repressed), but all of them motivate and determine equally.

To speak is also to want, at first, to hide.

Claude Viallat
"Fragments" *from the catalogue*
*Translated by John Shepley*

# France
# Centre Georges Pompidou
# Paris

## Viallat

born in 1936 in Nîmes, Gard, France
lives in Nîmes

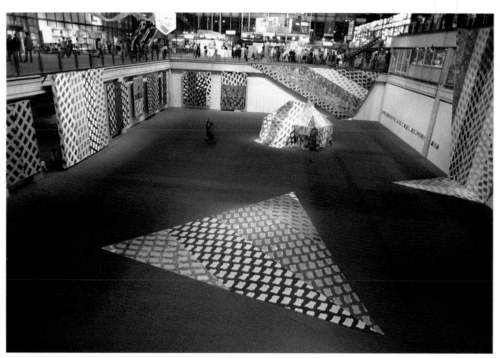

Installation in Forum of the Centre Georges Pompidou

*Parasol*, 1978, acrylic on cloth, diam. 72⅞" (185 cm)

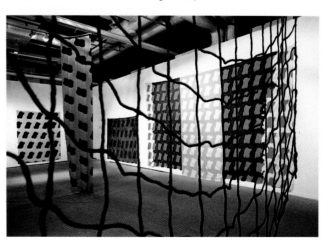

*Bâche en Corbeille*, 1979, acrylic on cloth

# France

## Centre Georges Pompidou
## Musée national d'art moderne, Paris

## 3-Totems-espace musical
## Takis

3 Totems - musical space/Takis

born in 1925 in Athens, Greece
lives in Paris and Athens

Three Totems—*Musical Space* by Takis, the most important work he has ever executed, conceived expressly for the Forum of the Centre to the scale of that immense site, is more than an environment. It is a personal and romantic conception of a total space, in which for the first time on such a scale Takis utilizes all the elements of his previous experiments: telelamps, magnetic fields, music. A Monument-Site that once again celebrates Electricity, and this time, as he himself says, in a nostalgic fashion.

Dominique Bozo
*from the catalogue*

*How do the telelamps work?*
This is an action that unfolds in a space limited by the lamps, a space that I consider as the spatial void, and where the electrons make light without there being any filaments as in a lightbulb. The combination of electrons striking the mercury causes the light. For this phenomenon to be produced, it is necessary to create a vacuum. I therefore use the cathode tube while interfering only with the number and form of its arms and reversing their usual functioning. I don't construct the lamp myself, but I decide certain of its aspects.
*How do you get this blue color and its variations?*
The color is that of the void, what you see in the sky. It is a small miniature of the void in space, a microcosm of the universe. If the heat rises, the light is greener; if it diminishes, it is more mauve, like the sky at the close of day when the atmosphere cools off. What fascinates me is to demonstrate something invisible with this trap for electrons, which is what the telelamp basically is.

Interview with Takis by Alfred Pacquement
*from the catalogue*
*Translated by John Shepley*

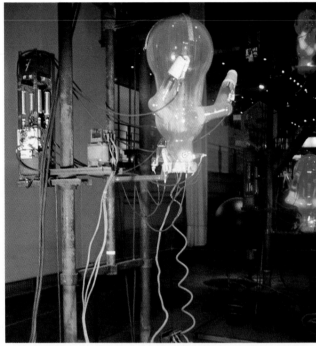

Detail of telelamp

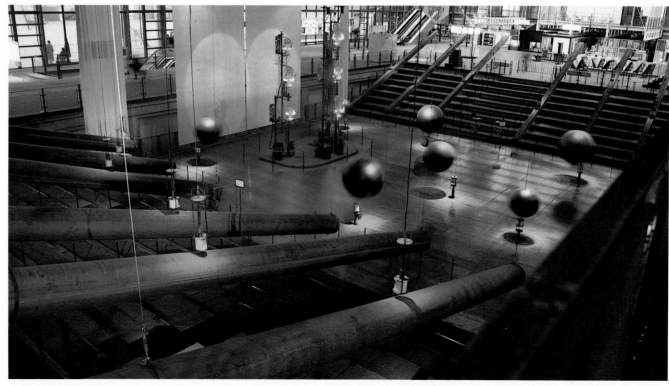

General view of installation: the mercury-vapor cathode lamps produce direct current that feeds electromagnets creating a magnetic field that moves the spheres

For his first and truly remarkable appearance in Paris, Joseph Beuys has created an installation that takes into consideration the topography of the premises assigned to him, in this case the new Durand-Dessert gallery. The result has been two weeks of work carried out on the spot with the help of materials that synthesize some of the determining elements of his plastic vocabulary: beeswax, butter, plaster, felt, and autobiographical photographic documentation...

In his search for an archaic state of human existence, Beuys conducts himself like a shaman who suspects the world of a false objectivity without trying to free it from it. Hence the strange, sometimes irritating feeling that his work communicates to us of seeking a fundamental gesture or space, as though civilization and nature had done nothing but undergo a series of mutually destructive separations. Without personally adhering to Beuys's philosophical concepts, and without being under the spell of his guilt-inducing morality, I recognize in his creations the huge merit of restoring absolute mobility to the interpretative mechanism, of leading perception back into those rarefied areas where the obscure meaning of things and the critical coldness of the intelligence cease to oppose each other...

Around this discreetly morbid, strangely vulnerable installation there is an atmosphere of sympathetic magic. The breath of ambivalence characteristic of ritual passes through it, so that the more one tries to protect oneself from its spell, the more one ends by submitting to it. By taking on aspects very similar to the hermetic practice of Zen philosophy, by denying the protection of the word, Beuys's work achieves a kind of provocation that, repulsing our inclination to rationalism, arrives most opportunely at the crisis of Western thought...

Anne Tronche
*Opus International*, Spring 1982, no. 4
*Translated by John Shepley*

born in 1921 in Kleves, West Germany
lives in Düsseldorf

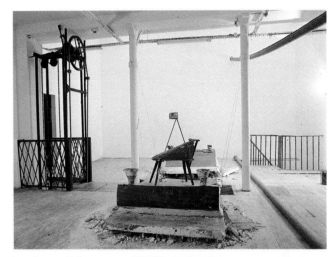

*Last Space with Introspector*, 1964-82, mixed media

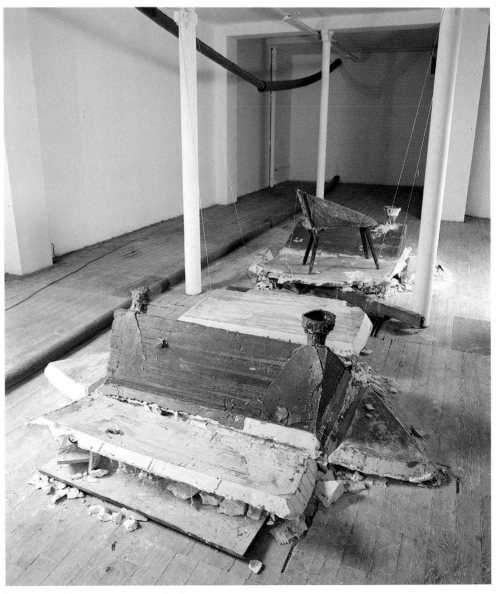

Joseph Beuys at work in the gallery courtyard

*Last Space with Introspector*, 1964-82, mixed media

# France

## Des Murs en France

13 Painters in 13 Cities

Daniel Pommereulle, painted wall, June 1982, acrylic on pyolite support, 305 sq.yds., Anthony

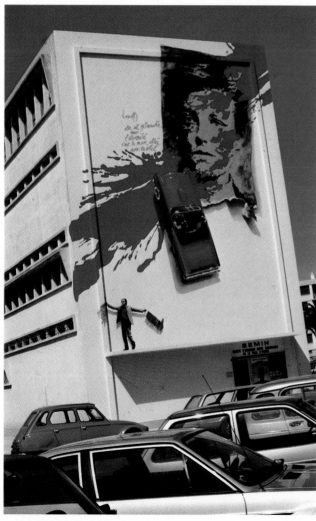

Ernest Pignon-Ernest, painted wall, May 1982, mixed media, 413 sq.yds, Hyères

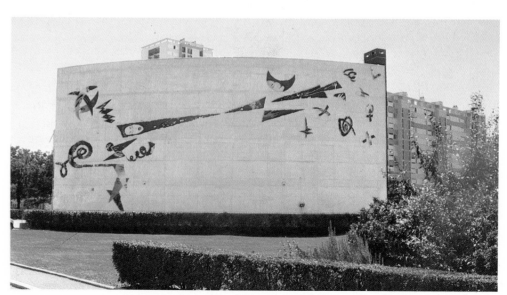

Annette Messager, painted wall, June 1982, 703 sq. yds, Maison des Jeunes, Bordeaux

At the initiative of the Association for the Development of the Artistic Environment, 13 artists and 13 municipalities have joined forces under the patronage and with the help of the French Ministry of Culture. They have painted 13 walls in 13 French cities. Each wall renders a specific local or regional quality, expresses a temperament, and shows a technical suppleness enabling the artist to treat the wall in terms of its nature (location, surface, quality, etc.).

Eight Frenchmen and five foreigners make up the team for WALLS IN FRANCE. All these artists live and work in France, which, despite any remarks to the contrary, remains a land of asylum and the mother of the arts. Chambas in Albi, Cueco in Limoges, Fromanger in Dreux, Pignon-Ernest in Hyères, and Pommereulle in Antony pay homage to their respective areas; while Bouillé in Montbéliard, Mahé in Le Mans, and Messager in Bordeaux emphasize the emotional or professional ties that have already been formed between the artist and the city that welcomed him.

Arroyo in Grenoble confirms the international destiny of the capital of the old province of Dauphiné; while Erró has turned his wall into a obvious bridge between the plastic arts and the comic strip that Angoulême has managed to enlarge. Fanti in Chambéry strengthens the intense cultural exchange between Savoy and Italy; while Ségui is perpetuating the memory of General San Martin, the *libertador* of Argentina, who died in exile at Boulogne-sur-Mer. At long last, Télémaque has found a true welcome in Rennes, at the heart of the maritime region.

Why these 13 walls? Because they also express the desire to create collective spaces and objects, accessible to everyone, as common property...

These walls are remarkably situated, right in the middle of the respective town or at a crossroads, a nerve center as it were. Each wall is perfectly integrated into the urban texture. All this—if additional proof is necessary—further demonstrates the enthusiasm of the municipalities and the great importance they attach to this pilot project.

The total surface area of the walls comes to 1,690 square meters. They average 130 square meters each, running from the smallest wall (Dreux, 42 square meters) to the largest (Chambéry, 350 square meters). The painting work was carried out, under the direction of the A.D.A.E. and the artists, by 13 teams of highly skilled and talented painter-decoraters, without whom this project could not have materialized in the brief space of four months (February 15 to June 15, 1982).

Gille de Bure
*from the catalogue*
*Translated by Joachim Neugröschel*

"Political" painting, no doubt, never an illustration or a message, always a painting incarnate, a conflict carried out, and experienced, in the space of the painting. Today, I have in my eyes, you have before your eyes, the last and also the hardest, the most intense of this series by a painter totally committed to his era and to his art.

It is the furious, and weary, vision of torture laid bare in its horror. It is a prodigious painting, forcing its distance, a retreat, the claw of a big, refractory beast in a zoological garden. Lurking. Draw near, and the material begins convulsing, its form explodes, returns to the rich pictorial magma, the primal vagueness of paints and colors from which it draws its strength, its movement, its dirft... Everything is seen, conceived, carried—the dot and the line, the spread or the spurt, the daub and the flow, the proliferation and the lacuna, the accent and the emptiness—everything is elaborated for a distant fascination, an immediate inscription of the act of painting in the development of the painting. Powerful paintings, unendurable, like the shrieks, like the silence of the torture victims that these paintings show us...

How can one paint the same scene ten times, despite the diversity of poses, in its unifying of horror? Should one reiterate the theme, like Cézanne with the apples or the Sainte-Victoires? It's similar, says the painter, I was never satisfied. Yet it's not similar... The painting of horror has no boundary, suffers no completion. We have to lose ourselves in it, recognize ourselves, with the fierceness of insanity, the surpassing of limits... We must drive in the nail ad nauseam, for one does not paint torture or suicide, it's impossible; the artist cannot lock himself up in his studio in order to experience them, in order to extract, exhaust the increased strength that shoots forth from that pain, that color...

Jacques Dupin
*from the catalogue*
*Translated by Joachim Neugröschel*

Failed Escapes
born in 1926 in Eymoutiers, Haute-Vienne, France
lives in Boudreville, Aube, France

Paul Rebeyrolle in his studio

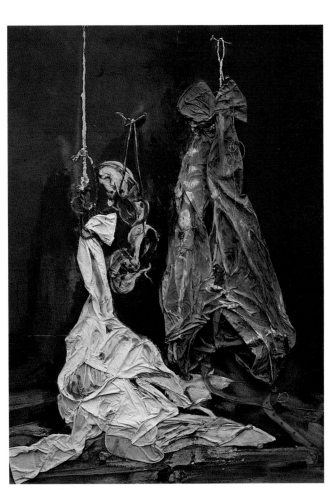

*Dépouilles pendues n° 1*, 1980, paint on canvas, 89⅜ × 65" (227 × 165 cm)

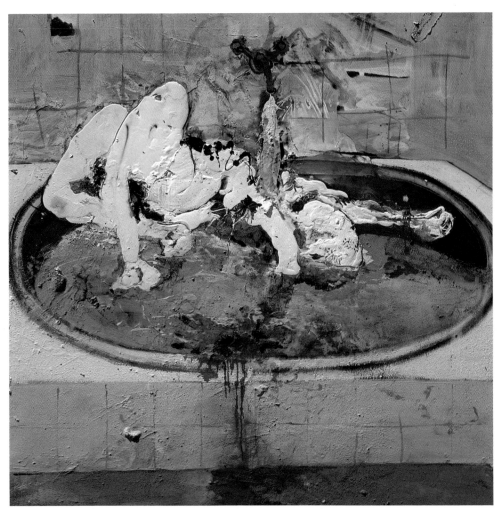

*Suicide No. 2*, 1982, paint on canvas, 89⅜ × 78¾" (227 × 200 cm)

# France
## Musée d'Art moderne de la Ville de Paris

## 12ᵉ Biennale de Paris

Paris Biennale

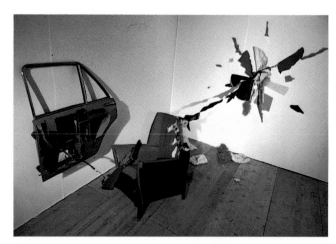

Bill Woodrow, *Car Door, Armchair, and Incident*, 1981, 8'2⅜" × 8'2⅜"

Jean-Charles Blais, *Untitled*, 1982, papers, posters, paint, 9'10⅛" × 8'2⅜"

George Rousse, *Untitled*, 1982, photo and glycerophthalic paint, 39⅜" × 51⅛"

Is it music or performance (knowing that performance claims its "origin" and the places for its practice among the plastic arts)?...

To us it seems very important that the punk deconstructors from Berlin are making their electric drills heard in the halls of ARC and not in some outlying shed. It is an operation in which location is temporarily taken over only to be revealed as a place of transition. To take up residence in a museum is not the aim. To settle down is the exact opposite of what is at stake in that art.

Neither music, nor performance, nor sport, and yet the element of sound combines with them and runs through these three forms of art.

— As though the decomposition, the deconstruction, of these three related but established forms might produce a development that would reexamine vocal, musical, and plastic practices.

— As though the cultural block were to be cracked to the point of allowing its structure and its relation to a past to be glimpsed in the ruins (we are struck, for example, by the return of the repressed acoustic of the Rome-Berlin axis in Vittore Baroni, or the Rasbin Stifftung group). It is obviously premature to speak of ruins for those forms that one would instead call unfinished, but ruin and unfinished construction are not far apart.

— As though something had been interrupted in the development of a work by its very method calling into question the notion of the work and its completion. A claim for the incomplete, the deconstructed, the brutal, the primitive does not seem irrelevant to everything we are offering. The cries of Annick Nozatti and M. B. Servier and those of the Eskimos of Baffin Island have something in common.

— As though we had rediscovered there what the myths tell us about the origin of a music linked to murder and to horror, born from noise and repeated for some of these forms by the Platonic city.

— As though it were necessary to repeat: art is dead, the theater changes scene, music is all alike, the opera dead or alive, etc., so that from this decomposition new formulas (in the sense of chemical formulas) arise that would no longer be the juxtaposition of different forms, but intrinsic and original alloys.

The challenge raised by the "Sound" section appears under three aspects unevenly divided among three forms of transmission and representation.

First, audio itineraries, events, and promenades, which unfold in the museum itself or in the large ARC auditorium... The audio events are also visual, whether they be the work of plastic artists or of musicians who have decided to create plastic works like Marc Monet with his "rose ballets."

Second, audio "installations" or structures that offer a plastic and audio itinerary, like Maria Klonaris and Katerina Thomadaki and their "androgyne" or Christine Kubich and her wall of sound.

Finally, a third form that to us seems necessary, both because it lies within the current aesthetic debate and because it allows one to hear in a radical way the "disorder of the world": the Radio.

To use radio as a means of expression—is that not inevitably to create?

This is the wager that the musical programs of France Culture, the producer of this section, have made with us. They are installing a studio in the museum to execute audio objects starting with the Biennale and in conjunction with it.

Monique Veaute and Marie-Noël Rio
*from "Sequel: 'Sound' Section" in the catalogue*
*Translated by John Shepley*

Several years ago Nam June Paik remarked that video would not replace radio as a form of communication, but instead would replace the airplane as a mode of transport. This is indeed what is happening today... Slowscan is a system that transmits an image by means of a regular international telephone line...

The Slowscan process starts with an image that may be photographic, video, a drawing, etc. The image is picked up on a television monitor by a camera poised above and arrested on a single image. This television image, which is composed of hundreds of sweeping lines, is then dismantled line by line by the Slowscan machine. Each line of electronic information is transformed into a sound signal that passes over a telephone line to be transformed back again into a television image. In the case of the exhibition, these televised images will be photographed by a large Polaroid camera and mounted as soon as they are received. The exhibition is thus constructed day by day for the duration of the Biennale. The transformation sequence is therefore photo, video, sound, telephone, video, photo.

Don Foresta
"Le Transport par la Communication"
*from the catalogue*

Whirled Music group, performance, 1982

Whirled Music group, performance, 1982

Bernd Kracke, *35 Seconds of Slowscan or Double-Quick Time on Two Images*, 1982

Avant-garde Trans avant-garde

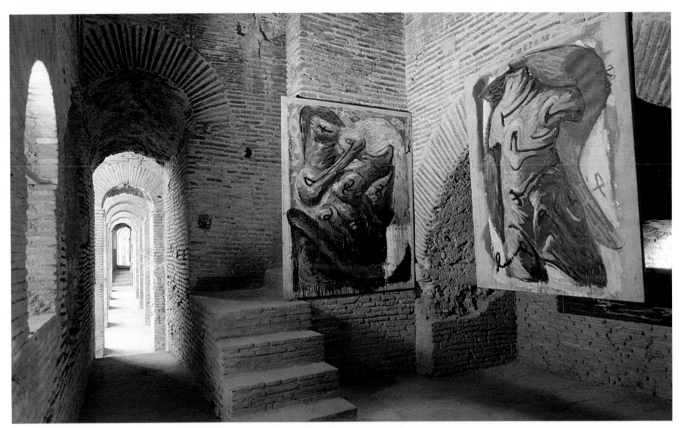

Interior of Aurelian Wall with a painting by Lüpertz

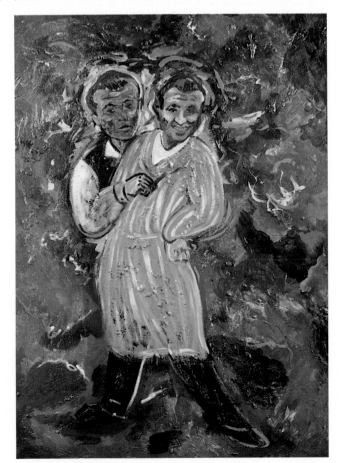

Sandro Chia, *Portrait of Achille Bonito Oliva,* 1980, oil on canvas

Daniel Buren, installation, interior view, 1982

Daniel Buren, installation, exterior view, 1982

"Art as art," if not a theme, is at least an intention, a provocation amid the fascinating ambiguities of our time. Even in its tautology, the title suggests that many gestures, acts, and facts are legitimate in the field of the visual arts not by virtue of certain conventional standards, but because of the ruptures, discardings, and radical discontinuities that have brought about a significant dislocation of the whole system of the visual arts outside its own principles and origins. Where an art once denied itself as art, through a stubborn wish to suspend the object and its immediate relation to reality in favor of other assumptions, such as the moment of the gesture, of the event, of the informal, of the open work, emphasizing the artist's intentions over the formal, finished qualities of his accomplishment, art as art ought instead to call attention to the physical concreteness of the work, to its formal constitution, its capacity for establishing itself less as force and event and opening, and more as substance, with an obvious reality of its own, a capacity for outlasting the impulse and immediacy of the original intuition...

Persistence of the work: the other side of persistence, its opposite, may be the fascination of the *cupio dissolvi*, the fleeting nature and dissolution of the image, the crisis of representation as crisis of presence. This other can only be the irresistible attraction of the work as process and not as product, the precariousness of a gesture that shatters conventions and convictions, the usual boundaries of art, the living and immobile surface of the work. What the persistence of the work is trying to resist is perhaps the death of art itself—a disturbing theme that has hung like a suspicion and an omen over so much of the recent cultural debate.

Therefore at this moment of persistence, have we not come to the return of the repressed, to the dark wishes of the object, to a change in the object if not a change in art? Is there in the aura of persistence an unconscious resistance to everything that dissolves in signs, in events, in images, as though persistence were also the consistency of things, the duration of events, the unsuppressible and perpetuating function of the symbol, the resistance of mankind, the wish for survival over the suggestions of death that run through the consumer society, which indeed in the very name it gives itself alludes to the connection between consumption and destruction?...

Sisto Dalla Palma
*from "Un prologo, un commiato" (A Prologue, a Departure),*
*the introduction to the catalogue*
*Translated by John Shepley*

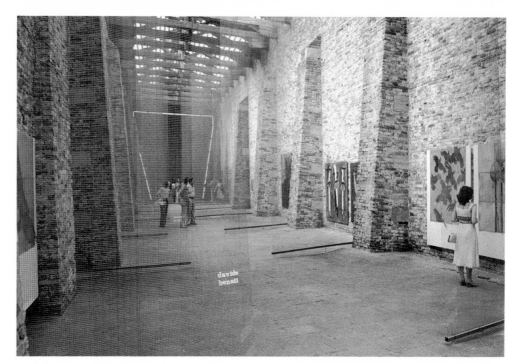

Interior view of the Magazzini del Sale on the Zattere. Overall conception by Nanda Vigo

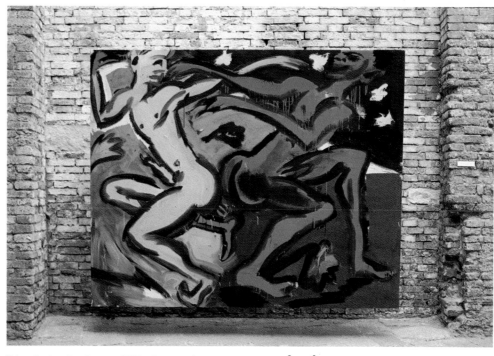

Rainer Fetting, *Due Danzatori II (Two Dancers II)*, 1982, oil on canvas, 78¾ × 98⅜" (200 × 250 cm)

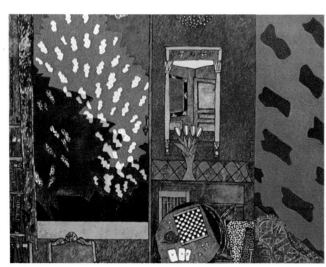

Vincent Bioulès, *Viallat chez lui (Viallat at Home)*, 1981, 74¾ × 98⅜"

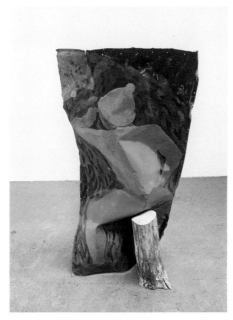

Catherine Blacker, *Uomo seduto su un tronco*, 1982

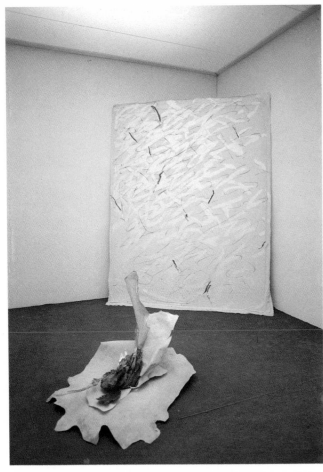

Marco Gastini, *Il peso della pelle (The Weight of the Skin)*, 1981, canvas, paint, wood, parchment, tin, 11'2⅛" × 9'6⅛" × 9'2" (340 × 290 × 280 cm)

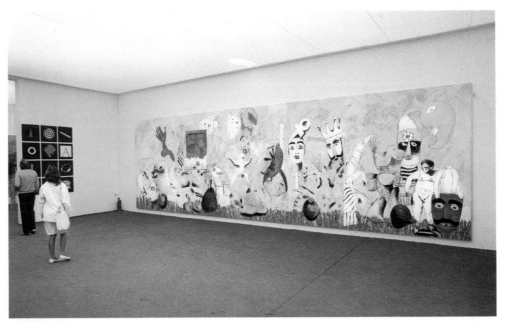

Concetto Pozzati, *Il presepe di Valdonica*, 1980-82, mixed media on wood, 9'10⅛" × 32'9⅝" (300 × 1 000 cm)

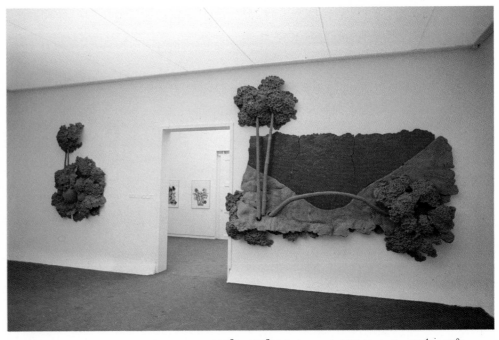

Luigi Mainolfi, *Alle forche caudine*, 1981, terracotta, 16'4⅞" × 16'4⅞"; left: *Lo stagno*, 1982, terracotta, 14'9⅛" × 8'2⅜"

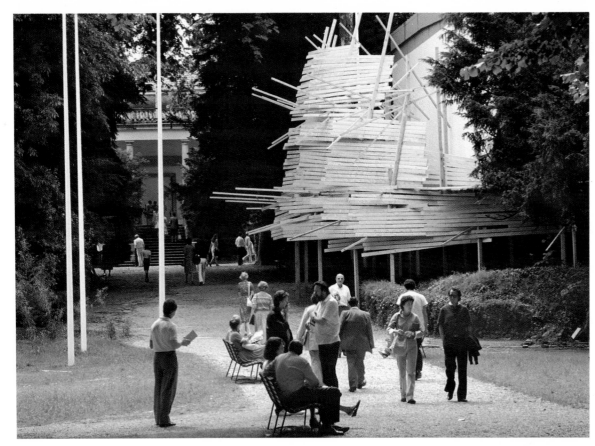

Tadashi Kawamata, entrance to Japanese pavilion

Wolfgang Laib, *Pollen*, dandelion pollen sifted on floor

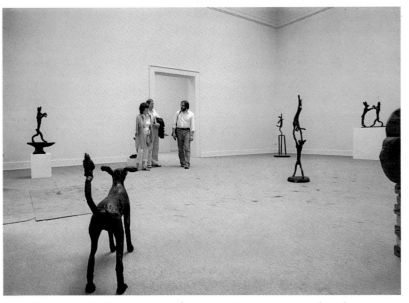

Barry Flanagan, *Opera Dog*, 1981, bronze, $30\frac{5}{8} \times 11'$; *Acrobats*, 1981, bronze, $60\frac{1}{4} \times 16\frac{1}{2}''$

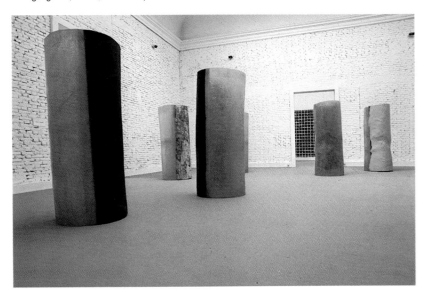

Toni Grand, *Untitled*, 1982, wood and polyester, $78\frac{3}{4} \times 31\frac{1}{2}''$ (200 × 80 cm)

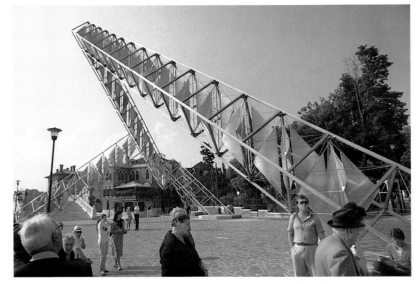

Alejandro Otero, *Abra solar (Solar Bay)*, 1982, stainless steel, 56 × 164' (17 × 50 m)

# Italy
## Fattoria di Celle
## Santomato, Pistoia

## Spazi d'Arte '82

Art Space '82

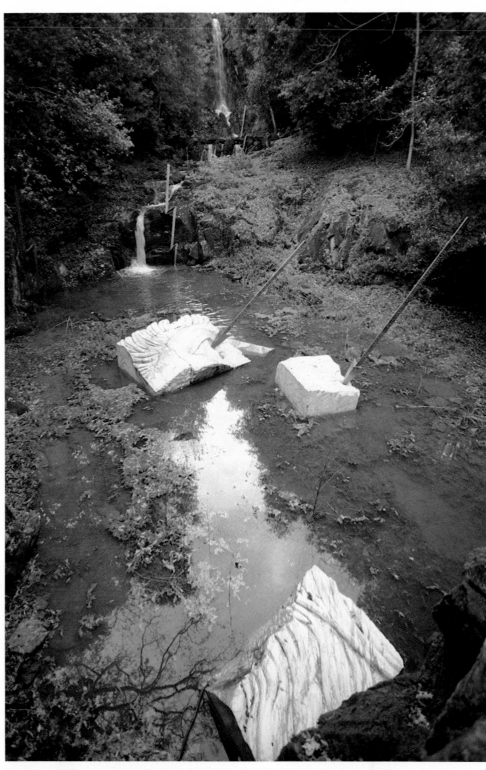

Anne and Patrick Poirier, *La Mort d'Ephialthes (The Death of Ephialthes)*, 1982, white Carrara marble and bronze

The concept on which Art Spaces is based is the creation and representation of non-nomadic art works, contradicting the approach of the museum as a container of preexisting art objects. In the Celle park the site of the executed work becomes a studio and its elements of nature become the materials, content, and point of departure. Most of the projects were planned by the artists directly, after examining the components of the site, challenged by its topography, vegetation, historical remnants, and cultural contents. The resulting projects, although sharing the same environment in a broad sense, are pluralistic in using different languages and concepts: Richard Serra's 8 naturally shaped 12 ton stone bodies "redefine and do not represent the site" by revealing the "logic" of a steep slope. So did Dani Karavan in his white cement floor "drawing", which directs our movement along vegetation rhythmically planted and pointing toward the lake. Behavior sculpture is also the concept of George Trakas in his valley staircases and pathway work, which bears a literary content.

Mythological content in the Poiriers' marble and bronze large scale fractured sculpture creates within the pool of the cascades an illusionistic site of the war between Zeus and the Giants. A quotation from the Renaissance culture of Tuscany is brought by R. Morris in his multipassages Labyrinth as green and white stripes of marble. The large scale metal project of Alice Aycock referring to astronomical astrolabes and measuring instruments, which led us to those of the Renaissance in Tuscany, is shaped according to the topographical values of her chosen site within the Celle park, as is the case with the recent version of Dennis Oppenheim's "construction of the mind." The triangular-shaped wall of Mauro Staccioli, bearing in its eight meter height the scale of the surrounding trees, is a minimal-shaped intervention of the "rational" into the "natural," while Ruckriem's sculpture in the local gray *pietra serena* deals with the energism of a stone cut, fractured, and put together again.

Inside the villa, the eighteenth-century architecture and the fresco-covered ceilings supply the "cultural nature" to which the participating Italian artists are connected in their present work at the Villa Celle. The plan to create a sector of contemporary Italian art in the inner space here is now being implemented. The artists who have already carried out their ideas run a wide gamut, from the *arte povera* [poor art] group of the 1960s to the younger generation that has come to be known as the "new Italian painters."

Amnon Barzel
*from the catalogue*

George Trakas, *Via de l'Amore*, 1982, wood, iron, cement

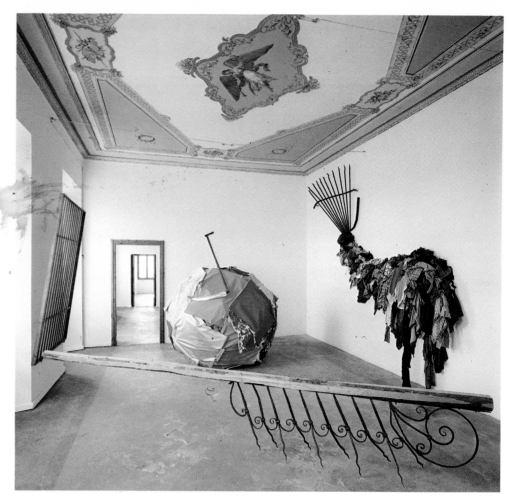

Michelangelo Pistoletto, *La Coda di Arte Povera (The Coda of Poor Art)*, 1982, mixed media

Dennis Oppenheim, *Formula Compound (A Combustion Chamber)*, 1982

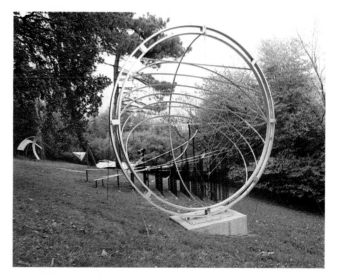

Alice Aycock, view of installation ; in the foreground, *The Astrolabe*, 1982

Richard Serra, *Open Field Vertical Elevations*, 1982, local stone, h. 78¾″ (2 m)

Mauro Staccioli, *Celle 1982*, cement

# Italy
## Galleria d'Arte Emilio Mazzoli
## Modena

## Scultura andata Scultura storna
## Sandro Chia, Enzo Cucchi

Sculpture back and forth

Emilio Mazzoli has had the idea of commissioning a two-man sculpture from Sandro Chia and Enzo Cucchi, a sort of aquatic monument, perhaps for use as a large fountain with numerous water jets, representing a sea monster emerging either from the sea or some underwater cave. Leaving aside the originality of the idea, that of combining the creative talents of two international and very Italian artists in a work of sculpture that they would most likely not have thought of themselves, Mazzoli became so absorbed in the idea as to offer himself, tacitly and unwittingly, as the model as well...

The result is a creature dripping with water and seaweed as though it has just emerged from those moist depths of an unconscious that we have already glimpsed and seen—even if drier, burnt, or even on fire—in the previous painted work of the two artists. In the scuffle of composition—that is, with hands in the clay and not brushes on the canvas—the two accomplices once again have not allowed the original scuffles of an art whose divinities lie in the names of Savinio and de Chirico to slip away from them...

Goffredo Parise
from "Un mostro acquatico fatto a quattro mani," *Corriere della Sera,* Friday, October 8, 1982

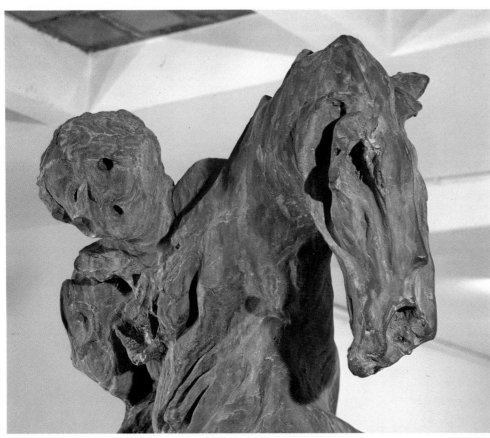

*Scultura andata Scultura storna,* detail

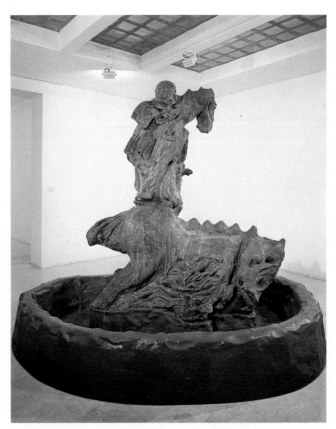

*Scultura andata Scultura storna,* 1982, bronze, h. 7'3" (220 cm)

The transavant-garde has, in contextual terms, replied to the generalized catastrophe of history and culture. It has overcome pure experimentation with new techniques and materials, arriving instead at something we might call "the inactuality of painting," or, the ability to endow the creative process with an intense eroticism, making rich images that still offer the pleasures of narration and representation.

The new art has reacted to the linguistic correspondences of the Sixties and Seventies by the recovery of the *genius loci* of the artist's anthropological roots in the cultural territory he inhabits, and of the particular individual or singular inspiration of the work.

The art of the German transavant-garde has aligned itself with the recovery of a national identity, which had been humiliated by the political realities resulting from the logic of the Second World War: the division of Germany into two parts and the separation of a single national consciousness into two antagonistic ideologies dependent on the international policies of the two blocs. The position of young German artists today regarding this situation can be transformed into creative tension operating within the adventure of painting.

Against the phenomenological suspension of the art that preceded it, and which was directed to the use of elementary and innocently active materials, the German transavant-garde has adopted a stance that discards the Duchamp option in favor of the recovery of Surrealist roots at the literary level (Lautréamont and Artaud) and Expressionist roots at the pictorial one. In this way, art heals a historical wound, restoring unity to the torn body of German culture through the reactivation of a cultural and linguistic root such as Expressionism, which amply represents the possibility of speaking a national and unified pictorial language.

Achille Bonito Oliva
*La transavanguardia tedesca, from the catalogue*
*Translated by John Shepley*

The German Transavant-garde

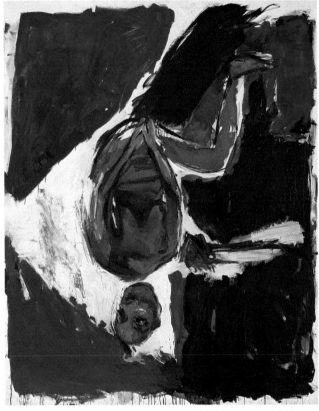

Georg Baselitz, *Eike,* 1977, oil on canvas, 8'2" × 6'6¾" (250 × 200 cm)

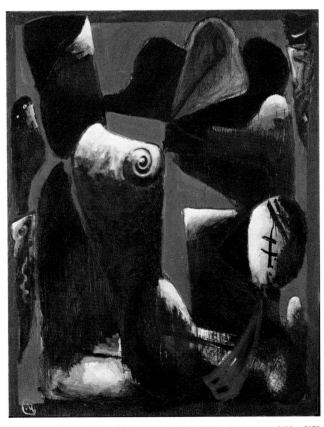

M. Lüpertz, *Composition with Arrow and Knife,* 1980, oil on canvas, 8'2" × 6'6"

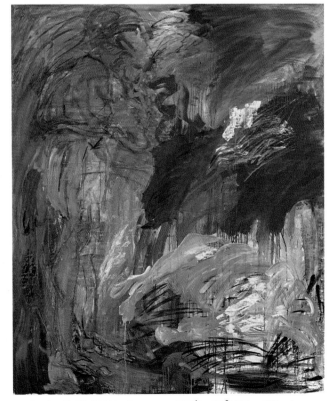

Per Kirkeby, *Untitled,* 1981, oil on canvas, 7'10½" × 6'6¾" (240 × 200 cm)

# Italy
## Centro di Cultura di Palazzo Grassi
## Venice

### Opere dal 1931 al 1981
### Guttuso

Works from 1931 to 1981
born in 1912 in Bagheria, Palermo, Sicily
lives in Bagheria and Rome

This Renato Guttuso exhibition is not only a personal retrospective, composed of choice pieces over a span of 50 years of work, and its purpose is not merely to celebrate an artist who from the age of 16 (and even before) has had painting as the essential goal of his existence. Rather it is to show how a pattern of such high committment has developed with ever new connections to the past, present, and future, over an unchanging *basso continuo*, which is Renato Guttuso himself:...

In addition, this exhibition offers typical proof of how, from the seemingly most objective natural fact, Guttuso derives images of clear formal consistency: this is the large painting *Vucciria,* one of the masterpieces of this century. Those fruits, those vegetables, that bovine carcass, those eggs stand as fruit, vegetables, and meat in all their intensity, but they cannot be touched and do not suggest a deceptive physical reality beyond the canvas. A fixed light, a specific weight, a very solid volume are there as though to flank the nakedness of the object, which is restored to painting without qualifications and without more ado: this is painting and only painting. Form, therefore, does not become a manneristic element of style, nor does it approach trompe l'œil: thus hidden in the object, it is as though it radiated from it.

This supreme mastery of the means of expression explains the ease with which Guttuso succeeds in passing without interruption from monochromy to color in the same painting, and the large *Funeral of Togliatti* would suffice to demonstrate it. Here the single color proclaimed by the countless red flags is like a shout, a repeated sound of trumpets, but of an expressive force that attains its height without strain, only by the dynamics of a color repeatedly pounding like a triumphal march.

Cesare Brandi
*from the introduction to the catalogue*
*Translated by John Shepley*

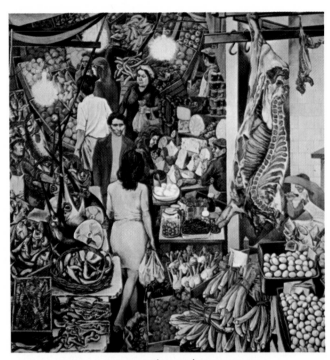

*La Vucciria*, 1974, oil on canvas, 9'10⅛" × 9'10⅛" (300 × 300 cm)

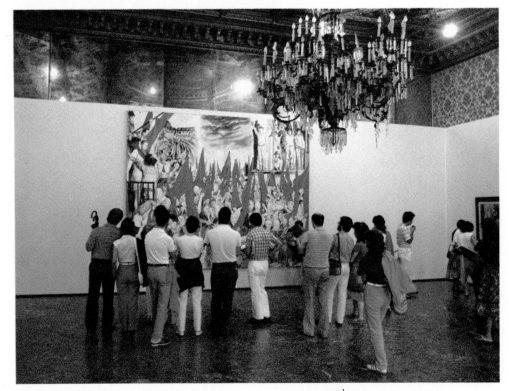

The Funeral of Togliatti, 1972, acrylic on paper mounted on plywood panels, 12'2⅛" × 14' (340 × 440 cm)

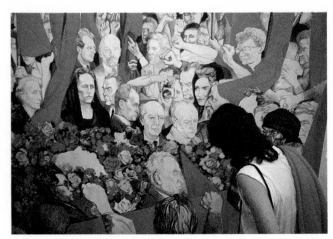

*The Funeral of Togliatti*, detail

Terrae Motus: Fifty of the most prominent contemporary artists (including Warhol, Rauschenberg, Cy Twombly, Joseph Beuys, Gerhard Richter, Mimmo Paladino, Sandro Chia, Nino Longobardi, Anselm Kiefer, Mario Merz, Ralf Penck, Mario Schifano, Ernesto Tatafiore, Enzo Cucchi, Julian Schnabel, David Salle, and Gilbert & George) are engaged in executing a series of large-scale works inspired by the catastrophe that devastated Naples and a large area of southern Italy on November 23, 1980. These works are intended as an artistic response to the now historical earthquake, as translated into a complex metaphor of human, social, and cultural disorder. The Amelio Foundation, recently set up in Naples especially for this project, will assemble the entire collection and see that it finds a proper place within the city.

Andy Warhol has kicked off the operation by executing three large canvases displaying once more the image of the catastrophe as though arranged on the cold marble of a morgue. There is an obvious connection with the themes developed in the *Disasters* series of the Sixties. With the renewed gusto of an urban vampire, the artist launches himself on the prey capable of satisfying his appetite as a tragic voyeur. The result is a shocker that would make even the most hardened and sophisticated newspaperman sit up and take notice. Warhol freezes the features of the drama in the lightning flash of a model image: unique, rapid, finite. In the three canvases entitled *Fate Presto,* the report and image of the disaster are drained of any emotion, any state of mind that might be reduced to simple compassion. Warhol, in his detachment, composes the remains of the tragedy on an autopsy table. The distance from the event is proclaimed by the use of images that have already been consumed, deprived of their emotional potential: the effect of the newspaper screaming the event is now, on the canvas, disengaged from any sentimental ambiguity. The canvas thus becomes a shroud on which only an impersonal and devitalized trace of the tragedy remains impressed. If the artist's refusal to employ any compromise with the effects of the event seems heightened in these works by the calcification of the image in white or its carbonization in black, to the point of turning them into tombstones containing no compassion, the two extreme colors are simultaneous aspects of the same hallucinatory and haunted vision of the tragedy.

Michele Bonuomo, Naples, November 1982
*Translated by John Shepley*

# Italy
## Terrae Motus
## Fondazione Amelio, Naples

### Fate Presto
### Andy Warhol

Hurry Up
born in 1928 in Pittsburgh, Pennsylvania
lives in New York

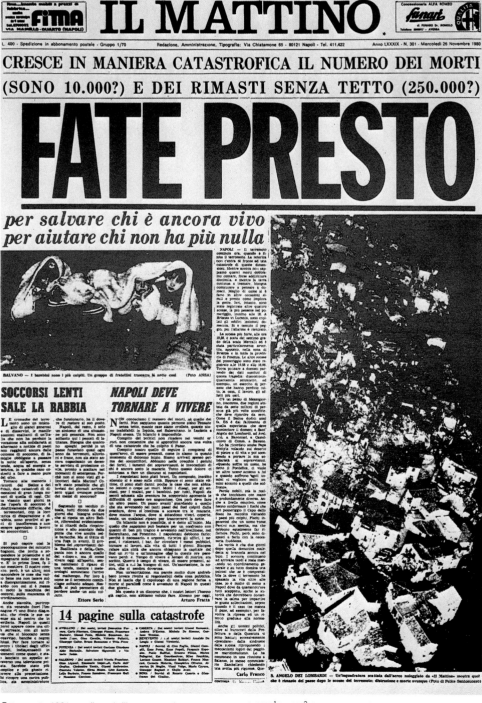

*Fate presto,* 1981, acrylic and silkscreen on three canvases, each 8'10¼" × 6'6¾" (270 × 200 cm)

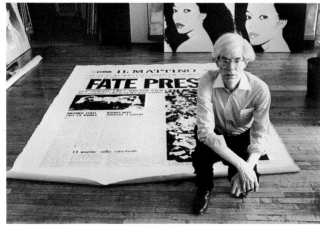

Andy Warhol at the Factory setting up one of the three *Fate presto* canvases

# Spain
## Salas Pablo Ruiz Picasso
## Madrid

112

## 20 años de Pintura, 1962-1982
## Eduardo Arroyo

20 Years of Painting, 1962-1982
born in 1937 in Madrid
lives in Paris

Eduardo Arroyo, who began his career by aligning himself with the most radical trends in European pop art, has employed all the most corrosive figurative means, including—and why not?—the use of the image as parody. There is not only the explicit brutality of the contents of his paintings and the sarcastic pronouncements of the titles both of which already begin to disturb the spectator, but also the impudent manipulation of the iconic fetishes and stylistic elements of the institutionalized avant-garde.

As in the *Crónica* series, he has taken his ruthless scissors to the sacrosanct territory of art history, but, in my opinion, he has done so without allowing for any quiet fluidity or elegant subtlety. In this way he can disembowel Duchamp, Miró, David, Gros, Velázquez, or Rembrandt; in these and many other cases there is always a strategy of visual consciousness: to connect with—and thus make audible—the latent shrillness, the veiled confusion that dwells within pictorial rhetoric, whether considered in itself or in terms of reality.

In addition we have a good selection from Arroyo's best series: from the earliest ones of the *Bridge of Arcole* or *Winston Churchill, Painter* to the most recent *Blind Painters* or *Exile (Angel Ganivet and J. M. Blanco White)*. With regard to this last, let me say that seldom have I seen images that express so powerfully, without breaking their cold detachment, the desolation, fear, impotence, and delirious mechanism of paranoia. The fact is that Arroyo combines a voyeur's premeditation of the scene with a guileful use of fetish objects extracted from the unconscious. The result is explosive. It is for that reason that as one traces his artistic development, always full of heightened dislocations, and especially on reaching the end, when his political anxiety seems lulled, what comes to mind is the image of the artist as Robinson Crusoe, the archetype of a forced solitude that can turn out to be lucid or touching.

Francisco Calvo Serraller
"Eduardo Arroyo, the artist as Robinson Crusoe", *El Pais*, June 1982
*Translated by John Shepley*

Chimney Sweep, 1980, bronze and mixed media, 17¾ × 11¾" (45 × 30 cm)

The Whole Town Is Talking About It, 1982, oil on canvas, 83⅞ × 74¾" (213 × 190 cm)

The artist in front of one of his works

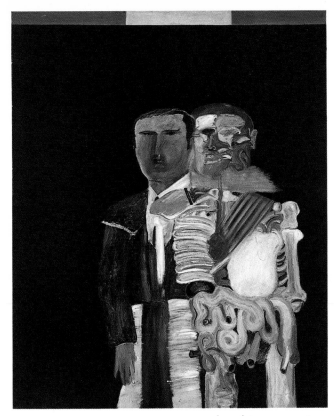

*Cuatro dedos (Four Fingers)*, 1963, oil on canvas, 64⅛ × 51⅛" (163 × 130 cm)

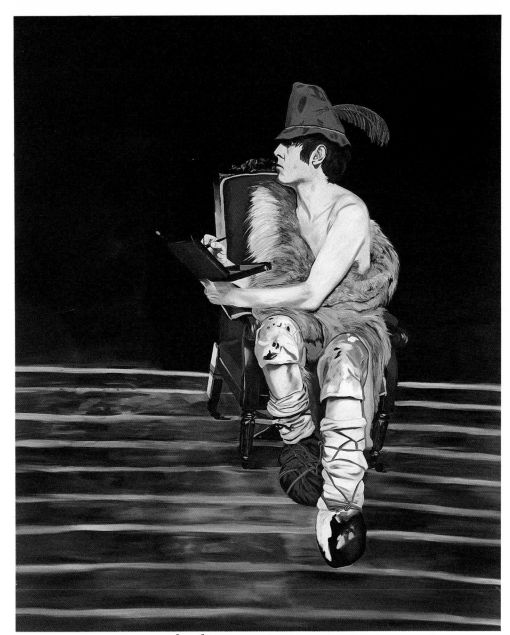

*Robinson Crusoe*, 1965, oil on canvas, 86⅝ × 70⅞" (220 × 180 cm)

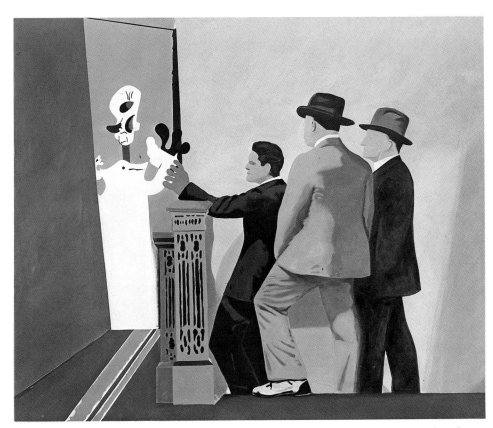

*Vernissage, or How to Get Used to Being Questioned by Underdeveloped Servants*, 1967, oil on canvas, 86⅝ × 70⅞"

# Spain
## Sala Gaspar
## Barcelona

## ferros i pedres 1980-1981
## Alfaro

Iron and Stone 1980-1981
born in 1929 in Valencia
lives in Valencia

Andreu Alfaro's work is of lively interest to us in 1981. While sculpture has been undergoing a great crisis, Alvaro stands out by virtue of his inner power. He possesses something which the majority of sculptors have lost, namely strong reasons for creating his works. And his interests are not merely problems of technique or self-reflective; he is concerned with man and society, with the network of human relations, with love and war; and he has not lost faith in the possibility of helping others.

His spatial designs in iron convey spontaneous joy. To a certain extent there are echos of Vienna of 1910 or Paris of 1920, both of them fervid and creative artistic periods. These works are beautiful games; they are youthful and playful.

Alongside the iron work, the marble pieces assume a sacred position: in their mystical intensity, their purity, and their understatement, they look back to, and approach, Modgliani and Brancusi. Looking at them and touching them, we cannot but hope that these pieces will force us to understand, for without understanding, we cannot fully reach that perceptual height that such great art affords. This is the achievement of a great sculpture, one that can distinguish and enhance the streets, the plazas, and the gardens, a sculpture that has the rare virtue of fusing intelligence with love and, obstinately enough, even with hope.

Alexandre Cirici
*from the catalogue*

*Al Brown Seen by Cocteau-Jesus-Arroyo,* 1980

*La dama del mar (The Lady of the Sea),* 1980, iron, 60¼ × 21⅝ × 5⅝"

*Sobre el amor "De la potencia al acto" (About Love "From the Potentiality to the Act"),* 1981, white marble, 18⅝ × 20⅝ × 12¼"

There is one thing, however, that I would like to emphasize, the imprint that has remained with me from the experience, that started with that first moment of fascination when I examined, with Alexanco himself, the systematic series of images with which he had made a visual collage containing the precious synthetic index of the birth and development of his most significant forms. It was then that I appreciated in all its clarity the unity of time that has presided over Alexanco's whole creative system, a unity that nowhere so well as here might be called the painter's music, gently unfolding in the infinite cadences of a fugue. Entangled in it, and under the effects of the recurrence with which it is imbued, we end up losing all notion of beginning and end, finally seeing nothing but the pure development that it essentially is. And it is in this sense and in the same way as the effort of elucidation by means of which this expressionist tries to neutralize in disciplined fashion his spontaneous subjective freedom that the whole process reveals itself to us as a "mechanics of beauty," a work which miraculously gives the impression of gradually creating itself.

But that is not all, for with Alexanco I have been able to discover a whole period in recent Spanish art, which, as I have ascertained, still awaits a really serious critical analysis; a period, moreover (and this is still more important), which, far from being over, is perhaps only now beginning to give of its best. I refer to the period of those artists whose work began in the Sixties and has developed steadily since then. More precisely, that of the generation which first appeared after the international crisis in nonfigurative art, a generation that nobody has so far succeeded in situating. It is true that in any attempt to evaluate individual talents it is difficult to deny the importance of artists like Alexanco himself, Luis Gordillo, Darío Villalba, Genovés, the members of the *Equipo Crónica,* Arroyo, Juan Navarro Baldeweg and Alfaro, to mention only some of the best-known and undeniably important.

Francisco Calvo Serraller
"The Mechanics of Beauty, An epilogue in the Form of a Prologue," *from the catalogue*

# Spain
## Galeria Fernando Vijande
## Madrid

### Pinturas 1977-1982
### Alexanco

Paintings 1977-1982
born in 1942 in Madrid
lives in Madrid

*Espacios de separación III (Spaces of Separation III)*, 1981, mixed media on cardboard, 22 × 31⅞" (56 × 81 cm)

*Dibujo (Drawing)*, 1982, mixed media on sailcloth, 5'10⅞" × 12'3⅝" (180 × 375 cm), triptych

# Great Britain
## Whitechapel Art Gallery
## London

## British Sculpture in the
## Twentieth Century

One of the outstanding characteristics of recent art has been the progressive erosion of national traits and the emergence of an international faction, which corresponded for the most part to the modernist notion of an avant garde. None of these sculptors belongs to this category, and it is doubtful whether many of them would wish to do so. This comparative isolation cuts both ways, but it does not mean that they are incapable of being set in any kind of context. One consequence of the Romantic movement was that it encouraged the belief that works of art could give insight into metaphysics, and as a result, aesthetics again became an important part of philosophy. It could be argued that some of this work demonstrates a resurfacing of Victorian qualities: a neurotic tension, a sense of drama and implied narrative, and an obsessional accumulation of detail. But none of these characteristics could be applied to all of the work and only some can be distinguished in the work of others. Each of these sculptors is a deliberate individualist—and it is this shared condition that not only heightens their separateness, but also paradoxically provides the strongest link between them. Most of them are still in their thirties, and we have not yet seen the full implications of the course they have taken.

Fenella Crichton
*from the catalogue*

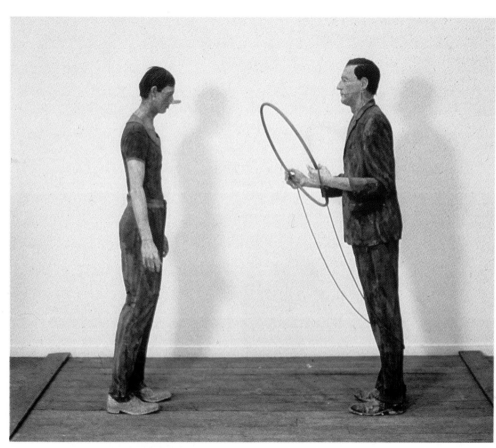

John Davies, *The Last,* 1975, mixed media, life-size, Annely Juda Fine Art and James Kirkman Ltd.

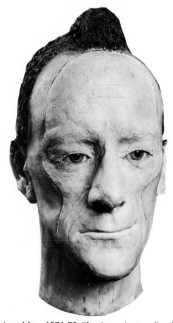

John Davies, *Uplees Man,* 1971-72, life-size, private collection

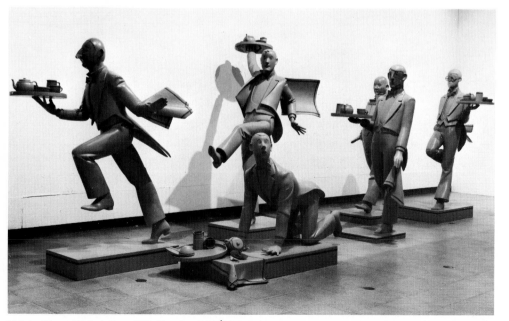

Nicholas Monro, *Waiter's Race,* 1975, fiberglass, l. 22'$\frac{1}{4}$" (671 cm)

In Monro's pea-green *Waiter's Race,* his peculiar kind of form, both bland and tough, is evident in every fluttering napkin or coattail. His cast of mind runs to speculative fantasy, fairy tale; what if *Martians* appeared before us like garden gnomes, or six apparitions of Max Wall, or a 27-foot *King Kong?* Yet somewhere at the heart, a deadly irony makes our laughter break off uneasily...

Davies's negation is more explicit. In *The Lesson,* faces and heads are cast from life, clothes and shoes are real, glass eyes and human hair complete the waxwork. But this verisimilitude is only a first step towards conjuring up an emotional *unreality.* Sleeves are cut away, whitewash poured, the figures festooned with a rope-ladder and made to stand too close for comfort, in a kind of inhibited embrace, without energy or hope. It's as though we've been made to *dream* them, figures seen through rain or tears, and to take on their burden of grief...

Both Monro and Davies might be seen as wearing a mask, one comic, the other tragic; creating not human beings but cartoon-figures and ghouls. In either mode (as in Ionesco or Beckett) the absurd may be a vein that comes a little too easily to us today...

Timothy Hyman
*from the catalogue*

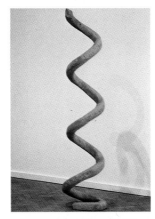

N. Pope, *Elmwood Column,* 1974

Stephen Cox, *Tondo, We Must Always Turn South,* 1981, Bath stone, h. 12⅜″

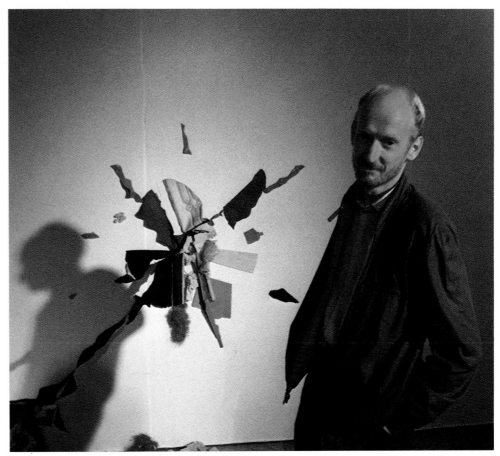

Bill Woodrow at the Paris Biennale

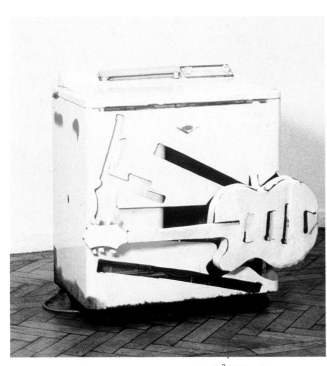

Bill Woodrow, *Twin Tub with Guitar,* 1981, steel, h. 39⅜″ (100 cm)

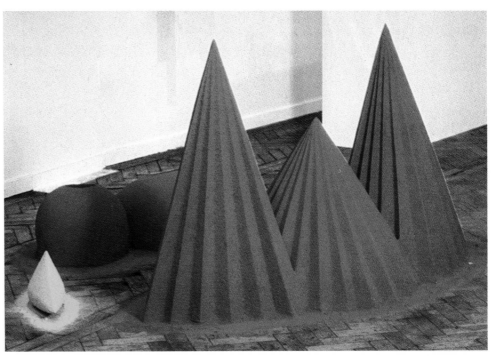

Anish Kapoor, *As If to Celebrate, I Discovered a Mountain Blooming with Red Flowers,* 1981, powdered pigment and wood

# Great Britain
## Ikon Gallery
## Birmingham

## Vibrating Forest
## Dennis Oppenheim

born in 1938 in Mason City, Washington
lives in New York

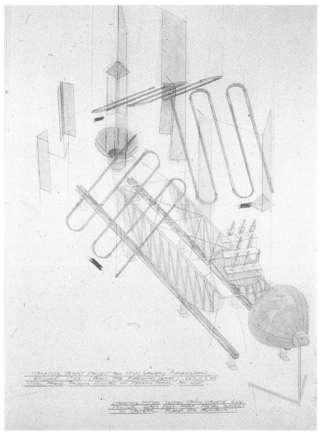

Drawing for *Vibrating Forest,* 1982, colored pencil and wash, 50 × 80"

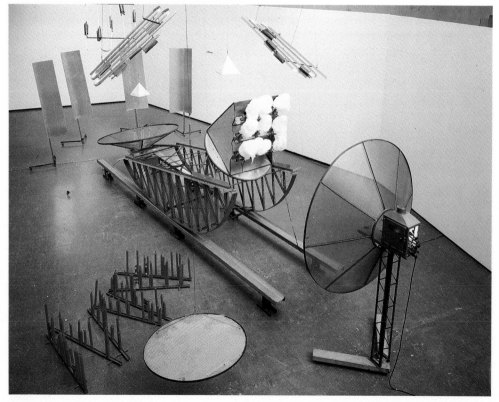

*Vibrating Forest,* 1982, steel, rockets, arc light, motors, cotton candy machine, gunpowder, glass rods, metal shields

A sense of nervous frustration, resulting from things being taken for something other than what they are, or being stretched beyond their limits, is present in much of Oppenheim's work of the late Seventies, but with his latest piece, the Ikon's *Vibrating Forest (from the Fireworks series)* things seem to have changed. Certainly it's more complex: "Surrounded by fireworks and flares, a rocking bridge holds a candy-floss machine at one end and a vibrating platform at the other. The candy-floss is transferred from end to end by the rocking motion of the bridge. Rockets and flares fastened to various numbers and mathematical symbols move along a track, setting each other off by collision, above the bridge. A carbon-arc light illuminates the activity".

In place of the relatively simple production lines of the earlier factories, the fireworks in *Vibrating Forest* are intended to set one another off, like ideas sparking one another in sequence, and the candy-floss is whipped up with gunpowder into an amorphous, potentially dangerous, and certainly unpredictable product. Oppenheim even hesitates to call it a factory, preferring the word 'armature', in the sense of an underlying structure. It's certainly more optimistic: whereas the works of the early Seventies now seem to Oppenheim to have lacked formal rigour despite their intellectual strength, and whereas the earlier factories are beginning to seem awkwardly straightforward, *Vibrating Forest* uses the language discovered in those early works in a more poetic way and achieves a more exciting dynamic between form (which Oppenheim calls 'structure') and meaning (which the structure 'hallucinates').

Robert Ayers
*from "Art Monthly," May*

Dennis Oppenheim's comments quoted in this article are taken from a conversation with Robert Ayers recorded during the installation of *Vibrating Forest.*

Certainly it is not the business of the artist to maintain style, to preserve its delicate purity. In art, style is not a vital consideration. Obviously, to be able to speak clearly and with conviction, stability in the formulation is necessary; otherwise the essential content of a work will evaporate in the spurious quest for 'the new', which is the scourge of art. Here style provides a certain elegance and control. These observations are prompted by the work of Ger van Elk, whose art evidently articulates a problem of conception which I consider to be central to the present situation. Not so long ago his mercurial art provoked certain objections; it was not, it was said, consistent. The acclaim it now finds, more and more, shows that our general conception of art has finally changed.

The way in which Ger van Elk moves from fantasy to fantasy, with supreme freedom, is exemplary. The inconsistency of this work, not chasing the same hare all the time, now appears as a major quality. Van Elk cannot accept that art should be a sermon about the purity of style: he prefers wit, and also in wit is seriousness. I know him as a very serious artist, one who always followed the lead of his artistic instinct. He went from moment to moment—I don't think there was ever an abstract model which he tried to pursue. He knows that roads in art are never straight but winding, and lead into a labyrinth where many marvels await us. It is the business of the artist to catch a star. There are no rules for this. There is however a certain decency to be observed: it should be perfect...

It is not the business of the artist to maintain style, it is the business of the artist to change it, to make it *contemporary*.

R.H. Fuchs
*from the catalogue*

# Great Britain
## Serpentine Gallery
## London

### Ger van Elk

born in 1941 in Amsterdam, The Netherlands
lives in Amsterdam

*Cactus Cloud*, 1975-81, color photograph and acrylic paint on canvas, $60\frac{1}{2} \times 62''$ (154 × 157 cm)

*Untitled 1*, 1981, acrylic on black-and-white photograph on canvas, $9'6\frac{1}{8}'' \times 9'6\frac{1}{8}''$

119

# Great Britain
## Walker Art Gallery
## Liverpool

### Paintings 1963-81
### Patrick Caulfield

born in 1936 in London
lives in London

Caulfield's work does not make use of any attention-getting devices. It remains firmly within the confines of easel painting relying on traditional subject matter of a familiarity bordering on blandness; still lifes, landscapes, and interiors predominate, with the occasional instance of what used to be known as "figure studies." The scale of the paintings is generally quite small and never larger than that dictated by the subject on a strictly logical basis, so that the largest canvases are those depicting domestic or public interiors. The obviously personal touch is eliminated in favor of an uninflected surface, with the images executed in a style that at first sight has more in common with children's coloring books or with the craft of the sign-painter than with the calligraphic flourishes that we tend still to associate with painting...

The profusion of styles in Caulfield's recent paintings may on first sight appear to constitute a rejection of his former reliance on a single method of delineating objects in black outline. The state of mind behind both systems, however, is the same. The idiom that Caulfield first devised for himself was ideally suited to his need for an apparently anonymous style. In time, however, its usefulness to him diminished, since the longer he employed the style, the more idiosyncratic and personal it became. He realized that if he limited himself to one style, no matter how neutral or depersonalized, the same thing would happen. His solution, therefore, has been to employ a wide variety of styles without declaring an allegiance to any of them. The appearance of his paintings, as a result, has changed radically, but his characteristic detachment is still intact.

Marco Livingstone
*from the catalogue*

*Town and Country,* 1979, acrylic on canvas, 91 × 65" (231.1 × 165 cm), Collection Leslie Waddington

*Still Life: Marcochydore,* 1980-81, acrylic/canvas, 60 × 60", Leslie Waddington

To say that Laurie Anderson is the most important performance artist today is to place the intrinsic value of her work on the top level of present-day art. A work that breaks with all genres, languages, supports, materials, techniques, and with relationships to space and to the audience. Without being a painter or a sculptor, she captures a multitude of media, coordinating them in cross-disciplinary fusion and ultimately reconstituting an ensemble of dialogues in which she is all speakers at once.

She is a composer, interpreter, writer, poet, photographer, moviemaker, and actress. The technological complexity of her work goes beyond all limits of brilliance and virtuosity. At her performances we watch the systematic diversion of instruments, tools, and techniques. She fuses with the violin, the vocoder—instruments that she transforms and denatures in adapting them to her goals...

Her early performances were based on texts that were commentaries on images. But little by little, the visual elements amplified words and sounds. With films and slides, sometimes superimposed, and with her physical presence in front of the images, she created kaleidoscopic spaces, in which everything combined into gestures, languages, visual, manual, and acoustic signs...

America is saturated with technology. Laurie Anderson abuses it. Her landscapes are technological surfeits. In the love song "Let X=X," there are no more stars in the sky, just satellites: Technology has replaced nature... Laurie arrives and asks a question: "Hello, excuse me, can you tell me where I am? Hello, excuse me, can you tell me where I am?... Hello, excuse me, can you..."

Jean-Pierre Van Tieghem
from "Laurie Anderson: Hello, Excuse me, Can You Tell Me Where I Am?" in +−0 No. 32-33, May 1981
*Translated by Joachim Neugröschel*

born in 1947 in Chicago, Illinois
lives in New York

Laurie Anderson performing at the Bobino, Paris, November 1982

*Artworks*, 1982, detail

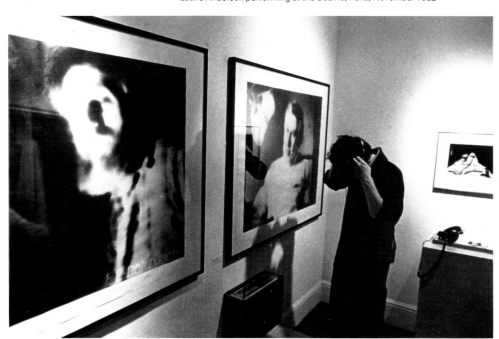

*Artworks*, 1982, photographs and tape recordings

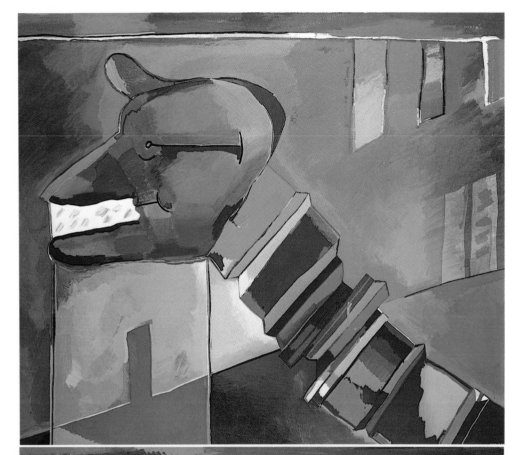

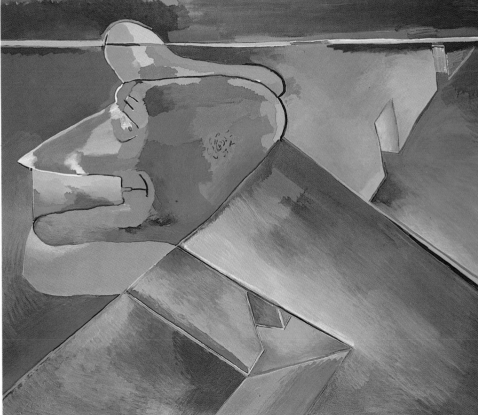

Luis Gordillo, *Los galindos A & B,* 1977-78, acrylic on canvas, each panel 4'9" × 5'10" (145 × 179 cm)

It may not be possible to talk of Spanish art if we accept the view held by many Spaniards that Spain is a kingdom comprising many different nations and races. Indeed, the artists selected for this exhibition were all born in Andalusia, and in the cases of Pérez Villalta and Chema Cobo they have spent a considerable amount of their careers in their native region. However, they have not been chosen to represent this particular region but because they are working in an idiom which I consider to be particularly interesting and which rightly or wrongly I consider to be fundamentally Spanish: a mixture of the fantastic, the surreal and the metaphysical. I am convinced that the northern concept of reality differs from that of the Spanish. What appears wayward or fantastic to a northerner may be natural to the Spanish.

The artists in this exhibition at various times in their lives have all been closely connected. Pérez Villalta was one of the early admirers of Gordillo; Chema Cobo has at times worked in collaboration with Pérez Villalta, and Costus were encouraged in their approach to painting by Pérez Villalta. If the connections between them are no longer so close, they are all part of a figurative revival in Spain of which there are many strands.

We would be justified in questioning whether figuration ever died, or whether during the Franco period it simply went underground. If it did go underground it surfaced once again in the mid-sixties when Luis Gordillo led the move back to a figuration influenced by British Pop Art. His rupture with the political gestures of the 'informalists' and his concern for issues exclusive to painting were welcomed by a new generation of artists born and brought up under a Fascist government, who knew no different way of life and who had little social conscience. The art of the new generation is generally speaking unpolitical. In the foreword to the catalogue of an exhibition entitled 1980 three prominent young art critics declared that politics is no longer 'made on canvas'. Amongst those for whom exception must be made are Costus whose work takes a definite sociopolitical stance.

Jeremy Lewison
*Spanish Art—a view from the outside, from the catalogue*

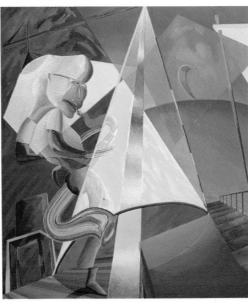
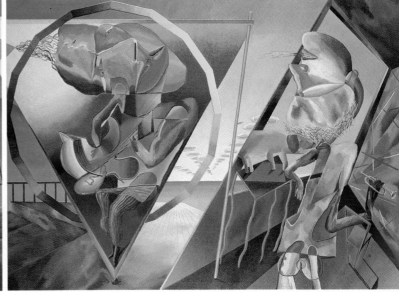

Chema Cobo, *Musicos (Hello Balop)*, 1979, acrylic on canvas, 4'7" × 10'4" (140 × 315 cm)

Costus (Juan Carrero and Enrique Naya), *La patria (El Valle de los caidos)*, 1981, acrylic on carboard, 5'10" × 7'10$\frac{1}{2}$" (180 × 240 cm)

Costus, *La marina te llama, nº 1*, 1980, acrylic on carboard, 8'1" × 4'

Italian Art 1960-1982

In art as in life, Italy, of all European countries, is still the most extreme, the most divided, and for that reason probably the most alive. The extremes may be hard to locate in this exhibition, partly through the muted moderation with which it has been selected, and partly because of the extraordinarily oblique and often esoteric way in which so many Italian artists reflect contemporary reality. Since this is the first full-scale exhibition of recent Italian art to be seen in this country, it might be worth considering a few of the basic characteristics that make it all so rich and tasty, so complex and sometimes so frustrating!...

The Italian critics who selected this show have maintained their pragmatism throughout, and are therefore able to include the new rude crude painting as just one of the "new tendencies" alongside less clamorous work. They have been restrained about the "Italian-ness" of the art of this period, perhaps through wariness of anything that smacks of nationalism, perhaps through a desire to redress the balance towards something less theatrical, and perhaps, too, because in times of uncertainty and turmoil, options are left open. As all those *nouveaux philosophes* keep telling us: "Zarathustra wishes to *lose* nothing of the human race's past: he wishes to throw it all into the crucible."

Caroline Tisdall
"From the Spirit of Inquiry to the Pleasure Principle." *from the catalogue*

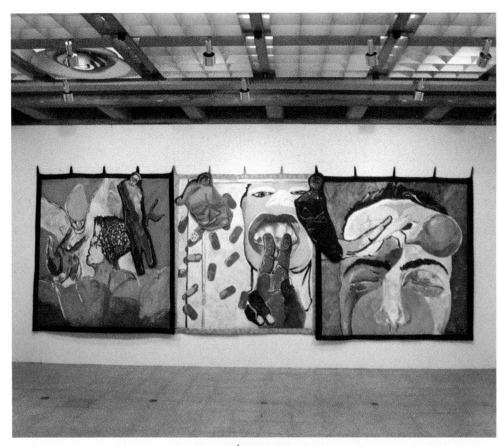

Francesco Clemente, *One, Two, Three,* 1981, 7'1" × 20'2⅛" (216 × 615 cm)

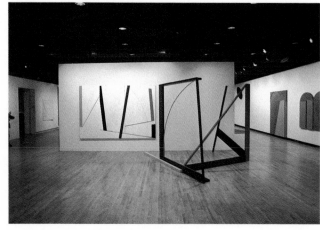

Left to right: Gianfranco Pardi, *Diagonale,* 1982; Giuseppe Uncini, *Dimore,* 1982

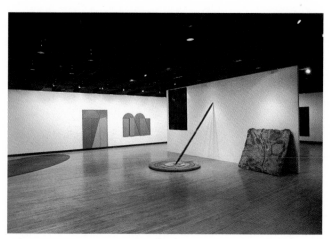

Left to right: G. Uncini, *Dimore,* 1982 ; G. Spagnulo, *Le armi di Achille*

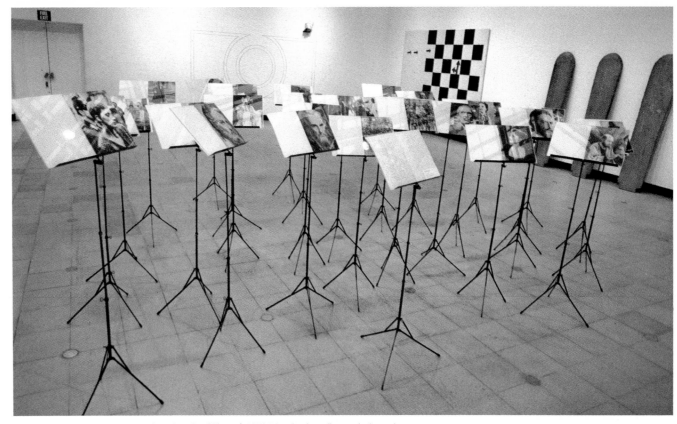

Giulio Paolini, *Apoteosi di Omero (Apotheosis of Homer)*, 1970-71, mixed media, musical stands

Michelangelo Pistoletto, *Un Uomo*, 1961, painting on a mirror, 78¾ × 47¼"

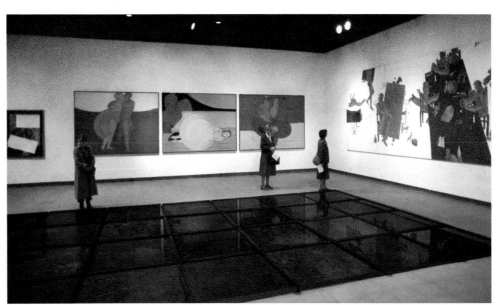

Background: Valerio Adami, *Metamorfosi*, 1982, *Teseo*, 1982, right: Emilo Tadini, *l'occhio della Pittura*, 1978

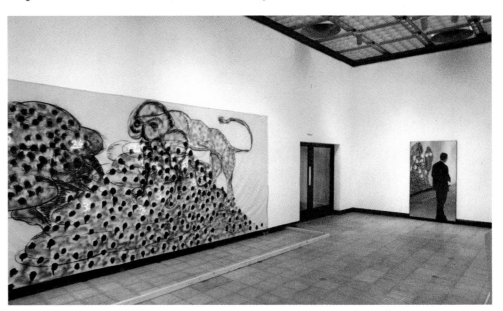

Mario Merz, *Leone di Montagna (Mountain Lion)*, 1981, mixed media and neon lights, 8'2¼ × 19'8¼" (250 × 600 cm)

# Iceland

## Norraena Husid
## Reykjavik

Erró

born in 1932 in Olafsvik, Iceland
lives in Paris

The young painters of "free figuration," who now take their images from cartoons, newspaper photos, or advertising iconography, may not realize it, but it is they who make Erro's work so topical.

Ever since images began to be produced and reproduced mechanically, the world has been teeming with them. They invade everything. They're like a swarm of sea gulls, with the same grace, the same shrieks, the same cruelty. Mechanical images are voracious birds. They peck out your eyes. They cut off your vision, they fragment it. Then they combine the fragments, arranging the combinations into series, with variants. These are: newspaper photos, comic strips, advertising illustrations. The visible world is shredded. It is reduced to stereotypes with multiple proofs. We hurry, we race, we keep wanting more and more, we want a flood of images. Real life becomes an alibi for the indefinite repetition of models. How can we escape this domination?

By outdoing it, if we are to believe Erro. He catches mechanical images, traps them in their own excesses. They cut up the visible world. Erro cuts up their cut-ups. Serial images never remain intact under his fingers; he destroys their seriality. They break the visible world into pieces, and Erro grabs the fragments. If their internal order is smashed, how can they repeat themselves? They lose sense, direction, the powers of their repetitions. Meaning deviates from the totality to one of its parts. And each part removed from a whole receives a different meaning from a different whole, which is, in turn, nonstereotypical since it mingles so many heterogeneous fragments! With pieces and fragments of series, Erro arranges assemblages, and each one of them is unique. Each one is irreducibly singular, because its "singularity" comes from a delirium.

Marc Le Bot
*Art Press,* No. 61, July/August 1982
*Translated by Joachim Neugröschel*

*A. Letian Tiger,* 1980, oil on canvas, 30¼" × 39⅜" (77 × 100 cm)

*1918-1945,* 1980, oil on canvas, 26⅜" × 38⅝" (67 × 98 cm)

*Chinese Petrol,* 1980, oil on canvas, 39⅜″ × 39⅜″ (100 × 100 cm)

*The Goldrush,* 1980, oil on canvas, 32⅝″ × 38⅛″ (83 × 97 cm)

*The Subway,* 1980, oil on canvas, 37⅜″ × 39⅜″ (95 × 100 cm)

# Argentina

## Argentina 1982
## por Abraham Haber

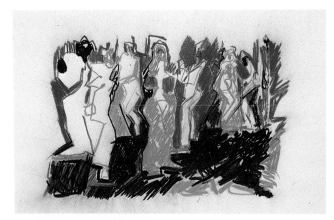

Inès Bancalari, *Ivanov Series N° 1*, pastels, $19\frac{5}{8} \times 27\frac{5}{8}''$ (50 × 70 cm)

Jorge de la Vega, *Untitled*, 1963, mixed media

Luis Felipe Noe, *Recorrido Amazonico*, detail, 1981: diptich, acrylic and oil on canvas, each section $57\frac{1}{2} \times 38\frac{1}{8}''$ (146 × 97 cm)

For the Argentine art world, 1981 was a year of unrest. A large group of artists signed a petition denouncing the censorship and the economic deterioration that is undermining art institutions and shackling artistic creation; nevertheless it was possible to see a number of good exhibitions, such as those of Alfredo Hlito, Raúl Alonso, Carlos Gorriarena, Adolfo Nigro, Carlos Silva, Luis Felipe Noé, César Cofone, Carlos Kusnir, Lopez Taetzel, and Martine Lecoq, a French artist now living in Vienna. The San Telmo Foundation held an exhibition of the Otra Figuración (Other Figuration) group—Deira, Maccio, Noé, and de la Vega—displaying canvases painted twenty years ago. This exhibition clearly showed that at that time a creative impulse had existed capable of making its own way and of anticipating tendencies that were later produced in the northern hemisphere. The exhibition was highly significant since the statement later issued by painters, sculptors, critics, and dealers further mentioned the need for an authentic art combining European influence with the expression of national life and culture. This attitude was misunderstood and characterized as xenophobic, and in 1982 the controversy was still in the air. These circumstances gave a special meaning to certain exhibitions organized this year. The sculptor Badi, always an advocate of a national art, held an exhibition of paintings. The Pablo Suárez show was also significant, with the artist's work hung alongside the paintings of masters who had influenced him; it is not by chance that these were Gramajo Gutiérrez, Molina Campos, and Antonio Berni, precursors of a national style. In the galleries of Buenos Aires one could again see works by Policastro, Victorica, and Xul Solar, who in their different ways gave consistency to the history of Argentine art; while the Museo Nacional de Bellas Artes showed Cándido López, the painter of the Paraguayan war. And Horacio Butler, one of the most famous academic painters in Argentina, was sufficiently touched by the climate as to venture to say that "what is national comes from a way of feeling." On the other hand, a high priest of criticism made statements indicating a knowledge of art in the rest of the world but said not a word about the situation in his own country.

The 1982 season opened in March with a series of drawings and pastels by Inés Bancalari, one of the most interesting figures in the current panorama of Argentine art. The series has as its theme scenes and characters from Anton Chekhov's play *Ivanov*. Despite the war in the Malvinas Islands, the cultural life of Buenos Aires pursued its course, and the public was able to see such interesting shows as those of Emilio Renart, Felipe Pino, Américo Castilla, Norberto Gómez, and of artists now deceased like Aldo Paparella and Marcos Tiglio. But the war climate did have some repercussions, since exhibitions and awards organized by Esso and Gillette were suspended.

Abraham Haber
*Original text*
*Translated by John Shepley*

Without falling into excessive naiveté or empty lyricism, the 1980s can be glimpsed as a new beginning, a recovery of the environment and, therefore, of people themselves.

This exhibition is a collective work by the CAYC Group, the authors of which speak out on this subject: They did so at the end of the Seventies—the decade in which the Group was consolidated—and of the dawn of the 1980s...

The archaeological books of Jacques Bedel, which are part of his work *The Cities of the Plate,* have been made with polyurethane resins and bathed in various metals. One of the things that most stimulates an artist is the relationship between the materials employed and the definitive image of his discourse... In this reflexion of the grandeur of a nation that goes from the cold wastes of Patagonia to tropical Mesopotamia, Bedel recombines materials culled from the different areas of Argentina and submits them to the same chemical process that is induced by natural aging.

An analysis of the antinomy, between Nature and Culture, which can sometimes result in a coincidence, is also given in the proposal by Luis Benedit. All of his terms are contained in wooden boxes as Bedel's are in books; but if the books appear to be allusions to Culture, the boxes, due to the wood in which they are made, suggest Nature, but it is a Nature shaped by man. Nevertheless, both books and boxes appear related by a common denominator—a sense of protection, of care, even in their packing for transportation...

Alfredo Portillos, who studies the mythical and religious rites of Argentina and other Latin American countries, observes with Myths Old and New the two Middle Ages of humanity and the immediate future. The little cart bearing fetishes symbolises the magic and occult typical of the first Middle Ages; its termination, as a moment in historical time, is signified by an oil streak. As we know, hydrocarbons were discovered in that period, and at the present time they are running out, a fact that has caused an economic crisis, armed struggle, and political strife...

For many historians the Middle Ages came to an end on October 12, 1492, the day when Christopher Colombus disembarked on the island of Guanahani. Maybe the Second Renaissance will include the definitive discovery of Latin American Art.

Jorge Glusberg
"Towards the End of the Second Middle Ages", *from the catalogue*

*Editor's note:* This exhibition was mounted by the CAYC group.

129

## Hacia el fin de la segunda edad media

Towards the End of the Second Middle Ages

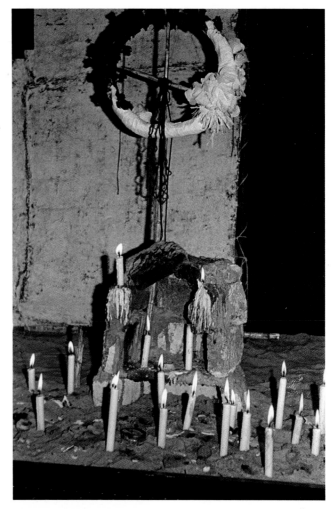

Alfredo Portillos, *Latin American Ceremony,* 1977, mixed technique, h. 78¾" (2 m)

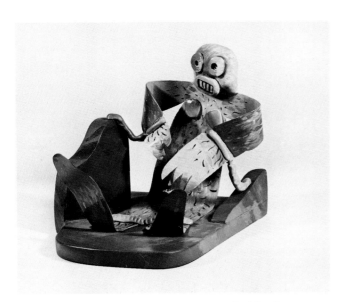

Jacques Bedel, *The Cities of Plate,* 1982, vacuum metalized fiberglass

Luis Benedit, *Toys,* 1982, mixed media, 19⅝" (0.50 m)

# Brazil

## Walter Zanini :
## Novos Centros Culturais

New Cultural Centers

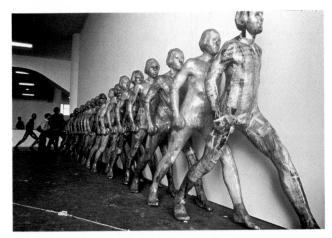

Karol Broniatowksi, *Figuras de Jornal (Newspaper Figures)*, 1975, mixed media

Exterior view of São Paulo Cultural Center

Culture fever reached the countries of Latin America in the years 1940-1960 when having art museums became a matter of honor conferring status on a city and again in more recent years when cultural centers began to spread. One of the largest, if not *the* largest on the continent, is still being constructed in an important park area (La Recoleta Park) in Buenos Aires. There is no lack of other examples. In Brazil two new cultural centers were recently inaugurated. Both are in São Paulo, where the city's population has reached eight million, with a high percentage of young people, thus creating pressing cultural needs.

Without surmounting the oppressive sobriety that characterized the industrial environment of former times, the architect Lina Bardi restored and modified an antiquated building in an industrial park of São Paulo, transforming it into "The Leisure Center SESC-Pompeia Factory." There are 16,000 square meters of space for artistic exhibitions, a theater, a library, a video center, workshops, a restaurant, and leisure areas. This exposition center, which began its activities in August and remains somewhat controversial, juxtaposes popular activities with an industrial environment.

Another location called the "Cultural Center of São Paulo" (run by the municipality) was inaugurated with much pomp before completion, as is customary in Brazil, especially during elections. This site, in an area adjacent to a highway with a lot of traffic, has not been successful despite its central location. Although the whole area totals 46,500 square meters, some parts seem to have insufficient space. Two architects of the new generation, Eurico Prado Lopes and Luis Telles, conceived and adapted a picture gallery, auditoriums, theaters, a cinema, a discotheque, and exhibition rooms—all built of light structures —to the inhospitable locale.

Surprisingly not officially counted as a cultural project, this new center opened in May 1982, to thousands of people on Saturdays and Sundays, with a documentary exposition (photographs and text) commemorating "Modern Art Week," an exhibition that took place on that site in 1922 and awakened Brazil to the new problems of art and culture.

Walter Zanini
*Original text*

In 1982, tho two most important Brazilian cities, Rio de Janeiro and São Paulo, reaffirmed their preeminence. In São Paulo, two large cultural centers began to operate, and we must emphasize their interdisciplinary character, something rare in the local panorama. In Rio, the Museum of Modern Art, devasted by fire in 1978, regained its role of informing and stimulating—a function that had made it the most important institution in the city.

At the instigation of Frederico Morais, the Museum of Modern Art has presented thematic exhibits, and the most timely of these exhibits, The Universe of Soccer, took advantage of Mundial 82 in order to show the Brazilian passion for soccer as reflected in art. It was particularly exciting to be able to compare statements by contemporary artists within the museum framework with the spontaneous and anonymous visual creation in the streets of Brazil, a country entirely "redecorated" by the collective agitation. Furthermore, the Rio Museum of Modern Art, together with Funarte (National Foundation of the Arts, a centralizing institution for government involvement in this area), kept a permanent open space for the exclusive showing of more contemporary works by such artists as the minimalist Adriano d'Aquino and the neo-expressionist Jorge Guinle.

A lack of support for both diffusion and discussion continues to be a serious cause of inertia in Brazilian art. On the other hand, we must stress the new dynamics of the magazine *Modulo,* started during the 1950s by the architect Oscar Niemeyer, which was particularly active in 1982. This journal allied itself with art galleries in Rio and São Paulo, to promote intelligent group exhibits, for example the House show at Rio's GB Gallery. Furthemore, *Modulo* opened its pages to the widest confrontation of ideas. Thus, its excellent surveys on "Brazilianism" and "contemporariness," published in the last two issues of 1982, did a serious and intelligent job of bringing together reflections by artists, art critics, and cultural promoters.

Roberto Pontual
*Original text*
*Translated by Joachim Neugröschel*

**Brazil**

**Roberto Pontual**
**Un Novo Dinamismo**

A New Dynamism

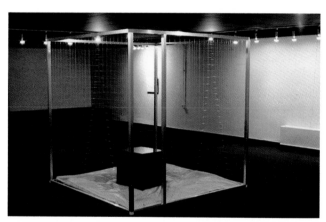

Paulo Roberto Leal, *A Casa,* 1982, installation for exhibition "The House"

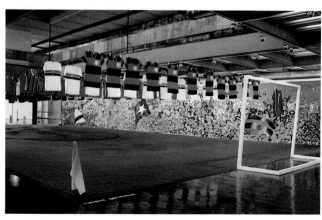

Rubens Gerchman, installation for "The Universe of Football," 1982

Rio de Janeiro: the city decorated for the World Cup '82

# Venezuela
## Museo de Arte Contemporáneo
## Caracas

## Sus Nuevos Espacios

Its New Spaces

An important cultural event in this country is the utilization of new spaces for expositions and recently inaugurated practical use areas within museums. They encompass a total surface of 5000 square meters divided into five levels designed to use modern museum resources for the conservation of works of art. Under the guidance of professionals from abroad and architects and technicians from Venezuela, internal spaces were designed and external areas were renovated to complement the lovely and interesting architectural structure of the museum. This expansion guarantees real operational possibilities for the Institution's functions and for the development of its programming in the immediate future.

One of the fundamental purposes of the Museum of Contemporary Art in Caracas is the formation, conservation, and use-in-depth of a collection of works by native and foreign artists. Since 1974, an exceptional group has been gathering the best that has been produced and is being produced in the medium of plastic arts in our century. They are permanently displayed in an area of the museum specially designed for this purpose. The works of Picasso, Braque, Matisse, Leger, Miró, Chagall, Vasarely, Bacon, Fontana, Segal, Ysoclis, Dubuffet, Latham, Rivers, Telemaque, Negret, Botero, Torres-Garcia, Biel-Bienne; and Venezuelan artists like Soto, Cruz-Diez, Marisol, among many others, make up a total of more than 600 works.

*New Spaces / The Collection of Works, from press notes*

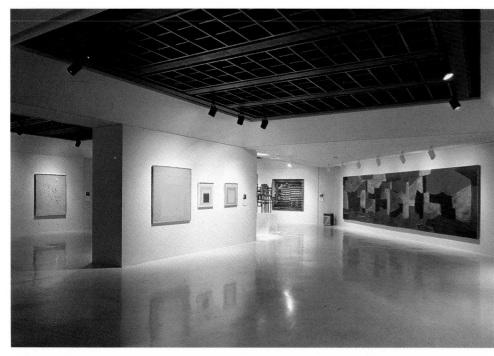

View of permanent collections in new rooms of the Museo de Arte Contemporáneo, Caracas

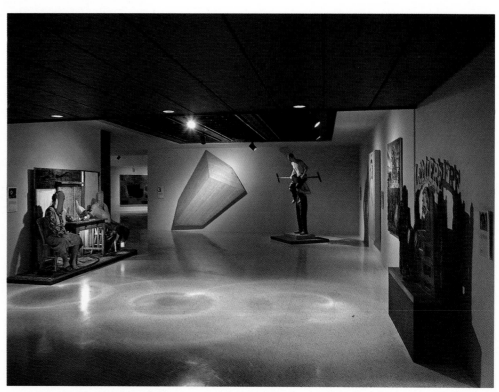

View of permanent collections in new rooms of the Museo de Arte Contemporáneo, Caracas

Juan Félix Sánchez has created many ineffable works, which have been realized with religious fervor. For the last 40 years, this work—until recently unknown—has been blossoming in the hands of an artist who has had no formal training, and who uses as his medium materials he can find in the forest or a well-wooded area. In his own words, these are places where he goes "to be closer to God," where stone, wood from unusual trees, and white clay are joined in a process in which the artist and his art seek to complement each other in the human re-creation of nature.

His work is a great architectural blend of Christian transformation, designed and created by the artist in an out-of-the-way place in Venezuela in the Cordillera of the Andes. Juan Félix Sánchez is an able mason of chapels made of *lajas*, thin, flat stones, as tall as their stability allows; he is a carver of figures swayed by their religious content, which remind us of the 11th and 12th centuries in Western Europe with their manifestations of Roman art. These the artist integrates with groups representing Calvary, the town of Bethlehem, and the Holy Sepulchre. His original and beautiful work recalls Gaudì in his inclination to discover and follow nature and reproduce it within man's limitations. Like Gaudì, Juan Félix follows vegetable sinuousness, penetrates into the structure of trunks, down to the deepest analysis.

He also reminds us of Cheval in his sense of establishing his own spiritual strengths by reconstructing magical abodes that isolate him from the ordinary. The Caracas Museum of Contemporary Art decided to make known the work of Juan Félix Sánchez and took charge of the work necessary to carry out this presentation without removing it from its natural environment.

*from the catalogue*

# Venezuela
## Museo de Arte Contemporáneo
## Caracas

133

## Lo Espiritual en el Arte
## Juan Félix Sánchez

The Spiritual in Art/Juan Félix Sánchez
born in 1900 in San Rafael de Mucuchies, Mérida, Venezuela
lives in El Potrero Valley, Mérida

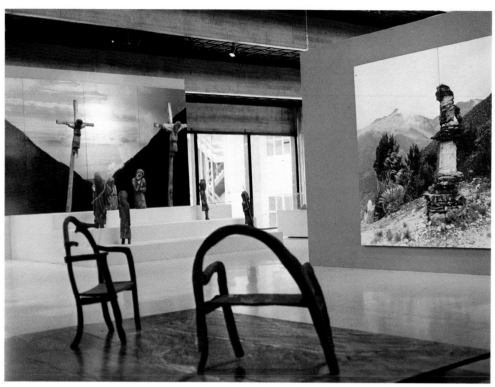

Chairs, 1967, wood, 31⅛″ × 29½″ × 15⅜″ (78.5 × 75 × 38.5 cm). *Calvary*, 1975-76, pine, h. 7′6½″ (230 cm)

Covers, weaving

The Sculptural Space

In order to honor and carry forward its educational role in the diffusion of culture—always the mission of the university—and also to commemorate the fiftieth anniversary of its independence, the University authorities have conceived and installed this striking cultural area on the university campus. With this work, modern sculptural art succeeded in giving material form to the "mad" enterprise of aesthetically imprisoning a telluric, natural, primeval, exciting, and disquieting space, by enclosing for artistic reasons an impressive surface of dermalithic lava, purposely deprived of soil and vegetation with the help of a bold platform topped with granular *tezontle* (red volcanic rock), on which stand 64 giant, hieratic concrete modules, 16 to each of the 4 quadrants, thus marking the limits of the forbidding and astonishing interior space.

The Sculptural Space, while being monumental, is an avant-garde artistic achievement, a constructive and public work of art open to everyone...

We who have participated in the university project for the Sculptural Space have sought to put into practice principles that have been forgotten for over a hundred years: to try to make art a great event for everyone and for always, while overcoming, at least during this experience, the voluntaristic, the individualistic, the self-sufficient, and the passé.

Helen Escobedo, Manuel Felguérez, Mathias Goeritz, Hersúa, Sebastián, Federico Silva, *extracts*

Partial view: outer platform in volcanic stone, ballast, and tezontle, 64 modules in concrete and cement

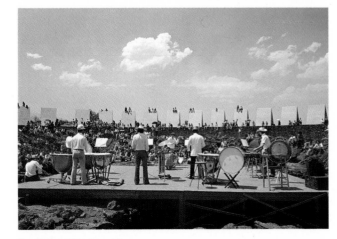

Partial view of Sculptural Space

Partial view of Sculptural Space

The plan for what is today the Tamayo Museum saw the light of day nine years ago when Rufino Tamayo voiced his idea of creating a place to hold the collection of contemporary art—paintings, sculptures, tapestries, and prints—that he had been collecting all his life and continues to collect.

It was then a question of conceiving a building for a total of more than two hundred works of modern art chosen by one of the protagonists of the modern movement. Besides, Tamayo was giving his collection on the condition that the building be situated in Chapultepec Park... At present the Park contains eight museums, including Rufino Tamayo's. Construction began in September 1979. The building is located 150 meters from the Paseo de la Reforma, in a clearing surrounded by sycamore trees. The major concern was to obtain a configuration appropriate to the surroundings. We have used three concepts: a building of compact volumes in concrete, with a single opening at the entrance; volumes spaced in such a way that when one is close their real dimensions are seen as diminished; finally, the building is surrounded on three sides by slopes that establish a continuity between the vegetation of the park and the walls of the museum. This integration with the environment gives the illusion that the building springs from the soil. The museum consists of two groups of exhibition rooms connected by a covered patio. The vestibule, the only open space toward the outside, is raised 1.5 meters above the entranceway. Inside, the balcony overlooks the patio designed for a complete view of the sculpture exhibition. Thus the works of 168 artists are displayed over an area of 2,500 square meters, providing an exciting panorama of the forms of our modernity.

*from the press kit*

## Museo Tamayo

Opening of the museum

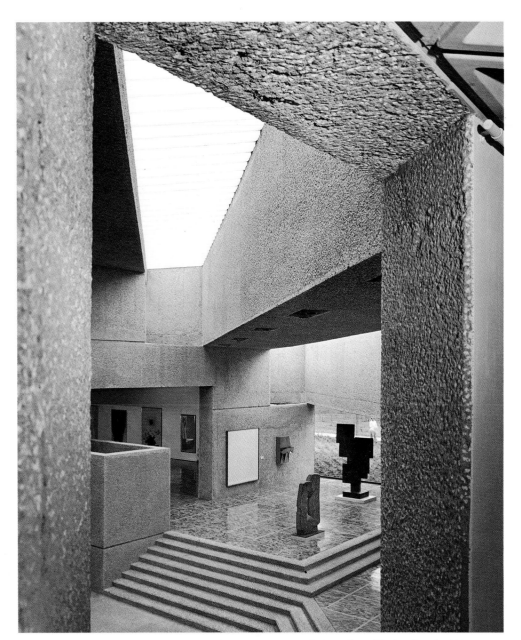

Interior view of patio where sculptures are displayed; architects: Abraham Zabludovsky and Teodoro Gonzalez de León

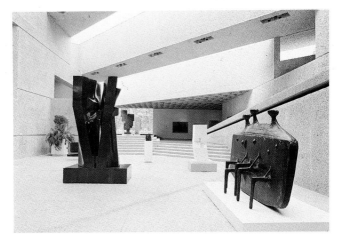

Presentation of collections

Entrance to museum

# Canada
## Musée d'art contemporain Montreal

## The Dinner Party
## Judy Chicago

born in 1939 in Chicago, Illinois
lives in Santa Monica, California

It all begins with a plate portraying a heroine of women's history. The plate rests on a cloth that serves to honor woman's sphere of life, a sphere with which she has maintained the harmonious or tense relations that are recorded in the material. Women's names are inscribed on the floor, as an accompaniment to each guest, placing her action in a broader context of female contributions to the culture of humanity.

Seeking the ideal embodiment for her work, Chicago has conceived (with the help of an architect and a designer) an independent structure that sums up its theme and stands as its ultimate context. Fitted out in white tiles (the material of the floor, whose symbolic color dominates the whole), the building consists essentially of a triangular hall surmounted by a pyramidal roof. An outer surface of beehive domes rounds its contours, evoking the image of the female sex already suggested by the plates. The building is the very prototype of symbolic architecture, a temple to the glory of woman. The reason put forward to justify this ambitious project? That the work should remain as compensation for all that has been lost, in a history written by men, of women's generous contribution to civilization...

This is my art, this is my sex. Chicago aims simultaneously at the consecration of woman and her own consecration as an artist. A reference to the Last Supper comes through pertinently in the image of the body transformed into the work.

Nicole Dubreuil-Blondin
from "Une communion au musée," *Spirale,* March 1982
*Translated by John Shepley*

*The Dinner Party,* 1971-79, triangular table for 39 guests on a pavement of triangular tiles, table 46½' (14 m) on each side, pavement 48' (15 m) on each side, covering an area of about 1,000 sq. ft. (100 sq. m).
Chalices, plates, flatware, and napkins on embroidered place settings and tablecloths of fine linen

*The Dinner Party,* detail: Eleanor of Aquitaine

*The Nuptial Chamber,* whose conception, staging, administration, and coordination of execution have been directed by Francine Larivée, has been conceived with few plastic elements. The circular structure (passageway and module) and iconographic tokens (the signboard and the scene of childbirth) are the only compositional elements outside *The Nuptial Chamber.* A delivery is proposed, a birth is announced. In no uncertain terms—a symbolic fetus at the entrance is attached to a long umbilical cord. This is not narcissistic navel-gazing; the plastic and semantic investment takes place inside, in the womb...

*The Nuptial Chamber,* parody and critique of several symbolic systems (art, religion, the social institutions of marriage and the family), reproduces the decadence of our human relations, the excessive materialism of our society, and the sentimental infirmity that accompanies the perpetuation of the species.

An instrument of communication, this work has been conceived as a place for questioning and reflection...

The birth announced at the entrance may take place elsewhere, outside the chamber. Crossing the umbilical cord and the chamber/womb promotes an emotional and introspective advance on the part of the male and female spectators...

*The Nuptial Chamber* reestablishes connections with a form of primitive art, as a representation of a social structuring and of a collective mythology...

Diane Guay
extract from *in the catalogue* "Parler d'elles à partir d'elles-mêmes"
*Translated by John Shepley*

Art and Feminism

Joyan Saunders, *Phone,* 1980, black-and-white photographs

Marie Décary and Lise Nantel, *La mère,* 1980, mixed media

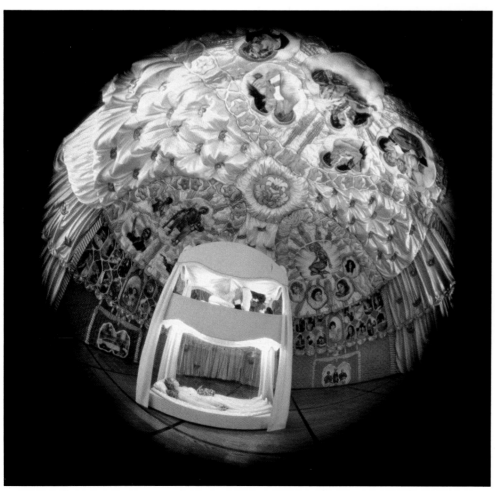

Francine Larivée, *La chambre nuptiale,* 1976, environment, mixed media, h. 21'8" (6.6 m), diam. 43'3½" (13.2 m)

# Canada
## Le centre d'exposition L'Imagier
## Quebec

## Louis Charpentier

born in 1947 in Montreal
lives in Montreal

In my recent drawings, the figures make a strong impression. They stand out from the background, divide and multiply themselves. With each repetition, the figures surrender a moment, fixed in time, of their existence. Just as they draw near to their image in a certain complicity, so the spectator is called upon to be an accomplice in this illusion of reality in order for intimacy to be created. Moreover, as people, they are both odd and familiar; one cannot approach them without a certain tenderness. I've become fond of them...

Louis Charpentier
*introductory note to the exhibition*

*La Dame de Montréal (The Lady from Montreal)*, 1982, colored pencil on paper, 23¼ × 35″ (59 × 89 cm)

*Carotène de Miss Clairol (Miss Clairol Redhead)*, 1982, colored pencil on paper, 13⅜ × 21⅝″ (34 × 55 cm)

The early works, a small orange monochrome painting of 1956 and the sculptures in the first few rooms, dated 1959 to 1961, are at the origin of Claude Tousignant's present-day position. In the tradition of constructivist sculpture, the artist reduces the language of color to its basic components. He elaborates his wall reliefs as if he were trying to make the normally flat surface of the painting become material. His language is still simple: grids, squares, rectangles. But the overal effect is one of freshness and originality, which were rare among us during the late Fifties. These early sculptural works of Tousignant are a revelation.

However, the chief attraction of this exhibit is the group of environmental works dated 1981-82. The things that evolved in the earlier works, cast about and arranged like rocks in a Zen garden, assume full meaning here. One room contains two parallel panels, facing each other, huge and thick, while two other identical planes lie on the floor. The organization of these four forms thus depends on the structure of the room. In another room, a huge, flat triangular shape is stuck to the wall, covering roughly half the surface. In the middle of the room, a long, volumetrical wall, 5 feet high and 8 inches thick, runs down the length of the room. The relation between the flat shape and the volumetrical shape, quite spectacular because of the architectural dimensions of the work, once again places us in the area of environmental art. As Normand Thériault writes, "The work as such is the room, its visual elements are the walls, its plastic tools are the panels."

Claude Tousignant's splendid exhibition marks a watershed both in the artist's (I don't dare call him a painter) *œuvre* and in the history of our art. His show magisterially illuminates earlier statements that sometimes seemed obscure (notably, the two-color "targets"), and the shadows have released an *œuvre* that had remained in the background since 1973.

Gilles Toupin
from "La corde raide de Claude Tousignant," *La Presse,* Montreal, Saturday, January 23, 1982

**Canada**
**Musée des Beaux-Arts**
**Montreal**

**Sculptures**
**Claude Tousignant**

born in 1932 in Montreal
lives in Montreal

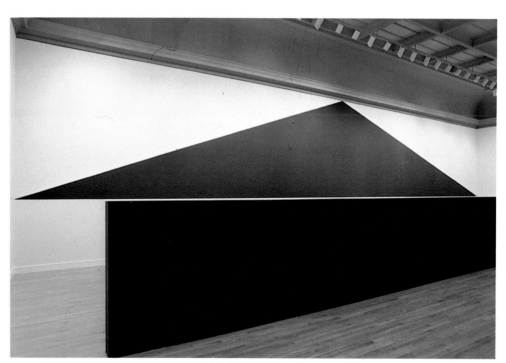

*Construction 419,* 1981-82, acrylic on wood and wall, installation in the Musée des Beaux-Arts, Montreal

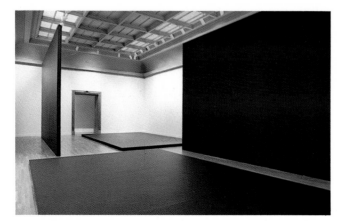

*Construction 420,* 1981-82, acrylic on wood

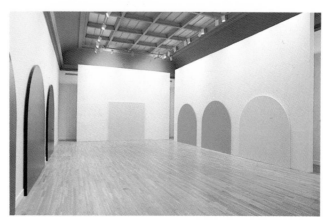

*Triptyque éblouissant (Dazzling Triptych),* 1975-76, acrylic on canvas

# Canada
## Art Gallery of Ontario
## Toronto

## Works on paper 1954-1976
## Cy Twombly

born in 1928 in Lexington, Virginia
lives in Rome

To enter the work of Cy Twombly is to discover a place where time is both contour and reflection. The onward march of movements and styles has been held in a state of suspension, urging one to rediscover the once vital and obvious connection between the passions of life and of art.

Twombly's is a deeply sophisticated art, which celebrates the cultivated sensuality of the classical Western tradition while speaking of it in the hushed and tentative tones of the modern age.

It may be said of Twombly's work that form is not all, that form must arise from need and must exist like a living thing possessed of a special spirit and its own unique manner of being. There is also modesty in his work, a willingness to stand back and let the work tell its story and occupy its own place in the world.

During the past five years, a generation of younger artists has emerged in Italy whose graphic imagery possesses a great deal of power and a state of awareness, which links personal experience to myth, history, and fantasy. These young Italians, most particularly Chia, Clemente, Cucchi, and Paladino, evidence an outlook that has much in common with the multileveled intellectual-emotional sphere first explored by Twombly in the late 1950s and early 1960s. Twombly's greatest influence has been on this generation of younger artists in Italy, his adopted homeland and the source of so much of his resonance and maturity as an artist.

Full of both doubt and courage, his work is, to borrow the line from Rilke once again, "like a ringing glass that shivers even as it rings."

Susan C. Larsen
*from the catalogue*

*Untitled,* 1970, mixed media on paper, 24¾ × 22⅜" (62.9 × 57.8 cm)

*Untitled (Captiva Island, Florida),* 1974, collage, adhesive tape, and crayon on paper, 29½ × 41½" (75 × 105.4 cm)

*Untitled,* 1954, crayon and paint on paper, 19 × 24 15/16″ (48.3 × 63.4 cm)

*Untitled,* 1969, graphite, felt marker ink, crayon, and colored pencil on paper, 27 5/8 × 39 1/4″ (70.2 × 99.7 cm)

# USA

## Mary Boone Gallery & Leo Castelli Gallery, New York

## David Salle

born in 1952 in Norman, Oklahoma
lives in New York

Salle had a lot of academic art training as a child in Wichita, Kansas. He went to Cal Arts in the early '70s and in the course of getting his MFA became, like almost everyone else there and then, a Conceptual artist making elegantly self-referential art gestures in the form of videotapes, environments, and so on. He moved to New York in 1975 and gradually worked back into painting via drawings on canvas of academically rendered nudes and, for instance, ambiguous images from old news photographs. The principle was "presentation," a cold-blooded, subversive distancing of images, revealing and undermining the way they hook us. His innovation was to use the formal repertoire of recent abstract painting, notably stained color fields and diptychs, as a kind of container-image, an image of itself, within which his borrowed, "hot" figurative images were presented like butterflies chloroformed and pinned in space. He complicated things further by the technical means of overlaying sharp contour drawings on fuzzy tonal ones, thus piggybacking images and activating contradictory types of pictorial space simultaneously...

The nearly absolute (no-two-alike) variety of the 20 paintings here bespeak incredible fecundity. His image scan reaches both higher and lower than before, from particular styles of modernist abstraction—in brilliant Kelly/Albers/Noland pastiches—to creepy old sci-fi comic books. Included are quotes from depression-era Social Realism (Reginald Marsh a specialty), some frenzied "Action" painting, more life-class nudes (female and male), schematic furniture and interiors (from what Salle calls "the lexicon of popular good taste"), on and on. There appears to be nothing he can't make work in a self-canceling, startling, exactly *off* way. Here and there he even goes all-out for sheer, sensuous, glistening beauty, and he gets it effortlessly, without the slightest loss of sardonic aplomb. As usual, his titles add another layer of unassimilable meaning, eagerly suggestive and no help at all. E.g., *The Old, the New, and the Different...*

Peter Schjeldahl
"David Salle's Objects of Disaffection", *The Village Voice*, March 23, 1982

*The Worst and Most General*, 1981, acrylic on canvas, 7'2" × 9'4" (218 × 284 cm)

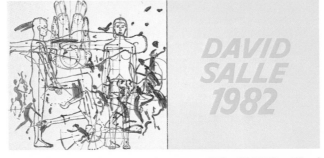

*The Name Painting*, 1982, oil and acrylic on canvas, 8'2" × 16'4" (249 × 498 cm)

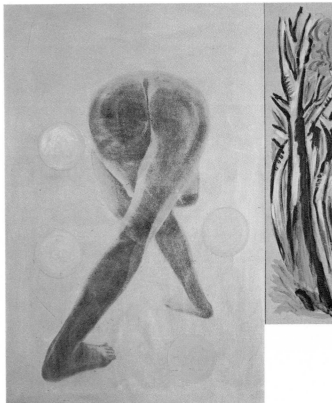

*The Extremely Anecdotal*, 1981, acrylic on canvas, 72 × 89" (183 × 226 cm)

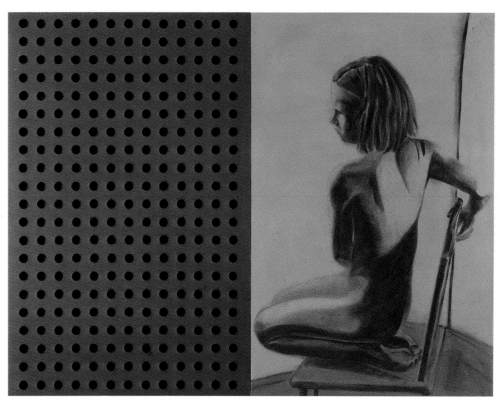

*My Subjectivity,* 1981, acrylic on canvas and masonite, 7'2" × 9'4" (218 × 284 cm)

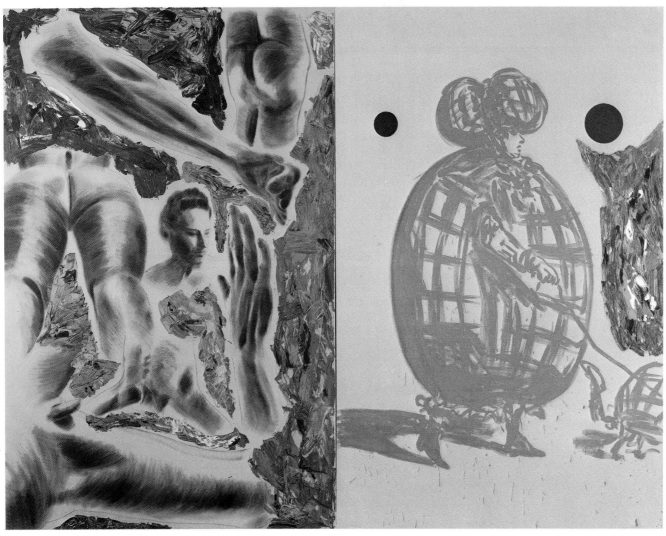

*Walking the Dog,* 1982, oil and acrylic on canvas, 7'2" × 9'4" (218 × 284 cm)

# USA
## Corcoran Gallery of Art
## Washington, D.C.

## Black Folk Art in America
## 1930-1980

In gathering together the material for this exhibition, we found ourselves increasingly responding to the aesthetic it represents with a sensation of convulsive recognition, as though one had seen these images before, or as if vestiges of one's own past were reappearing in fragmented segments. There was a nagging experience of recollected feeling, something like hearing long-forgotten music. Not one of these 20 artists ever communicates any hint of sentimentality: indeed the underlying irony, toughness, often a conscious crudity or aggression, which especially characterize Mose Tolliver, Steve Ashby, and Sam Doyle, are in *conscious* opposition to any sentimentalizing tendency. Yet even these most relentlessly coarse or repellent artifacts finally provoke a wrenchingly nostalgic response; we somehow feel that their authors represent an optimistic aspect of human nature, and that the spirit in which their homely sculptures and paintings are crafted encapsulates a long episode of flashing humor and curiosity and suppressed wisdom. It is a nostalgia perhaps springing from the tense closeness of this art to popular culture, yet without truly being *of* popular culture. Great art is never simply popular art. That the black artist in America, the artist descended from slaves, should emerge in the foreground of the recent American mainstream aesthetic, obviously implies a great deal about both the psychology of the so-called folk aesthetic, and the psychology of the black aesthetic. It suggests, for example, that the ethnically cohesive strata in our society create a truth we need to acknowledge. This art expresses a sensibility to which every one of us can relate on some level, whether out of the most basic or the most specialized capacity to appreciate visual form. Just as an entire global community has been touched by American black music, so might the whole world respond to this astounding black American visual outpouring.

Jane Livingston
*from the catalogue*

Bill Traylor, *Self-Portrait*, 1939-42, pencil, crayon, gouache on paper, 17⅞ × 11"

Nellie Mae Rowe, *Red and Blue Fish*, 1980, acrylic on wood, 23 × 9½ × ¾" (58 × 24 × 2½ cm)

Mose Tolliver, *Figure on Bicycle*, 1975, enamel on wood

David Butler, *Walking Stick with Figure*, 1975

The bulk of the exhibition is devoted to the miniature "Dwellings" that have been Mr. Simonds's principal preoccupation for the past decade. These are tiny, quasi-primitive structures made of unfired clay bricks so small that they can only be put in place by using metal tweezers. Paint is then applied to these clay surfaces, and the look that is obviously aimed for is that of a ruin, or survival, of a lost, or at least a threatened, primitive civilization. Mr. Simonds conceives of these "Dwellings" as the habitations of an imaginary race of migratory "Little People." He does not actually show us this race of miniature beings, however. Presumably they have been driven from their "Dwellings" by the pressures and cruelties of the modern world. The "Dwellings," too, are thus a species of "Mythologies."

At the outset of his work on these "Dwellings," Mr. Simonds was content to think of them as throwaway creations, more or less in keeping with the cult of perishable art that flourished in the early Seventies. He is said to have constructed some 300 of these works in the crumbling walls and on building ledges and window sills in neighborhoods where he had every reason to expect that they would be destroyed, and most of them have been. They did not go unrecorded, however. In one of the films we are shown at the museum, we see Mr. Simonds at work on location in an urban slum, looking rather like a missionary intent upon bringing the gospel of the "Little People" to a neighborhood where, as Mr. Neff puts it, "the concerns of both museums and the art market are worlds away."

Still, life in our wicked society being what it is, the concerns of the art museum—and even, alas, the art market—could not, apparently, be permanently resisted. And so Mr. Simonds has lately taken to giving his "Dwellings" a more permanent and—dare one say it?—a more saleable form. They are now constructed as tabletop landscape sculptures, and very pretty they often are, too! I am not too keen on the 1978 series that are made to look like landscapes consisting entirely of female breasts—and painted a very fleshy pink, lest we miss the point!—but the landscapes adorned with towers and toylike fortresses and settlements have an undeniable childlike charm. Their contribution to the art of sculpture may be nil, but they have a certain visual interest, all the same, and they have much to tell us about the appeal that archaism, regression and the romance of primitivist sensibility continues to exert on the contemporary mind.

Hilton Kramer
from "An Artist Emerging From the 60's Counterculture," *The New York Times*, December 13, 1981

born in 1945 in New York
lives in New York

*Brick Blossom (House Plants),* 1981, unbaked clay

*Number 6 (Untitled),* 1978, unbaked clay

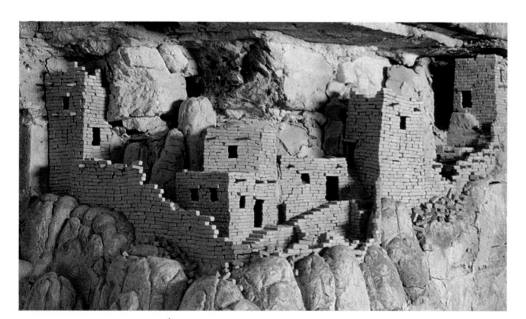

*Dwellings,* 1981, unbaked clay (bricks ½" [1.3 cm] in length)

born in 1923 in New York
lives in New York

This survey of work made during an active 11-year period, 1970-80, is arranged by thematic groupings and demonstrates that Lichtenstein's essential responses need not be related from one move to the next. From the highly original Mirrors, Entablatures, Still Lifes, Abstractions, Brushstrokes to his daring art history coloring book of subjects (Cubism, Futurism, Purism, Surrealism, Expressionism), different things in any group may provide points of focus, in any order. This inherent unpredictability is an essential, modern ingredient, restating Lichtenstein's quality as *provocateur...*

Lichtenstein overloads the issue, playing the traditional and tedious art historical game of source so constantly against itself that the point is eventually negated. His antiquarianism is his own peculiarly radical vernacular and he leaves us with source/antisource/nonsource, establishing in this way a contemporary non sequitur...

Lichtenstein has seemingly reversed the Readymade process by inventing an art object intended to be associated with nonart and objectified and evaluated by the viewer at the everyday, lower, common denominator. The migration of these symbols from painting/drawing/life into sculpture challenges our patterns of perception and identification. Lichtenstein works succinctly within the system (since, in truth, there are other artists who have more radically revised notions of sculpture) but he still leaves us here, as in the paintings, with a characteristic: What you think you see is not what you get...

Jack Cowart.
*from the catalogue*

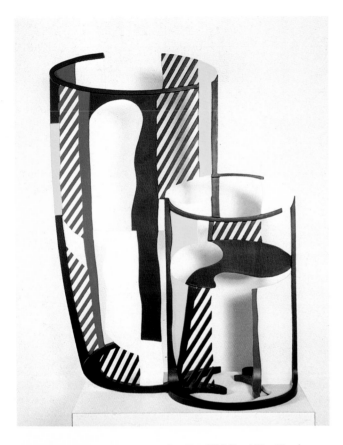

*Double Glass,* 1980, painted bronze, 56 × 42 × 17" (143 × 109 × 44 cm)

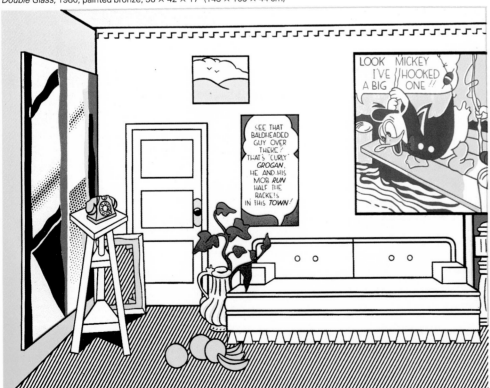

*Artist's Studio, Look Mickey,* 1973, oil and magma on canvas, 96 × 128" (244 × 341 cm)

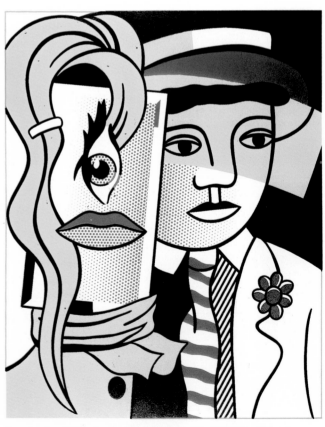

*Stepping Out,* 1978, oil and magma on canvas, 86 × 70" (219 × 178 cm)

Larry Rivers continues as the art world's personality kid, unmatched in his excess of graphic talent and dearth of aesthetic taste. His new paintings are, in the fashion which made him famous, mostly drawings, graphite on sparkling white canvas with intermittent paint. It's all here, the quick, accurate line, the scumbling out and whiting over, the shifts from black and white to color, from outlined to fully shaded, the stops, the starts, the hesitations, the reconsiderations, all played to the hilt.

Many of the drawings are quite large and feature cut-outs of the artist at work, mediating between real and pictorial space. In fact, Rivers is ubiquitous, drawing and painting his friends (Frank Lloyd, Henry Geldzahler, Joe Hirshhorn), his family, gleefully spanking the naked ass of a '20s vamp in *Boucher's Punishment. Now and Then* features a double image: young artist with young wife and baby, older artist (still looking good) with a new companion. When Rivers isn't working, he's talking on the phone, his image almost pushed off the canvas by a cloud of enlarged phone-pad notes and doodles. These and renderings of photographs of his children, drawings on yellow legal paper, and letters from friends make for a lot of trompe l'œil/collage effects.

The sense of industry and concentration, of Rivers connecting again with his maniacal energy and self is stronger here than in recent years and fascinating in a sickening way, which quickly wears thin. It's all that enthusiastic, unquestioning self-involvement. If only the life Rivers is full of weren't so relentlessly his own.

Roberta Smith
from "Misplaced Attentions", *The Village Voice*, March 2, 1982

# USA
## Malborough Gallery Inc.
## New York

## The Continuing Interest in Abstract Art/Larry Rivers

born in 1923 in New York
lives in New York

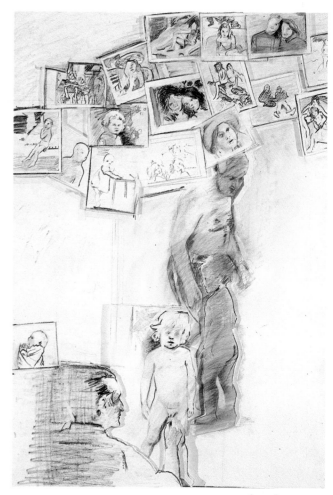

*From Photos of Gwynne and Emma Rivers*, 1981, collage, 46⅛ × 32⅛"

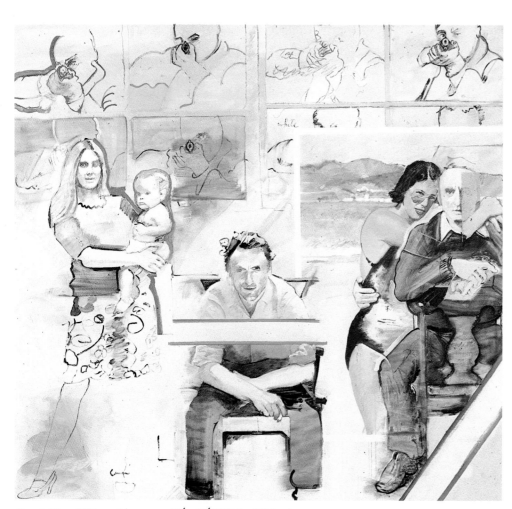

*Now and Then,* 1981, acrylic on canvas, 76⅛ × 80½" (193.4 × 204.5 cm)

*Tinguely's Letter,* 1981, collage, 29⅛ × 27⅝" (73.7 × 70 cm)

**Neil G. Ovsey Gallery
Los Angeles, California**

148 **Eric Orr**

born in 1939 in Covington, Kentucky
lives in Venice, California

Orr's art, with its predilection for the aesthetics of infinity, is based on the religio-philosophical tendency of space worship, found in Platonism, Hinduism, Taoism, the Cabala, and elsewhere. These traditions regard materiality as primarily a limitation and aspire to a state where gravity and spatial boundaries will have been left behind. Within such a horizon, space is not regarded as dead emptiness.

*Blue Void* (Los Angeles, 1981) was a black granite slab installed high up in a wall with a nearly square hole at the top opening onto the sky. Daylight flowed brilliantly over the edges and corners of the frame and locked one's gaze on the bright emptiness of the distant sky—a "piece" of infinity framed in granite as an icon of itself. At the same time, the Egyptian references (granite, vision directed through sighting holes or channels, the sky as destination) while muted, swim vaguely in the viewer's consciousness.

In *Mu 2* (1982 [in Japanese art a *mu* painting is a painting of zero]) a central monochrome area of gray-white fades floatingly from top to bottom, ringed with a thin dark border and framed by two narrow, gold-leaf-covered uprights. In this series the formal values grasp the viewer so directly and satisfyingly that the occult coding of the materials recedes into the background. Still, the conceptual point of the materials is profound: we see the void within our own bodies. The materials are drawn from the living matter of immediate human experience—from a shaman's cave rather than a chemist's laboratory.

If art consists in the way of experiencing rather than the type of object experienced, then the artist-shaman's job is not to create art objects, but to cleanse perceptual equipment or attitudes; at the very least, to create a suspension of past and future awareness which wipes out the viewer's systems of memory and expectation and presents a glimpse of the here-and-now shining in its implacable factuality.

Thomas McEvilley
"Negative Presences in Secret Spaces, the Art of Eric Orr",
*Artforum,* Summer 1982

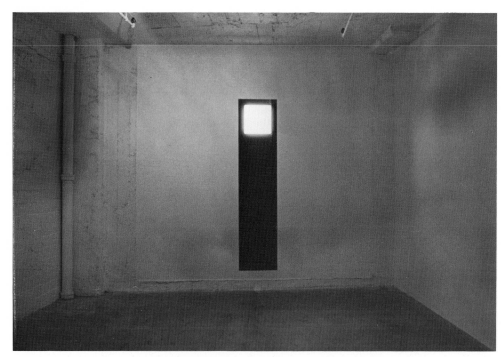

*Blue Void,* 1981, black granite, 24 × 94⅛" (61 × 239 cm)

*MU-6,* 1982, lead, gold leaf, mixed media, 53½ × 44" (135 × 112 cm)

*R-1* (revised), 1982, lead, gold leaf, mixed media, 24 × 38" (61 × 96.5 cm)

This first major retrospective exhibition of the work of Edward Ruscha traces his artistic development from 1959 to the present. The exhibition is comprised of 55 paintings, 71 works on paper, and the artist's self-published books. Ruscha's early collages are included as well as his paintings of objects, words, and phrases using organic substances and his more recent horizontal paintings. This careful selection of his work provides an opportunity to examine his diversity, his innovative use of a variety of materials, and his refined draftsmanship while allowing the viewer to compare his use of similar imagery in different media...

Over the last 20 years, Ruscha's paintings, drawings, prints, and books have developed independently of a particular art movement. The word and object paintings of the early Sixties combine the ordinary associations we attach to familiar objects with the literal and symbolic significance of words to create meanings that exist on different levels. These early works relate to everyday living and sometimes refer to the specifics of Ruscha's life in southern California. Ruscha later turned to words or phrases that became both the subject and object of his compositions. In more recent work, his use of words and objects offers a commentary more universal in content. Ruscha's work is a challenge to comprehend even though every word is understandable and every image is recognizable. Like a puzzle, his work delights as it perplexes, and therein lies much of its importance. His art is like that of no other artist. Though letters, words, phrases, and common objects are his subject matter, the artist's paintings and drawings rise above the mundane and make Edward Ruscha an artist of the vernacular and a poet of the visual.

Robert Whyte and Louise Katzman
*from the exhibition notes*

born in 1937 in Omaha, Nebraska
lives in Los Angeles, California

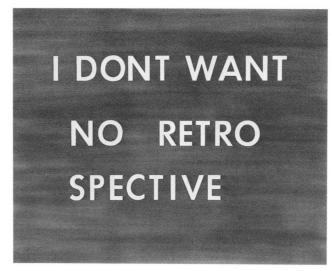

*I Don't Want No Retrospective,* 1979, pastel on paper, 23 × 29″ (58.5 × 74 cm)

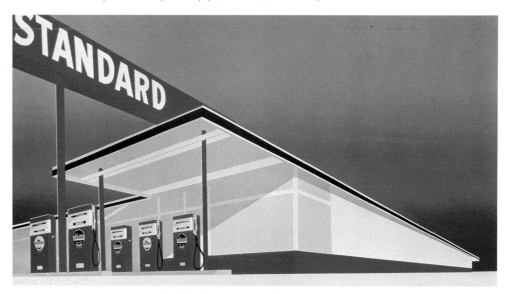

*Standard Station,* 1966, screen print, 25¾ × 40″ (65.5 × 102 cm)

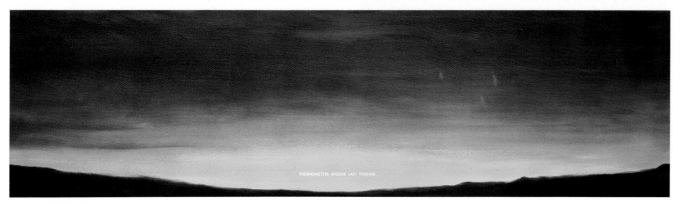

*Thermometers Should Last Forever,* 1977, oil on canvas, 22 × 80″ (56 × 203 cm)

# USA

## The Solomon R. Guggenheim Museum
## New York

### Italian Art Now
### An American Perspective

The seven artists in this exhibition—Sandro Chia, Enzo Cucchi, Nino Longobardi, Luigi Ontani, Vettor Pisani, Giuseppe Penone, Gilberto Zorio—are not meant to be seen as members of a single, identifiable movement or school but to express the ongoing vitality of Italian art today. Chia's uncommonly voracious appetite is stimulated by Cocteau, Malevich, Léger, Rosai, de Kooning, the art of Pompeii and the art of the streets. His is an art that celebrates the universe of the imagination and the drama of pure painting. Cucchi is more self-enclosed, drawing inspiration from a more concentrated vision, rooted in saints, medieval mysteries and strong, primitive color. Zorio and Penone, both based in Turin, share a common use of reductive forms and certain materials, such as terra-cotta. But Zorio's crystalline sculpture synthesizes the lean and the sensual, the rational and the alchemical, while Penone's work recalls Brancusi in its expression of the mystery of nature and a sense of its organic structure. Pisani and Ontani both evolve out of performance. Like de Pisis, Ontani travels through his artistic adventures in various disguises. He is like both St. Exupéry and his voyager, *le petit prince*. He re-creates the vision of a child, calling upon mythology, nursery rhymes or cartoon characters, endowing his work with the flavor of innocence tinged with eroticism, with humor and fantasy. On the other hand, Pisani, like de Chirico, is fascinated by northern artists such as Boecklin, Khnopff and Beuys. Duchamp is also a major source for his complex, hermetic and visually compelling art. Longobardi has integrated props such as tiger skins and chairs into otherwise spare canvases and has attached various painted objects to the encrusted surfaces of other paintings. More recently, a devastating earthquake in Naples has inspired a series of works depicting nature in chaos, populated by disquieting, spectral figures.

Diane Waldman
*from the introduction to the catalogue*

Giuseppe Penone, *Albero di 12 metri*, 1982, wood, 42' × 15" (120 × 38 cm)

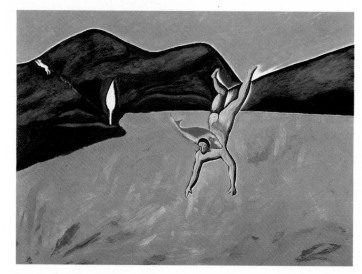

Enzo Cucchi, *Pesce in schiena del Mare Adriatico*, 1980, oil on canvas, 78¾ × 107½"

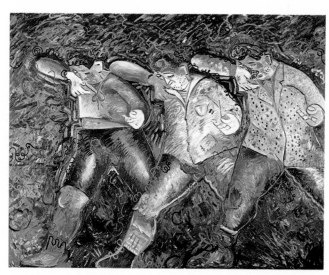

S. Chia, *Energumeni come protagonisti della fantasia erotica di una scimmia*

In the main Haring's output consists of witty but oddly unsettling images that read like runes or cave paintings. Human limbs, for example, metamorphose into snakes; cartoonlike telephones, video screens and saucers emit powerful "zapper" beams; hapless human forms are swallowed up by whales; dogs leap through holes in space, and crowds worship giant lightbulbs. It all forms a vocabulary of images that Haring arranges and rearranges at will, much in the way his hero, the writer William Burroughs, reshuffled bits of text to make his famous "cut-ups" of the 1950s.

The first Haring figures, naively rendered outlines of infants and adults, began crawling and somersaulting across Johnny Walker Red subway billboards sometime last winter, but they soon surfaced independently, forming part of a sign language that draws in equal parts on biblical, mythological and science-fiction themes. "It was important to me that the figures be universally readable as signs or images, to be combined with other universally readable signs or images," says the artist...

The son of an electrician in Kutztown, Pa., Haring bolted for Pittsburgh at 18, and briefly studied commercial art. Soon disenchanted, he moved to New York and enrolled in the School of Visual Arts, where his education included an investigation of semiotics, the study of signs and symbols.

Perhaps because he is a natural subversive, Haring found it fitting and expedient to take his work to public art events, New Wave rock and culture centers, such as Club 57, and finally, directly to the streets...

Haring is still attached to graffiti writers, some of whom he regularly invites to his basement studio on Manhattan's Lower East Side.

Ruth La Ferla
from "The Underground Man," *Daily News Record*, February 10, 1982.

born in 1958 in Kutztown, Pennsylvania
lives in New York

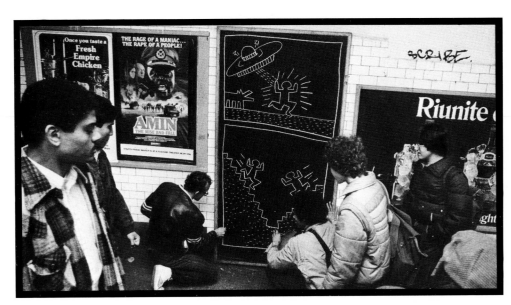

*The Artist Drawing in the Subway, New York*

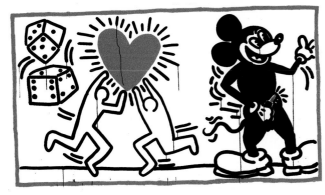

*Untitled,* 1982, sumi ink and enamel on paper, 6' × 9'6" (183 × 290 cm)

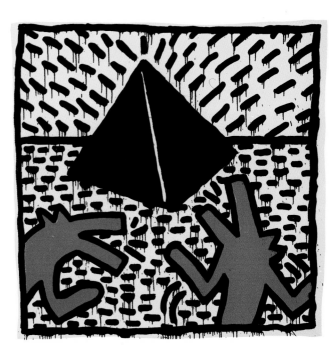

*Untitled,* 1982, acrylic on canvas, 8 × 8' (244 × 244 cm)

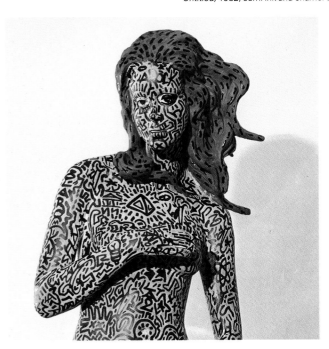

*Untitled vase* (detail), 1982

# USA

## Wave Hill
## Bronx, New York

### New Perspectives
### Justen Ladda

born in 1953 in Grevenbroich, West Germany
lives in New York

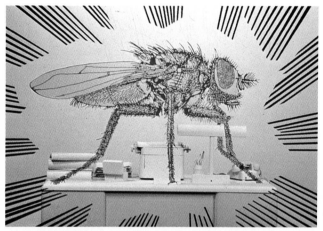

*Fly Bigger than Life (Nature over Man)*, 1982, latex paint on environment

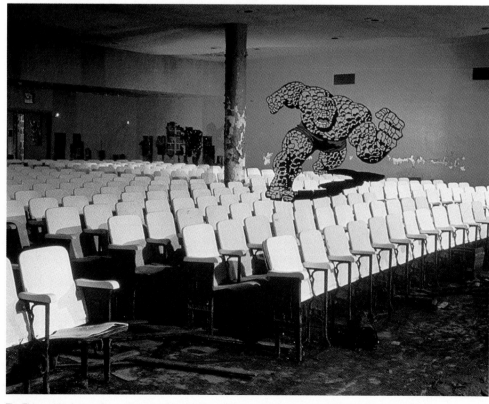

*The Thing*, 1981, latex paint, tempera, and enamel in auditorium of abandoned school in The Bronx, New York

*The picture is in my eye,*
*but I am not in the picture.*
Jacques Lacan

Having come from Germany to the United States after a detour through Latin America, Justen Ladda has lived in New York for four years, in a Puerto Rican enclave on the Lower East Side between Chinatown, the Bowery, and the East River.

His presence was remarked upon in the *Times Square Show* in June 1980, when a number of young artists took over a former massage parlor on Forty-second Street. There he had traced a sort of magic circle in white, in a room where the rest of the walls, floor, and ceiling were covered with countless hand prints.

The following year, but this time alone, he chose another site marked by urban decay, the auditorium of an abandoned school in the South Bronx. Others have already described this kind of descent into hell by sticky, blackened stairs, the crossing of endless rooms by the light of storm-lanterns, and in the end the apparition of the *Thing,* a sort of King Kong leaping toward the visitor from the wall above the seats, while on the platform a heap of books looks as though it has been collected for a symbolic auto-da-fé.

This year, at Wave Hill, on the grounds of an old mansion in the suburbs of New York, Ladda has used the site of an abandoned swimming pool to offer an immensely enlarged view of a fly. Nestled in a corner, the huge insect, as seen from the position in which the visitor is placed, seems about to fly away on some sinister mission.

Ladda works in accordance with a technique that might be called "painting in space." The traditional laws of perspective are here reversed so that the image is coherent from only a single vantage point. Instead of being a window opening on something, a *trompe l'œil* in some way, the image, which literally comes to meet us, would be rather a *dompte regard* ("gaze-subduer"), in Lacan's terminology. The gaze here re-cognizes a reality that is already familiar to it. The individual and collective disturbances engendered by urban life, the permanent threat made to weigh on the future of mankind by scientific and technical progress, the precarious biological equilibrium on the face of the earth, and so on.

Without the slightest trace of subjective complacency or expressionism, since the images he offers us belong to our collective iconography—comic strips and works of popular science—Ladda creates a bond between the site, which provides a context for the work, and the work, which reactivates the reality of the site. His images reach us like signals imbued with extraordinary intensity and strength of conviction.

Claude Gintz
Original text, July 1982
*Translated by John Shepley*

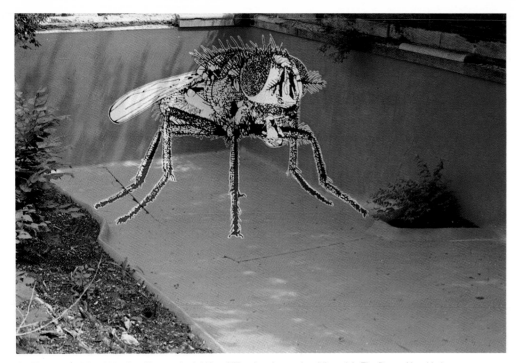

*Fly Bigger than Life,* 1982, oil and latex paint in Wave Hill swimming pool, public park in The Bronx, New York

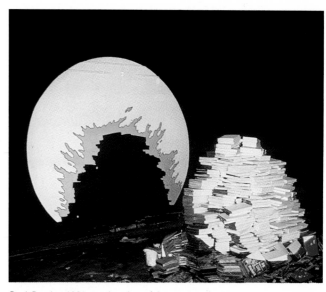

*Book Burning,* 1981, another view of the same work

*Fly Bigger than Life,* 1982, another view of the same work

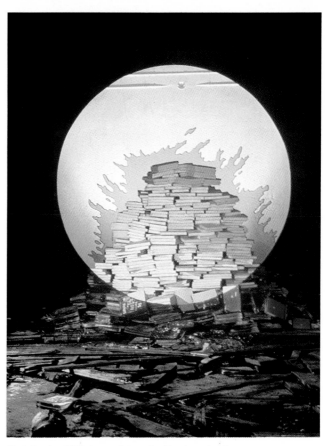

*Book Burning,* 1981, latex paint on pile of books and wall, abandoned school in The Bronx, New York

# USA
## Susan Caldwell Inc.
## New York

## Leon Golub

born in 1922 in Chicago, Illinois
lives in New York

Leon Golub's "Mercenaries and Interrogations" show is an open statement that manages to be both formally impressive and intensely critical of the world it clarifies. It's the hardest hitting "realism" I've seen... The tensions in these paintings, the sense of time passing unbearably slowly, is integrally interwoven with their use of space... In "Giganto-machy" of 1966, an earlier large canvas shown in a separate room, heroic nude figures flow across the surface and in their motion are truly monumental. The new works; however, are more so, heightened by their eerie sense of arrest and containment, their cruel, almost balletic, stopped-time gestures. The inherent violence is all the more appalling because it hasn't happened yet. Similarly the paint surface itself is very dry, as though the pain of the victims were literally drawn out, bled through the canvas... An acute anxiety connects all the work discussed here. It also connects modernism and social activism. Golub's new paintings achieve grandeur, maybe even "greatness"—a notion so abused by patriarchy and commercialism that I heartily mistrust it. He uses the extremes of military degradation—hired killers, torture—to comment on "the motives for actions announced as forthcoming." In other words, our future.

Lucy Lippard
from "Making Manifest," *Village Voice*, January 27

The artist

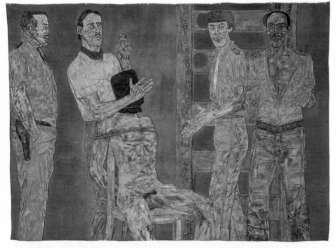

*Interrogations II*, 1980-81, acrylic on canvas, 10 × 14' (305 × 427 cm)

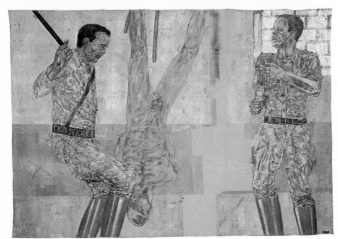

*Interrogations I*, 1980-81, acrylic on canvas, 10' × 14'8" (305 × 447 cm)

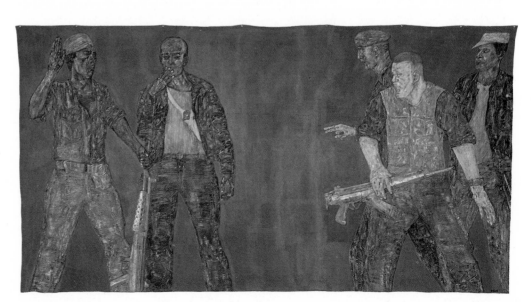

*Mercenaries IV*, 1980, acrylic on canvas, 10' × 19'2" (305 × 584.5 cm)

"In the Garden" was about the ways in which the insignificant can be made significant by art. It was also about making the outdoor world mate and merge with the indoor world. Around that same time Jennifer Bartlett was asked by Mr. and Mrs. Charles Saatchi to make an environmental work for their London house in which the outside of the house and its garden would be brought indoors in as many idioms as she liked to attempt. The house was hers to play with, they said, and she obliged with a kind of visual encyclopaedia in which every contribution was from the same restless hand...

"Up the Creek" contrasts in every possible way with "To the Island." It has, for instance, a precise and limited location—a well-watered glade not far from New York City that seems to some people an earthly paradise and to others a suburban slit in the ground. It is enclosed, leafy and strewn with stones. There is a field that abuts onto some woods, but fundamentally this is a place where light is hooded and refracted, fresh water chatters on its way downhill and the sun is seen rather than felt...

Such is the inbuilt variety of these two works that the uninformed visitor might mistake this for a group exhibition. Not only is there a variety of medium, but there is a variety of concept that goes all the way from straight description to the very edge of abstraction. There is also a variety of focus that runs from a deep tunneled space to a close-up that brings us nose to nose with the image.

The exhibition as a whole is about two totally different worlds, and about the ways in which they can be stalked, captured, and brought home to the studio as an archetypal New Found Land.

John Russell
from "Jennifer Bartlett Creates an Archetypal New Found Land" *New York Times*, May 23, 1982

**Up the Creek, To the Island**
**Jennifer Bartlett New Paintings**

born in Long Beach, California
lives in New York

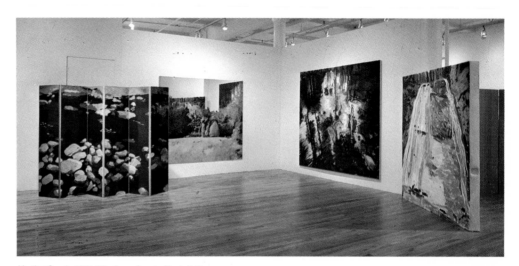

*Up the Creek,* 1981-82, view of part of installation

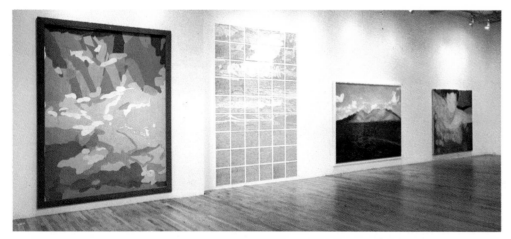

*To the Island,* 1982, view of part of installation

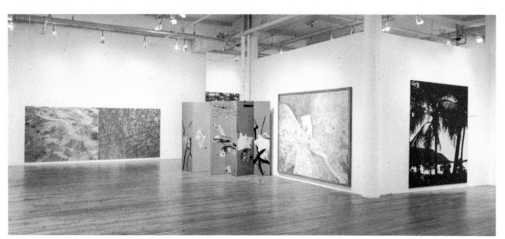

*To the Island,* 1982, view of part of installation

*Up the Creek,* detail, 1980-81, enamel and silkscreen on steel plate, 9'8" × 6'5"

# The Visual Arts Museum
# New York

**Robert Longo**

From the exhibition "New Reliefs"
born in 1953 in Brooklyn, New York
lives in New York

Robert Longo's most recent relief, *Men in the Cities: The Final Life,* is, for him, the culmination of this series and what he labels his mannerist phase, which in part refers to a more eccentric, asymmetrical handling of the figures. The piece, which is 26 feet long, incorporates four 8-by-4-foot framed drawings of cropped figures, two of which (a man and a woman) flank an 8-by-6-foot relief of a building on each side. It functions like a colonnade, a format with some significance for Longo. He associates it with architectural arrangements through history which carry both political and aesthetic meaning. While forming a group, it also allows the parts to function as autonomous units. Like a series of musical notes or a film strip, one moves from frame to frame. For Longo, motion has to do with impact.

In the more recent works where he combines reliefs with drawings, while the relief remains a single color, it is in sharp contrast with the black and white drawings, lending dramatic impact. And color can be mood-generated. The red in *The Final Life* may have a subliminal reference to things "American."

Longo shares with Segal a concern with American attitudes, contemporary attitudes, regional attitudes. "My neighborhood is important, everybody wears shirts and ties... men are always beating each other up around here. Although I was linked to New Wave, I was never part of it. I came and went."

Jeanne Siegel
from "The New Reliefs," *Arts,* April 1982

Robert Longo in front of one of his works, New York, 1982

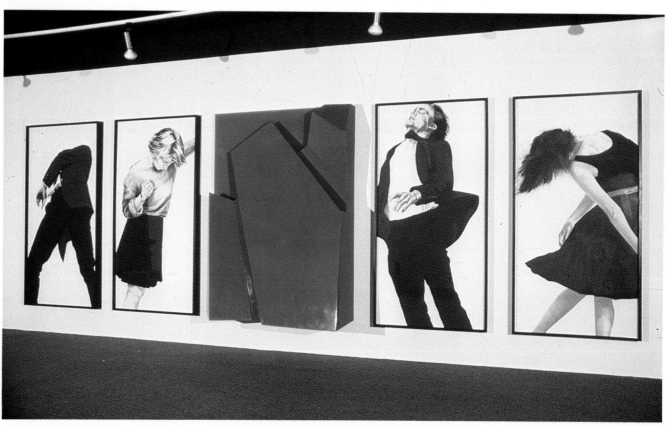

*Men in the Cities: Final Life,* 1981-82, lacquer on wood, graphite and charcoal on paper, 8 × 25′ (244 × 762.5 cm)

Cindy Sherman's recent show of ten 2-by-4-foot color photographs—of herself in the roles of various withdrawn (anxious or dreamy or stupefied) women—is the sleeper hit of the season so far, and the movie jargon is not strained. This is photography as one-frame movie-making. The pictures feature widescreen proportions, high-angle midshot compositions, "classy" cinematographic lighting, punched-up color, and the look of Method acting. The subtlest and most effectively cinematic element is a way of framing that does not crop expressively, like the usual photograph's, but, like the movie's, functions as the passive container of a complete, fictionalized reality (or real fiction), a world-in-a-rectangle that addresses itself directly to the imagination.

Part of what's prepossessing about these pictures is what they aren't: narcissistic or exhibitionistic, for instance. Much in and about them suggests both syndromes, but all of it mediated through the work's stylistic intelligence. Sherman the performer is wholly obedient to Sherman the director. In herself, she has an extraordinary actress—selfless and undemanding, game for unflattering angles—and she knows how to use her, as she knows how to employ the talents of Sherman the lighting technician, costumer and makeup artist. The sense of, as it were, team discipline is exhilarating, incidentally making me realize how seldom this sense is met with even in superior movies...

Like Hitchcock or Kubrick, Sherman appears to understand that the success of a technological art, after the stage of conception, is largely a technical affair: realizing the idea to the practical limits of the medium...

Very much unlike Hitchcock or Kubrick, Sherman takes the movie fiction of a character observed in vulnerable solitude as the departure point for an exploration, in depth, of vulnerability itself.

In each case, the "outside"—costume, wig, makeup, props—is a concise set of informational cues for a performance that is interior, the dream of a whole, specific life registering in a bodily and facial expression so right and eloquent—albeit "blank," "vacant," and "absent-minded" —as to trigger a shock of deep recognition...

Peter Schjeldahl
"Shermanettes," *Art in America,* March 1982

born in 1954 in Glen Ridge, New Jersey
lives in New York

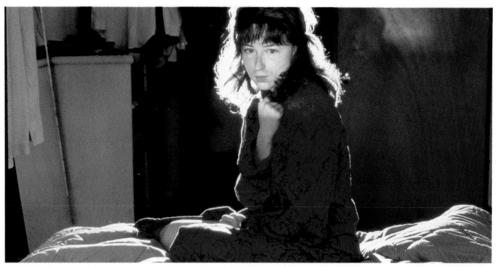

*Untitled,* 1981, color photograph, 24 × 48" (61 × 122 cm)

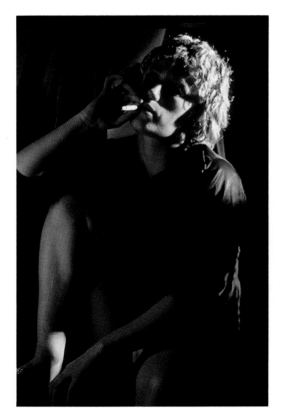

*Untitled,* 1982, color photograph, $29\frac{1}{2} \times 44\frac{7}{8}$" (75 × 114 cm)

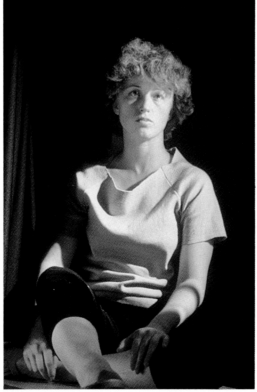

*Untitled,* 1982, color photograph, $29\frac{1}{2} \times 44\frac{7}{8}$" (75 × 114 cm)

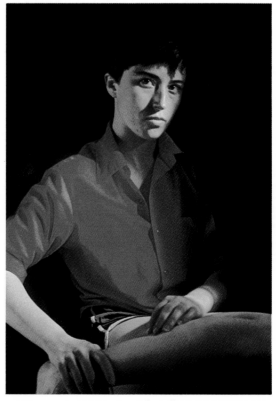

*Untitled,* 1982, color photograph, $29\frac{1}{2} \times 44\frac{7}{8}$" (75 × 114 cm)

# Whitney Museum of American Art
# New York

**Nam June Paik**

born in 1932 in Seoul, Korea
lives in Düsseldorf, West Germany, and New York

Through the 1960s and 1970s video emerged and established itself in America as a new art form. The key figure in this development has been the Korean-born composer, artist, and performer Nam June Paik. His career is a series of landmarks in the history of the transformation of television and the appropriation of the new technologies of video into contemporary art making. From Paik's show at the Galerie Parnass in Wuppertal, West Germany, in 1963, the first exhibition of video art anywhere, to his recent collaboration exploring the projection of video images by laser, Paik has set the example and paved the way for others. As both artist and visionary thinker, Paik has perceived the possibilities and the impact that video would have when placed in the hands of artists.

Paik's art and his career have been informed by a complex network of associations and relationships with visual artists, composers, technicians, television stations, and galleries, operating within several different art movements. Paik's wide-ranging interests in all forms of art making and in the exploration of aesthetic and scientific ideas have shaped his aesthetic discourse, bringing myriad resources and materials into his individual performances and compositions, videotape projects, and video sculpture. In addition, Paik refashions earlier work in a process that constantly reflects on the past while thinking about the future.

John G. Hanhardt
from the preface to the catalogue

*Random Access/Paper TV*, 1978-81, mixed media

*Global Groove*, 1973, videotape

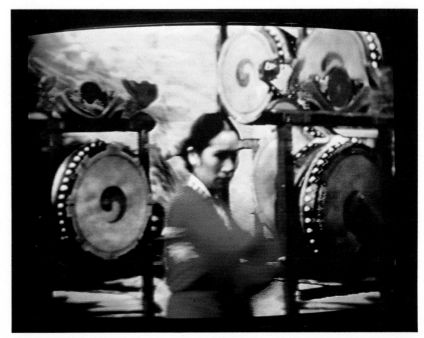

*Global Groove*, 1973, videotape

*Global Groove,* 1973, videotape

*Global Groove,* 1973, videotape

**Appendix**

On the occasion of its tenth anniversary, CalArts mounted an exhibition of alumni work that spoke primarily of the strategies whereby its graduates have achieved visibility in the contemporary art world.

"The mystique of the painter, the place where he worked, or the models he drew are only a part—albeit a significant section—of the deeper dilemma facing the modern artist: the necessity of being original, of being unique. Those artists who rebelled against standard tradition, who cast aside the absolutes of the classical past, were able to use the studio as an environment where they could commune with themselves... It was not until the twentieth century, when the studio was found everywhere, even in the artist's mind, that the significance of this theme as a symbol of increasing artistic originality and uniqueness was most apparent."[1]

In 1967 and '68, when Dan Flavin visited a number of art schools and departments to lecture "... on an American artist's education...," he announced that the era of the artist's studio as the *unique* space of artistic production was drawing to a close:

"The romance of days of belabored feeling, of precious, pious, compulsively grimy studio-bound labor by haphazardly informed neurotic "loners," often verging on mental illness, relying desperately on intuitive good sense, is passing from art. The contemporary artist is becoming a public man, trusting his own intelligence, confirming his own informed ideas."[2]

Since the studio functions not only as a place of production, but also of instruction, the advent of post-studio art precipitated a crisis—this was the main thrust of Flavin's address—in the training of professional artists. Art schools and university art departments had become, in Flavin's view, little more than "technical vocational training institutes" offering "formal indoctrination... in art historical media"—that is, in conventional studio practice. (Flavin's own work, referred to on this occasion as "recent misadventures in artistic electric lighting," demonstrates the extent to which post-studio art escapes the conventional categories, painting and sculpture, of studio-bound art.) Couched in the rhetoric of crisis—the claim that art has entered a critical phase in its development, that the present marks a watershed, a turning point—Flavin's remarks were animated by the adversary culture of the Sixties, not only by its sense of imminent cultural revolution, but also by the student movement's critique of the American university. (Indeed, the "open studio" and the "open university" were products of the same historical moment.) Thus, Flavin concluded with a series of proposals for reforming the art-educational system; among them were the following:
— The artist should not be condemned officially to adapt himself to falsified arts, a curriculum of artificial proficiency in various, separately categorized media such as painting on canvas kept distinct from sculpture of stone which disciplines have been construed as such and appropriate from the history of art.
— The artist of independent prospect... ought to be able to depend upon the educational center of the college or university to support him and his art. He should not be impeded by an administration and teaching faculty still enamored of a policy of formal art historical indoctrination.
— To supplant the present structured instructional functions in studio, shop and class, an open continuing visiting artist, lecturer and demonstrator program should be begun.

Several of Flavin's proposals would be implemented three years later, when the California Institute of the Arts was founded in Valencia. Arising out of the same sense of cultural crisis that fueled Flavin's remarks, CalArts was particularly responsive to the demands of the counterculture; its commitments "to be independent of any government or university structure", "to focus on the contemporary" and "to be an educational community particularly responsive to the needs of its members" all speak of the specific historical juncture at which the institution was conceived. In the School of Art and Design, shaped by John Baldessari and Paul Brach, required courses were replaced by a mentor system, an active visiting-artist program was initiated, and work in photography and video, sound and film, installation and performance was encouraged. Although instruction in traditional mediums has always been available, painting and sculpture have generally taken back seats at CalArts, where hybridization has been the rule: as the catalogue states, "a painter may use a darkroom, a photographer may use the color video equipment, a designer may create a performance". At CalArts, these activities have been situated within the context of an on-going discussion of the economic, ethical and political ramifications of art-making; thus, the three faculty members most responsible for CalArts' distinctive profile—Baldessari, Douglas Huebler and Michael Asher—identify themselves in the catalogue not according to medium, nor as conceptualists, but as post-studio artists.

On the occasion of CalArts' tenth anniversary, the School of Art and Design mounted an ambitious exhibition of work by alumni of its three divisions—photography, graphic design, and art. Although the first two sections were not without interest, my remarks are occasioned by the last, curated by Helene Winer of Metro Pictures (a New York gallery) and former director of Artists Space. Winer has come under attack for her selection criterion: only artists who have achieved some degree of art-world recognition—that is, *visibility*—were invited to participate. The resultant exhibition seemed less concerned with presenting an approach specific to CalArts, and more with promotion: CalArts grads, we were told, are having a significant impact on (the) contemporary art (market). Thus, the exhibition might be construed as a challenge to what cynics perceive as CalArts' incurable "idealism", for when we examine the strategies whereby these artists have achieved visibility, we discover that the most successful among them, at least according to this exhibition's standards, are those who have returned to conventional mediums and modes of production. Within the highly specific context of CalArts, then, the exhibition was indeed adversarial, for it spoke of a massive retreat to the studio.

In order to understand what is at stake in this retreat, it is necessary to review, however briefly, the history of post-studio art. Like all cultural shifts, its advent was multiply determined. On the one hand, the accelerating infiltration of artistic production by techniques of mechanical reproduction had largely discredited the attributes of uniqueness and originality that the studio had come to represent: thus Warhol transformed the artist's studio into a Factory. On the other hand, the advent of post-studio art can be traced to that moment in the mid-Sixties when the modernist critique of the formal and material properties of the art work was extended to include the conditions of its perception. This was, of course, the project of Minimalism, which initiated an investigation into the conditions of art's *publicity*. If the studio is the place where the artist, screened from public view, produces work in intense privacy, Minimalist artists advocated an aesthetics of full disclosure. They worked to make the place of a work's production coincide with its place of exhibition: thus, the installation of Robert Morris' *Continuous Project Altered Daily* in 1970 at the Whitney was staged as a public performance, recorded by a film crew. And in the performances which Yvonne Rainer mounted in conjunction with Morris's *Project,* the rehearsal of material was part of the performance, thus exposing the secrets of the *dancer's* studio as well. (Performance, of course, is the post-studio art par excellence.)

Later in the Seventies, Minimalist installation would develop into the institutional critiques of Michael Asher and Dan Graham, as well as Daniel Buren, who wrote a text in 1971 deconstructing "The Function of the Studio"[3]; in the related work of Michelangelo Pistoletto and Marcel Broodthaers, the studio itself became the object of scrutiny. And no survey, no matter how cursory, of post-studio art can overlook the scale and scope of Robert Smithson's ambition, which definitively exceeded both the architectural and the ideological limitations of the studio. As he stated in 1972, Smithson removed his work from the studio-gallery nexus in order to escape that network of art-world institutions that works to alienate an artist from his production; among these, the studio is simply the first, upon which all the others—gallery, museum, art history—depend.

An art-world institution of long standing, the studio belongs more to the sociology and less to the history of art, insofar as the latter is conceived as a chain of masterpieces linked in unbroken succession. Yet post-studio artists reject this distinction, for objects fabricated in the studio must conform to certain specifications. They must be sufficiently portable to allow easy transport from their place of production to their place of exhibition; they must be relatively autonomous and self-sufficient, for the conditions in which they will be seen are different from those in which they are executed. It is this initial separation of place of production from place of exhibition that alienates an artist from his production, reducing him to a supplier of commodities to a speculative art market.

This, the fundamentally economic purpose of the studio is masked, however, by its ideological function. For the existence of the studio encourages the artist to retreat into a profound isolation, thus reinforcing the privatization of experience in late capitalist society. This retreat into privacy allows a deeply entrenched, obscurantist view of artistic production to flourish. For not only is the artist's studio an alchemist's laboratory where matter is magically transmuted into form (this is the source of the art work's special value, simultaneously economic and aesthetic); the very constitution of the studio makes it an emblem of creativity as self-expression: the inaccessible private space from which issue forth testament after testament to an artist's uniqueness, his originality.

It may seem anachronistic, even nostalgic, to rehearse this history in 1981, for over the past few years we have witnessed a massive retreat from politics and back into the psyche. Although this phenomenon requires art-historical, psychoanalytic, *and* economic analysis, it must ultimately be seen as part of the widespread backlash against the Sixties counterculture that motivates the Neoconservative platform for the economic and spiritual "renewal" of the U.S., and which culminated in November 1980 in the election of the celebrity-commodity to the presidency[4]. In a period of conservative revanche, I believe it is essential to restate the premises of post-studio art for two reasons: first, to understand what is at stake in its repudiation, and how this repudiation is responsible for the atmosphere of melancholy and helplessness that pervades contemporary art; second, to amplify and extend the radical discourse inaugurated in the Sixties, in the face of a practice that has generally dismissed it.

What characterizes the group of CalArts alumni that dominated this show is that while the majority of them now make easel paintings, they display little conviction in the efficacy of the medium. Their return to the tangible—and, what is more important, marketable—object seems motivated less by faith in the continuing viability of painting than by its sheer persistence. Despite more than a decade of post-studio art, painting continues to function as one of the primary signs whereby serious artistic intention is recognized; ephemeral modes like installation and performance risk *invisibility* in a society that remains fundamentally invested in the object. (Jack Goldstein is a case in point: after nearly a decade of relative obscurity as a performance artist and filmmaker, he is now achieving some degree of recognition, but as a painter.) Thus, it may at times be necessary, or so these artists would have us believe, to exploit discredited mediums and modes of production simply in order to be *seen*. (Not all of the artists in the exhibition are implicated in this strategy, of course, but those who are not—I am thinking primarily of Ericka Beckman and Barbara Bloom, who make super-8 films; Michael Kelley, who mounts performances; and James Casebere and James Welling, who make photographs—are exceptions that prove the rule, for their work remains largely unknown outside a small group of cognoscenti.)

This desire for visibility requires some kind of theoretical justification, lest it be mistaken for mere self-display. Thus, more and more often do we hear apologies that invoke the seductive notion of a "subversive complicity" with art-world institutions; the only way to destroy painting, we are told, is from within, by exposing its own internal contradictions.

from *Art in America*, no. 1, January

*Notes:*
1. Gabriel P. Weisberg, Foreword to Ronnie L. Zakon, *The Artist and the Studio,* Cleveland, The Cleveland Museum of Art, 1978, p. 5.
2 Dan Flavin, "... on an American artist's education...", *Artforum,* VI, 7 (March 1968), 32.
3 Written in 1971, Buren's text was not published until 1979; see *October,* 10 (Fall 1979), 51-58.
4 This phenomenon is the subject of my forthcoming essay, "The Politics of Postmodernism".

## Avant-garde Trans-avant-garde

The art of the Sixties went through many trials, including the struggles of the youth movement, politics and feminism, while contributing to the development of a different and alternative outlook. Our relation with nature and culture discovered in artistic activity the possibility of articulating itself in new ways of thinking, seeing, and feeling... To the formalization of a world frozen inside its productive functions, art responds with a fluidity that unfreezes the materials from their initial position, in order to introduce them into the dynamic fabric of the work, at the crossroads of many media... Hence the interest taken even in the physical position of artist, and in his manner of confronting the work in its formation, growth, and development...

The *ideology of the permanent ephemeral* is the matrix of thought that underlies the panorama of the figurative arts in the Sixties... The consequence is the reduction of the future to the liberated present, as well as the need to experience openly the motivations that propel the making of art... The debate of the Sixties is based on the possibility of setting up a dialectical polarity between aesthetic commitment and political commitment. It is obviously necessary to start from an analysis that demystifies the system (the rupture between the individual and society, the conversion of intellectual and productive work into merchandise), while at the same time assigning a role to the intellectual now uprooted from society, and also seeing if the possibility exists of defining him as a class or something less... In fact, the mentality of the whole Modern Movement transposes to an extended and macroscopic plane the commensurable intention of Baudelaire and Whitman to accept the dynamic precariousness of the world as a *de facto* condition on which to graft the vertical thrust of their own imagination. The pattern of the Sixties reveals a shared approach in which artists accept the emotional oscillation of their own existence as an increasing affirmation of the anxiety of freedom. For it is no longer a declaration of principle but a demand unleashed by the structures of the unconscious. Aesthetic activity then becomes pure procedure, which cannot be interrupted by the propriety of form, since the release of energy becomes progressive and steadily increases.

This generation of artists has tried to overcome the mentality of an art as the privileged area of languages, in the sense of the production of aesthetic objects developed in accordance with the linguistic evolution of forms... Following the sociological verification of Pop art upon the fabric of urban life, and the concrete-reductive operation of primary and minimal structures, these artists have also overcome the last margin of separateness and have resolved to operate in a total dimension... Now the materials adopted are arranged by simple association, since the artist's ideology is not intent on constructing a mechanism to compete with the aseptic perfection of technology, but in lighting the fuse for a process to produce the movement of the artist's total fantasy...

By now the work is entrusted to materials no longer durable, that ought not to freeze aesthetic activity but instead underscore the new way of making art. A way whose intention is to create a mental and vital liberation of the individual apparatus... By an oscillating attitude and a continual discarding from his imagination, the artist executes works in which even the temporal unity of perception is transgressed. He entrusts himself to the flow of his own mental and vital energy and to the time span of his life, which thus also becomes the time in which to operate...

If the social system always keeps the psychology of man segregated, as not being objectified in a system of productive signs, these artists instead become reconnected only with themselves, confirming the mentality that considers one's own mnemonic and imaginative activity as the matrix of productive behavior. And this production has the same weight and concreteness as that of the world... Art becomes the instrument that projects, through the imaginary, spaces of fruition that extend the field of individual and social sensitivity, setting itself up in mirror opposition with reality... The obvious example is, precisely in this sense, that art that has felt the need to designate itself by the adjective *povera*... Under the influence of '68, it entertains the possibility of an artistic practice that would succeed in presenting itself as corresponding to—and the image of—the first incidents of urban guerrilla warfare that were beginning to occur in large European and American cities... Such a self-punishing and masochistic attitude, expressing the self-expropriation of creative pleasure and its consequent eroticism, is the moralistic result of a herd mentality of art toward politics. It was in this perspective that the artists of the Sixties essentially lived the drama of politics and nature: nature as the virginal place of origins and source of energy, as against the corrupt and excessively structured social place... To a reality designated in all its functions and wholly named, the artist ingenuously responds with works that bear as their designation the word "untitled", and which is intended to protect art from being seized upon by the world... It is not by chance that works are going back to having titles. No longer afraid of finding a link of communication with the world, they now go so far as actually to adopt a linguistic model tending toward the figurative...

The cultural area in which the art of the Eighties operates is that of the *transavant-garde*, which considers language as an instrument of transition, of passage from one work to another, from one style to another... The dematerialization of the work and the impersonality of its execution, which characterize the art of the Seventies in accordance with a strictly Duchampian development, yield to a restoration of manual skill, to the pleasure of an execution that reintroduces into art the tradition of painting... Essentially the new avant-gardes have believed in the principle of dialectics, in the possibility that art can overcome and reconcile contradictions and differences...

The artists of the transavant-garde have understood that the fabric of culture not only grows upward but also develops downward, through the autonomy of anthropological roots that nevertheless all tend to affirm the biology of art, the demand for a creativity bent on establishing its own experience as the place of temptation and change...

Persistence and emergence are the characteristics of the new image, which are understood on the one hand as the possibility of resuming the traditional procedures of art and the constant felicity that sustains them, and on the other of discarding and making distinctions with respect to past results. The art of the most recent generation is rediscovering the pleasure of an open illusoriness, created also by the recovery of languages, positions, and methods belonging to the past... If the previous art thought to participate in social transformation through the expansion of new procedures and materials, the present art tends not to create illusions for itself outside itself and to retrace its steps... Indeed, the work also collects inside itself the cultural and visual memory of other works, not however as quotation, but on the contrary as shifting and gradual adherence to previous linguistic models... This renewal does not mean identification, but the possibility of a duet and a duel likewise spanned by other conflicts of language... The work always responds to the demands of an occasion that is unrepeatable, because the shifting relation of the artist to his own instruments of expression is unrepeatable...

The work presents itself with a deliberately unhomogeneous result, open to color, to material, to the figurative sign as well as the abstract one. The pleasure principle replaces the reality principle, understood as the gratifying economy of artistic work. The work becomes the place for an opulent

representation that no longer sets out to save but to waste, and no longer recognizes a privileged reserve on which to draw... The many directions are also those of language and its places of recovery, which now can no longer be circumscribed since they are subject to a diligent pursuit, to an intense courtship with neither privileges nor prohibitions. The new art draws on the deposits of an inexhaustible and continuous reserve, where abstract and figurative, avantgarde and tradition, live at the crossroads of many encounters.

excerpts from *Avanguardia Transavanguardia,* Electa
*Translated by John Shepley*

**Alain Jouffroy**

## Introduction to the Landscapes

Matta, a Chilean who had worked for Le Corbusier and had begun to paint after an encounter with the surrealists, or just before, after an encounter with Lorca, created in his turn a new revolution. After 1938 he threw color on his canvases, and from these colors, with brush and rag, he made new imaginary spaces emerge. They resembled the true vision of the universe that one might create for oneself by clinging simultaneously to the milieu of atoms and the milieu of planets, inner thought and the interior of a star. Matta tried to invade the spectator with these spaces, as though they contained the consciousness of the universe, the "I" of the universe, which makes everything move freely in everyone's thought. It was then that new painters, born in the early Thirties or shortly before, appeared in force from Iceland, France, Italy, Spain, and from Yugoslavia and Germany, to carry out in Paris their own revolution of the urban landscape: Cremonini, Erró, Monory, Arroyo, Fromanger, Klasen, Aillaud, Baruchello, Pommereulle, Mondino. They were the first to take seriously everything that had happened since Cézanne. Art books had been published, and films existed about the painters whom people had mocked for so long, and these painters accepted them and truly respected them. The Frenchman Fromanger respected Giacometti; the Icelander Erró respected Matta; the Italian Baruchello respected Marcel Duchamp, the artist who, as people had just realized, had executed in New York, during the war, a huge picture on glass, in which no one except Breton and two or three other poets had been interested, and which was now beginning to arouse innumerable and endless comments, analyses, speculations, questions, and interpretations. It was called *The Bride Stripped Bare by Her Bachelors, Even,* and Duchamp had had it placed before a window in the Philadelphia Museum, to which it had been donated by the collector Walter Arensberg. And when Duchamp was asked why he was so insistent that this work be placed before that French window, he said: "so that the garden can be seen through it." As though this work, so mysterious and difficult to understand, had to be viewed at the same time as nature at its most simple and natural, from which Duchamp absolutely did not wish it to be separated. And something exactly similar happened next. The new painters did some very large paintings, as the great painters of the nineteenth century, David, Géricault, Delacroix, and Courbet, had done, and in all these paintings they revived the image of the world. The first to have taken truly seriously all their predecessors and to have respected them for what they had done, and not for the money they had earned or allowed others to earn, they were also the first to arouse neither true scandal nor true understanding. They were attentive, enthusiastic, ready, and everything interested them: American paintings, comic strips, films, newspapers, the media, political events, opera, travel, encounters, revolutions in the Third World, streets, sports, eroticism, and with all this they painted landscapes, large landscapes of love and hate, highways, the desert of Death Valley, department-store show windows, posters, animals in zoos, war scenes, crimes, windows opening on the countryside, news dealers, old paintings redone in their own style, letters, postcards, trains, airplanes, rockets, stars, the cosmos, black holes—everything. For the first time since the beginning of the twentieth century, and thanks to the pioneers, it was possible to reinvent the landscape of the entire world, the landscape of memory and thought, the landscape of man's history and the landscape of autobiography. Jean-Paul Chambas succeeded them, then came Fanti, Antoni Taulé, and Christian Bouillé, more attentive still, more eager to know and understand everything, eager for life and knowledge, smiling, independent, full of humor, and sometimes drama as well. Their young elders, Erró, Fromanger, Monory, Arroyo, Aillaud, Recalcati, Mondino,

and those already past fifty, Baruchello, Cremonini, those who made the idea of the revolutionary landscape triumph, the landscape where everything happens and anything is possible, have observed them carefully. And they were right. For landscape is the face that each gives to the universe, that is to say the face of our destiny, the haunting image that tomorrow may act on countless people and make whole generations dream. Or no one. Landscape is this mad history of landscape, it is this new history painting reflecting all landscapes, outer and inner. Matta had advised them all to seek the unknown image of the world, but they did not listen to him. Out of the world they made images of the unknown, images of doubt about the future, images of nostalgia and criticism, images of thought, and for this they took everything, they absorbed everything, everything done by the impressionists, the fauves, the cubists, dada, the surrealists, and also Nicolas de Staël and Tal Coat, all those who have skirted death or rushed into it like Réquichot, because before the Sixties it was too early to believe in the final triumph of the modern landscape, which merges with the total victory of modern art. A victory that may still last for a long time, allowing itself to be disturbed by crises and defeats, but changing throughout all this the image of the world that to us is necessary in order to truly transform the world —, a generous, pluralistic, nondogmatic, critical, loving, passionate, lucid revolution.

*from the catalogue "Revolutionary Figurations-From Cézanne to the Present"*

The poet and art critic Shuzo Takiguchi was born in Toyama, Japan in 1903 and died in 1979. Now, the Museum of Modern Art in the Prefecture of Toyama is honoring him with a huge exhibition of some thirty major postwar artists.

During the late 1920s, Takiguchi, who was greatly attracted to surrealism, began to correspond with André Breton. Then, in 1930, he translated Breton's *Surrealism and Painting* into Japanese. Although partly silenced during the repressive era of Japanese militarization, Takiguchi introduced the European avant-garde into prewar Japan. After the war, he became an animator of the Japanese avant-garde. Directing a noncommercial gallery, he organized exhibits of young, contemporary artists. His articles in magazines and newspapers decisively contributed to forming the first postwar golden age. During this era, the new legendary "Yomiuri Salon of the Independents," was the crossroads of these *enfants terribles,* who shocked art viewers. We may recall On Kawara, Tetsumi Kudo, or Shusaku Arakawa, to mention just a few names that have now become famous.

During the 1960s, Takiguchi gave up this public work and immured himself in silence—this time voluntary. He wrote only a few prefaces far from the broader media. But his silence was respected by those loyal to him. It was a silence like that of his friend Duchamp, whom Takiguchi translated and published in Japan.

However, the young artists, that is, the generation of minimalists and conceptualists, forgot Takiguchi in favor of a vocal criticism, more practical than poetic, in which a realistic critic, adjusted to the transformation of the worldwide art scene, even went so far as to sully his hands in the marketplace. We may say that when Takiguchi lapsed into silence, Japan gave birth to a system of art animated by cooperation between the gallery and the art critic. In this respect, Japan was following the Western example.

Below, we have excerpts from a conversation between the artists Ikeda and Kudo, who have been active since the Takiguchi era. We also have fragments from Takiguchi's autobiography, which allow us to focus on certain aspects of his personality. Takiguchi was never a militant critic. He never cared to have a position of power. He preferred being an amateur, a dilettante, a passive visionary, rather than an agitator. In a sense, he was fragile: realizing that it was impossible to unite his surrealism with the social reality or the contemporary art movement in present-day society, he opted for a silent loyalty to surrealism.

Nakamura
Paris, December 1982

*Ikeda:* In 1956, there was an exhibition entitled *Art of Today* at the Takashimaya department store. The show was organized by the Art Club, which had been founded two years earlier. Its chairman was Taro Okamoto, and Takiguchi had joined it at the very start. On this occasion, Sam Francis showed 'all white' paintings for the first time. Mathieu demonstrated his painting technique by taking huge leaps in a store window. Fautrier and Dubuffet also participated, as did young art critics such as Hariu, Segi, Tono, Nakahara. The club was not just a social gathering-place of so-called avant-garde artists. Its goal was to promote a movement of art and experimentation.

Although Takiguchi claimed that he preferred making "appreciations" rather than "depreciations," Hanada feels that he wasn't entirely correct. "We may say," Hanada points out, "that anyone who fails to catch the depreciation concealed in Takiguchi's appreciation is a big imbecile."

In 1960, Takiguchi began to write/draw[1] "lines that are not characters." Takiguchi had been interested in photography and cinema since his childhood. He was I think, more drawn to visual phenomena such as "painting" or the "cinematic image" than words. That is why Takiguchi was a reliable art critic.

*Kudo:* I agree with you. He was a very intuitive man. In 1958, he went to Europe with Tono. This was his first trip abroad, and people were already deifying him. When André Breton stepped towards him to shake his hand, Takiguchi stepped back. And when André Breton took another step towards him, Takiguchi stepped back again. It was Tono who reported this very funny anecdote to me, and beyond Takiguchi's great timidity, I can feel the tenacity that characterized him. After shaking hands with Breton, he had tears in his eyes. He was a very sincere man, and also a very persistent man.

In 1969, I returned to Japan, and on this occasion, I saw Takiguchi again. I drank a lot, and he kept me company. Gathering goodness knows what strength, I told him point blank (naturally, I was a child revolting against a father) that I did not trust poets. My drunkenness probably gave me the courage and strength to anger him. Takiguchi's face turned pale all at once... but he did not lose his temper. He simply told me that I was entitled to my opinion and he gazed into the distance. I stopped speaking. I can still see the delicate expression on his face. I can only imagine what was going on inside of him. He left us the pleasure of picturing it...

*Ikeda:* It may sound a bit simplistic, but one had the impression that he was a transparent man.

*Kudo:* For me, Takiguchi is a translucent man. And even if his skin is removed, he still remains, gray, translucent...

from *About the Shuzo Takiguchi Exhibition of Post War Art,* July-September 1982, Museum of Modern art in the Prefecture of Toyama.

1914. I was eleven years old. I wrote a letter to Natsume Soseki, although now I cannot remember what I said. I received an answer signed Kinnosuke (his real first name). "I am replying to you because you enclosed a stamp..." That was how his letter began. It was a very severe letter. Annoyed by the business about the stamp and impelled by goodness knows what feeling, I ripped up the letter. This caused me remorse for a long time. I did not dare throw out the pieces or show them to anyone else. The letter was burned up during the war, like so many other things.

*1951* [*48 years old*]. In February, the Yomiuri Independent Salon was to exhibit such surrealists as Magritte, Matta, Lam, and postwar artists such as Pollock and Dubuffet. I wrote a catalogue preface on these foreign works, completing it in one night.

On June 1, the Takemiya Gallery opened. It planned to make its premises available for free to young artists. I was asked to take charge of this project and I was given full power to choose the artists. I agreed on condition that I receive no payment. That year, the "experimental studio" (my term) took off with sculptors such as Yamaguchi, S. Kitaya, H. Fukushima, the critic K. Akiyama and composers such as M. Takemitsu, S. Yuasa, and H. Sukuzi.

*1958* [*55 years old*]. On August 25, I left Tokyo for the Venice Biennale. Then I went to Paris, my base for visiting other European countries. That same month, I visited Dali, through whom I met Marcel Duchamp and his wife. In October, I had the chance of a lifetime: I met Breton. Nor will I ever forget my meeting with Henri Michaux.

*1959.* I began to have doubts about my work as an art critic. I realized the difficulty of leaving this world which I had entered.

*1960.* Beginning of the year. On a drawing pad, I drew lines that did not represent letters [characters]. Consciously or not, I must have wanted to find the common point between the motivation for drawing and the motivation for writing.

*1964* [*61 years old*]. Since the previous year, I had been thinking of opening a store for objects. I asked Duchamp to provide a name for this store, which did not as yet exist. In March, Duchamp gave me the name Rose Sélavy, which had been his pseudonym during his youth.

*1965* Genpei Akasegawa copied a thousand-yen note and was indicted as a counterfeiter. I became his lawyer.

from the *Autobiography of Takiguchi*

---

1 The expression chosen by Ikeda is deliberately ambiguous.

# Julio Le Parc      Valorization: Key Weapon for Culture Penetration

Selected from the paper "Valorization, a Key Weapon for Cultural Penetration", presented by Julio Le Parc at *Encounters of Intellectuals for the Sovereignty of the Nations of Our America,* which took place in Havana in September 1981 and which was organized by the *Casa de las Americas,* Cuba. More than three hundred Latin American intellectuals attended.

What we need are contributions by artists from all over the world, as they develop a truly investigative and creative approach to the fine arts. In contrast, the things that must be prohibited are utilization, manipulation, and the artificial and exclusive valorization by wielders of international or local power.

... Throughout my contacts with groups of young artists in various Latin American countries, I have noted a justified loss of confidence with regard to the art centers of the world. I have told these Latin Americans that these centers, nevertheless, have young artists like themselves involved in a permanent struggle against a hostile environment, in which the diffusion of art outside the private market is directed by technocrats, most of whom are deaf, insensitive, and alienated from the problems of artists. We must resist a cultural penetration that exports new things as well as value standards; and likewise, we must also establish contact with all those who, throughout the world, plan, in some way or other, to establish conditions for a different kind of art.

Artistic creation per se has no intrinsic value that defies time and extends to all latitudes. There are, however, people who want the values to which they devote themselves to be universal and self-evident. Still, their works and the artistic trends illustrated by their works do contribute to their era; they are registered and classified by the ruling class along the most superficial lines and thus included in the "history of art" written by the ruling class which denaturalizes the artist's contribution.

These words and tendencies, thereby devitalized, become part of the exclusive heritage of the ruling class, which dictates its standards of appreciation and tells the general audience how to react to this art. Nor is it a coincidence that the public's position in regard to these works is always one of inferiority, passivity, and dependence. This situation makes people more submissive to the established order, prevents them from developing their own appreciation, lulls their natural creative ability, and isolates them in individual contemplation making it impossible for them to interfere with what they regard as alien and what is presented to them as "Art" with a capital A.

...From my point of view, the present-day situation of the plastic arts is a chain, in which we find the producer and his product, the diffuser and the object diffused, the consumer and the object consumed, the key issue being "valorization". This valorization is in the hands of a tiny number of people who decide what is and what is not art, who circulated whatever has been chosen and deemed worthy of a social reality sanctioned by the collector's art of purchase or hallowed by art officials in the privileged places of art: shows, international exhibits, public sites, museums, etc. The man in the street is excluded from all these places, barely admitted into certain museums, generally regarded as a well-meaning but powerless amateur, suspected of being uncivilized and liking only kitsch, of poking fun at or even ignoring avant-garde art, which strikes him in most cases as hostile, incomprehensible, and remote from his everyday concerns.

Just as valorization on an international level conditions aesthetic tastes world-wide, so too local valorization conditions local responses that are more or less submissive, depending on the extent to which international values are parroted. Now it is here, locally, that one can strike a breach in a system which excludes any valorization but its own.

A great number of initiatives can be suggested and even demanded, above all with public funds, to realize a different cultural policy. This can be achieved by means of a wide confrontation that will contribute multiple values and make possible new bases for artistic creation.

Creation, like all aspects of societal life, must be the concern of all people and should not be delegated to a small group. This applies both to the artistic and social values of creation and to their assimilation in society.

In the countries within the capitalist system, we have to smash the legendary individualism of artists, so that they, as a group, may reflect on their social system, on the system of creation, valorization, and diffusion, and on the social function of their work. In this way they will have a collective influence on their own milieu and will be able to denounce the arbitrary factors ruling it. They will be able to act in order to transform the cultural system by joining forces with progressive groups in other fields and coordinating their efforts towards achieving change.

Thus, in such current phenomena as exhibits, government buying of art works, public commissions, national selections, official exhibits, etc., one may demand a direct participation by artists, critics, art specialists, officials, and the general public through a system of multiple selections and valorizations by means of constant confrontation. This would lead to a steady exchange of opinions and constructive criticism: a true dialogue. Ultimately, there would be new bases for appreciating art, with shared responsibility, creating new relations among all people interested in art. As a result, the creative act would extend to new forms and to more popular levels of society.

The first step would be to think of the viewer not as caged in his present passive, dependent, and unimportant role, not even as living in a reality that must be transformed; but as a spectator capable of observing, reflecting, comparing, having an opinion, acting a social being like any other, able to establish his own criteria, to grasp problems, and to offer solutions.

This is how to lay the foundation of Latin American identity. Such identity cannot be decreed by governments or universities or even by revolutionary avant-gardes. Latin American cultural identity is a present and future task, and must be the concern of all Latin Americans to the extent that their enormous creative capacities can be freely developed and not destroyed by atrocious dictatorships or imperialist oppression. This cultural identity exists tacitly and encompasses everything that helps to keep alive popular aspirations towards a new kind of life in our Latin America.

In finishing my discussion, I would like to point out several concrete measures for reaffirming and increasing everything that has been done and is still being done every day in the plastic arts in order to establish solidarity with everything that is authentically Latin American and with Latin America's struggles. These things include:
— multiple positions taken against social injustice; support of humanitarian causes; defense of human and national rights; solidarity with just popular aspirations;
— precise attitudes towards the arbitrary elements in our cultural environment; precise efforts towards changing the system that rules the functioning of the plastic arts;
— the use of professional abilities in the service of specific causes relating to popular struggles;
— serious investigative and creative efforts within the parameters of the plastic arts;
— open positions on interdisciplinary and collective work tied to social reality.

To conclude, I would like to make a more concrete suggestion regarding the House of the Americas, which I believe would aim at creating a broad Latin American front of intellectuals and artists.

The House of the Americas has been and still is the center of an effervescent cultural activity, a meeting place, a site of exchanges and achievements that has been giving a new physiognomy to Latin American cultural activities. The value and importance of this new physiognomy for creative Latin Americans and the diffusion of their works are immeasurable.

Many of us would be happy to see numerous Houses of the Americas developing on our continent and even in Europe. They would be an ideal method of spreading Latin American creativity. They would intensively enrich mutual knowledge of what is happening in the various Latin American countries, and they would bring about greater confrontation between different creative aspects and Europe, allowing the development of the necessary interrelationship with all living European culture...

# Group Exhibitions

## Japan, The 1950's
Tokyo Metropolitan Museum of Art, Tokyo, September 12 -
November 8, 1981

Nobuya Abé, Masanori Aï, Aïó, Hiroshi Akana, Saori Akutagawa,
Setsu Asakura, Jiró Asazuma, Saburō Asō, Yutaka Bito, Yan Gyu-
Cho, Hisao Domoto, Eïkyu, Hiroshi Fujimatsu, Akiko Fujita, Hideko
Fukushima, Timeï Hamada, Nankoku Hidaï, Masakazu Horiuchi,
Yoshikuni Iida, Masuo Ikeda, Tatsuo Ikeda, Toshimitsu Imaï, Bukishi
Inoue, Tchōsaburō Inoue, Shigéo Ishii, Shigéru Izumi, Akira
Kanayama, Mitsuo Kano, Tadashi Kato, Hiroshi Katuragawa, Minoru
Kawabata, On Kawara, Yasuo Kazuki, Kentarō Kimura, Shozo
Kitadaï, Tetsurô Komaï, Jōsaku Maeda, Iri Maruki, Makoto Mikami,
Bushiro Mōri, Takashigé Mori, Yoshio Mori, Sadamasa Motonaga,
Ryōkichi Mukaï, Masanari Muraï, Saburo Murakami, Hiroshi
Nakamura, Tatsuoki Nanbata, Taro Okamoto, Toshinobu Onosato,
Yoshishigé Saïto, Shōzô Shimamoto, Morio Shinoda, Kazuo Shiraga,
Masaki Suematsu, Tadashi Sugimata, Yasukazu Tabuchi, Atsuko
Tanaka, Kakuzo Tatehata, Kojin Toneyama, Shindo Tsuji, Masao
Tsuruoka, Shigéru Ueki, Hideko Urushibara, Kazuo Yagi, Kaoru
Yamaguchi, Katsuhiro Yamaguchi, Takéo Yamaguchi, Haruo
Yamanaka, Kikuji Yamashita, Misao Yokoyama, Tashio Yoshida,
Tadashi Yoshii, Jiro Yoshihara, Michio Yoshihara, Taïzo Yoshinaka.

*Catalogue,* with text by Yasuhiro Yurugi, 118 pages, illus.
Tokyo Metropolitan Art Museum.

## The 1960's : A Decade of Change in Contemporary Japanese Art
The National Museum of Modern Art, Tokyo, December 4, 1981 -
January 31, 1982
The National Museum of Modern Art, Kyoto, February 10 - March 14,
1982

Ai-ō, Gempei Akasegawa, Shūsaku Arakawa, Kenjirō Azuma, Akira
Baba, Hisao Dōmoto, Shū Eguchi, Hiroshi Fujimatsu, Michio
Fukuoka, Hideo Hagiwara, Kei Hiraga, Masakazu Horiuti, Masuo
Ikeda, Tatsuo Ikeda, Toshimitsu Imai, Yukihisa Isobe, Takayasu Itō,
Mitsuo Kanō, Yuki Katsura, Tatsuo Kawaguchi, Mokuma Kikuhata,
Kentarō Kimura, Nobuaki Kojima, Tetsumi Kudō, Yayoi Kusama,
Tadaaki Kuwayama, Jōsaku Maeda, Tomio Miki, Aiko Miyawaki,
Hisayuki Mogami, Sadamasa Motonaga, Ryōkichi Mukai, Saburō
Muraoka, Masanari Murai, Masayuki Nagare, Hiroshi Nakamura,
Natsuyuki Nakanishi, Tatsuoki Nambata, Minoru Niizuma, Jō Oda,
Shinjiro Okamotō, Tadahiro Ono, Toshinobu Onosato, Yoshishige
Saïtō, Nobuo Sekine, Yoshio Sekine, Morio Shinoda, Yoshio
Shinohara, Kazuo Shiraga, Kumi Sugai, Tadashi Sugimata, Yasukazu
Tabuchi, Minami Tada, Jirō Takamatsu, Atsuko Tanaka, Shintarō
Tanaka, Kakuzō Tatehata, Shindō Tsuji, Waichi Tsutaka, Tomonori
Toyofuku, Keiji Usami, Masaaki Yamada, Katsuhiro Yamaguchi,
Takeo Yamaguchi, Kikuji Yamashita, Tadanori Yokoo, Jirō Yoshihara,
Hideo Yoshihara, Masunobu Yoshimura, Taizō Yoshinaka, Kazuo
Yuhara, Isamu Wakabayashi.

*Catalogue,* texts by Kenji Adachi, Michiaki Kawakita and Tamon Miki,
224 pages, illus.
The National Museum of Modern Art, Tokyo.

## Aspects of British Art Today
Tokyo Metropolitan Art Museum, February 27 - April 11, 1982
Tochigi Prefectural Museum of Fine Arts, Utsunomiya, April 24 - May
30, 1982
The National Museum of Art, Osaka, June 12 - July 25, 1982
Fukuoka Art Museum, August 7 - August 29, 1982
Hokkaido Museum of Modern Art, September 9 - October 9, 1982

Roger Ackling, Art and Language, Franck Auerbach, Adrian Berg,
Mark Boyle, Anthony Caro, Patrick Caulfield, Tony Cragg, Michael
Craig-Martin, John Davies, Braco Dimitrijević, John Edwards, Barry
Flanagan, Lucian Freud, Hamish Fulton, Gilbert & George, Alan
Green, Anthony Green, Nigel Hall, John Hilliard, David Hockney,
Howard Hodgkin, John Hoyland, Phillip King, Bob Law, Richard Long,
Bruce McLean, Kenneth Martin, Keith Milow, David Nash, Paul
Neagu, Bridget Riley, John Walker.

*Catalogue,* with texts by David Brown, John Burgh and Kenjiro
Okamoto, 208 pages, illus.
The Bureau for the Exhibition, British Council and Tokyo Metropolitan
Art Museum.

## Revolutionary Figurations : From Cezanne to the Present
Commemoration of Thirtieth Anniversary of Bridgestone Museum

Bridgestone Museum, Tokyo, April 18 - May 16, 1982

Gilles Aillaud, Eduardo Arroyo, Balthus, Gianfranco Baruchello, Pierre
Bonnard, Christian Bouillé, Georges Braque, Paul Cézanne, Jean-Paul
Chambas, Christo, Leonardo Cremonini, Dado, Salvador Dali, Giorgio
De Chirico, Robert Delaunay, André Derain, Jean Dubuffet, Marcel
Duchamp, Raoul Dufy, Max Ernst, Erró, Lucio Fanti, Louis Fernandez,
Tsugouharu Foujita, Gérard Fromanger, Alberto Giacometti, Francis
Gruber, Jean Hélion, Jean-Olivier Hucleux, Peter Klasen, Fernand
Léger, Albert Marquet, Titina Maselli, André Masson, Henri Matisse,
Roberto Matta, Henri Michaux, Joan Miró, Aldo Mondino, Claude
Monet, Jacques Monory, Pablo Picasso, Edouard Pignon, Daniel
Pommereulle, Man Ray, Martial Raysse, Bernard Réquichot, Antonio
Recalcati, Georges Rouault, Henri Rousseau, Gérard Schlosser, Paul
Signac, Chaïm Soutine, Nicolas de Staël, Pierre Tal-Coat, Yves
Tanguy, Antoni Taulé, Hervé Télémaque, Maurice Utrillo, Jacques
Villon.

*Catalogue,* with texts by Alain Jouffroy, Ichiro Hariu and Makoto
Ohoka, 120 pages, illus.
Bridgestone Museum, Ishibashi Foundation, Tokyo.

## Japan '70, Exhibition of Contemporary Japanese Art ;
## Tendencies in Japanese Art of the 1970s
Gallery of the Institute for Cultural and Artistic Development, Seoùl,
November 6 - November 23, 1981

Ay-o, Kōji Enokura, Michio Fukuoka, Takeshi Hara, Noriyuki
Haraguchi, Naoyoshi Hikosaka, Yoshikumi Iida, Shōichi Ida, Kenji
Inumaki, Takamichi Itō, Kōshō Itō, Shin Kamiya, Mitsuo Kanō,
Kyūbei Kiyomizu, Tatso Kawaguchi, Susumu Koshimizu, Akira
Kurosaki, Tadaaki Kuwayama, Masabumi Maita, Joōsaku Maeda,
Akira Matsumoto, Kōzō Mio, Hisayuki Mogami, Sadamasa
Motonaga, Tomoharu Murakami, Natsuyuki Nakanishi, Tetsuya
Noda, Ü-Fan Ri, Satoshi Saitō, Yoshishige Saitō, Nobuo Sekine,
Kuniichi Shima, Susumu Shingū, Kishio Suga, Kumi Sugai, Minami
Tada, Shū Takahashi, Jirō Takamatsu, Isao Tanaka, Toeko Tatsuno,
Kaoru Ueda, Keiji Usami, Isamu Wakabayashi, Makio Yamaguchi.
Takeo Yamaguchi, Katsurō Yoshida.

*Catalogue,* with text by Yusuké Nakahara, 108 pages, illus.
The Japan Foundation 1981.

## 11 Artists 11 Critics
Gallery of Seoul, January 16 - February 12, 1982

Kim Kyung-In, Kim Yong-Min, Kim Jang-Sup, Kim Jung-Heon, Kim
Tae-Ho, No Jue-Seong, Sim Jeong-Soo, Lee Chung-Woon, Lim Ok-
Sang, Jeong Kyong-Yon, Choi Wook-Kyong.

*Catalogue,* 28 pages, illus.
Gallery of Seoul.

## EKO
Moderna Museet, Stockholm, March 20 - May 2, 1982

Lars Englund, Bernard Kirschenbaum, Kjell Ohlin.

## Materia/Minne
Lunds Konsthall, Lund, Sweden ; Kunstnerenes Hus, Oslo, Norway ;
Bjorneborg Museum, Bjorneborg, Finland ; Konstnarsgillet, Helsinki,
Finland ; Charlottenborg, Copenhagen, Denmark

Bård Breivik, Jan Håfström, Anders Knutsson.

*Materia/Minne Matter/Memory,* Book published in conjunction with
the exhibition, with texts by Douglas Feuk, Bo Nilsson, Lars Nittve,
and Cecilia Nelson ; 96 pages, illus.
Production Matter/Memory.

## '60'80 attitudes/concepts/images
Stedelijk Museum, Amsterdam, April 9 - July 11, 1982

Vito Acconci, Bas Jan Ader, Laurie Anderson, Carl Andre, Ben
d'Armagnac, Arman, Armando, Francis Bacon, Georg Baselitz,
Joseph Beuys, Christian Boltanski, Marcel Broodthaers, Stanley
Brouwn, Daniel Buren, John Cage, Elliott Carter, Sandro Chia,
Christo, Constant, Enzo Cucchi, Merce Cunningham, René Daniels,
Hanne Darboven, Ad Dekkers, Jan Dibbets, Jim Dine, Jean Dubuffet,

Ger van Elk, Brian Eno, Luciano Fabro, Lucio Fontana, Simone Forti, Gilbert George, Dan Graham, Pauline de Groot, Sigurdur Gudmundsson, Hans Haacke, Richard Hamilton, Anton Heyboer, David Hockney, Hans van Hoek, Nan Hoover, Neil Jenney, Jasper Johns, Joan Jonas, On Kawara, Ellsworth Kelly, Anselm Kiefer, Edward Kienholz, Yves Klein, Willem de Kooning, Joseph Kosuth, Jannis Kounellis, Sol LeWitt, Roy Lichtenstein, Richard Long, Lucassen, Lucebert, Piero Manzoni, Brice Marden, Agnes Martin, Gordon Matta-Clark, Mario Merz, Pieter Laurens Mol, Meredith Monk, François Morellet, Robert Morris, Musica Elettronica Viva MEV, Bruce Nauman, Barnett Newman, Claes Oldenburg, Dennis Oppenheim, Nam June Paik, Charlemagne Palestine, Giulio Paolini, Giuseppe Penone, Markus Raetz, Yvonne Rainer, Robert Rauschenberg, Roger Raveel, Martial Raysse, Gerhard Richter, Ulrike Rosenbach, Dieter Roth, Ulrich Rückriem, Edward Ruscha, Robert Ryman, Wim T. Schippers, Julian Schnabel, Jan Schoonhoven, Richard Serra, Paul Sharits, Barbara Smith, Michael Snow, Jesus Raphael Soto, Daniel Spoerri, Frank Stella, Jean Tinguely, David Tudor, Richard Tuttle, Günther Uecker, Frances-Marie Uitti, Ulay/Marina Abramović, Ben Vautier, Emo Verkerk, Bill Viola, Carel Visser, André Volten, Andy Warhol, Lawrence Weiner, Co Westerik, Robert Whitman.

*Catalogue,* with texts by Wim Beeren, Cor Blok, Antje van Graevenitz, Ad Petersen, Gijs van Tuyl, George Weissman, Edy de Wilde ; 252 pages, illus.
Stedelijk Museum Amsterdam/Van Gennep Amsterdam.

---

**Beuys, Rauschenberg, Twombly, Warhol: Sammlung Marx**
Nationalgalerie Berlin, Staatliche Museen Preussischer Kulturbesitz, March 2 - April 12, 1982
Städtisches Museum Abteiberg, Mönchengladbach, May 6 - September 30, 1982

Joseph Beuys, Robert Rauschenberg, Cy Twombly, Andy Warhol.

*Catalogue,* texts by Heiner Bastian, Dieter Honisch, Erich Marx, 256 pages, illus.
Prestel-Verlag München and Heiner Bastian, Berlin.

---

**Documenta 7**
Museum Fridericianum, Orangerie, Neue Galerie, Karlsaue, Kassel, June 19 - September 28, 1982

Marina Abramovic/Ulay, Vito Acconci, Anatol, Carl Andre, Giovanni Anselmo, Siegfried Anzinger, Siah Armajani, Armando, Art & Language, Richard Artschwager, Michael Asher, Elvira Bach, Marco Bagnoli, Gerrit van Bakel, John Baldessari, Miquel Barcelo, Robert Barry, Georg Baselitz, Jean-Michel Basquiat, Lothar Baumgarten, Bernd & Hilla Becher, Joseph Beuys, James Biederman, Dara Birnbaum, Alighiero Boetti, Jonathan Borofsky, Troy Brauntuch, Marcel Broodthaers, Stanley Brouwn, Günther Brus, Daniel Buren, Alberto Burri, Scott Burton, Michael Buthe, James Lee Byars, Miriam Cahn, Loren Calaway, John Chamberlain, Alan Charlton, Sandro Chia, Abraham David Christian, Francesco Clemente, William Copley, Tony Cragg, Enzo Cucchi, Walter Dahn, René Daniels, Hanne Darboven, Jan Dibbets, Martin Disler, Jirí Georg Dokoupil, Gino de Dominicis, Felix Droese, Marlene Dumas, Edward Dwurnik, Ger van Elk, Luciano Fabro, Stanislaw Filko, Barry Flanagan, Hamish Fulton, General Idea, Isa Genzken, Ludger Gerdes, Gilbert & George, Jack Goldstein, Ludwig Gosewitz, Dan Graham, Erwin Gross, Hans Haacke, Keith Haring, Frank van Hemert, JCJ van der Heyden, Albert Hien, Antonius Höckelmann, Hans van Hoek, Jenny Holzer, Rebecca Horn, Jörg Immendorff, Joan Jonas, Donald Judd, On Kawara, Anselm Kiefer, Per Kirkeby, Pierre Klossowski, John Knight, Imi Knoebel, Joseph Kosuth, Jannis Kounellis, Barbara Kruger, Wolfgang Laib, Maria Lassing, Bertrand Lavier, Bernhard Leitner, Barry Le Va, Sherrie Levine, Sol LeWitt, Christian Lindow, Guido Lippens, Richard Paul Lohse, Richard Long, Robert Longo, Markus Lüpertz, Luigi Mainolfi, Robert Mangold, Robert Mapplethorpe, Nicola de Maria, Carlo Maria Mariani, Stephen McKenna, Bruce McLean, Gerhard Merz, Mario Merz, Marisa Merz, Klaus Mettig, Matt Mullican, Bruce Nauman, Hermann Nitsch, John Nixon, Maria Nordman, Oswald Oberhuber, Claes Oldenburg, Meret Oppenheim, Eric Orr, Mimmo Paldino, Brett de Palma, Guilio Paolini, A.R. Penck, Giuseppe Penone, Michelangelo Pistoletto, Sigmar Polke, Norbert Prangenberg, Lee Quiñones, David Rabinowitch, Markus Raetz, Arnulf Rainer, Roland Reiss, Gerhard Richter, Judy Rifka, Martha Rosler, Ulrich Rückriem, Edward Ruscha, Claude Rutault, Reiner Ruthenbeck, Robert Ryman, David Salle, Salomé, Sarkis, Juliao Sarmento, Remo Salvadori, Klaudia Schifferle, Barbara Schmidt-Heins, Gabriele Schmidt-Heins, Jean-Frédéric Schnyder, Horst Schuler, Richard Serra, Joel Shapiro, Cindy Sherman, Katharina Sieverding, Ettore Spalletti, Klaus Staeck, P. Struycken, Volker Tannert, Signe Theill, Imants Tillers, Niele Toroni, Richard Tuttle, Cy

Twombly, Emilio Vedova, Toon Verhoef, Jean-Luc Vilmouth, Antonio Violetta, Jeff Wall, Franz Erhard Walther, Andy Warhol, Isolde Wawrin, Boyd Webb, Lawrence Weiner, Ian Wilson, Rémy Zaugg, Michele Zaza.

*Catalogue,* with texts by J.L. Borges, Saskia Bos, Coosje van Bruggen, Germano Celant, Hans Eichel, T.S. Eliot, R.H. Fuchs, Johannes Gachnang, J.W. von Goethe, F. Hölderlin, Walter Nikkels, Gerhard Storck ; 2 volumes, 480 pages and 427 pages, illus.
D + V Paul Dierichs GmbH & Co KG, Kassel.

**K 18-Stoffwechsel**
Hall K 18, International Art Exhibition, Kassel, June 20 - September 29, 1982

Frederic Amat, Elsbeth Arlt, Hamdi el Attar, Georges Badin, Ursula Bauer, Bergmann/Lorbeer, Silvia Breitwieser, Josef Bücheler, Linda Christanell, Waltraud Cooper, Wolfgang Denk, Georg Dietzler, Edith van Driessche, Wincenty Dunikowski, Veerle Dupont, Lillian Elliott/Patricia Hickmann, En Avant Comme Avant, Renate Faulhaber, Thomas Fischer, Wil Frenken, Mathias Frey, Peter Gilles, Akio Hamatani, Werner Hartmann, Norbert Hinterberger, Horst Hohheisel, Katherine Howe, Hansi Hubmer, Kazuo Katase, Csilla Kelecsényi, Ulrich Klieber, Wolfgang Kliege, Saimi Kling, Reiko Kurosu, Vollrad Kutscher, Marie-Jo Lafontaine, Theo Lenders, Franca Maranó, Sachiko Marino, Gilbert Mazliah, Dorothé Momm, E.R. Nele, John Newton, Susan Nininger, Rolf Nolden, Koichi Ono, Irene Peschik, Maria Pininska-Beres, Karl Plotzke, Jane Reichhold, Peter Reuter, Raffael Rheinsberg, Burkhardt Rokahr, Maria-Ilona Ruegg, Ann Savageau, Deidi von Schaewen, Roland Schmitt, Harald Schmitz, Petra Lydia Schmorl, Volker Schreiner, Cindy Snodgras, Keiko Takegaki, Friedrich Teepe, Ilse Teipelke, Kawashima T. Tsutsumi, Syb Velink, Peter John Voormeij, Ilse Wegmann-Hacker, Mario Yagi.

*Catalogue,* with texts by Hamdi el Attar, G. Bussmann, Heinz Thiel ; 312 pages, illus. Projektgruppe Textilforum/Ghk, Kassel.

---

**Ten Young German Artist**
Museum Folkwang, Essen, February 5 - March 21, 1982

Hans Peter Adamski, Peter Bömmels, Walter Dahn, Georg Dokoupil, Rainer Fetting, Gerard Kever, Milan Kunc, Helmut Middendorf, Gerhard Naschberger, Salomé.

*Catalogue,* text by Zdenek Felix, 128 pages, illus.
Museum Folkwang Essen.

---

**Aspects of Soviet Art**
Kölnischer Stadtmuseum, Cologne, July 6 - September 5, 1982
Neue Galerie-Sammlung Ludwig, Aachen, July 3 - August 29, 1982

*Painting :* Andronow, Arschakuri, Baschbeuk-Melikowa, Bragowsky, Brajnin, Bulgakowa, Dementiew, Filatschew, Grube, Gudajtis, Iltner, Iwanow, Jegoschijn, Jegorschina, Kalinin, Kryschewsky, Lednew, Lubennikow, Mylnikow, Narimanbekow, Nazarenko, Neledwa, Nesterowa, Nikitsch-Krilitschewsky, Nikonow, Nischaradzte, Obrosow, Ossipow, Ossowski, Papikjan, Petrow, I.A. Popow, Romadin, Salachow, Sawitzkas, Schilinskij, Sidnikow, Silins, Skulme, Sowlatschkow, Starschenitzkaja, Stoschanow, Subbi, Swemp, Swerkow, Tscheponis, Tkatschew, Tuljenew, Tutunow, Tyschler, Wetzosoltz, Wolkow, Wukolow, Zarinsch, Zipljauskas.
*Sculpture :* Baranow, Sawranska, Schilinskaja, Tschernow.
*Drawings :* Abramowa, Achunow, Alymow, Atlanow, Batschurin, Bejsembinowa, Bisti, Blagowolin, Bolschakowa, Borodin, Demko, Eelma, Fejdin, Gretschina, Golitzyn, Helmuts, Katarow, Kjutt, Konstantinow, Kuzminskis, Leonow, Majofis, Makarewitsch, Martschenko, Moltschanowa, Morozawa, Pimenow, Poplawski, N.J. Popow, Podzniakowa, Prokofiew, Puustak, Romadin, Schejnes, Sidorkin, Skirutite, Slepytschew, Schmochin, Stantschikaitje, Suworow, Tolli, Tulin, Utenkow, Vinn, Wilner, Wint, Wolowitsch, Zacharow, Zigal, Zirulis.

*Catalogue,* with texts by Wolfgang Becker, Hugo Borger, Karl Ruhrberg ; 180 pages, illus.
Museum Ludwig, Köln & Neue Galerie-Sammlung Ludwig, Aachen.

---

**Feeling and Hardness : New Art from Berlin**
Kulturhuset, Stockholm
Kunstverein, Munich, October 8 - November 14, 1982

Dieter Appelt, Peter Chevalier, Frank Dornseif, Rainer Fetting, G.L. Gabriel, Barbara Heinisch, ter Hell, Anne Jud, Andreas Kaps, Thomas Lange, Elke Lixfeld, Rainer Mang, Helmut Middendorf, Reinhard Pods, Gerd Rohling, Martin Rosz, Heike Ruschmeyer, Salomé, Hella Santarossa, Bernd Zimmer.

*Catalogue,* with texts by Richard Anders, Staffan Gunnarson, Ursula Prinz, Wolfgang Jean Stock, and individual texts on each artist ; 122 pages, illus.
Kunsteverein München, Frölich & Kaufmann, Berlin.

---

**Zeitgeist, International Art Exhibition Berlin 1982**
Martin-Gropius-Bau, Berlin, October 16, 1982 - Juanuary 16, 1983

Siegfried Anziger, Georg Baselitz, Joseph Beuys, Erwin Bohatsch, Peter Bömmels, Jonathan Borofsky, Werner Büttner, James Lee Byars, Pierpaolo Calzolari, Sandro Chia, Francesco Clemente, Enzo Cucchi, Walter Dahn, René Daniels, Jiři Georg Dokoupil, Rainer Fetting, Barry Flanagan, Gérard Garouste, Gilbert & George, Dieter Hacker, Antonius Höckelmann, K.H. Hödicke, Jörg Immendorff, Anselm Kiefer, Per Kirkeby, Bernd Koberling, Jannis Kounellis, Christopher Lebrun, Markus Lüpertz, Bruce McLean, Mario Merz, Helmut Middendorf, Malcolm Morley, Robert Morris, Mimmo Paladino, A.R. Penck, Sigmar Polke, Susan Rothenberg, David Salle, Salomé, Julian Schnabel, Frank Stella, Volker Tannert, Cy Twombly, Andy Warhol.

*Catalogue,* wiht texts by Walter Bachauer, Thomas Bernhard, Karl-Heinz Bohrer, Paul Feyerabend, Christos M. Joachimides, Hilton Kramer, Vittorio Magnago Lampugnani, Robert Rosenblum, Norman Rosenthal ; 296 pages, illus.
Kunstbuch Berlin Verlagsgesellschaft mbH, Frölich & Kaufmann, Berlin.

---

**Paris 1960-1980, Panorama of Contemporary Art in France**
Museum des 20. Jahrhunderts, Vienna, May 14 - July 25, 1982

*New Abstraction :* Jean Degottex, Simon Hantaï, Jean-Pierre Pincemin, François Rouan, Claude Viallat.
*New Figuration :* Valerio Adami, Gilles Aillaud, Eduardo Arroyo, Erró, Jean Hélion, Martial Raysse.
*Conceptual :* Christian Boltanski, Marcel Duchamp, Paul-Armand Gette, Jean Le Gac, Anne and Patrick Poirier.
*New Subjectivity :* Avigdor Arikha, Balthus, François Barbâtre, Alberto Giacometti, Raymond Mason, Zoran Musič, Sam Szafran.
*Neo Romanticism :* Gérard Barthélémy, Olivier O. Olivier, Joerg Ortner, Yvan Theimer.

*Catalogue,* with texts by Jean Clair, Wolfgang Drechsler, Dieter Ronte, Eliane Wauquiez, Helmut Zilk ; 172 pages, illus.
Wien Kultur, Wien.

---

**New Sculpture**
Galerie nächst St. Stephan, Vienna, June 3 - July 17, 1982

Robert Adrian, John Ahearn, Siegfried Anzinger, Peter Bömmels, Michael Buthe, Deborah Butterfield, Marc Camille Chaimowicz, Tony Cragg, Jiri Georg Dokoupil, Marianne Eigenheer, Olivia Etter, Peter Fischli/David Weiss, Isa Genzken, Jörg Immendorff, Bertrand Lavier, Renato Maestri, Oswald Oberhuber, C.O. Paeffgen, Mimmo Paladino, Hannes Priesch, Hubert Schmalix, Thomas Stimm, Lois Weinberger, Franz West, Bill Woodrow, Erwin Wurm.

*Catalogue,* G.R. Denson, Helmut Draxler, Patrick Frey, Michael Newman, 64 pages, illus.
Galerie nächst St. Stephan, Wien.

---

**Object Lessons/Sachkunde**
Kunsthalle Bern, Bern, June 9 - July 25, 1982
Musée Savoisien, Chambéry, August 8 - September 27, 1982

Tony Cragg, Gloria Friedmann, Alexandre Gherban, Bertrand Lavier, Patrick Saytour, Jean-Luc Vilmouth, William Woodrow.

*Catalogue,* with text by Jean-Hubert Martin ; interviews with the artists by Jean-Hubert Martin and Catherine Ferbos, 148 pages, illus.
Kunsthalle Bern.

---

**Carlos Figueira, Federico Winkler, Matthias Aeberli, Josef Felix Müller, Anna Winteler, Jürg Stäuble**
Kunsthalle Basel, Basel, January 24 - February 28, 1982

*Catalogue,* with text by Jean-Christophe Amman and individual texts on each artist ; 124 pages, illus.
Basler Kunstverein.

---

**Young Art from the Netherlands : Form und/and Expression**
Sonderschau Kunstmesse Basel -ART13'82, June 15 - July 21, 1982

Ansuya Blom, Jan Commandeur, René Daniels, Marlene Dumas, Kees de Goede, John van't Slot, Kees Smits, Emo Verkerk, Henk Visch, Henk van Woerden.

*Catalogue,* texts by Will Hoogstraate and Gijs van Tuyl, 52 pages, illus.
Bureau Beeldende Kunst Buitenland, Ministerie voor Cultuur, Recreatie en Maatschappelijk werk, Amsterdam.

---

**Videoart : Third International Festival of Video Art**
Projections/Installations/Work shops/Seminars on Video Art
Locarno-Ascona
Projections : Studio Facs, Locarno ; Teatro Materno, Ascona.
Exhibitions of Swiss installations : Museo Comunale, Ascona.

*In competition :*
Marie André, Jacques Charlier, Shirley Clarke, Radomir Damnjan, Wolfgang Flatz, Daizaburo Harada, Claus Holtz, E.P.S. Huayco, Mako Idemitsu, Richard Layzell, Hartmut Lech, Teodoro Maus, Nesa Paripovic, Servaas, Michael Smith, Moniek Toebosch, Edin Velez, Bill Viola, Klaus vom Bruch, Rodney Werden, V.A. Wölf, Paul Wong.
*Not in competition :*
Groupe Frigo de Lyon, Groupe de Belgrade, Gruppo di Locarno, Nam June Paik, Gerald Minkoff, Muriel Olesen, Videoteca Giaccari...

---

**The Pictorial Wish : The Aftermath of Contemporary Belgian Painting**
Het Picturaal Verlangen, mogelijkheden van een actuele belgische schilderkunst
Galerie Isy Brachot, Brussels, June 3 - September 4, 1982

Fred Bervoets, Jan Burssens, Robert Clicque, Jan Cox, Serge De Backer, Stefan De Jaeger, Dirk De Vos, Karel Dierickx, Hugo Duchateau, Etienne Elias, Jérôme Fonchain, Walter Goossens, Sigefride Hautman, Sara Kaliski, Pierre Lahaut, Mark Luyten, René Magritte, Albert Pepermans, Roger Raveel, Pjeroo Roobjee, Walter Swennen, Narcisse Tordoir, Thé Van Bergen, Philippe Vandenberghe, Fik Van Gestel, Siegfried Van Malderen, Jan Van Riet, Luk Van Soom, Carlo Verbist, Patrick Verelst.

*Catalogue,* texts by Florent Bex and Wim Van Mulders, 48 pages, illus.
Galerie Isy Brachot, Bruxelles.

---

**The Magic of the Image**
Palais des Beaux-Arts, Brussels, June 3 - July 4, 1982

Jacques Charlier, Jérôme Fonchain, Michel François, Sigefride Hautman, Mark Luyten, Albert Pepermans, Walter Swennen, Narcisse Tordoir, Philippe Vandenberghe, Siegfried Van Malderen, Carlo Verbist.

*Catalogue,* with texts by Florent Bex ; 64 pages, illus.
Vereniging voor Tentoonstellingen van het Paleis voor Schone Kunsten, Brussel/Société des Expositions du Palais des Beaux-Arts, Bruxelles.

---

**Ateliers 81/82**
ARC, Musée d'Art Moderne de la Ville de Paris, November 27, 1981 - January 3, 1982 (Part 1) and January 14 - February 21, 1982 (Part 2)

Jean-Michel Alberola, Tjeerd Alkema, François Boisrond, François Bouillon, Bertrand Canard, Thierry Cheverney, Alain Clément, Robert Combas, Noël Cuin, Hervé Di Rosa, Pascal Doron, En Avant Comme Avant, Philippe Favier, Nicolas Fédorenko, Alain Fleischer, Jean-Pierre Giard, Jaffrenou-Bousquet, Atelier Jeanclos-École Nationale Supérieure des Beaux-Arts, Patrick Lanneau, André Léocat, Francis Limérat, Gudrun Von Maltzan, Richard Monnier, Pierre Nivollet, Edouard Nono, Christiane Parodi, Gaston Planet, Patrick Plantié, Jean-Luc Poivret, Raquel, Pierre Savatier, Christian Sindou, Vladimir Skoda, Otto Teichert, Gérald Thupinier, Daniel Tremblay, Jacques Vieille, Section vidéo.

*Catalogue,* with texts by Suzanne Pagé and individual texts on each artists 152 pages, illus.
Musée d'Art Moderne de la Ville de Paris.

---

**L'air du Temps, Free Figuration in France**
Galerie d'Art Contemporain des Musées de Nice, February 27 - April 11, 1982

Jean-Michel Alberola, Jean-Charles Blais, Rémy Blanchard, François Boisrond, Denis Castellas, Robert Combas, Raymond Denis, Hervé

Di-Rosa, En Avant Comme Avant, Philippe Favier, Jacqueline Gainon, Jean-Pierre Giard, Denis Laget, Patrick Lanneau, Georges Rousse.

*Catalogue,* with texts by Claude Fournet, Xavier Girard, Otto Hahn, Bernard Lamarche-Vadel/Kimitaké Isozaki, Marc Sanchez, Ben Vautier/Andy Warhol. Press clippings and diverse texts ; 60 pages, illus. Direction des Musées de Nice.

## Walls in France
Albi, Angoulême, Antony, Bordeaux, Boulogne-sur-mer, Chambéry, Dreux, Grenoble, Hyères, Limoges, Le Mans, Montbéliard, Rennes

Eduardo Arroyo, Christian Bouillé, Jean-Paul Chambas, Henri Cueco, Erró, Lucio Fanti, Gérard Fromanger, Gilles Mahé, Annette Messager, Ernest Pignon-Ernest, Daniel Pommereulle, Antonio Segui, Hervé Télémaque.

*Catalogue,* with texts by Gilles de Bure, Jack Lang, and individual texts on each artist ; 32 pages, illus.
Association pour le Développement de l'Environnement Artistique.

## Paris Biennale
Musée d'Art Moderne de la Ville de Paris, October 2 - November 14, 1982

### Plastic Arts, Performance, Photo, Video

*Argentina :* Enesto Bertani, Carlos Eduardo Lennon, Daniel Merle, Jorge Ignacio Orta, Pablo Reinoso. *Australia :* John Lethbridge, Mandy Martin, Robert Randall & Frank Bendinelli, Kevin Sheehan. *Austria :* Alfred Klinkan, Brigitte Kowanz & Franz Graf, Peter Marquant. *Belgium :* Guillaume Bijl, Ludo Geysels, Frank van Herck, Alain Lambillotte, Serge Nicolas. *Bolivia :* Groupe « Tinkuy ». *Brazil :* Flavio Pons. *Canada :* David MacWilliam, John Scott, Caroline Simmons. *Chile :* Groupe C.A.D.A., groupe Crili, Carlos Leppe. *Cyprus :* Loizos Serghiou. *Colombia :* Antonio Barrera, Gustavo Vejarano, Beatriz Elena Vila. *South Korea :* Souk-Choul Ji, Sun Kim, Ki-Duk Son. *Cuba :* Flavio Garciandia Oraa, Gustavo Perez Monzon. *Denmark :* Berit Jensen, Kurt Borge Simonsen, Nina Sten-Knudsen, Hanne Lise Thomsen. *Spain :* Miquel Navarro, Luis Perez-Minguez, Carlos Pujol. Alberto Zush. *Finland :* Martii Aiha, Marja Kanervo, Leena Luostarinen, Olli Lyytikainen, Marika Makela. *France :* Jean-Baptiste Audat, William Betsch, Jean-Charles Blais, Jean-Charles Blanc, François Boué, Bénédicte Delesalle & Marie-Ange Poyet, Philippe Favier, Jean-Marc Ferrari, Groupe Frigo, Rolino Gaspari, Jean-Michel Gautreau, Patricia Hearn, Denis Laget, André Léocat, Claude Lévêque, Jean-Philippe Lhotellier, Élisabeth Mercier, Pierre Mercier, Michel Paysant, Oonagh Regan, Sophie Ristelhueber, Georges Rousse, Bruno Stevens, Philippe Suter, Groupe Zardec (ENSAD), Wonders Products Video. *Great Britain :* Stehen Farthing, Anish Kapoor, Bill Woodrow. *Greece :* Georges Lappas, Manolis Polymeris, Aris Prodromidis, Thanassis Totsikas, Christos Tzivelos, Xanthippos Vissios & Aris Giorgiou, Constantin Vrouvas & Nakis Tastsioglou, Nikos Zoumboulis & Titsa Grecou. *Hungary :* Ferenc Banga, El Kazovskij, Gabor Zaborszky. *Ireland :* Brian King, Eilis O'Connell, Anna O'Sullivan, Kathy Prendergast, Charles Tyrrel. *Iceland :* Magnus V. Gudlaugsson, Kristin Hardason, Steingrimur Kristmundsson, Thor Elis Palsson. *Israel :* Joshua Borkovsky, Maor Hayim, Ami Levi, Yudith Levin, Ilana Tencer. *Italy :* Gianni Dessi, Pietro Fortuna, Omar Galliani, Marcello Jori, Felice Levini, Luigi Mainolfi, Piero Manai. *Japan :* Mami Aoyama, Toyomi Hoshina, Yoshiro Negishi, Kenjiro Okazaki, Nobuo Yamanaka. *Luxembourg :* Andrée Staar. *Morocco :* Fouad Bellamine. *Mexico :* Carlos Aguirre, Oliveiro Hinojosa, Non-Groupe, Pablo Monasterio Ortiz, Pola Weiss. *Norway :* Johanne Marie Hansen-Krone, John Audun Hauge, Kjell Nupe, Johan Sandborg. *The Netherlands :* Christian Bastiaans, René van den Broek, Cécile Van der Heiden. *Péru :* J. Carlos Belon Lemoine, Franklin Guillen, Marcel Madueno, F. Moron-Campodonico. *Philippines :* Dindo Angeles, Johny Manahan, Nonon Padilla, Jun Yee. *Poland :* Marek Chlanda, Andrzej Paruzel, Janusz Polom, Jacek Siudzinski. *Portugal :* José Carvalho, Pinto Cerveiro, Sergio Pombo. *Dominican Républic :* Vitico Cabrera, José R. Garcia Cordero, Géo Ripley, Bismark Victoria. *East Germany :* Lutz Friedel, Johannes Heisig, Walter Libuda, Thomas Ziegler. *West Germany. :* Peter Chevalier, Stephan Dillemuth, Olivier Hirschbiegel, Hartmut Neumann, Marcel Odenbach, Frank Roda. *Rumania :* Sorin Dumitresco, Wanda Mihuleac. *Santa Lucia :* Winston Branch. *Sweden :* Göran Gidenstam, Kajsa Mattas, Jörgen Platzer. *Switzerland :* Jérôme Baratelli, groupe Dioptre, Emery Matteo, Véronique Mori. *Tunisia :* Khaled Ben Slimane, Lamine Sassi. *U.S.A. :* Peter Agostino, Anne-Marie Arnold, Bradley Bailey, Kevin Boyle, Joe Catanzarite, Cecilia Condit, Judith Corona, Pamela Ellenberger, Sean Elwood, Jon Fisher, Dwight Frizzel, Denis Joyce, Jack Kaminski, John Kessler, William Kocher, Bernd Kracke, Scott Miller & Scott Mehno, École de Paris/Pittsburgh/Lodz, Christy Phillips, Alex Roshuk, Charles Stanley, Herbert Wentscher, Ann-

Sargent Wooster. *Venezuela :* Carmelo Nino, Pancho Quilici, Yeni (Jennifer Hackshan) & Nan (Maria-Luisa Gonzales). *Yugoslavia :* groupe Alter Imago, Nina Ivancie, Jozé Slak, Studio Visuel.

### Sound and Voice

*Argentina :* Rodolpho Natale. *Belgium :* Lion Orchestra, *Denmark :* William Louis Soerensen. *Spain :* Llorenç Barber. *France :* Olivier Coupille, Berndt Deprez, François Duconseille, Catherine Lahourcade, Groupe Lucrate Milk, Annick Nozati, Jacqueline Ozanne, Franck Royon Le Mee, Marie-Berthe Servier, Martine Viard. *Great Britain :* Groupe Whirled Music. *Greece :* Maria Klonaris & Katerina Thomadaki. *Italy :* Simposio Differante, Vittore Baroni, Tony Rusconi. *Japan :* Mami Aoyama, Ushio Torikai. *New Zealand :* Group From Scratch. *The Netherlands :* Leigh Landy. *West Germany :* Group Neubaten Einsturzende, Group Butzmann Frieder, Christina Kubisch, Group Raskin-Stichting, Thomas Schulz, Groupe Die Todliche Doris. *Switzerland :* Group Espaces (Rainer Boesch). *U.S.A. :* Diamanda Gallas & Patrick Zvonar, Eugénie Kuffler.

*Catalogue,* with texts by Alain Avila, Jacques Louis Binet, Bernard Blistène, Dany Bloch, Georges Boudaille, Catherine Francblin, Carole Naggar, Jean-Marc Poinsot and numerous other texts, in particular those from different national commissioners, 384 pages, illus. Biennale de Paris.

## Avant-garde Trans-avant-garde 68-77
Mura Aureliane, Rome, April-July 1982

Carla Accardi, Vito Acconci, Carl Andre, Georg Baselitz, Jean-Michel Basquiat, Joseph Beuys, Alighiero e Boetti, Jonathan Borofsky, Daniel Buren, Pier Paolo Calzolari, Sandro Chia, Christo, Francesco Clemente, Enzo Cucchi, Nicola De Maria, Martin Disler, Luciano Fabro, Gilbert & George, Anselm Kiefer, Per Kirkeby, Joseph Kosuth, Jörg Immendorff, Sol Lewitt, Nino Longobardi, Markus Lüpertz, Mario Merz, Marisa Merz, Robert Morris, Dennis Oppenheim, Mimmo Paladino, Giulio Paolini, A.R. Penck, Vettor Pisani, Michelangelo Pistoletto, Sigmar Polke, Gerhard Richter, David Salle, Mario Schifano, Julian Schnabel, Frank Stella, Niele Toroni, Giulio Turcato, Cy Twombly, Ger van Elk, Emilio Vedova.

*Catalogue,* edited by Achille Bonito Oliva, with texts by Alberto Arbasino, Giulio Carlo Argan, Paolo Bertetto, Achille Bonito Oliva, Massimo Cacciari, Enrico Filippini, Ruggero Guarini, Alberto Moravia, Renato Nicolini, Beniamino Placido, Paolo Portoghesi, Anne-Marie Sauleau-Boetti, Pierluigi Severi, Gianni Vattimo ; 144 pages, illus. Gruppo Editoriale Electa, Milano.

## Biennale Venice : Visual Arts Section
Giardini di Castello, Scuola Grande di San Giovanni Evangelista, Cantieri Navali della Giudecca, Magazzini del Sale alle Zattere

### Hommage to Matisse. Homage to Schiele. Homage to Brâncuşi. Art as Art : The Work's Endurance :
Jean Amado, Jiří Anderle, Avigdor Arikha, Frank Auerbach, Ulrich Baehr, Floriano Bodini, Josè Luis Cuevas, Georg Eisler, Gianfranco Ferroni, Franco Francese, Lucien Freud, Antonio Lopez Garcia, Johannes Grützke, Piero Guccione, Robert Guinan, Alfred Hrdlicka, Horst Janssen, Jess, Tadeusz Kantor, Ronald Kitay, Evert Lundquist, Marwan, Raymond Mason, Anton Zoran Music, Ion Nicodim, Olivier O. Olivier, Irving Petlin, Richard Poussette D'Art, Martial Raysse, Jean-Paul Riopelle, Seymour Rosofsky, François Rouan, Guillermo Roux, Sam Szafran, Norbert Tadeusz, Antoni Tàpies, Yvan Theimer, Vito Tongiani, Raoul Ubac, Varlin, Co Westerik, Giuseppe Zigaina, Georg Eisler, Lucien Freud, Tadeusz Kantor, Ronald Kitay, Seymour Rosofsky. **National Pavillon.** *Argentina :* Marino Di Teana, Miguel Ocampo, Clorindo Testa. *Australia :* Peter Booth, Rosalie Gascoigne. *Austria :* Walter Pichler. *Belgium :* Jörs Madlener, Marthe Wéry. *Brazil :* Sergio de Camargo, José de Barros Carvalho e Mello (Tunga). *Canada :* Paterson Ewen. *China :* Papiers découpés. *Colombia :* Carlos Rojas, Hernando Tejada. *Cuba :* Raul Martinez Gonzales, Manuel Costellamos Lopez, Manuel Mendive, Pedro Pablo Oliva Rodriguez, Alfredo Sosabravo. *Egypt :* Hussein El Gebali, Kamal El Sarrag. *France :* Toni Grand, Simon Hantai. *Japan :* Naoyoshi Hikosaka, Tadashi Kawamata, Yoshio Kitayama. *Great Britain :* Barry Flanagan. *Greece :* Diamantis Diamantopoulos, Costas Koulentianos. *India :* Balan Nambiar. *Israel :* Tamar Getter, Michal Na'aman. *Italy :* Luca Alinari, Rodolfo Aricò, Renata Boero, Andrea Cascella, Mario Ceroli, Pietro Coletta, Pietro Consagra, Lucio Del Pezzo, Beppe Devalle, Piero Dorazio, Salvatore Emblema, Marco Gastini, Marcello Jori, Luigi Mainolfi, Paolo Minoli, Luigi Montanarini, Mario Nigro, Gianfranco Notargiacomo, Achille Pace, Concetto Pozzati, Mario Schifano, Emilio Tadini, Giulio Turcato, Nanni Valentini, Emilio Vedova. *Yougoslavia :* Bora Iljovski, Andraž Šalamun, Edita Schubert, Tugo Šušnik. *The Netherlands:* Stanley Brouwn. *Scandanavian Countries :* Eva Sørensen (Denmark), Juhana

Blomstedt (Finlande), Jón Gunnar Arnason, Kristján Guðmundsson (Iceland), Synnøve Anker Aurdal (Norway), Ulrik Samuelson (Sweden). *Poland* : Jan Kucz, Adolf Ryszka. *Portugal* : Helena Almeida. *East Germany* : Sighard Gille, Heidrun Hegeward, Uwe Pfeifer, Volker Stelzmann. *West Germany* : Hanne Darboven, Gotthard Graubner, Wolfgang Laib. *Rumania* : Florin Codre, Ion Gheoghiu. *San Marino* : Marina Busignani Reffi, Walter Gasperoni, Gilberto Giovagnoli. *Spain* : José Abad, Eugenio Chicano, Francisco Cruz de Castro, Josep Guinovart, Rosa Torres Molina. *United States* : Robert Smithson. *Switzerland* : Dieter Roth. *Hungary* : Erzsébet Schaár. *USSR* : Shukhrat Abdurascitov, Nikolaj Andronov, Rimas Bicunas, Olga Bulgakova, Karlis Dobrajs, Oleg Filatcev, Viktor Ivanov, Olga Kotjuzhanskaya, Galina Lekareva, Tatjana Nazarenko, Xenia Necitaylo, Galina Neledva, Natalia Pasciucova, Viktor Popkov, Elena Romanova, Vladislav Rozhnev, Aleksandr Sitnikov, Irina Starzhenetskaya, Marina Talascenko, Tatjana Tsigal, Vladimir Vladykin, Dmitrij Zhilinskij, Ninel Boguscevskaya, Jury Cernov, Khachatur Iskandarian, Tatjana Kalenkova, Juozas Kedainis, Davide Kheidze, Daniele Mitlyansky, Adelaida Pologova, Vakhrameev, Zandberga. *Venezuela* : Alejandro Otero. **Antoni Tàpies,** Works from 1946 to 1982. **Riccardo Tommasi Ferroni.** ☐ **Aperto 82** — *Time* : Jean-Michel Alberola, Carlo Alfano, Enrico Barbera, Herbert Bardenheuer, Vincent Bioulès, Catherine Blacker, Oscar Bony, Troy Brauntuch, Vito Bucciarelli, Stephen Cox, Marco Del Re, Donna Dennis, David Deutsch, Braco Dimitrijević, Stefano Di Stasio, Omar Galliani, Charles Garabedian, Gerard Roger Garouste, Isa Genzken, Antony Gormley, Tim Head, Anish Kapoor, Christina Kubish, Nino Longobardi, Riccardo Lumaca, Carlo Maria Mariani, Maurizio Mochetti, Elisa Montessori, Idetoshi Nagasawa, Gottardo Ortelli, Laura Panno, Filippo Panseca, Claudio Parmiggiani, Judy Pfaff, Franco Piruca, David Salle, Remo Salvadori, Anna Maria Santolini, Julian Schnabel, Cindy Sherman, Keith Sonnier, Jean-Luc Vilmouth, William Wegman, Bill Woodrow. *Space* : Filippo Avalle, Alice Aycock, Ubaldo Bartolini, Davide Benati, Danilo Bergamo, Jean-Sylvain Bieth, Danièle Bollea, Mauro Brattini, Jürgen Brodwolf, M. Patrizia Cantalupo, Casa degli Artisti Milano, Jean Commandeur, Filippo Di Sambuy, Jiri Georg Dokoupil, Rainer Fetting, Antonio Freiles, Ferruccio Gard, Patrizia Guerresi, Shirazeh Houshiary, Enzo Indaco, Barbara Kruger, Christopher Lebrun, Bernard Lüthi, Bruno Marabini, Teresa Marasca, Claudio Marini, Franco Morresi, Andrea Nelli, Sergio Pacini, Claudio Papola, Giordano Pavan, Max Pellegrini, Carmine Rezzuti, Quintino Scolavino, Aldo Spoldi, Marco Tirelli, Michael Tracy, Stephen Willats.

*Catalogue,* with texts by Sisto Dalla Palma, Matthias Eberle, Giuseppe Galasso, Guido Perocco, Tommaso Trini, Fortunato Bellonzi, Carmine Benincasa, Maurizio Calvesi et Serge Sabarsky, 226 pages, illus.
Electa Editrice, Milano & La Biennale di Venezia, Venezia.

### Art Space '82
Fattoria di Celle, Santomato, Pistoia

*Interior* : Nicola De Maria, Luciano Fabro, Mimmo Paladino, Giuseppe Penone, Michelangelo Pistoletto, Aldo Spoldi, Gianni Ruffi, Gilberto Zorio.
*Exterior* : Alice Aycock, Dani Karavan, Robert Morris, Dennis Oppenheim, Anne and Patrick Poirier, Ulrich Ruckriem, Richard Serra, Mauro Staccioli, George Trakas.

### Sculpture, Back and Forth
Galleria Emilio Mazzoli, Modena, September 18 - December 20, 1982

Sandro Chia, Enzo Cucchi.

*Book,* with texts by Sandro Chia and Enzo Cucchi ; 92 pages, illus.
Emilio Mazzoli, Modena.

### The German Trans-avant-garde
Galleria Nazionale d'Arte Moderna, Republic of San Marino July 24 - August 29, 1982

Georg Baselitz, Jörg Immendorff, Per Kirkeby, Markus Lüpertz, A.R. Penck.

*Catalogue,* edited by Achille Bonito Oliva ; with texts by Achille Bonito Oliva ; 87 pages, illus.
Galleria Nazionale d'Arte Moderna, Reppublica di San Marino.

### British Sculpture in the Twentieth Century
Whitechapel Art Gallery, London
I. Image and Form 1901-50, September 11 - November 1, 1981
II. Symbol and Imagination 1951-80, November 27 - January 24, 1982
1982

Ivor Abrahams, Robert Adams, David Annesley, Kenneth Armitage, Keith Arnatt, Michael Ayrton, Clive Barker, Stuart Brisley, Ralph Brown, Victor Burgin, Laurence Burt, Reg Butler, Anthony Caro, Patrick Caulfield, Lynn Chadwick, Geoffrey Clarke, Stephen Cox, Tony Cragg, Michael Craig-Martin, Hubert Dalwood, John Davies, Kenneth Draper, John Ernest, Barry Flanagan, Elisabeth Frink, George Fullard, Gilbert & George, Stephen Gilbert, Antony Gormley, Nigel Hall, Ian Hamilton-Finlay, Anthony Hatwell, Tim Head, Barbara Hepworth, Charles Hewlings, Anthony Hill, John Hilliard, Allen Jones, Peter Joseph, Anish Kapoor, Michael Kenny, Phillip King, Bryan Kneale, Bruce Lacey, Peter Lanyon, John Latham, Bob Law, Dante Leonelli, Liliane Lijn, Kim Lin, Richard Long, Roelof Louw, Leonard McComb, Bruce McLean, F.E. McWilliam, Kenneth Martin, Mary Martin, Bernard Meadows, Keith Milow, Nicholas Monro, Henry Moore, David Nash, Martin Naylor, Paul Neagu, Victor Newsome, John Panting, Eduardo Paolozzi, Victor Pasmore, Roland Piché, Carl Plackman, Nicholas Pope, Malcolm Poynter, William Pye, Robert Russell, Michael Sandle, Tim Scott, Peter Startup, David Tremlett, William Turnbull, Ken Turnell, Brian Wall, Stephen Willats, Glynn Williams, Bill Woodrow.

*Catalogue,* Edited by Sandy Nairne and Nicholas Serota, with texts by Jane Beckett, Richard Calvocoressi, Lynne Cooke, Richard Cork, Fenella Chrichton, Dennis Farr, Richard Francis, John Glaves-Smith, Alastair Grieve, Anna Gruetzner, Charles Harrison, Timothy Hyman, Stuart Morgan, Sandy Nairne, Brendan Prendeville, Ben Read, Nicholas Serota and Richard Shone ; 264 pages, illus.
Trustees of the Whitechapel Art Gallery, London.

### New Spanish Figuration
Kettle's Yard Gallery, Cambridge, July 10 - August 19, 1982
Institute of Contemporary Arts, London, August 27 - October 3, 1982
Cartwright Hall, Bradford, October 9 - November 14, 1982 Third Eye Centre, Glasgow, November 27 - Décember 19, 1982

Chema Cobo, Costus (Juan Carrero & Enrique Naya), Luis Gordillo, Guillermo Pérez Villalta.

*Catalogue,* with texts by Jeremy Lewison & Francisco Calvo Serraller ; 52 pages, illus. Kettle's Yard Gallery, Cambridge.

### Italian Art 1960-1982
Hayward Gallery, London, October 20 - January 9, 1983
Institute of Contemporary Arts, London, October 12-24, 1982

Vincenzo Accame, Valerio Adami, Vincenzo Agnetti, Rodolfo Aricò, Ferruccio Ascari, Enrico Baj, Luciano Bartolini, Carlo Battaglia, Mirella Bentivoglio, Valentina Berardinone, Alberto Biasi, Alighiero e Boetti, Agostino Bonalumi, Cioni Carpi, Ugo Carrega, Nicola Carrino, Alik Cavaliere, Mario Ceroli, Giuseppe Chiari, Claudio Cintoli, Luisa Cividin/Roberto Taroni, Francesco Clemente, Pietro Coletta, Gianni Colombo, Pietro Consagra, Dadamaino, Dal Bosco/Varesco, Fernando De Filippi, Lucio Del Pezzo, Beppe Devalle, Piero Dorazio, Falso Movimento, Vincenzo Ferrari, Giosetta Fioroni, Fonosfera (Armando Adolgiso, Pier Pinotto Fava), Lucio Fontana, Gaia Scienza, Omar Galliani, Marco Gastini, Gianikian/Ricci Lucchi, Andrea Granchi, Giorgio Griffa, Gruppo T (Giovanni Anceschi, Davide Boriani, Gianni Colombo, Gabriele De Vecchi, Grazia Varisco), Emilio Isgrò, Marcello Jori, Jannis Kounellis, Ugo La Pietra, Arrigo Lora-Totino, Francesco Lo Savio, Luigi Mainolfi, Piero Manai, Piero Manzoni, Giuseppe Maraniello, Enzo Mari, Plinio Martelli, Vittorio Matino, Eliseo Mattiacci, Mario Merz, Eugenio Miccini, Maurizio Mochetti, Magdalo Mussio, Mario Nanni, Ugo Nespolo, Gianfranco Notargiacomo, Gastone Novelli, Anna Oberto, Martino Oberto, Claudio Olivieri, Luigi Ontani, Mimmo Paladino, Giulio Paolini, Antonio Paradiso, Gianfranco Pardi, Pino Pascali, Luca Maria Patella, Lamberto Pignotti, Vettor Pisani, Michelangelo Pistoletto, Fabrizio Plessi, Arnaldo Pomodoro, Giò Pomodoro, Concetto Pozzati, Bepi Romagnoni, Mimmo Rotella, Salvo, Michele Sambin, Mario Schifano, Gianni Emilio Simonetti, Giuseppe Spagnulo, Adriano Spatola, Aldo Spoldi, Mauro Staccioli, Antonio Syxty, Emilio Tadini, Tancredi, Giuseppe Uncini, Franco Vaccari, Valentino Vago, Michele Zaza, Gilberto Zorio, Giuliano Zosi.

*Catalogue,* with texts by Guido Aghina, Guido Ballo, Renato Barilli, Flavio Caroli, Andrew Dempsey, Joanna Drew, Vittorio Fagone, Loredana Parmesani, Roberto Sanesi, Caroline Tisdall, Carlo Tognoli ; 288 pages, ill.
Art Council of Great Britain and Gruppo Editoriale Electa, Milano.

### Towards the End of the Second Middle Ages
Centro de Arte y Comunicación, Buenos Aires

Jacques Bedel, Luis Benedit, Oscar Bony, Jorge Gonzalez Mir, Victor Grippo, Leopoldo Maler, Vicente Marotta, Alfredo Portillos, Clorindo Testa.

*Catalogue,* texts by Jorge Glusberg et Horacio Safons, 40 pages, illus.
Ediciones Centro de Arte y Comunicacion, Buenos Aires.

**Art and Feminism**
Musée d'art contemporain, Montréal, March 11 - May 2, 1982

Louise Abbott, Elise Bernatchez, Louise Bilodeau, Andrée Brochu,
Marie Chouinard, Sorel Cohen, Carmen Coulombe, Michèle
Cournoyer, Judith Crawley, Lorraine Dagenais, Marie Décary,
Éditions du Remue-Ménage (Raymonde Lamothe, Madeleine Leduc,
Ginette Loranger), Mira Falardeau, Louisette Gauthier-Mitchell,
Sheila Greenberg, Louise de Grosbois, Anne de Guise, Clara
Gutsche, Freda Guttman-Bain, Michèle Héon, Lise Landry, Lise-
Hélène Larin, Francine Larivée, Doreen Lindsay, Jovette
Marchessault, Marshalore, Nicole Morisset, Lise Nantel, Ann
Pearson, Pol Pelletier, Plessisgraphe (Marik Boudreau, Suzanne
Girard, Camille Maheux), France Renaud, Hélène Roy, Joyan
Saunders, Sylvie Tourangeau, Josette Trépanier, Marion Wagschal.

*Catalogue,* with texts by Rose Marie Arbour, Aline Dallier, Nicole
Dubreuil-Blondin, Suzanne Foisy, Diane Guay, Johanne Lamoureux,
Suzanne Lamy, Thérèse Saint-Gelais ; 224 pages, illus.
Ministère des Affaires Culturelles, Québec.

**Black Folk Art in America 1930-1980**
Corcoran Gallery of Art, Washington, January 15 - March 28, 1982
J.B. Speed Museum, Louisville, Kentucky, April 26 - June 13, 1982
The Brooklyn Museum, Brooklyn, New York, July 4 - September 12,
1982
Craft and Folk Art Museum, Los Angeles, November 30, 1982 -
February 3, 1983

Jesse Aaron, Steve Ashby, David Butler, Ulysses Davis, William
Dawson, Sam Doyle, William Edmondson, James Hampton, Sister
Gertrude Morgan, Inez Nathaniel-Walker, Leslie Payne, Elijah Pierce,
Nellie Mae Rowe, James 'Son Ford' Thomas, Mose Tolliver, Bill
Traylor, George White, George Williams, Luster Willis, Joseph
Yoakum.

*Catalogue,* with texts by John Beardsley, Jane Livingston, Peter C.
Marzio, Regenia A. Perry ; 188 pages, illus.
University Press of Mississippi, Jackson, & the Center for the Study
of Southern Culture, for the Corcoran Gallery of Art.

**Italian Art Now : An American Perspective 1982**
**Exxon International Exhibition**
The Solomon R. Guggenheim Museum, New York, April 2 - June 20,
1982

Sandro Chia, Enzo Cucchi, Nino Longobardi, Luigi Ontani, Giuseppe
Penone, Vettor Pisani, Gilberto Zorio.

*Catalogue,* with texts by Lisa Dennison, Thomas M. Messer, Diane
Waldman ; 144 pages, illus.
The Solomon R. Guggenheim Foundation, New York.

# Artists

**Abe, Nobuya**
Nigata, Japan, 1913 ; died in
1971

Group Exhibition
"Japan : The 1950's,"
Metropolitan Art Museum,
Tokyo

Bibliography
*Catalogue :* Metropolitan
Museum, Tokyo

---

**Abramovic & Ulay**
Abramovic, Marina : Belgrade
1946 ; lives in Amsterdam
Ulay (Uwe F. Laysiepen),
Solingen (West Germany),
1943 ; lives in Amsterdam

Performances
*Nightsea crossing*
Skulpturenmuseum im
Glaskasten, Marl (West
Germany)
Performance Festival,
Künstlerhaus Bethanien, Berlin
Kölnischer Kunstverein,
Cologne
"'60'80", Stedelijk Museum,
Amsterdam
"Contemporary Art of the
Netherlands," Museum of
Contemporary Art, Chicago
A Space, Cityhall, Toronto
Documenta 7, Kassel
Kuntsmuseum, Düsseldorf

Bibliography
*Catalogues :* Stedelijk
Museum, Amsterdam.
Documenta 7, Kassel.
Kölnischer Kunstverein, Köln.

---

**Adami, Valerio**
Bologna, Italy, 1935 ; lives in
Paris

Exhibition
Lens Fine Arts, Antwerp

Group Exhibitions
"Paris 1960-1980," Museum
des 20. Jahrhunderts, Vienna,
Austria
"Arte Italiana," Hayward
Gallery, London ; ICA, London
"Choix pour aujourd'hui,"
Centre Georges Pompidou,
Paris

Bibliography
*Catalogues :* Museum des 20.
Jahrhunderts, Wien. Hayward
Gallery, London. Centre
Georges Pompidou, Paris

---

**Aeberli, Matthias**
Basel 1952 ; lives in
Switzerland

Exhibition
Raum für aktuelle Schweizer
Kunst, Lucerne

Group Exhibitions
Kunsthalle Basel, Basel
St. Galerie, Saint Gall
"Avantgarde suisse,"
Galerie Nouvelles Images,
The Hague

Bibliography
Kunsthalle, Basel

---

**Alberola, Jean-Michel**
Saïda, Algeria, 1953 ; lives in
Le Havre

Exhibition
Galerie Daniel Templon, Paris

Group Exhibitions
"Ateliers 81-82," ARC, Musée
d'art moderne de la Ville de
Paris, Paris
Galerie Katia Pissaro, Paris
Salon de Montrouge, Hauts-
de-Seine
"L'air du temps," Galerie d'art
contemporain des musées de
Nice, Nice
"Mythe, drame, tragédie,"
Musée d'art et d'industrie,
Saint-Étienne
Bonlow Gallery, New York
"Aperto 82," Biennale Venice

Bibliography
Abadie, Daniel : "Jean-Michel
Alberola, Galerie Daniel
Templon," *Cimaise,* Paris,
n. 159
Francblin, Catherine : "Free
French," *Art in America,* New
York, September
Loisy, Jean de : "L'air du
temps," *Flash Art,* Milano,
n. 107, May
Poinsot, Jean-Marc : "New
Painting in France," *Flash Art,*
Milano, n. 108, Summer
Strasser, Catherine : "Jean-
Michel Alberola," *Art Press,*
Paris, n. 58, avril
*Catalogues :* ARC, Musée
d'art moderne de la Ville de
Paris, Paris. Salon de
Montrouge, Montrouge.
Galerie d'art contemporain des
musées de Nice. Musée d'art
et d'industrie, Saint-Étienne.
Biennale di Venezia, Electa ed.

---

**Alexanco, Jose Luis**
Madrid, Spain, 1942 ;
lives in Madrid

Exhibition
Galería Fernando Vijande,
Madrid

Bibliography
Calvo Serraller, Francisco :
"El pasado y el presente de
Alexanco," *El País,* Madrid, 3
de Abril
Calvo Serraller, Francisco,
*Lectura en Imágenes,* ed.
Fernando Vijande, Madrid,
publication date 1983
Garcia, Aurora : "Alexanco,"
*Vardar,* Madrid, n. 5
Santos Amestoy, Dámaso :
"Alexanco," *Pueblo,* Madrid,
26 de Marzo

---

**Alfaro, Andreu**
Valencia 1929 ; lives in Valencia

Exhibitions
Sala Gaspar, Barcelona
Galerie Dreiseitel, Cologne
Museo de Arte
Contemporaneo, Madrid

Group Exhibition
Internationaler Kunstmarkt,
Düsseldorf

Bibliography
Cirici Pellicer, Alexandre :
"Un nuevo Andreu Alfaro,"
catalogue, Sala Gaspar,
Barcelona
Morago, A. : "Profeta en
Europa," *Cambio 16,* Madrid,
4 de Octubre
Puig, Arnau : "Alfaro," *Artes
Plasticas,* Madrid, n. 50
Richter, Horst : "Aktivierung
des Raums," *Weltkunst,*
Munich 1er Januar
Rodriguez, Conxa : "Andreu
Alfaro : Nadie inventa nada,
todo es historia," *El Mon,*
Barcelona, 26 de Octubre

---

**Anderson, Laurie**
Chicago 1947,
lives in New York.

Exhibitions and
performances
"Photopiece," Stedelijk
Museum, Amsterdam
"A Lecture," Stedelijk
Museum, Amsterdam
"United States II," Stedelijk
Museum, Amsterdam
"Festival d'Automne,"
Théâtre Bobino, Paris
ICA, London ; Ikon Gallery,
Birmingham

Group Exhibitions
"'60'80," Stedelijk Museum,
Amsterdam
"Soudings," Neuberger
Museum, State University
of New York, New York
Bell Art Gallery-List Art Center,
Brown University, Providence,
Rhode Island
"Art-Cars," P.S. 1, New York
"Atomic Salon," Ronald
Feldman, New York
Aldrich Museum of
Contemporary Art, Ridgefield,
Connecticut

Bibliography
Anderson, Laurie : "United
States (Part II)," *Art Press,*
Paris, n. 64, novembre
Foster, Hal : "The Problem of
Pluralism," *Art in America,*
New York, January
Flood, Richard : "Purchase,
Soundings, Neuberger
Museum, State University of
New York," *Artforum,* New
York, May
Gould, Melissa, *Art Express,*
New York, January-February
Nilsson, Bo : "Nasta platta du
lyssnar pa kan vara Konst,"
*Kalejdaskop,* Jan
Palmer, Robert : "Laurie Ander-
son : Ephemeral turns
permanence," *New York
Times,* April 21.
Usenko, Lydia : "Profile," *Bell
Telephone Magazine,*
December-January, *American
Film,* Vol. 7, June

---

"Music," *Fashion News,*
Tokyo, May
*Catalogue :* '60'80, Stedelijk
Museum, Amsterdam

---

**André, Marie**
Etterbeek, Brussels, 1951 ;
Linkebeek, Belgium

Group Exhibitions
"Voir des Vidéos", Brussels
IIIe Festival International d'Art
Vidéo, Locarno, Switzerland
World Wide Festival,
The Hague
XXX International Film
Festival, Saint-Sébastien, Spain
Biennale de Paris, Musée
d'Art Moderne de la Ville de
Paris, Paris
Galerie 2016, Brussels
Circom, Venice
Festival du Film de Femmes,
Brussels
Festival Vidéo, Montréal
Vidéographie, Télévision :
Centre R.T.B.F., Liège
Ire Manifestation
Internationale de Vidéo,
Montbéliard, France
Vidéo Roma, Rome

Bibliography
Aubenas, J. : "Marie André,
une cinéaste autodidacte,"
*Voyelles,* mars
Fargier, Jean-Paul : "Greffes,
Festival de San Sebastian,"
*Video,* novembre
*Catalogue :* Biennale de Paris

---

**Arroyo, Eduardo**
Madrid, Spain, 1937 ; lives in
Paris

Exhibitions
"Eduardo Arroyo : 20 años de
pintura," Salas Picasso, Madrid
Centre Georges Pompidou,
Paris
Galeria Documenta, Turin
Eva Cohen Gallery, Highland
Park, Chicago
Cloître Saint-Louis, Festival de
Musique, Aix-en-Provence

Group Exhibitions
"Peinture actuelle en France,"
ICC, Antwerp
"Paris 1960-1980," Museum
des 20. Jahrhunderts, Vienna
"El Mundial," La Caixa, Madrid

Bibliography
Arroyo, Eduardo : "Pour
s'attaquer au gros méchant
loup," *Le Matin*
Arroyo, Eduardo : *"Panama"
Al Brown (1902-1951),* Paris
Astier, Pierre : *Eduardo
Arroyo,* Paris
Besson, Ferny : *"Panama" Al
Brown,* Bruxelles
Bratchi, Georges : "De la
peinture au punching-ball," *La
Tribune de Genève*
Dalmace-Rognon, Michèle :
"Arroyo Siniestro o Arroyo de
la Luz," catalogue, Madrid
Fanti, Giorgio : "Storia di un
boxeur un po' maledetto
narrata da un pittore," *Paese*
Sera, Roma
Gómez, José Luis : "Las
escenografias ejemplares del
pintor Eduardo Arroyo," *El
País,* Madrid
Semprun, Jorge : "Eduardo
Arroyo, pintura del exilio y
exilio de la pintura," catalogue,
Madrid
Zweite, Armin : Engagement
und Zitat, *Die Kunst,* Munchen
*Catalogues :* Salas Picasso,
Madrid. Centre Georges
Pompidou, Paris. ICC, Anvers.
Museum des 20.
Jahrhunderts, Wien

---

**Art & Language**
Harrison, Charles : Chesham
1942, G.B.
Ramsden, Mel : Ilkeston 1944,
G.B.
Baldwin, Michael : Chipping
Norton 1945, G.B.
lives in Oxfordshire, Great
Britain

Exhibitions
Musée de Toulon, France
"Index : The Studio at 3
Wesley Place, Painted by
Mouth," De Vleeshal,
Middelburg

Group Exhibitions
Documenta 7, Kassel
"Aspects of British Art
Today," Tokyo Metropolitan
Art Museum, Tokyo ; Tochigi
Prefectural Museum of Fine
Arts, Utsunomiya ; The
National Museum of Art,
Osaka ; Fukuoka Art Museum,
Fukuoka ; Hokkaido Museum
of Modern Art, Sapporo
"Mannerism : A Theory of
Culture," The Vancouver Art
Gallery, Vancouver

Bibliography
Amman, Jean-Christophe :
"Documenta : Reality and
Desire," *Flash Art,* Milano,
November
"Art & Language : Manet's
Olympia and Contradiction,"
*Style,* Vancouver, March
"Art & Language : Painting by
Mouth," De Vleeshal,
Middelburg
"Art & Language : Selected
Essays," catalogue, Musée de
Toulon, Toulon
"Art & Language : By Mouth,"
catalogue, The British Council
& The Metropolitan Museum
Tokyo, London & Tokyo
"Art & Language : Kangaroo ?
— Some Songs by Art &
Language & The Red Crayola,"
*Art Journal,* Summer
"Art & Language : Future
Pilots and Ratman the
Weightwatcher," in "Live to
Air," *Audio Arts,* Vol. V, N. 3 &
4, August
"Art & Language : Essays,"
*Art-Language,* Vol. V, N. 1,
October
Harrison, Charles, *Art and its
Languages : The Last Twenty
Years,* The Durning Lawrence
Lectures, University College,

London, Autumn
Harrison, Charles & Orton, Fred, *A Provisional History of Art-Language*, Paris
Harrison, Charles & Orton, Fred : "An Edited Extract from a Conversation between Fred Orton and Charles Harrison," catalogue, Documenta 7, Kassel
Morgan, Stuart : Review, *Artforum*, New York, September
*Catalogues* : Musée de Toulon, Toulon. Kassel. The British Council, Tokyo Metropolitan Museum of Art

**Recordings**
"The Red Crayola with Art & Language," *Corrected Slogans*, RCAL 1848, Recommended Records, 1982 (reissue)

---

**Aycock, Alice**
Harrisburg, Pa., 1946 ; lives in New York

**Exhibitions**
Lawrence Oliver Gallery, Philadelphia
John Weber Gallery, New York
"The Miraculating Machine in the Garden (Tower of the Winds)," Douglas College, New Brunswick, New Jersey
"Hoodo (Laura) Vertical and Horizontal Cross Sections of the Ether Wind," The Atrium Building, Philadelphia
The Museum of Contemporary Art, Chicago

**Group Exhibitions**
"Metaphor, New Projects by Contemporary Sculptors," Hirshhorn Museum and Sculpture Garden, Washington D.C.
Villa Celle, Pistoia
"Drawing, New Directions," Summit Art Center, Summit, New Jersey
"Prints by Contemporary Sculptors," Yale University Art Gallery, New Haven
"Past-Present-Future," Württembergischer Kunstverein, Stuttgart
"Chicago International Art Exposition 1982," Navy Pier, Chicago
"Artists' Books, A Survey 1960-1981," Ben Shahn Gallery for the Visual Arts, William Paterson College, Wayne, New Jersey
"Ten Artists From New York," Sonny Savage Gallery, Boston
"Drawings, Models and Sculptures," 14 Sculptors Gallery, New York
"Postminimalism," Aldrich Museum of Contemporary Art, Ridgefield
"20th Anniversary Exhibition of the Vogel Collection," Brainerd Art Gallery, State University College, Postdam
Biennale Venice

**Bibliography**
"Alice Aycock", in *Benzene*, Spring/Summer, n. 5-6
Boralevi, Antonella di :

"Giuliano il Magnifico", *Panorama*, 26 luglio
Fry, Edward F. : "Prints by Contemporary Sculptors : An Exhibition At Yale, May 18-Aug. 1982," *The Print Collector's Newsletter*, Sept.-Oct.
Gleason, Norma Catherine : "Artists and Architecture", *Willamette Week's Fresh Weekly*, Oregon, Oct. 26-Nov. 27
Graevenitz, Antije von : "Alice Aycock", *MuseumJournaal*, Amsterdam, 6 Gulden, n. 27-1
Holmes, Ann : "The Shape of the Future", *Houston Chronicle*, Nov. 7
Lubecker, Pierre : "Favntag med Naturen," *Politiken*, 21-6
Stevens, Mark : "Shifting Shapes of Sculpture," *Newsweek*, November 22
Tacha, Athena : "Complexity and Contradiction In Contemporary Sculpture," *The Gamut, A Journal of Ideas & Information*, Cleveland State University, n. 5, Winter
Tsai, Eugenie : "A Tale of (At Least), Two Cities : Alice Aycock's Large Scale Dis/Integration of Microelectric Memories, (A Newly Revised Shantytown,)" *Arts Magazine*, June
*Catalogues* : Yale University, New Haven. Hirshhorn Museum and Sculpture Garden, Smithsonian Institute, Washington. The Aldrich Museum of Contemporary Art, Ridgefield. Brainerd Art Gallery, Potsdam. Württembergischer Kunstverein, Stuttgart. Biennale di Venezia, Electa

---

**Bancalari, Inès**
Buenos Aires 1946, lives in Martinez, near Buenos Aires

**Exhibition**
Teatro Payró, Buenos Aires

**Group Exhibitions**
Fondo Nacional de las Artes
Salón de Santa Fe
Salón de Tigre
Prix Gillete

**Bibliography**
*La Prensa*
*La Nación*
*El Cronista Comercial*
*Gente*

---

**Baranow, Leonid M.**
1943 ; lives in Moscow

**Group Exhibition**
"Aspekte Sowjetischer Kunst der Gegenwart," Kölnischer Stadtmuseum, Cologne ; Neue Galerie-Sammlung Ludwig, Aachen

**Bibliography**
*Catalogue* : Museum Ludwig, Köln, & Neue Galerie-Sammlung Ludwig, Aachen

---

**Bartlett, Jennifer**
Long Beach, California, 1941 ; lives in New York

**Exhibitions**
Joslyn Art Museum, Omaha
Paula Cooper Gallery, New York
Tate Gallery, London

**Group Exhibitions**
"U.S. Art Now," Nordiska Kompaniet, Stockholm
"American Prints : 1960-80," Milwaukee Art Museum, Wisconsin
"The R.S.M. Collection," Krannert Drawing Room, Purdue University, Indiana
"Surveying the Seventies : Selections from the Permanent Collection," Whitney Museum of American Art ; Fairfield County, Stamford, Connecticut

**Bibliography**
Field, Richard S. : "On Recent Woodcuts," *The Print Collector's Newsletter*, New York, March-April
Hornick, Lita : "Night Flight," The Kulchur Foundation, New York
Russell, John : "Jennifer Bartlett Creates an Archetypal New Found Land," *New York Times*, New York, May 23
Saatchi, Doris : "A New Spirit in Painting," *Royal Academy of Arts Yearbook*, London, 1981-82
Seebohm, Caroline : "Making Room for Romance," *House and Garden*, New York, February
*Catalogues* : Tate Gallery, London. Milwaukee Art Museum, Wisconsin. Joslyn Art Museum, Omaha.

---

**Baselitz, Georg**
Deutschbaselitz, Saxe 1938 ; lives in Derneburg, Hildesheim, West Germany

**Exhibitions**
Galerie nächst St. Stephan, Vienna
Ileana Sonnabend Gallery, New York
"Gouachen, Zeichnungen," Michael Werner, Cologne
Helen van der Meij Gallery, Amsterdam
Galerie Neuendorf, Hamburg
Waddington Galleries, London
Anthony D'Offay, London
Xavier Fourcade, New York
Brooke Alexander, New York

**Group Exhibitions**
Studio Marconi, Milan
"Avanguardia Transavanguardia," Mura Aureliane, Rome
"German Drawings of the Sixties," Yale University Art Gallery
Documenta 7, Kassel
"Zeitgeist," Internationale Kunstausstellung, Martin-Gropius-Bau.
"'60-'80," Stedelijk Museum, Amsterdam
"La Transavanguardia tedesca," Galleria Nazionale d'Arte Moderna, San Marino
"Mythe, drame, tragédie," Musée d'art et d'industrie de Saint-Étienne
Marlborough, New York
Young Hoffman, Chicago

Galeria Heinrich Ehrhardt, Madrid
"Choix pour aujourd'hui," Centre Georges Pompidou, Paris

**Bibliography**
Blau, Douglas : "Georg Baselitz," *Flash Art*, Milano. n. 106
Bonito Oliva, Achille, *Avanguardia Transavanguardia*, catalogue, Electa, Milano
Gachnang, Johannes : "New German Painting," *Flash Art*, Milano, n. 106
Gohr, Siegfried : "In the Absence of Heroes, the Early Work of Georg Baselitz," *Artforum*, New York, Summer
Gohr, Siegfried : "The Situation and the Artists," *Flash Art*, Milano, n. 106
Gohr, Siegfried : "La peinture en Allemagne : les confusions de la critique," *Art Press*, Paris, n. 57, mars.
Groot, Paul : "The Spirit of Documenta 7," *Flash Art*, Milano, n. 108
Heere, H. : "G. Baselitz - Zeichnungen," catalogue Galerie M. Werner
Kuspit, Donald B. : "Georg Baselitz at Fourcade," *Art in America*, New York, February
Kuspit, Donald B. : "Acts of Aggression : German Painting Today," *Art in America*, New York, September
Liebmann, Lisa : "Georg Baselitz," *Artforum*, New York, March
Pohlen, Annelie : "Georg Baselitz," *Flash Art*, Milano, n. 105
*Catalogues* : Documenta 7, Kassel. Stedelijk Museum, Amsterdam. Martin-Gropius-Bau, Berlin. Galleria Nazionale d'Arte Moderna, Repubblica di San Marino. Musée d'art et d'industrie, Saint-Étienne. Centre Georges Pompidou, Paris

---

**Bedel, Jacques**
Buenos Aires 1947 ; lives in Buenos Aires

**Group Exhibitions**
Centro de Arte y Comunicación (CAYC), Buenos Aires
Galeria del Retiro, Buenos Aires

---

**Benedit, Luis**
Buenos Aires 1937 ; lives in Buenos Aires

**Group Exhibitions**
Centro de Arte y Comunicación (CAYC), Buenos Aires
Galeria del Retiro, Buenos Aires

---

**Bervoets, Fred**
Burcht, Belgium, 1942 ; lives in Antwerp

**Exhibitions**
"Hommage aan een vriend," Cultureel Centrum, Strombeek-Bever

"Wounded Knee," Galerij De Zwarte Panter, Antwerp
"Fred Bervoets, schilderijen en grafiek" (1958-1982)," Koninklijk Museum voor Schone Kunsten, Antwerp

**Group Exhibitions**
"Aanwinsten 1979-1982," Provinciaal Museum voor Moderne Kunst, Lakenhalle, Ypres
"Plastisch werk uit Zwijndrecht-Burcht," Gildehuis, Zwijndrecht
"Ontmoetingen met 89 Vlaamse kunstenaars," 't Poortje, Haasdonk
"Kunstwerken verworven door de Staat 1979-1981," St.-Pietersabdij, Gand
"Le Désir Pictural," Galerie Isy Brachot, Bruxelles
"Schilderkunst na 1945," Galerie De Vuyst, Lokeren

**Bibliography**
Buyck, J.F. : "Woord Vooraf," catalogue, Koninklijk Museum voor Schone Kunsten, Antwerpen
Van Mulders, Wim : "Fred Bervoets en de eklektische schilderkunst," catalogue Koninklijk Museum voor Schone Kunsten, Antwerpen
*Catalogues* : Koninklijk Museum voor Schone Kunsten, Antwerpen. Galerie Isy Brachot, Bruxelles

---

**Beuys, Joseph**
Cleve, West Germany, 1921 ; lives in Düsseldorf, West Germany

**Exhibitions**
Gallery Ronald Feldman, New York
Galerie Schellman & Klüser, Munich
"Joseph Beuys : A Major Sculpture," Anthony D'Offay, London
Galerie Malacorda, Geneva
Galerie Durand-Dessert, Paris
Henie-Onstad Kunstsenter, Høvikodden, Norway

**Group Exhibitions**
"German Drawings of the Sixties," Yale University Art Gallery, New Haven
"Arte Povera, Antiform," CAPC, Bordeaux
"Video Art in Germany, 1963-82," Kölnischer Kunstverein, Cologne
"Beuys, Rauschenberg, Twombly, Warhol, Sammlung Marx," Nationalgalerie Berlin ; Städisches Museum Abteiberg, Mönchengladbach
Zeitgeist, Berlin
"'60'80", Stedelijk Museum, Amsterdam
"Avanguardia Transavanguardia," Mura Aureliane, Rome
Documenta 7, Kassel
"Thoughts and Action," Laforet Museum, Tokyo ; Tokyo Metropolitan Art Museum, Tokyo

**Bibliography**
Goldcymer, Gaya &

**Reithmann, Max** : "Le dernier espace de Joseph Beuys ?" *Art Press*, Paris, n. 58, avril
Hovdenakk, Per : "Kunst og Kommunikasjon — eller kunstverket som transportmiddel," *Prismanytt*, Henie-Onstad Kunstsenter, Høvikodden, n. 1
Morgan, Stuart : "Joseph Beuys," *Artforum*, New York, Summer
Tisdall, Caroline : "Joseph Beuys, dernier espace avec introspecteur," London
Tronche, Anne : "Joseph Beuys," *Opus International*, Paris, n. 84, printemps
*Catalogues* : CAPC, Bordeaux. Collection Marx, Berlin, Mönchengladbach. Martin-Gropius-Bau, Berlin. Stedelijk Museum, Amsterdam. Mura Aureliane, Roma. Kassel. Henie-Onstad Kunstsenter, Høvikodden.

---

**Bioulès, Vincent**
Montpellier 1938 ; lives in Montpellier

**Exhibition**
Gallery Robert Miller, New York

**Group Exhibitions**
Biennale Venice
FIAC, Paris

**Bibliography**
Larson, Kay : "Shotgun Wedding," *New York Magazine*, New York, February 22
Russell, John, *The New York Times*, New York, February 12
*Catalogues* : Biennale di Venezia, Electa
Statements New York, 82, Association Française d'Action Artistique

---

**Blacker, Catherine**
Petersfield, Great Britain, 1955 ; lives in London

**Exhibitions**
Coracle Press, London
Galerie 121, Antwerp

**Group Exhibitions**
Whitechapel Open, Whitechapel Gallery, London
"South Bank Show," London
Biennale Venice
Hayward Annual, Hayward Gallery, London
"London-New York," Lisson Gallery, London
"Vol de Nuit," Galerie Eric Fabre, Paris

**Bibliography**
Francis, Mark, *The Arts Magazine*, London
Newman, Michael, *Art in America*, New York
*Catalogues* : Biennale di Venezia, Electa

---

**Blais, Jean-Charles**
Nantes, France, 1956 ; lives in Paris

**Exhibitions**
Galerie Yvon Lambert, Paris

Baronian-Lambert, Gand
Ugo Ferranti, Rome

**Group Exhibitions**
CAPC, Bordeaux
Biennale Paris
Galerie Yvon Lambert, Paris

**Bibliography**
*Catalogues* : CAPC, Bordeaux. Biennale de Paris

---

**Blanchard, Rémy**
Nantes, France, 1958 ; lives in Paris

**Group Exhibitions**
Galerie Yvon Lambert, Paris
Galerie Eva Keppel, Düsseldorf
Galerie Swart, Amsterdam
"L'Air du Temps, Figuration libre en France," Galerie d'Art Contemporain des Musées de Nice, Nice
Holly Solomon Gallery, New York

**Bibliography**
Dupuis, Sylvie : "Rémy Blanchard," *Art Press*, Paris, n. 58, avril
Francblin, Catherine : "Free French," *Art in America*, New York, September
Girard, Xavier : "Rémy Blanchard," *Art Press*, Paris, n. 56, février
Poinsot, Jean-Marc : "New Painting in France," *Flash Art*, Milano, n. 108, Summer
*Catalogues* : Galerie d'Art Contemporain des Musées de Nice, Nice. Statements New York 82, Association Française d'Action Artistique

---

**Boisrond, François**
Paris 1959 ; lives in Paris

**Exhibitions**
Galerie Farideh Cadot, Paris
Galerie Catherine Issert, Saint-Paul-de-Vence, France

**Group Exhibitions**
"Ateliers 81-82," ARC, Musée d'Art Moderne de la Ville de Paris, Paris
"L'Air du Temps, Figuration libre en France," Galerie d'Art Contemporain des Musées de Nice, Nice
"Kunst unserer Zeit," Groningen, Holland
Galerie Catherine Issert, Saint-Paul-de-Vence
FIAC, Paris

**Bibliography**
Francblin, Catherine : "Free French," *Art in America*, New York, September
Girard, Xavier : "François Boisrond," *Art Press*, Paris, n. 58, avril
Loisy, Jean de : "L'Air du Temps," *Flash Art*, Milano, n. 107
Strasser, Catherine, "François Boisrond," *Art Press*, Paris, n. 62, septembre
*Catalogues* : ARC, Musée d'Art Moderne de la Ville de Paris, Paris. Galerie d'Art Contemporain des Musées de Nice, Nice

**Bömmels, Peter**
Frauenberg 1951 ; lives in Cologne

**Exhibition**
"Orbis Pictus," Galerie Paul Maenz, Cologne

**Group Exhibitions**
"10 junge Künstler aus Deutschland," Museum Folkwang, Essen
"12 Künstler aus Deutschland," Kunsthalle, Basel ; Museum Boymans-van Beuningen, Rotterdam
Galerie 121, Antwerp
Galerie Swart, Amsterdam
"Neue Skulptur," Galerie nächst St. Stephan, Vienna
"Zeitgeist," Martin-Gropius-Bau, Berlin

**Bibliography**
"Deutsche Malerei, hier heute", *Kunstforum International*, Mainz, Dez. 1981-Jan. 1982
Faust, Wolfgang Max & De Vries, Gerd : Hunger nach Bildern, Köln
Marcelis, Bernard : "Mülheimer Freiheit," *Art Press*, Paris, n. 58, avril
*Catalogues* : Museum Folkwang, Essen. Galerie nächst St. Stephan, Wien. Martin-Gropius-Bau, Berlin. Kunsthalle Basel. Museum Boymans-van Beuningen, Rotterdam

---

**Borofsky, Jonathan**
Boston 1942 ; lives in Venice, California

**Exhibitions**
Museum Boymans-van Beuningen, Rotterdam
Museum van Hedendaagse Kunst, Gand
Paula Cooper, New York

**Group Exhibitions**
"Painting," Metro Pictures, New York
"Eight Artists : The Anxious Edge," Walker Art Center, Minneapolis
"Focus of the Figure : 20 Years," Whitney Museum of American Art, New York
"Painting and Sculpture Today 1982," Indianapolis Museum of Art
Documenta 7, Kassel
"Avanguardia Transavanguardia," Mura Aureliane, Rome
"Zeitgeist," Martin-Gropius-Bau, Berlin
American Graffiti Gallery, Amsterdam
"Fast," Alexander F. Milliken Inc., New York
"Energie New York," ELAC, Lyon
"Murs," Centre Georges Pompidou, Paris

**Bibliography**
Dimitrijevic, Nena : "Jonathan Borofsky : ICA," *Flash Art*, Milano, n. 105
Simon, Joan : "Jonathan Borofsky," *Art Press*, Paris, n. 59, mai

*Catalogues* : Kassel. Mura Aureliane, Roma. Martin-Gropius-Bau, Berlin. Centre Georges Pompidou, Paris.

---

**Bouillé, Christian**
Montereau, France, 1948 ; lives in Paris

**Exhibitions**
Galerie "L'autre musée", Brussels
Centre d'Art Contemporain, Annecy, France
Centre d'Art Contemporain, Privas, France
Centre d'Art Contemporain, Vesoul, France
Centre d'Art Contemporain, Montbéliard, France
Galerie Krief-Raymond, Paris
Maison de la Culture, Orléans, France

**Group Exhibitions**
"Revolutionary Figurations From Cezanne to the Present,"
Bridgestone Museum, Tokyo
"New Figurations in France," Seoul Gallery, Korea
"L'Art Vivant à Paris," Mairie annexe du XVIIIe arrondissement, Paris

**Bibliography**
Melèze, Josette, *Pariscope*, Paris
*Catalogues* : Centre d'Art Contemporain, Montbéliard. Bridgestone Museum, Tokyo

---

**Breivik, Bård**
Född, Sweden, 1948 ; lives in Stockholm

**Exhibitions**
Gallery Aronowitsch, Stockholm
Henie-Onstad Kunstsenter, Høvikodden, Norway

**Group Exhibitions**
"Scandinavia To-day," Solomon R. Guggenheim Museum, New York
"Materia/Minne," Lunds Konsthall, Lund (Sweden)
"Ibid*)," Danviken, Stockholm

**Bibliography**
*Catalogues* : Henie-Onstad Kunstsenter, Høvikodden. Materia/Minne, Lunds Konsthall, Lund

---

**Broniatowski, Karol**
Lodz, Poland, 1945

**Group Exhibition**
XVI Biennale de São Paulo

---

**Bruch, Klaus von**
Cologne 1952 ; lives in Cologne

**Group Exhibitions**
"Videokunst in Deutschland," Kölnischer Kunstverein, Cologne ; Kunsthalle, Hambourg ; Badischer Kunstverein, Karlsruhe ; Westfälischer Kunstverein, Münster ; Stadtische Galerie im Lenbachhaus, Münich

"IIIe Festival International d'Art Vidéo," Locarno, Switzerland

**Bibliography**
*Catalogues* : Kölnischer Kunstverein, Köln. IIIe Festival International d'Art Vidéo, Locarno

---

**Buren, Daniel**
Boulogne-sur-Seine, 1937 ; lives in Paris

**Exhibitions**
David Bellman Gallery, Toronto
Galerie France Morin, Montréal
Haus Esters, Krefeld Museum, Krefeld (West Germany)
Konrad Fischer Galerie, Düsseldorf
Performance in Genazzano (Italy)
Le Nouveau Musée, Villeurbanne
"Le mur du fond," Centre Georges Pompidou, Paris
Hoshour Gallery, Albuquerque, New Mexico
Staadtisches Museum, Mönchengladbach
Performance, Laforet Museum, Tokyo
Kanransha Gallery, Tokyo
FR3 Bourgogne, Dijon (France)
Bus Benches, Los Angeles
Philipps Gallery, Banff, Alberta (Canada)
Banco, Milan

**Group Exhibitions**
"Avanguardia Transavanguardia," Mura Aureliane, Rome
"'60'80," Stedelijk Museum, Amsterdam
Documenta 7, Kassel
"Thoughts and Action," Laforet Museum, Tokyo ; Tokyo Metropolitan Art Museum, Tokyo

**Bibliography**
Kirshner, Judith Russi : "Daniel Buren," *Artforum*, New York, February
*Catalogues* : Mura Aureliane, Roma, Electa. Stedelijk Museum, Amsterdam. Kassel

---

**Butler, David**
Saint Mary Parish, Louisiana, 1898 ; lives in Patterson, Louisiana

**Group Exhibition**
"Black Folk Art," Corcoran Gallery of Art, Washington D.C. ; J.B. Speed Museum, Louisville, Kentucky ; The Brooklyn Museum, Brooklyn, New York ; Craft and Folk Art Museum, Los Angeles ; The Institute for the Arts, Rice University, Houston

**Bibliography**
*Catalogue* : Corcoran Gallery of Art, Washington, University Press of Mississippi

---

**Byars, James Lee**
Detroit 1932 ; lives in New York and Europe

**Exhibition**
Westfälischer Kunstverein, Münster

**Group Exhibitions**
Documenta 7, Kassel
"Zeitgeist," Martin-Gropius-Bau, Berlin
Marian Goodman Gallery, New York

**Bibliography**
Deecke, Thomas : catalogue James Lee Byars, Westfälischer Kunstverein, Münster
McEvilley, Thomas : "James Lee Byars & The Atmosphere of Question," Artforum, New York, Summer
Pohlen, Annelie : "James Lee Byars," Flash Art, Milano, n. 109
Catalogues : Kassel. Martin-Gropius-Bau, Berlin

---

**Cage, John**
Los Angeles, California, 1912, lives in New York

**Exhibitions, Performances and Concerts**
"Roaratorio — An Irish Circus on Finnegans Wake," New Music Concerts, Toronto, Canada ; Almeida Festival, London
University of Alabama, Tuscaloosa
"Scores and Prints," Whitney Museum of American Art, New York ; Museum of Art, Philadelphia
University of Puerto Rico, Rio Piedras, with the Merce Cunningham Dance Company
Contemporary Music Festival, Institute of the Arts, Valencia, California
"Wall-to-Wall John Cage and Friends," a 70th Birthday Tribute," Symphony Space, New York
"Three Evenings of Music by John Cage by the S.E.M. Ensemble," Whitney Museum of American Art, New York
Cooper Union, New York
City Center, New York
"Witten Festival," Witten, West Germany
"Études Australes," Théâtre Am Turm, Frankfurt, Konzerthaus, Vienna, Austria
"A House Full of Music," Pro Musica Nova, Radio Bremen, Bremen
"Music Today Festival," Seibu Theater, Tokyo
'60-'80, Stedelijk Museum, Amsterdam
"New Music America," The Museum of Contemporary Art & the Mayor's Office of Special Events, Chicago
11th International Music Festival, Cadaquès, Spain
Dance/4 Orchestras," Cabrillo Music Festival, Aptos, California
"Postcard from Heaven," 70th Birthday Celebration, the Walker Art Center, Minneapolis, Minnesota ; The American Center, Théâtre du Rond-Point des Champs-Élysées, Paris

"30 Pieces for 5 Orchestras," Biennale Venice
European Tour with the Merce Cunningham Dance Company
"A Tribute to John Cage," with The Bowery Ensemble & David Tudor, Washington Performing Arts Society, Washington
Lecture by John Cage, Washington Project for the Arts

**Bibliography**
Ashbery, John : "The Look of Music," Newsweek, March 22
Sargent, David : "The John Cage Century," Vogue, September
Gagne, Cole & Caras, Tracy : Soundpieces, The Scarecrow Press, Inc., Metuchen, New Jersey & London
Catalogue : Stedelijk Museum, Amsterdam

---

**Caulfield, Patrick**
London 1936 ; lives in London

**Exhibitions**
Tate Gallery, London
Nishimura Gallery, Tokyo

**Group Exhibitions**
"Aspects of British Art Today," Tokyo Metropolitan Art Museum, Tokyo ; Tochigi Prefectural Museum of Fine Arts, Utsunomiya ; The National Museum of Art, Osaka ; Fukuoka Art Museum ; Hokkaido Museum of Modern Art, Sapporo
"British Sculpture in the Twentieth Century," White chapel Art Gallery, London

**Bibliography**
McEwen, John : "Report from London," Art in America, New York, Summer
Rose, Andrea : "Air on a G-Plan : Patrick Caulfield at Mid-Term," The London Magazine, Vol. 21, n. 11
Catalogues : Tate Gallery, London. The British Council & Tokyo Metropolitan Art Museum, Tokyo

---

**Charlier, Jacques**
Liège 1939, lives in Liège

**Exhibitions**
"Les nuits blanches et les autres," Galerie Fabien de Cugnac, Bruxelles
De Waterpoort, Courtrai

**Group Exhibitions**
Oudenaarde
"Collection du Musée d'art contemporain de Gand," Palais des Beaux-Arts, Bruxelles
"La magie de l'image," Palais des Beaux-Arts, Bruxelles

**Bibliography**
Catalogues : Palais des Beaux-Arts, Bruxelles. Museum van Hedendaagse Kunst, Gent

---

**Charpentier, Louis**
Montreal 1947 ; lives in Montreal

**Exhibition**
Centre d'exposition
L'Imagier, Aylmer, Quebec

**Group Exhibitions**
Maltwood Art Museum Gallery, Victoria, British Columbia
Ring House Gallery, University of Alberta, Edmonton, Alberta
The Delegation of Quebec in New England, Boston
Estevan National Exhibition Center, Estevan, Saskatchewan
Dunlop Art Gallery, Regina, Saskatchewan
Confederation Art Center, Charlottetown, Prince Edward Island
New Brunswick Museum, Saint-Jean, New Brunswick

**Bibliography**
Baele, Nancy : "Charpentier adds nuances to familiar fashion poses," The Citizen, Ottawa, July 31
Joubert, Suzanne : "Tout le charme de l'été," Le Droit, Ottawa, 31 juillet
Leblond, Jean-Claude : "Louis Charpentier : Deux moments de pose," Vie des Arts, Montréal, printemps, vol. XXVI, n. 106
"Louis Charpentier... : La délégation du Québec en Nouvelle-Angleterre," Boston, Cahiers des arts visuels au Québec, Montréal, automne, vol. 4, n. 15

---

**Chia, Sandro**
Florence 1946 ; lives in Rome

**Exhibitions**
Anthony D'Offay, London
James Corcoran Gallery, Los Angeles
Albert Baronian, Bruxelles
Sperone Westwater Fischer, New York

**Group Exhibitions**
"'60'80," Stedelijk Museum, Amsterdam
"Avanguardia Transavanguardia," Mura Aureliane, Rome
"Transavanguardia," Galleria Civica, Modena
"Scultura andata, Scultura storna," Galleria Emilio Mazzoli, Modena
"Italian Art Now : an American Perspective," Solomon R. Guggenheim Museum, New York
Documenta 7, Kassel
"Zeitgeist," Martin-Gropius-Bau, Berlin
"De la catastrophe," Centre d'art contemporain, Genève
"Mythe, drame, tragédie," Musée d'art et d'industrie, Saint-Étienne
Marlborough, New York
Giuliana de Crescenzo, Rome

**Bibliography**
Berger, Danny : "Sandro Chia in his Studio : An Interview," The Print Collector's Newsletter, New York, Bd. XII, n. 6, January/February
Collings, Matthew : "Sandro Chia at Anthony D'Offay,"

Artscribe, London, n. 33, Feb.
De Ak, Edit & Cortez, Diego : "Baby Talk," Flash Art, Milano, n. 107
Hughes, Robert : "Wild Pets, Tame Pastiche," Time, Bd. 119, n. 17, April 26th
Morgan, Stuart : "Sandro Chia, Anthony D'Offay Gallery," Artforum, New York, May
Payant, René : "Ces formes qui ironisent," Art Press, Paris, n. 57, mars
Ratcliff, Carter : "On Iconography and Some Italians," Art in America, New York, September
Schjeldahl, Peter : "Treachery on the High C's," The Village Voice, New York, Bd. XXVII, Nr. 17, April 27
Catalogues : Stedelijk Museum, Amsterdam. Mura Aureliane, Roma. Galleria Civica, Modena. Solomon R. Guggenheim Museum, New York. Kassel. Martin-Gropius-Bau, Berlin. Centre d'art contemporain, Genève. Musée d'Art et d'Industrie, Saint-Étienne. Galleria Emilio Mazzoli, Modena

---

**Chicago, Judy**
Chicago 1939 ; lives in Santa Monica, California

**Exhibitions**
"The Dinner Party," Musée d'art contemporain, Montreal ; Art Gallery of Ontario, Toronto ; Sculptural Arts Museum, Atlanta ; Glenbow Museum, Calgary
"The Birth Project," Through The Flower Gallery, Benicia, California ; Artisans Gallery, Mill Valley, California ; Trinity Hall Gallery, Chico, California
"Myth and Creation Drawings," Through The Flower Gallery, Benicia, California ; Whitman College Gallery, Walla Walla, Washington

**Group Exhibition**
De Anza College, Cupertino, California

**Bibliography**
Through The Flower, revised edition, Doubleday Press, September
Toronto Star, Toronto, March
Chatelaine, Montréal, vol. 23, n. 3, mars
Embroidery Canada, vol. IX, n. 2, February
En Route, Toronto, vol. 10, n. 3, March
Montreal Calendar Magazine, Montréal, March
La Vie en Rose, Montréal, mars-avril-mai
Virus-Montréal Le Guide Complet, Montréal, mars
Le céramiste, Montréal, vol. 1, n. 4, juin-juillet
Macleans, Toronto, vol. 95, n. 14, April 5

---

**Christo**
Gabrovo, Bulgaria, 1935 ; lives in New York

**Exhibitions**
Galerie Catherine Issert, Saint-Paul-de-Vence, France
Juda Rowan Gallery, London
"Five Works in Progress," Dumont Landis Gallery, New Brunswick, New Jersey
"Christo : Collection on Loan from the Rothschild Bank, Zürich." The Nickle Arts Museum, University of Calgary, Calgary, Alberta, Canada
"Wrapped Coast, One Million square feet, Little Bay, Australia, 1969, Documentation exhibition," Colby College Museum of Art, Waterville, Maine
"Projekte in der Stadt, 1961-81," Kunstlerhaus Bethanian, Berlin, Stadel Museum, Frankfurt, West Germany ; Musée Cantonal, Lausanne
"Wrapped Walk Ways, Kansas City, Missouri 1977-78, Documentation Exhibition," Carnegie Hall, University of Maine, Orono, Maine ; The Hara Museum of Contemporary Art, Tokyo
"Christo : Collection on Loan from the Rothschild Bank, Zürich," Art Gallery of Hamilton, Hamilton, Ontario, Elvehjem Museum of Art, University of Wisconsin, Madison
"Surrounded Islands, projects for Biscayne Bay, Greater Miami, Florida, Documentation exhibition," Miami-Dade Public Library, Miami, Florida

**Group Exhibitions**
"L'empreinte du nouveau réalisme," Galerie Bonnier, Genève
"Avanguardia Transavanguardia," Mura Aureliane, Rome
"Collection du musée de Gand," Palais des Beaux-Arts, Bruxelles
"Revolutionary Figurations : From Cezanne to the Present", Bridgestone Museum, Tokyo

**Bibliography**
Catalogues : Mura Aureliane, Roma, Electa. Bridgestone Museum, Tokyo

---

**Clemente, Francesco**
Naples 1952 ; lives in Rome and New York

**Exhibitions**
Wadsworth Atheneum, Hartford, Connecticut
Galerie Daniel Templon, Paris
Patrick Verelst, Anvers
Galerie Paul Maenz, Cologne
Galleria Maria Diacono, Rome

**Group Exhibitions**
"Issues : New Allegory I," Institute of Contemporary Art, Boston
Documenta 7, Kassel
"Transavanguardia," Galleria Civica, Modena
Anthony D'Offay, London
Holly Solomon Gallery, New York

Galleria Emilio Mazzoli, Modena
Fast, Alexander F. Milliken
Inc., New York
Marlborough, New York
"Zeitgeist," Martin-Gropius-
Bau, Berlin

**180**

**Bibliography**
Berger, Danny : "Francesco
Clemente at the
Metropolitan : An Interview,"
*The Print Collector's
Newsletter,* New York, Bd.
XIII, Nr. 1, March/April
Buchloh, B.H.D. :
"Autoritarisme et régression,"
éd. Territoires, Paris
De Ak, Edit & Cortez, Diego :
"Baby Talk," *Flash Art,* Milano,
n. 107
Kontova, Helena : "From
Performance to Painting,"
*Flash Art,* Milano, n. 106
Ratcliff, Carter : "On
Iconography and Some
Italians," *Art in America,* New
York, September
Stevens, Mark : "Revival of
Realism : Art's Wild Young
Turks," *Newsweek,* New
York, Bd. XCIX, Nr. 23, June 7
Strasser, Catherine :
"Francesco Clemente, le son
du corps," *Art Press,* Paris,
n. 59, mai
Tucker, Marcia : "An
Iconography of Recent
Figurative Painting : Sex,
Death, Violence, and the
Apocalypse," *Artforum,* New
York, Bd. XX, n. 10, June
*Catalogues :* Kassel. Martin-
Gropius-Bau, Berlin

**Cobo, Chema**
Tarifa, Cadiz, 1952 ; lives in
Madrid

**Exhibition**
The Institute for Art and Urban
Resources, Inc., P.S. 1, New
York

**Group Exhibitions**
"Pintores Andaluces que viven
fuera de Andalucía," Museo
de Arte Contemporáneo,
Seville ; Palacio de la
Diputación, Cadiz ; Centro
Cultural de la Villa de Madrid,
Madrid ; Museo de Bellas
Artes Bilbao
"New Spanish Figuration,"
Kettle's Yard Gallery,
Cambridge ; Institute of
Contemporary Arts, London ;
Cartwright Hall, Bradford ;
Third Eye Center, Glasgow
"Chicago Art Fair 1982," Navy
Pier, Chicago
"26 Pintores 13 Críticos," La
Caixa, Traveling exhibition in
Spain
"Carnegie International,"
Museum of Art, Pittsburgh ;
Seattle Art Museum, Seattle ;
Western Australia Art Gallery,
Perth ; National Gallery of
Victoria, Melbourne ; Art
Gallery of South Wales, Sydney
"Iª Bienal Nacional de las
Artes Plásticas," Saragosse,
Traveling exhibition in Spain
"2ᵗᵉ Internationale
Jugendtriennale der
Zeichnung," Nuremberg
"El Paisaje en la Pintura

Andaluza Actual," Galería
Antohio Machado, Madrid
"Otras Figuraciones," La
Caixa, Madrid

**Bibliography**
Bumpus, Judith : "New
Spanish Figuration," *Art and
Artists,* August
Calvo Serraller, Francisco :
"The New Figurativists," *Flash
Art,* n. 107, May
Calvo Serraller, Francisco,
catalogue, Kettle's Yard
Gallery, Cambridge
Cork, Richard : "Art on View,"
*Evening Standard,* London,
September 16
Feaver, William : "New
Spanish Figuration," *Vogue,*
London, September
Feaver, William : "New
Spanish Figuration," *The
Observer,* London, Sept. 5
Januszczak, Waldemar :
"New Spanish Figuration,"
*The Guardian,* London, Sept. 7
Lewison, Jeremy : catalogue,
Kettle's Yard Gallery,
Cambridge
Mullaly, Terence : "Full of
Spanish Promise," *Daily
Telegraph,* London, September
Pastor, Perico : "Spain : The
Painting is not the Only
Painting," *Art News,* New
York, January
Russell Taylor, John :
"Madrid and the Picasso
Legacy," *The Times,* London,
December 22
Russell Taylor, John :
"Headlong Flight from Ghastly
Good Taste," *The Times,*
London, July 20
Russell Taylor, John, *The
Times,* London, September 7
Shepherd, Michael : "New
Spanish Figuration," *Arts
Review,* London, July 30
Shepherd, Michael : "Spanish
Blend," *Sunday Telegraph,*
London, July 25
Tio Bellido, Ramón : "Notes
de voyage : Madrid-
Barcelona," *Axe Sud,*
Toulouse, n. 3, 1ᵉʳ trimestre
Vaizey, Marina : "Images for
the Consumer," *The Sunday
Times,* London, September 5
*Catalogues :* Kettle's Yard
Gallery, Cambridge

**Combas, Robert**
Lyon, 1957 ; lives in Paris

**Exhibitions**
Baronian-Lambert, Gand
Galerie Swart, Amsterdam
Galerie Yvon Lambert, Paris

**Group Exhibitions**
Holly Solomon Gallery, New
York
Galerie Beaubourg, Paris
Galerie Eva Keppel, Düsseldorf
Galerie Yvon Lambert, Paris
"L'Air du Temps, Figuration
libre en France," Galerie d'Art
Contemporain des Musées de
Nice, Nice
"Ateliers 81-82," ARC 2,
Musée d'Art Moderne de la
Ville de Paris, Paris

**Bibliography**
Couturier, Elisabeth :

"Lanneau, Combas. Société
Cacharel," *Art Press,* Paris,
n. 55, février
Francblin, Catherine : "Free
French," *Art in America,* New
York, September
Marcelis, Bernard : "Robert
Combas," *Art Press,* Paris,
n. 57, mars
Poinsot, Jean-Marc : "New
Painting in France," *Flash Art,*
Milano, n. 108
Prévost, Jean-Marc :
"Combas," *Flash Art,* Milano,
n. 108
Strasser, Catherine : "Robert
Combas," *Art Press,* Paris,
n. 58, mai
*Catalogues :* Galerie d'Art
Contemporain des Musées de
Nice, Nice. ARC 2, Musée
d'Art Moderne de la ville de
Paris. Statements New York
82, Association Française
d'Action Artistique

**Costus (Juan Carrero &
Enrique Naya)**
Carrero, Juan : Palma de
Majorca 1955, lives in Madrid
Naya, Enrique : Cadiz 1953,
lives in Madrid

**Group Exhibitions**
"Pintores Andaluces que viven
fuera de Andalucía," Palacio
de la Diputación, Cadiz ;
Museo de Arte
Contemporáneo, Seville ;
Centro Cultural de la Villa de
Madrid, Madrid ; Museo de
Bellas Artes, Bilbao ; Museo
Municipal, Jaen
Galería Angulo, Ceuta
"New Spanish Figuration,"
Kettle's Yard Gallery,
Cambridge ; Institute of
Contemporary Arts, London ;
Cartwright Hall, Bradford ;
Third Eye Center, Glasgow

**Bibliography**
Bumpus, Judith : "New
Spanish Figuration," *Art and
Artists,* August
Calvo Serraller, Francisco,
catalogue, Kettle's Yard
Gallery, Cambridge
Cork, Richard : "Art on View,"
*Evening Standard,* London,
September 16
Feaver, William : "New
Spanish Figuration," *Vogue,*
London, September
Feaver, William : "New
Spanish Figuration," *The
Observer,* London,
September 5
Januszczak, Waldemar :
"New Spanish Figuration,"
*The Guardian,* London,
September 7
Lewison, Jeremy : catalogue,
Kettle's Yard Gallery,
Cambridge
Lewison, Jeremy : "Costus,"
*Flash Art,* Milano, n. 107
Mullaly, Terence : "Full of
Spanish Promise," *Daily
Telegraph,* London, September
Queralt, Rosa : "Costus," *Art
Press,* Paris, n. 56, février
Russell Taylor, John :
"Headlong Flight from Ghastly
Good Taste," *The Times,*
London, July 20
Russell Taylor, John, *The*

*Times,* London, September 7
Shepherd, Michael : "New
Spanish Figuration," *Arts
Review,* London, July 30
Shepherd, Michael :
"Spanish Blend," *Sunday
Telegraph,* London, July 25
Tio Bellido, Ramón : "Notes
de voyage Madrid-Barcelona,"
*Axe Sud,* Toulouse, n. 3,
1ᵉʳ trimestre
Vaizey, Marina : "Images for
the Consumer," *The Sunday
Times,* London, September 5
*Catalogue :* Kettle's Yard
Gallery, Cambridge

**Cox, Stephen**
Bristol, Great Britain, 1946 ;
lives in London

**Exhibitions**
Galleria La Salita, Rome
"XXV Festival dei due Mondi,"
Palazzo del Commune, Spoleto

**Group Exhibitions**
"British Sculpture in the
Twentieth Century,"
Whitechapel Art Gallery,
London
"Generazioni in confronto,"
University of Rome
"Aperto 82," Biennale
Venice
"Englische Plastik Heute,"
Kunstmuseum, Lucerne
"A Journey across
Contemporary Art with
Marilena Bonomo," Centre
d'art contemporain, Genève

**Bibliography**
Alleu : "Englische Plastik
Heute — im Kunstmuseum
Luzern," *Aargauer Anzeiger-
Wochenend Magazin,* Aug.
Caroli, Flavio : *Magico
Primario, L'arte degli anni
Ottanta,* Milano
Caroli, Flavio : "Protagonisti
tra tanti Maestri i Giovani
Artisti Italiani," *Il Globo,* 12
Giugno
Caroli, Flavio : I Mondiali dei
Giovani, *Bolaffi Arte,* n. 121,
Luglio-Agosto
D'Amico, Fabrizio : "La Pietra
Ferita di Cox," *La Repubblica,*
Roma, 28.2/1.3
Feaver, William : "Soft Core
Chic at the Venice Biennale,"
*Art News,* September
Kunz, Martin : "Neue Skulptur
auf Biespiel englischer
Kunstler," *Kunstbulletin,* Bern,
N. 6, Juni
Lux, Simonetta : "Stephen
Cox, Galleria La Salita," *Flash
Art Italiana,* Milano, Maggio
Monteil, Annemaie : "Englische
Plastik Heute," *Basler Zeitung,*
Basel, 26 Juli
Newman, Michael : "British
Sculpture : The Empirical
Object," *Art in America,* New
York, April
Parmesani, Loredana :
"Stephen Cox Artra Studio,"
*Flash Art Italiana,* Milano,
n. 106
Vaizey, Marina : "England
Takes the Honours Report
from Venice," *The Sunday
Times,* London, 13th June
Wechsler, Max : "Fund
Bildhauer aus England,"

*Vaterland,* Luzern, 15 Juli
Zellweger, Harry : "Von
Außen nach innen,"
*Suddeutsche Zeitung,*
Stuttgart, 24 Aug.
"Englische Plastik Heute,"
*Neue Zurcher Zeitung,* Zürich,
26 August
*Catalogues :* Biennale di
Venezia, Electa. Whitechapel
Art Gallery, London

**Cragg, Tony**
Liverpool 1949 ; lives in
Wuppertal, West Germany

**Exhibitions**
Badischer Kunstverein,
Karlsruhe
Kanransha Gallery, Tokyo
Galerie Chantal Crousel, Paris
Nisshin Gallery, Tokyo
Schelmann & Kluser, Munich
Lisson Gallery, London
Konrad Fischer, Düsseldorf
Kröller-Müller Museum, Otterlo
Marian Goodman Gallery, New
York

**Group Exhibitions**
"Young British Sculpture,"
Fruit-Market, Edinburgh
"Aspects of British Art
Today," Metropolitan
Museum, Tokyo, Traveling
exhibition in Japan
"Art and Architecture," ICA,
London
Fifth Triennale India, New Delhi
"De la Catastrophe," Centre
d'art contemporain, Genève
Documenta 7, Kassel
"Leçons de Choses,"
Kunsthalle, Berne ; Musée
Savoisien, Chambéry ; Chalon-
sur-Saône
"Englische Plastik heute,"
Kunsthaus, Lucerne
"Kunst wird Material,"
Nationalgalerie, Berlin
"Choix pour aujourd'hui,"
Centre Georges Pompidou,
Paris
"Neue Skulptur," Galerie
nächst St. Stephan, Vienna
"British Sculpture in the
Twentieth Century,"
Whitechapel Art Gallery,
London

**Bibliography**
Cragg, Tony : "Street Life,"
*Furor,* Genève, n. 5, janvier
Lyton, Norbert : "Introduction
to the Tony Cragg Exhibition,"
in catalogue Tony Cragg, Fifth
Triennale India, New Delhi
Martin, Jean-Hubert :
Entretien avec Tony Cragg,
catalogue, Kunsthalle, Bern
Maubant, Jean-Louis :
"Découpage/Collage à propos
de Tony Cragg," *Cahiers du
CRIC,* Le Nouveau Musée,
Limoges-Lyon, mai
Newman, Michael : "Vom
Konzept zum Symbol,"
catalogue, Badischer
Kunstverein, Karlsruhe
Newman, Michael : "New
Sculpture in Britain," *Art in
America,* New York,
September
Newman, Michael : "Tony
Cragg : Fragments and
Emblems," catalogue
Kunstmuseum Luzern

Nuridsany, Michel : "Tony Cragg," *Art Press*, Paris, n. 60, juin
*Catalogues* : Fifth Triennale India, New Delhi. Galerie nächst St. Stephan, Wien. Whitechapel Art Gallery, London 1981. The British Council & Metropolitan Museum, Tokyo. Centre d'art contemporain, Genève. Kassel. Centre Georges Pompidou, Paris. Kunsthalle, Berne. Centre d'Art Contemporain, Genève. Badisher Kunstverein, Karlsruhe

**Craig-Martin, Michael**
Dublin 1941 ; lives in London

Exhibition
Waddington Galleries, London

Group Exhibitions
Fourth Triennale India
"Aspects of British Art Today," Tokyo Metropolitan Art Museum, Tokyo ; Tochigi Prefectural Museum of Fine Arts, Utsunomiya ; The National Museum of Art, Osaka ; Fukuoka Art Museum, Fukuoka ; Hokkaido Museum of Modern Art, Sapporo
*Catalogues* : The British Council & Tokyo Metropolitan Museum of Art, Tokyo

**Cucchi, Enzo**
Morro d'Alba 1950 ; lives in Ancona

Exhibitions
Zeichnungen, Kunsthaus, Zürich ; Museum Groningen, The Netherlands
Anthony D'Offay, London
Paul Maenz, Cologne

Group Exhibitions
"Avanguardia Transavanguardia," Mura Aureliane, Rome
"Transavanguardia," Galleria Civica, Modena
"'60'80," Stedelijk Museum, Amsterdam
Documenta 7, Cassel
"Zeitgeist," Martin-Gropius-Bau, Berlin
"Italian Art Now : An American Perspective," Solomon R. Guggenheim Museum, New York
"Scultura andata, scultura storna," Galleria Emilio Mazzoli, Modena
Galleria Persano, Turin
Galleria Giuliana de Crescenzo, Rome
Marlborough, New York
"Mythe, drame, tragédie," Musée d'art et d'industrie, Saint-Étienne

Bibliography
Cucchi, Enzo : "Di certo comunque c'è che l'immagine," catalogue. Galerie Paul Maenz, Köln, 1981-82
Groot, Paul : "Enzo Cucchi," *Flash Art*, Milano, n. 106
Hughes, Robert : "Wild Pets, Tame Pastiche," *Time*, New

York, Bd. 119, Nr 17, April 26
Panicelli, Ida : "Italian Art Now : An American Perspective," *Flash Art*, Milano, n. 108
Payant, René : "A propos de Sandro Chia et d'Enzo Cucchi," *Art Press*, Paris, n. 57, mars
Schjeldahl, Peter : "Treachery on the High C's," *The Village Voice*, Bd. XXVII, Nr. 17, April 27
*Catalogues* : Mura Aureliane, Roma, Electa. Stedelijk Museum, Amsterdam. Kassel. Martin-Gropius-Bau, Berlin. Solomon R. Guggenheim Museum, New York. Galleria Emilio Mazzoli, Modena. Musée d'art et d'industrie, Saint-Étienne. Galerie Paul Maenz, Köln.

**Davies, John**
Cheshire 1946 ; lives in Kent, G.B.

Exhibitions
Badischer Kunstverein, Karlsruhe
Ferens Art Gallery, Hull

Group Exhibitions
"Milestones in Modern Britisch Sculpture," Mappin Art Gallery, Sheffield
"British Sculpture in Twentieth Century," Whitechapel Art Gallery, London
"Aspects of British Art Today," Tokyo Metropolitan Art Museum,. Tokyo ; Tochigi Prefectural Museum of Fine Arts, Utsunomiya ; The National Museum of Art, Osaka ; Fukuoka Art Museum ; Hokkaido Museum of Modern Art, Sapporo

Bibliography
Kinmonth, Patrick : "Spotlight. John Davies Watching & Waiting," *Vogue*, September
"Jasia Reichardt on John Davies," *Studio International*, vol. 195, n. 993/4
*Catalogues* : Whitechapel Art Gallery, London. Badische Kunstverein, Karlsruhe. The British Council & Tokyo Metropolitan Museum of Art, Tokyo

**Davila, Juan**
Santiago, Chile, 1946 ; lives in Melbourne, Australia

Exhibitions
Roslyn Oxley Gallery, Sydney
Tolarno Galleries, Melbourne

Group Exhibitions
"Vision in Disbelief," Fourth Biennale of Sydney, Art Gallery of New South Wales, Sydney
"Popism," National Gallery of Victoria, Melbourne

**Décary, Marie**
Lachine, Quebec, 1953 ; lives in Montreal

Exhibitions
Exposition à l'occasion du Colloque international sur la recherche relative aux femmes organisé par l'institut Simone de Beauvoir, Hall de l'Université Concordia

Group Exhibitions
"Les rendez-vous d'automne," Cinémathèque québécoise, Montreal
"Art et Féminisme," Musée d'art contemporain, Montreal

Bibliography
Tourangeau Jean : "Art et féminisme," *La Presse*, Montréal, 20 mars
*Catalogue* : Musée d'Art Contemporain, Montréal

**Dimitrijevic, Braco**
Sarajevo, Yougoslavia, 1948 ; lives in London

Group Exhibitions
"Culturescapes," Deweer Art Gallery, Zwegenottegen
Biennale Venice
"Aspects of British Art Today," Tokyo Metropolitan Art Museum, Tokyo ; Tochigi Prefectural Museum of Fine Arts, Utsunomiya ; The National Museum of Art, Osaka ; Fukuoka Art Museum, Fukuoka ; Hokkaido Museum of Art, Sapporo

Bibliography
*Catalogues* : Biennale di Venezia, Electa
The British Council & Tokyo Metropolitan Art Museum, Tokyo

**Dine, Jim**
Cincinnati, 1935 ; lives in U.S.A.

Exhibition
Waddington Galleries, London

Group Exhibitions
Collection du Musée de Gand, Palais des Beaux-Arts, Bruxelles

Bibliography
Liebmann, Lisa : Jim Dine, *Artforum*, New York, February
*Catalogue* : Museum van Hedendaagse Kunst, Gent

**Di Rosa, Hervé**
Sète, France, 1959 ; lives in Paris

Exhibitions
Galerie Eva Keppel, Düsseldorf
Galerie Swart, Amsterdam
Galerie Gillepsie-Laage-Salomon, Paris

Group Exhibitions
"L'Air du Temps, Figuration Libre en France," Galerie d'Art Contemporain des Musées de Nice, Nice
"Four Contemporary French Artists," Holly Solomon Gallery, New York
Galerie Catherine Issert, Saint-Paul-de-Vence

Salon de Montrouge, Montrouge, Hauts de Seine
"École Normale and Friends," Galerie Hartmut Beck, Frauen Museum, Bonn
"Réseau Art," organisé sur panneaux d'affichage par Art & Prospect, Paris
"L'Art en Sous-Sol ou Félix Potin vu par le Groupe Figuration Libre," Métrobus Station Invalides, Paris
121 Art Gallery, Antwerp, Belgium
Galerie Swart, Amsterdam
"Figuration Libre," Galleria Fernando Pellegrino, Bologna
"Figuration Libre," Galleria Marilena Bonomo, Bari, Italy
"Peinture en Direct," Gare Montparnasse, Paris, pour le journal *Actuel*
"Peinture en Direct par les Artistes de la Figuration Libre," Comédie de Caen, France

Bibliography
Francblin, Catherine : "Free French," *Art in America*, New York, September
Lamarche-Vadel, Bernard : "Finir en Beauté," *Artistes*, Paris, n. 9-10
Poinsot, Jean-Marc : "New Painting in France," *Flash Art*, Milano, n. 108, Summer
Vautier, Ben : "Pour et Contre Combas et Di Rosa," *Flash Art*, Milano, n. 104
*Arts*, Paris, n° 57, mars
*Art Press*, Paris, n° 58, avril
*Le Quotidien de Paris*, Paris, 3 mai
*Catalogues* : Galerie d'Art Contemporain des Musées de Nice, Nice

**Dubuffet, Jean**
Le Havre, France, 1901, lives in Paris

Exhibitions
The Waddington Galleries, Toronto
"Les Psychosites," Galerie Jeanne Bucher, Paris
Studio Cannaviello, Milan
Kunsthalle, Tübingen

Group Exhibitions
Louisiana, Humlebæk, Denmark
"Revolutionary Figurations : From Cezanne to the Present," Bridgestone Museum, Tokyo

Bibliography
*Catalogue* : Louisiana, Humlebaek. Bridgestone Museum, Tokyo

**Efrat, Benni**
Beirut, Lebanon, 1938, lives in New York

Exhibition
Galerie de France, Paris

Bibliography
Le Bot, Marc : "Benni Efrat et les paradoxes," *La Quinzaine littéraire*, Paris, 16 octobre
Sgan-Cohen, Michael : "Benni Efrat, dynamique de la

lumière," *Art Press*, Paris, n. 59, mai
Slama, Jean-Luc : "La dialectique de Benni Efrat," *Réalités d'Israël*, n. 99
Gintz, Claude : "Benni Efrat," *Art Press*, Paris, n. 64, novembre
*Catalogue* : Galerie de France, Paris

**El Attar, Hamdi**
Cairo 1938 ; lives in Kassel

Group Exhibitions
Stoffwechsel (Textile Metabolism), K 18, Kassel

Bibliography
*Catalogue* : K 18, Kassel

**Eldred, Dale**
Minneapolis, Minnesota, 1934 ; lives in Kansas City, Missouri

Exhibitions
"Phoenix Project," Phoenix Art Museum, Phoenix, Arizona
"Dale Eldred Helsinki Project," Helsingin Kaupungin Taidemuseo & Jugendsali Museum, Helsinki, Finland
"Line of Fire," on the Danube River, Ars Electronica, Linz, Austria. Sky Art Conference, sponsored by the Massachusetts Institute of Technology (M.I.T.)

Bibliography
"Helsinki project," *Artforum*, New York, Summer
"Helsinki Project," *Taide*, Helsinki, March
*Hokki*, Helsinki, April
*Suomen Kuvalehti*, Helsinki, June 26
*Nuance* (Northrup University Magazine), International Issue, April-May
*Catalogue* : Helsingin Kaupungin Taidemuseo, Helsinki. *AIA Journal*, February

**Elk, Ger van**
Amsterdam 1941, lives in Amsterdam

Exhibitions
Serpentine Gallery, London
Arnolfini Gallery, Bristol
Karen & Jean Bernier, Athens
Marian Goodman Gallery, New York

Group Exhibitions
'60'80, Stedelijk Museum, Amsterdam
Documenta, Kassel
"Art & Project," Amsterdam
Galerie Durand-Dessert, Paris

Bibliography
Einzig, Hetty : "Ger van Elk," *Art Monthly*, London, n. 54, March
Groot, Paul : "Ger van Elk," *Flash Art*, Milano, n. 108, Summer
Hill, Peter : "Ger van Elk at the Fruitmarket," Edinburgh, *Artscribe*, London, n. 33, February
Kuspit, Donald B. : "Ger van

Elk, Marian Goodman Gallery," *Art in America,* New York, February
Linker, Kate : "Ger van Elk, Marian Goodman Gallery," *Artforum,* January
*Catalogues* : Stedelijk Museum, Amsterdam. Kassel. Serpentine Gallery, London

**En Avant Comme Avant**
A.B.S. : Aix-les-Bains 1958 ; lives in Paris
Bouquerel, Rodolphe : Paris 1948 ; lives in Paris
Chardin, Pascal : Paris 1958 ; lives in Paris
Deroo, Eric : Paris 1952 ; lives in Paris
Sourdille, Blaise : Paris 1953 ; lives in Paris
Titus : Paris 1951 ; lives in Paris
Trier, Michael : Cologne 1954 ; lives in Paris

**Exhibitions**
Galerie Eric Fabre, Paris
Galerie Détails, Paris
Galerie Corinne Hummel, Basel
Galleria Diagramma, Milan
Galleria Luciano Inga-Pin, Milan
Int. Kunstmark, Düsseldorf

**Group Exhibitions**
"Ateliers 81-82," ARC, Musée d'Art Moderne de la Ville de Paris, Paris
"L'Air du Temps, Figuration Libre en France," Galerie d'Art Contemporain des Musées de Nice, Nice
Documenta 7, Kassel
"Stoffwechsel," K 18, Kassel
Mécénat Industriel, Avignon

**Bibliography**
Artaud, Evelyne : "En Avant comme Avant," *Arts,* Paris, n. 47
Dagbert, Anne : "En Avant comme Avant, Galerie Eric Fabre," *Art Press,* Paris, n. 59, mai
Gassert, Siegmar : "Art contemporain : En Avant comme Avant," *Basler Zeitung,* Basel, n. 227, September 29
Joppolo, Giovanni : "L'aire post-moderne," *Opus International,* Paris, n. 84, printemps
Lévêque, Jean-Jacques : "Les derniers peintres à la mode," *Les Nouvelles Littéraires,* Paris, mai
Manescau, J. : "En Avant comme Avant : les sept samouraï de la peinture. Première exposition au Musée d'Art Moderne," *IL,* mars
Schneider, Pierre : "Style rockoco," *L'Express,* Paris, 13-19 août
Tronche, Anne : "Polémique autour de la "bad Painting," *Arts,* Paris, mai
*Connaissance des Arts,* Paris, juin
*Flash Art,* Milano, summer
*Jardin des Modes,* Paris, mai, n. 52
*Tages-Anzeiger,* Zurich, 5 Aug.
*Les Cahiers théoriques d'En Avant comme Avant*

*Catalogues* : Musée d'Art Moderne de la Ville de Paris, Paris. Galerie d'Art Contemporain des Musées de Nice, Nice. Kassel. K 18, Kassel

**Englund, Lars**
1933, lives in Stockholm

**Exhibition**
Galerie Astley, Skinnskatteberg, Sweden

**Group Exhibitions**
"EKO," Moderna Museet, Stockholm
"Sleeping Beauty - Art Now," Guggenheim Museum, New York ; Museum of History, Philadelphia.
Bonlow Gallery, New York

**Bibliography**
Granath, Olle : "3 + 3 = Världen utan återvändo," *Moderna Museet,* Stockholm, N. 1

**Enokura, Koji**
Tokyo 1942 ; lives in Tokyo

**Exhibitions**
Ryo Gallery Ryo, Kyoto
Lumière Gallery, Yamagata

**Group Exhibitions**
"Japan 70," Institute for Cultural Development, Seoul, Korea
"Aspects of Contemporary Japanese Oil Painting," Prefectural Modern Art Museum, Toyama

**Bibliography**
Nakamura, Keiji : "Koji Enokura at the Ryo Gallery," *Yomiuri,* June 11
*Catalogue,* Institute for Cultural Development, Seoul, Korea

**Erro**
Olafsvik, Iceland, 1932 ; lives in Paris and Bangkok

**Exhibitions**
"Erro, peintures politiques," Maison de la Culture, Chalon-sur-Saône, France ; Galerie Jan Six, Paris
Norraena Husid, Reykjavik, Iceland
FIAC, Galerie Le Dessin, Paris

**Group Exhibitions**
"Des Murs en France," Angoulême, France
Traveling exhibition organized by P.A.R.C., Montpellier ; Nîmes ; Perpignan ; Béziers
"Paris, 1960-1980," Museum des 20. Jahrhunderts, Vienna

**Bibliography**
Asgeirsson, Bragi : "Erro, 1001 nott geimfarar," *Morgunblaðid,* Reykjavik, 22-9
Bergsson, Guðbergur : "Erro, Goði Hirðinn," *Helgar Posturinn,* Reykjavik, 24-9
Bragadottir, Agnes : "Erro," *Timinn,* Reykjavik, 5-7
Cabanne, Pierre : "Un Erro de

légende," *Elle,* Paris, 3 mai
Chalumeau, Jean-Luc : "Erro," *Arts,* Paris, 23 avril
Diehl, Gaston : Erro, *Nouvelles de France,* 1er mai
Gunnlaugsson, Hrafn : catalogue, Norraena Husid, Reykjavik
Hahn, Otto : "L'ogre mangeur d'actualité," *L'Express,* Paris, 30 avril
Kvaran, Gunnar B., *Dagbladid Visir,* Reykjavik, 7-8
Lévêque, Jean-Jacques : "Le discours sur une folie ordinaire," *Le Quotidien du Médecin,* Paris, 23 avril
Lévêque, Jean-Jacques, *Les Nouvelles Littéraires,* Paris, 14 avril
Runolfsson, Halldor B. : "Taknmyndir nutimans," *Thjodviljinn,* 25-9
Tronche, Anne : "Les gaietés de la manipulation," *Arts,* Paris, n. 56
"La peinture d'Erro," *Midi Libre,* 5 juin
"Deux 'narratifs' face au pouvoir," *Midi Libre,* 4 septembre
"Erro et Jorda aux tours narbonnaises," *L'Indépendant,* 25-8
*Catalogues* : Norraena Husid, Reykjavik. Maison de la Culture de Chalon-sur-Saône & Galerie Jan Six, Paris

**Etter, Olivia**
Zurich 1956, lives in Zurich

**Exhibition**
St. Galerie, Saint Gall

**Group Exhibition**
Neue Skulptur, Galerie nächst St. Stephan, Vienna

**Bibliography**
*Catalogue* : Galerie nächst St. Stephan, Wien

**Fetting, Rainer**
Wilhemshaven, West Germany, 1949 ; lives in Berlin

**Exhibitions**
Mary Boone Gallery, New York
Anthony D'Offay, London
Galerie Paul Maenz, Cologne

**Group Exhibitions**
"Zehn Künster aus Deutschland," Folkwang Museum, Essen
"Zwolf Künstle aus Deutschland," Kunsthalle, Basel ; Museum Boymans-van Beuningen, Rotterdam
"Aperto 82," Biennale Venice
Spiegelbilder, Kunstverein, Hanover
"Gefühl und Härte," Kulturhuset, Stockholm ; Kunstverein, Munich
"The Pressure to Paint," Marlborough Gallery, New York
"La rage de peindre," Musée des Beaux-Arts, Lausanne
"Zeitgeist," Berlin
"Im Westen nichts Neues," Centre d'art contemporain, Genève ; Neue Galerie, Sammlung Ludwig, Aachen

**Bibliography**
Bastian, Heiner : "Bilder von Rainer Fetting, Bilder in Berlin," *Du,* Zurich, Januar
Faust, Wolfgang Max & De Vries, Gerd : "Hunger nach Bildern," Köln
Kuspit, Donald B. : "Acts of Aggression : German Painting Today," *Art in America,* New York, September
Liebmann, Lisa : "Rainer Fetting at Mary Boone," *Art in America,* New York, February
Simmen, Jeannot L. : "New Painting in Germany," *Flash Art,* Milano, n. 109, November
Zimmer, William : "Blitzkrieg Boppt, Why Germans Can't Paint," *Soho News,* New York
"Deutsche Kunst, hier-heute," *Kunstforum,* Mainz, Nr. 47
*Catalogues* : Folkwang Museum, Essen. Kunsthalle, Basel. Biennale di Venezia. Kunstverein, München. Musée des Beaux-Arts, Lausanne. Kunstmuseum Luzern ; Centre d'art contemporain, Genève ; Neue Galerie, Sammlung Ludwig, Aachen. Martin-Gropius-Bau, Berlin

**Figueira, Carlos**
Cape Verde, 1952 ; lives in Basel

**Exhibition**
Galerie Stampa, Basel

**Group Exhibition**
Kunsthalle, Basel

**Bibliography**
Gassert, Siegmar : "Gegenbilder oder was lässt uns leben ?," *Basler Zeitung,* Nr. 20, Montag, 25. Januar
"Jeunes artistes de Suisse," *La Liberté,* 14.2
"Neun Künstler in der Basler Kunsthalle," *Basellandschaftl. Zeitung,* 27.1
"Stampa : Carlos Figueira," *Basler Zeitung,* Nr. 222, Donnerstag, 23. September
"Vom (zu) schnellen Gang der Kunst," *Schaffhauser Nachrichten,* 5.2
*Catalogue* : Kunsthalle, Basel

**Flanagan, Barry**
Prestatyn, Wales, 1941 ; lives in London

**Exhibitions**
Art & Project, Amsterdam
John Hansard Gallery, Southampton, G.B.
Galerie Durand-Dessert, Paris
British Pavilion, Biennale Venice ; Museum Hans Esters, Krefeld, West Germany

**Group Exhibitions**
Documenta 7, Kassel
"British Sculpture in the Twentieth Century," Whitechapel Art Gallery, London
"Aspects of British Art Today," Metropolitan Art Museum, Tokyo ; Tochigi Prefectural Museum of Fine Arts, Utsunomiya ; The

National Museum of Art, Osaka ; Fukuoka Art Museum, Fukuoka ; Hokkaido Museum of Modern Art, Sapporo
"Zeitgeist," Martin-Gropius-Bau, Berlin

**Bibliography**
Dimitrijevic, Nena : "Barry Flanagan," *Flash Art,* Milano, n. 106, February-March
Hilton, Tim & Compton, Michael : catalogue, The British Council, London
Kinmonth, Patrick, *Vogue,* London
*Art Magazine,* London, July
*Stern,* Oktober
*Catalogues* : Kassel. Whitechapel Art Gallery, London. The British Council & Tokyo Metropolitan Art Museum,. Tokyo. Martin-Gropius-Bau, Berlin

**Fromanger, Gérard**
Pontchartrain, Yvelines, 1939 ; lives in Paris

**Exhibitions**
"Entrez dans la danse," mur peint sur une place publique, Dreux, France
"Gérard Fromanger, estampes," French Cultural Center, Peking

**Group Exhibitions**
"Revolutionary Figurations: From Cezanne to the Present," Bridgestone Museum, Tokyo
"New Figurations in France," Seoul Gallery, Seoul, Korea
"Les Hommages," Musée des Beaux-Arts André-Malraux, Le Havre, France
"Le Dessin," Galerie Breteau, Paris
Salon de Montrouge, France
"Où," Galerie Paul Ambroise, Paris

**Bibliography**
Deleuze, Gilles & Peignot, Jérôme : *Des Murs en France,* juillet
Jammes, R. : "Gérard Fromanger," *Nice-Matin,* Nice, 10 juillet
Jouffroy, Alain : "Gérard Fromanger," catalogue. Bridgestone Museum, Tokyo
Jouffroy, Alain : "Gérard Fromanger," catalogue Seoul
Paluet-Marmont, Claudia : "Fromanger — les peintres et la photo," *Galerie des Arts,* avril
"Gérard Fromanger à Dreux," *Écho Républicain,* 5 mai
*Catalogues* : Bridgestone Museum, Tokyo. Galerie Paul Ambroise, Paris

**Garouste, Gérard Roger**
Paris 1946 ; lives in Paris

**Exhibitions**
Galerie Durand-Dessert, Paris
"Dall'Enigma del Canis maior," Museo Civico d'Arte Contemporanea, Gibellina, Italy

**Group Exhibitions**
Holly Solomon, New York

"In Situ," Centre Georges Pompidou, Paris
"Choix pour aujourd'hui," Centre Georges Pompidou, Paris
"Generazioni a confronto," Istituto di Storia dell'Arte dell'Università di Roma
Biennale Venice
"Zeitgeist," Martin-Gropius-Bau, Berlin

**Bibliography**
Calvesti, Mauricio, L'Espresso, 31 ottobre
Cerquant, Jean-Pierre : Un conceptuel tendance Greco, Libération, Paris, 1er avril
Cornand, Brigitte : Garouste et l'esprit du temps, Axe Sud, Hiver 82-83, n° 7
Enrici, Michel, Artistes, Paris, septembre
Garouste, Gérard, catalogue In Situ, Centre Georges Pompidou, Paris
Gintz, Claude, catalogue Statements, New York
Hahn, Otto, Connaissance des Arts, février
Lamarche-Vadel, Bernard, Artistes, Paris
Lemaire, Gérard-Georges, Opus, Paris, n° 87
Metken, Günter : Im zeichen des grossen Hundes, Kunst und Antiquitäten, Münich, Sept.-Okt.
Metken, Günter : Orion und der Grosse Hund, Süddeutsche Zeitung, 13-5
Paparoni, Demetrio, catalogue Dall'Enigma del Canis maior, Museo Civico d'Arte Contemporanea, Gibellina, Italie
Paparoni, Demetrio : La matita del gioco, Sicilia, 14-3
Strasser, Catherine : Éloque du déplacement, Artistes, Paris, n. 9-10
Catalogues : Statements New York 82, Association Française d'Action Artistique. Centre Georges Pompidou, Paris. Biennale di Venezia, Electa. Martin-Gropius-Bau, Berlin

---

**Gasiorowski, Gérard**
Paris 1930, lives in Paris

**Exhibition**
Galerie Adrien Maeght, Paris

**Group Exhibition**
Collection Bernard Lamarche-Vadel, Musée Sainte-Croix, Poitiers

**Bibliography**
Enrici, Michel, Artistes, n. 12
Goldcymer, Gaya, Art Press, Paris, n. 59
Tronche, Anne, Opus, Paris, n. 85
Catalogue : Galerie Adrien Maeght, Paris

---

**Gastini, Marco**
Turin, 1938, lives in Turin

**Exhibitions**
Galleria d'Arte Moderna, Bologna
Städtische Galerie im Lenbachhaus, Munich

**Group Exhibitions**
"Registrazione di Frequenze," Galleria Civica d'Arte Moderna, Bologna
"11 Italienische Künstler in München," Munich
Biennale Venice
"Arte Italiana 1960-1982," Hayward Gallery, London ; ICA, London

**Bibliography**
Catalogue : Arte Italiana, London

---

**Gerchman, Rubens**
Rio de Janeiro, Brazil, 1942 ; lives in Rio de Janeiro

**Group Exhibition**
"O Universo do Futebol," Museum of Modern Art, Rio de Janeiro

**Bibliography**
Canongia, Lígia : "Gerchman Voyeur," Módulo, Rio de Janeiro, n. 69

---

**Geys, Jef**
Leopoldsburg 1939 ; lives in Balen, Belgium

**Exhibition**
Gewad, Gand

**Group Exhibitions**
Collection du Musée d'Art Contemporain de Gand, Palais des Beaux-Arts, Bruxelles
Abdy Maagdendale, Oudenaarde, Belgium

**Bibliography**
Tydschrift Gewad, Jg 2, nr 3
Catalogue : Museum van Hedendaagse Kunst te Gent

---

**Gilbert & George**
Proesch, Gilbert : Dolomites, Italy, 1943
Passmore, George : Totness, Devon, G.B., 1942
lives in London

**Exhibitions**
Anthony D'Offay, London
Sonnabend Gallery, New York
Gewad, Gand

**Group Exhibitions**
Anthony D'Offay, London
"Avanguardia Transavanguardia," Mura Aureliane, Rome
Documenta 7, Kassel
"Aspects of British Art Today," Tokyo Metropolitan Art Museum, Tokyo ; Tochigi Prefectural Museum of Fine Arts, Utsunomiya ; The National Museum of Art, Osaka ; Fukuoka Art Museum, Fukuoka ; Hokkaido Museum of Modern Art, Sapporo
"Zeitgeist," Martin-Gropius-Bau, Berlin

**Bibliography**
Kontova, Helena : "From Performance to Painting," Flash Art, Milano, n. 106, February-March
McEwen, John : "Life and Times : Gilbert & George,"

Art in America, New York, May
Newman, Michael : "Gilbert & George," Flash Art, Milano, n. 106, February-March
Catalogues : Mura Aureliane, Roma, Electa. Kassel. The British Council & Tokyo Metropolitan Art Museum, Tokyo. Martin-Gropius-Bau, Berlin

---

**Golub, Leon**
Chicago 1922, lives in New York

**Exhibitions**
Susan Caldwell Inc., New York
Young Hoffman Gallery, Chicago
"Leon Golub, Mercenaries and Interrogations," ICA, London

**Group Exhibitions**
"Realism & Realities : The Other Side of American Painting, 1940-1960," Rutgers University ; Montgomery Museum of Fine Arts ; University of Maryland
"American Figurative Expressionism 1950-1960," Marilyn Pearl Gallery, New York
"Homo Sapiens," Aldrich Museum, Richfield, Connecticut
"Mixing Art & Politics," Randolph St.Gallery, Chicago
"Selections from the Dennis Adrian Collection," Museum of Contemporary Art, Chicago
"Painting & Sculpture Today," Indianapolis Museum of Art

**Bibliography**
Dreiss, Joseph : "Leon Golub," Arts Magazine, New York, January
Levin, Kim : "Voice Centerfold : Art," Village Voice, New York, January
Lippard, Lucy : "Making Manifest," Village Voice, New York, January 17
Marzorati, Gerald : "Art Picks," The Soho News, New York, January 26
Perrault, John : "Realpolitik," The Soho News, January 26
Tully, Judd : " Flash Art Reviews," Flash Art, Milano, n. 106, Feb-March
Yoskowitz, Robert : "Art Reviews," Arts Magazine, New York, March
Bird, Jon & Newman, Michael, catalogue, ICA, London
Catalogue : ICA, London

---

**Gordillo, Luis**
Séville 1934, lives in Madrid

**Group Exhibitions**
"Artesur," Galería Theo, Valencia
Feria de Arte Contemporáneo "Arco," Madrid
"Pintores Andaluces que viven fuera de Andalucía," Palacio de la Diputación, Cadix ; Museo de Arte Contemporáneo, Seville ; Centro Cultural de la Villa de Madrid
"New Spanish Figuration," Kettle's Yard, Cambridge ; Institute of Contemporary

Arts, London ; Cartwright Hall, Bradford ; Third Eye Center, Glasgow
Chicago Art Fair, Navy Pier, Chicago
"Quatre images séditieuses," Fondation Château de Jau, Cases-de-Penne, France
Carnegie International, Museum of Art, Pittsburgh ; Seattle Art Museum, Seattle ; Western Australia Art Gallery, Perth ; National Gallery of Victoria, Melbourne ; Art Gallery of South Wales, Sydney.
"Otras Figuraciones," La Caixa, Madrid

**Bibliography**
Aguirre, Juan Antonio, catalogue Premios Nacionales de Artes Plasticas 1981, Ministerio de Cultura, Octubre
Bumpus, Judith : "New Spanish Figuration," Art and Artists, August
Calvo Serraller, Francisco, catalogue, Kettle's Yard Gallery, Cambridge
Calvo Serraller, Francisco : "The New Figurativists," Flash Art, Milano, n. 107, May
Cork, Richard : "Art on View," Evening Standard, London, September 16
Feaver, William : "New Spanish Figuration," Vogue, London, September
Feaver, William : "New Spanish Figuration," The Observer, London, September 5
Lewison, Jeremy : catalogue, Kettle's Yard Gallery, Cambridge
Januszczak, Waldemar : "New Spanish Figuration," The Guardian, London, September 7
Mullaly, Terence : "Full of Spanish Promise," Daily Telegraph, London, September
Pastor, Perico : "Spain : The Painting is not the Only Painting," Art News, New York, January
Russell Taylor, John : "Headlong Flight from Ghastly Good Taste," The Times, London, July 20
Russell Taylor, John, The Times, London, Septembre 7
Shepherd, Michael : "New Spanish Figuration," Arts Review, July 30
Shepherd, Michael : "Spanish Blend," Sunday Telegraph, London, July 25
Tio Bellido, Ramón : "Notes de Voyage : Madrid-Barcelona," Axe Sud, Toulouse, n. 3, 1er trimestre
Urrutia, Antonio : "Luis Gordillo," Art Press, Paris, n. 55, janvier
Urrutia, Antonio : "Peinture espagnole 1940-1980," Art Press, Paris, n. 56, février
Urrutia, Antonio : catalogue, Fondation Château de Jau
Urrutia, Antonio : "Gordillo, Barjola, Saura, Equipo Crónica," Axe Sud, Toulouse, n° 4-5, printemps-été
Vaizey, Marina : "Images for the Consumer," The Sunday Times, London, September 5

Catalogue : Kettle's Yard, Cambridge. Premios Nacionales de Artes Plasticas 1981, Ministero de Cultura. Fondation Château de Jau

---

**Graham, Dan**
Urbana, Illinois, 1942 ; lives in New York

**Exhibitions**
Gewad, Gand
Galerie Durand-Dessert, Paris
Nicholas Logsdail Lisson Gallery, London

**Group Exhibitions**
Documenta 7, Kassel
"Thoughts and Action," Laforet Museum, Tokyo ; Tokyo Metropolitan Art Museum
"Progressions numériques dans l'art contemporain," Musée des Beaux-Arts, Besançon ; Musée Rolin, Autun, France

**Bibliography**
Miller, Sanda : Dan Graham, Art Press, Paris, n. 57, mars
Catalogues : Kassel. Laforet Museum, Tokyo

---

**Grand, Toni**
Gallargues, Gard, France, 1935 ; lives in Mouries, Bouches-du-Rhône, France

**Group Exhibitions**
"Choix pour aujourd'hui," Centre Georges Pompidou, Paris
Biennale Venice

**Bibliography**
Girard, Xavier : "L'équivoque de la sculpture," Art Press, Paris, n. 64, novembre
Catalogues : Centre Georges Pompidou, Paris. Biennale di Venezia, Electa

---

**Grützke, Johannes**
Berlin 1937, lives in Berlin

**Exhibitions**
Ladengalerie, Berlin
Galerie Künze, Berlin
Public Press Galerie, Düsseldorf
Kunstverein Neüstadt an der Weinstrasse

**Group Exhibitions**
"Goethe Museum für einen Abend," Frankfort ; Kunstverein, Hanover
Biennale Venice
"Spiegelbilder," Kunstverein, Hanover ; Lehmbruckmuseum, Duisburg ; Haus am Waldsee, Berlin
"Abendmahl," Brüderkirche, Kassel
"Vergil," Kunstverein Wolffenbuttel
"Deutsche Radierer der Gegenwart," Kunsthalle, Darmstadt
Grosze Düsseldorfer Kunstausstellung

**Bibliography**
Catalogue : Biennale di Venezia, Electa

**Gudmundsson, Sigurdur**
Reykjavik, Iceland, 1942 ; lives in Amsterdam

**Group Exhibition**
"'60–'80," Stedelijk Museum, Amsterdam

**Bibliography**
*Catalogue :* Stedelijk Museum, Amsterdam

---

**Guttuso, Renato**
Bagheria, Palermo, Italy, 1912 ; lives in Bagheria and Rome

**Exhibition**
Palazzo Grassi, Venice

**Group Exhibition**
Galleria Gastaldelli, Milan

**Bibliography**
*Catalogue :* Palazzo Grassi, Venezia

---

**Håfström, Jan**
Stockholm, Sweden, 1937 ; lives in Stockholm

**Exhibitions**
Galleriet, Lund, Sweden
Gallery Per Sten, Copenhagen
Galerie Belle, Västerås, Sweden
Galerie Nemo, Eckernförde, West Germany
Künstlerhaus, Hamburg

**Group Exhibitions**
"Materia/Minne," Lunds Konsthall, Lund (Sweden) ; Kunstnerernes Hus, Oslo (Norway) ; Taidehalle, Helsinki (Finland) ; Taidehalle, Pori (Finland) ; Charlottenborg, Copenhagen (Denmark)
"Ibid*.)," Danviken, Stockholm
"Du livre," Musée des Beaux-Arts, Rouen, France

**Bibliography**
Feuk, Douglas : "Jan Håfström," catalogue, Lunds Konsthall, Lund, Sweden
*Catalogue :* Lunds Konsthall, Lund. Danviken, Stockholm

---

**Hamilton, Richard**
London 1922, lives in Oxfordshire, Great Britain

**Group Exhibitions**
"Torden and Wetterling," Gotenburg, Switzerland
"Image and Process," Provincial Museum, Hasselt, Belgium

---

**Haring, Keith**
Kutztown, Pennsylvania, 1958 ; lives in New York

**Exhibitions**
Rotterdam Arts Council, Rotterdam Kunststichting
West Beach Cafe, Venice, California
Tony Shafrazi Gallery, New York
Bonlow Gallery, New York

**Group Exhibitions**
Young Hoffman Gallery, Chicago
"The Agitated Figure," Hall Walls, Buffalo, New York
Wave Hill, Bronx, New York
Holly Solomon Gallery, New York
"The Pressure to Paint," Marlborough Gallery, New York
Ronald Felman Gallery, New York
"Fast," Sandy Milliken Gallery, New York
"Young Americans," Tony Shafrazi Gallery, New York
Larry Gagosian Gallery, Los Angeles
Blum Helman Gallery, New York
Richard Hines Gallery, Seattle, Washington
Documenta 7, Kassel
"The U.F.O. Show," Queens Museum, New York
"New Painting 1 : Americans," Middendorf Lane Gallery, Washington
"Art of the '80's," Wesport Weston Arts Council, Wesport, Connecticut
"Urban Kisses," ICA, London

**Bibliography**
Alinovi, Francesca, *Flash Art* (ed. italiana), Milano, feb.-marzo
Anderson, Alexandra : "Vignettes," *Portfolio Magazine*, New York, July-August
Balet, Marc & Becker, Robert : "Shoe Boxes," *Interview*, New York, October
Brook, Adams : "Keith Haring : Subways Are for Drawing," *The Print Collector's Newsletter*, New York, May-June
De Santis, Tullio Francesco, *Reading Eagle*, January 17
Cortez, Diego : catalogue, Marlborough Gallery, New York
DeAk, Edit & Cortez, Diego : "Baby Talk," *Flash Art* (U.S.A. edition), Milano, n. 107, May
Deitch, Jeffrey, Pincus-Witten, Robert & Shapiro, David : "Keith Haring," Tony Shafrazi Gallery, New York
Donker Duyvis, Paul : catalogue, Museum Journal, Amsterdam
Frackman, Noel & Kaufman, Ruth : "Documenta 7 : The Dialogue and A Few Asides," *Arts Magazine*, New York, October
Gablik, Suzi : "Report from New York, The Graffiti Question," *Art in America*, New York, October
Gablik, Suzi : "Graffiti in Well Lit Rooms," *Brand New York*
Goldstein, Richard : "Art Beat," *The Village Voice*, New York, September 21
Glueck, Grace, *The New York Times*, New York, June 12
Kates, Brian, *Daily News*, New York, June 11 & June 12
LaFerla, Ruth : "The Underground Man," *Daily News Record*, New York, February
Morera, Daniela, *L'Uomo Vogue*, Maggio
Morphett, Alexandra, Princenthal, Nancy & MacNair, Andrew : "Keith Haring

Above Ground," *Express Magazine*, Fall 1982
Nadelman, Cynthia : "Graffiti is a Thing That's Kind of Hard to Explain," *Art News*, New York, October
Norklun, Kathi, *L.A. Weekly*, June 4
Owens, Craig : catalogue, Wave Hill, New York
Rose, Barbara : "Talking About Art," *Vogue Magazine*, August
Schjeldahl, Peter : "Spacey Invaders," *The Village Voice*, New York, September 14
Storr, Robert : "Review," *Art in America*, New York, March
*Catalogues :* Marlborough Gallery, New York. Wave Hill, New York. Kassel. Rotterdam Kunststichting, Rotterdam. Hall Walls, Buffalo. Kassel

---

**Hautman, Sigefride**
Bornem, Belgium, 1955 ; lives in Antwerp

**Group Exhibitions**
"Le désir pictural," Galerie Isy Brachot, Bruxelles
"La Magie de l'Image," Palais des Beaux-Arts, Bruxelles
"Galerie Camomille," Bruxelles

**Bibliography**
Bex, Florent : catalogue, Palais des Beaux-Arts, Bruxelles
Bex, Florent & Van Mulders, Wim : catalogue, Galerie Isy Brachot, Bruxelles
Bex, Florent : "New Painting in Belgium," *Flash Art*, Milano, n. 109, November
*Catalogues :* Palais des Beaux-Arts, Bruxelles. Galerie Isy Brachot, Bruxelles

---

**Hell, ter**
Norden, West Germany, 1954 ; lives in Berlin

**Exhibition**
"Kompliment an alle," P.S.1, New York

**Group Exhibitions**
"Gefühl und Härte," Kulturhuset, Stockholm ; Kunstverein, Münich
"Intern. Jugendtriennale der Zeichnung," Kunsthalle, Nuremberg ; Lausanne ; Lisbon
"Trivial als Signal," Städt. Galerie, Regensburg
"New European and American Drawing," Obazne Galerije, Piran, Yugoslavia

**Bibliography**
Kuspit, Donald B., *Art in America*, New York, February
Maath, B., *Flash Art*, Milano, Summer
Faust, W.M., *Kunstforum International*, Mainz, Januar
*Catalogue :* Kunstverein, München

---

**Hockney, David**
Bradford, Great Britain ; lives in California

**Exhibitions**
"New Portraits," Knoedler

Gallery, London
"The Drawings and Watercolors from the China Diary," Knoedler Gallery, London
"Hockney, Drawings & Prints," Albert White Gallery, Toronto
"David Hockney photographe," Centre Georges Pompidou, Paris
"David Hockney, Graphics 1964-81," Christies' Contemporary Art, New York
"David Hockney, Drawing with a Camera," Andre Emmerich Gallery, New York ; Louver Gallery L.A., Venice, California

**Group Exhibitions**
"Aspects of British Art Today," Tokyo Metropolitan Art Museum, Tokyo ; Tochigi Prefectural Museum of Fine Arts, Utsunomiya ; The National Museum of Art, Osaka ; Fukuoka Art Museum, Fukuoka ; Hokkaido Museum of Modern Art, Sapporo
"British Drawings & Watercolors," Traveling exhibition in China, organized by The British Council ; Royal Scottish Academy, Edinburgh
*Catalogues :* The British Council & Tokyo Metropolitan Art Museum, Tokyo. Centre Georges Pompidou, Paris

---

**Hoshina, Toyomi**
Nagano, Japan, 1953 ; lives in Chiba-Ken

**Exhibitions**
Galerie K, Tokyo
Galerie N.A.F., Nagoya
G. Art Gallery, Tokyo
"By Coast," Hayama seaside, Kanagawa

**Group Exhibitions**
Biennale de Paris, Musée d'Art Moderne de la Ville de Paris
"Open-air works in Hamamatsu," The Imakiri Seaside, Hamamatsu, Japan
"Paper Works," Museum of Modern Art, Seoul, Korea

**Bibliography**
Francblin, Catherine, *Art Press*, Paris, septembre
Hayami, Takashi : catalogue "Japon, 12e Biennale de Paris," The Japan Foundation
Hirano, T., *Ryūkō-Tsūshin*, Tokyo, 5 mai
Moulin, Raoul-Jean, *L'Humanité*, Paris, novembre
Murata, M., *Calendar*, Tokyo, janvier
Tamura, T., *Ryū Seï*, Tokyo, 12 décembre
*Catalogues :* Biennale de Paris, The Japan Foundation

---

**Iida, Yoshikumi**
Totchiki, Japan, 1923, lives in Japan

**Group Exhibitions**
"Japan '70," Institute for Cultural Development, Seoul, Korea

**Bibliography**
*Catalogue :* Institute for Cultural Development, Seoul

---

**Immendorff, Jörg**
Bleckede, Lüneburg West Germany 1945, lives in Düsseldorf

**Exhibitions**
"Café Deutschland/Adlerhälfte," Kunsthalle, Düsseldorf
"Klein Licht für wen ?," Galerie Michael Werner, Cologne
Grüsse von der Nordfront, Galerie Fred Jahn, München
Galerie Strelow, Düsseldorf
Galerie Gewad, Gand
Galerie Templon, Paris
Galerie Springer, Berlin
Ileana Sonnabend Gallery, New York

**Group Exhibitions**
"German Drawings of the 60's," Yale University Art Gallery, New Haven
Studio Marconi, Milan
"Avanguardia-Transavanguardia," Mura Aureliane, Rome
"La Transavanguardia Tedesca," Galleria Nazionale d'Arte Moderna, Republic of San Marino
"Neue Skulptur," Galerie nächst St. Stephan, Vienna
Documenta 7, Kassel
"Zeitgeist," Berlin
"The Pressure to Paint," Marlborough, New York

**Bibliography**
Brandenburger Tor, Museum of Modern Art publication, New York
Gachnang, Johannes : "New German Painting," *Flash Art*, Milano, n. 106, February-March
Gohr, Siegfried : "The Situation and the Artists," *Flash Art*, Milano, n. 106, February-March
Gohr, Siegried : "La peinture en Allemagne : les confusions de la critique," *Art Press*, Paris, n. 57, mars
Immendorff, Jorg & Riegel, Hans Peter : "Was Kunst soll," *OETZ*, Düsseldorf, Nr. 5, Feb
Kuspit, Donald B. : "Acts of Aggression : German Painting Today," *Art in America*, New York, September
Pohlen, Annelie : "Jörg Immendorff," *Flash Art*, Milano, n. 108, Summer
*Catalogues :* Kunsthalle, Düsseldorf. Galerie Michael Werner, Köln. Mura Aureliane, Roma. Galleria Nazionale d'Arte Moderna, Repubblica di San Marino. Galerie nächst St. Stephan, Wien. Kassel. Martin-Gropius-Bau, Berlin. Yale University. Galerie Fred Jahn, München

---

**Irwin, Robert**
Long Beach, California, 1928 ; lives in Los Angeles

**Exhibitions**
"Three Rooms," Louisiana Museum of Modern Art,

Humlebæk, Denmark
The Pace Gallery, New York
Daniel Weinberg Gallery,
Venice, California

**Group Exhibition**
Daniel Weinberg, Los
Angeles-San Francisco

**Installations**
"9 spaces-9 Trees," North
Plaza Public Safety Building,
Seattle, Washington
"Flying V," University
Campus, San Diego, California

**Bibliography**
Weschler, Lawrence :
"Profile," *New Yorker*, New
York, March 8, March 15
Weschler, Lawrence : "Lines
of Inquiry," *Art in America*,
New York, March
Weschler, Lawrence :
"Seeing is Forgetting the
Name of the Thing One Sees,"
University of California Press
*Catalogue* : Louisiana
Museum of Modern Art,
Humlebæk

---

**Jang-Sup, Kim**
Seoul, Korea, 1953, lives in
Seoul

**Group Exhibition**
"11 artists, 11 critics," Seoul
Gallery, Seoul, Korea

---

**Jung-Soo, Shim**
Seoul, Korea, 1942 ; lives in
Seoul

**Group Exhibitions**
"11 artists, 11 critics," Seoul
Gallery, Seoul, Korea

---

**Kapoor, Anish**
Bombay, India, 1954 ; lives in
London

**Exhibitions**
Walker Art Gallery, Liverpool
Lisson Gallery, London

**Group Exhibitions**
"Aperto 82," Biennale
Venice
"Englische plastik heute,"
Kunstmuseum, Lucerne,
Switzerland
Biennale Paris
"Préfiguration du nouveau
musée," Chambéry, France

**Bibliography**
Cork, Richard, *Evening
Standard*, London, May 20
Feaver, William, *Observer*,
London
Kunz, Martin : "Neue Skulptur
aus Biespiel englischer
Kunstler," *Kunstbulletin*, n. 6,
Juni, Bern
Kunz, Martin : catalogue,
Kunstmuseum, Luzern
Livingstone, Marco :
Monograph
MacEwen, John : *Spectator
Magazine*, London, April
Newman, Michael, *Art
Monthly*, London, n. 58,
July/August
Newman, Michael : "Anish
Kapoor," catalogue

---

Kunstmuseum, Luzern
Newman, Michael : "New
Sculpture in Britain," *Art in
America*, New York,
September
Rose, Andrea, *London
Magazine*, London, August
*Catalogues* : Biennale di
Venezia, Electa. Biennale de
Paris. Kunstmuseum, Luzern

---

**Karavan Dani**
Tel Aviv, Israël, 1930 ; lives in
Tel Aviv and Paris

**Exhibitions and Permanent
Projects**
"Selfportraits," Uffizi, Florence
"Makom, Indoor Outdoor
Environment," Tel Aviv
Museum, Tel Aviv
Environmental Sculpture,
"Line in nature," Permanent
Project, Fattoria di Celle,
Pistoia, Italy
"Makom, Indoor Outdoor
Environment," Kunsthalle,
Baden-Baden
"White Square, Environmental
Sculpture," Permanent
Project, Louisiana Museum,
Humlebæk, Denmark

**Group Exhibitions**
"Spazi d'Arte," Fattoria di
Celle, Pistoia, Italy
Tel Aviv Museum, Tel Aviv
Biennale of multiples,
Municipio di Peve di Cadore,
Italy
"Forme del fuoco," Galleria di
Sesto Fiorentino

**Works in Progress**
"Environmental Square,"
Museum Ludwig, Cologne,
West Germany, 1980-86
"Axe majeur," Cergy-
Pontoise, France, 1980-89

**Bibliography**
Barilli, R., *L'Espresso*, 19 sett.
Bargiachi, R., *Domus*, Nov.
Bar Kadma, *Jediot Ahronot*,
15-1
Baruch, A., *Jediot Ahronot*, 29-1
Binder-Hagelstange, Ursula :
"Dem unbekannten Gott,"
*Frankfurter Allgemeine*, 15-7
Bode, Peter M. : "Eine
Treppe durch den Sand,"
*Abendzeitung*, München, 21-7
Boralevi, A., *Panorama*, 26
luglio
Braxmaier, Rainer : "15
Kubikmeter Holz und 20
Tonnen Sand," *Bad. Tagblatt*,
Baden-Baden, 18-6
Castelano, A., *Villa e giardini*,
dicembre
Engel, R., *Maariv*, Jan. 22
Engelhard, Günter : "Am
Fusse der Jakobsleiter,"
*Rheinischer Merkurchrist und
Welt*, 30-7
Goldfine, G., *Jerusalem Post
Magazine*, Jan. 22
Halder, J., *Das Kunstwerk*,
Oktober
Kenan, A., *Jediot Ahronot*,
Jan. 22
Lubecker, P., *Politiken*,
Köbenhavn, Ju. 21, Sept. 23
Maliniak, N., *Haaretz*, Jan. 15
Marquart, Christian : "Wie
altgediente Propheten,"

---

*Stuttgarter Zeitung*, Stuttgart,
24-7
Meinhardt, J., *Kunstforum*, Aug
Monteil, Annemarie :
"Unterwegs : "Wege" und
"Orte" — auch das Ziel ist
wichtig," *Basler Zeitung*,
Basel, 16-7
Michel, Jacques, *Le Monde*,
Paris, 7 octobre
Palosca, T., *La Nazione*,
Firenze, 9 giugno
Restany, Pierre, *Domus*,
luglio-agosto
Vinca-Mazzini, *Bazar*, Sett.-Ott.
Zand, Nicole, *Le Monde*, Paris,
3 mars
*Catalogues* : Tel Aviv
Museum, Tel Aviv. Galleria
degli Uffizi, Firenze.
Kunsthalle, Baden-Baden.

---

**Kawamata, Tadashi**
Hokkaido, Japan, 1953 ; lives
in Tokyo

**Exhibitions**
Kobayashi Gallery, Tokyo
Gallery Haku, Osaka
Kaneko Art Gallery, Tokyo
Appartement n. 205, Tokyo

**Group Exhibitions**
Biennale Venice
Drawing Triennale, Nuremberg
"6 artists," Kaneko Art Gallery,
Tokyo
"3 artists," Haku Gallery, Osaka

**Bibliography**
Chiba, S., *Yomiuri-Shinbun*
Haryu, I., *Shūkan Shʼnchō*
Hirano, T., *Ryuko tsushin*, May
Tanaka, *Sogetsu*, Tokyo, Spring
Tani, A., *Bijutsu-Tēchō*,
October
*Catalogue* : Biennale di
Venezia, Electa

---

**Kawara, On**
Aïchi, Japan, 1933 ; lives in
New York

**Group Exhibitions**
Documenta 7, Kassel
"The 1950's," Metropolitan
Art Museum, Tokyo

**Bibliography**
*Catalogues* : Kassel.
Metropolitan Art Museum,
Tokyo

---

**Kever, Gerard**
Aachen, West Germany,
1956 ; lives in Cologne

**Group Exhibitions**
"10 junge Künstler aus
Deutschland," Museum
Folkwang, Essen
"12 Künstler aus
Deutschland," Kunsthalle,
Basel ; Museum Boymans-van
Beuningen, Rotterdam

**Bibliography**
Marcelis, Bernard :
"Mülheimer Freiheit," *Art
Press*, n. 58, avril
*Catalogues* : Museum
Folkwang, Essen. Kunsthalle,
Basel

---

**Kiefer, Anselm**
Donaueschingen, West
Germany, 1945 ; lives in
Hornbach, Odenwald, West
Germany

**Exhibitions**
Whitechapel Art Gallery,
London
Galerie Paul Maenz, Cologne
Marian Goodman Gallery, New
York
Mary Boone Gallery, New York

**Group Exhibitions**
"Landscapes," Robert Miller,
New York
Anthony D'Offay, London
Studio Marconi, Milan
"Fast," Alexander F. Milliken
Inc., New York
Christian Stein, Turin
"Mythe, Drame, Tragédie,"
Musée d'Art et d'Industrie,
Saint-Étienne
"De la catastrophe," Centre
d'art contemporain, Genève
Documenta 7, Kassel
"Vergangenheit-Gegenwart-
Zukunft," Württembergischer
Kunstverein, Stuttgart
"'60'80," Stedelijk Museum,
Amsterdam
"Avanguardia
Transavanguardia," Mura
Aureliane, Rome
"Zeitgeist," Martin-Gropius-
Bau, Berlin

**Bibliography**
Gachnang, Johannes : "New
German Painting," *Flash Art*,
Milano, n. 106, February-March
Gohr, Siegfried : "The
Situation and the Artists,"
*Flash Art*, Milano, n. 106,
February-March
Kuspit, Donald B. : "Acts of
Aggression : German Painting
Today," *Art in America*, New
York, September
Liebmann, Lisa : "Anselm
Kiefer," *Artforum*, New York,
Summer
Pohlen, Annelie : "Anselm
Kiefer," *Flash Art*, Milano,
n. 105, December 1981-
January 1982
Serota, Nicholas : "Anselm
Kiefer : les plaintes d'un
Icare," catalogue, Museum
Folkwang Essen &
Whitechapel Art Gallery,
London, 1981-82
Zdenck, F. : "Palette mit
Flügeln," catalogue, Museum
Folkwang Essen &
Whitechapel Art Gallery,
London, 1981-82
*Catalogues* : Musée d'art et
d'industrie, Saint-Étienne.
Centre d'art contemporain,
Genève. Kassel. Stedelijk
Museum, Amsterdam.
Museum Folkwang, Essen.
Mura Aureliane, Roma. Martin-
Gropius-Bau, Berlin

---

**Kirkeby, Per**
Copenhagen, Denmark, 1938 ;
lives in Copenhagen and
Karlsruhe

**Exhibitions**
Galerie Michael Werner,
Cologne
Galerie Rudolf Springer, Berlin

---

Nigel Greenwood, London
Stedelijk van Abbemuseum,
Eindhoven

**Group Exhibitions**
Annemarie Verna, Zurich
Galeria Heinrich Ehrhardt,
Madrid
Studio Marconi, Milan
"Avanguardia
Transavanguardia," Mura
Aureliane, Rome
"Transavanguardia Tedesca,"
Galleria Nazionale d'Arte
Moderna, République de
Saint-Marin
Documenta 7, Kassel
"Zeitgeist," Martin-Gropius-
Bau, Berlin

**Bibliography**
Gachnang, Johannes : "New
German Painting," *Flash Art*,
Milano, n. 106, February-March
Gohr, Siegfried : "The
Situation and the Artists,"
*Flash Art*, Milano, n. 106,
February-March
*Catalogues* : Mura Aureliane,
Roma. Galleria Nazionale
d'Arte Moderna, Repubblica di
San Marino. Kassel. Martin-
Gropius-Bau, Berlin

---

**Kirschenbaum, Bernard**
New York 1924, lives in New
York

**Group Exhibitions**
"Englund, Kirschenbaum,
Ohlin," Moderna Museet,
Stockholm
Max Hutchinson Gallery, New
York

**Bibliography**
Granath, Olle : "3 + 3 =
Värlen utan återvändo,"
*Moderna Museet*, n. 1

---

**Kiyomizu, Kyubei**
Aichi, Japan, 1922 ; lives in
Kyoto

**Exhibition**
Fuji TV Gallery, Tokyo ; Kaiser
Center, Oakland, U.S.A.

**Group Exhibition**
"Japan '70," Institute for
Cultural Development, Seoul,
Korea

**Bibliography**
*Catalogues* : Fuji TV Gallery,
Tokyo. Institute for Cultural
Development, Seoul

---

**Knutsson, Anders**
Malmo, Sweden, 1937 ; lives
in New York

**Exhibitions**
Arkiv Museet, Lund, Sweden
Utstallningen i Hylteberga,
Skurup, Sweden

**Group Exhibitions**
Grommet Gallery, New York
Powerhouse Gallery, Montreal
"Materia/Minne," Lunds
Konsthall, Lund, Sweden ;
Kunstnerenes Hus, Oslo,
Norway ; Bjorneborg
Museum, Bjorneborg,

Finland ; Konstnarsgillet, Helsinki, Finland ; Charlottenborg, Copenhagen, Denmark
"Red, Red all Red," Performance with Sandra Binion, Korshack, Chicago Park West Galleries, Detroit Galleri Ressle, Stockholm Stratton Arts Festival, Stratton, Vermont

**Bibliography**
Kahlo, Arden : "Anders Knutsson — Color and Luminous Painting 1975-1981"
Nilsson, Bob : "Anders Knutsson," catalogue, Lunds Konsthall, Lund
*Catalogue :* Lunds Konsthall, Lund

---

**Koshimizu, Susumu**
Uwajima, Ehimé Pref., Japan, 1944 ;
lives in Ikeda, Osaka Pref.

**Group Exhibitions**
"Art and/or Craft — U.S.A. & Japan," MRO Hall, Kanazawa
"Wood and Paper Works '82," Gallery Warehouse, Tokyo
"Sculpture Today," Grand Magasin, Seibu, Tokyo
"Contemporary Paperworks, Japan-Korea," Seoul, Korea
"Japan '70," Institute for Cultural Development, Seoul, Korea

**Bibliography**
"Wood and Paperworks '82," *le Mainichi,* Tokyo, 16 October
*Catalogue :* Institute for Cultural Development

---

**Kounellis, Jannis**
Piraeus, Greece, 1936 ; lives in Rome, Italy

**Exhibitions**
Salvatore Ala, Milan
Galerie Schellmann & Klüser, Munich
Christian Stein, Turin
Galleria d'Anna d'Ascanio, Rome
Stedelijk Van Abbemuseum, Eindhoven ; Whitechapel Art Gallery, London ; Staatliche Kunsthalle, Baden-Baden ; Galeria Fernando Vijande, Madrid

**Group Exhibitions**
"Arte Povera Antiform," CAPC, Bordeaux
Galerie Munro, Hamburg
Galerie Durand-Dessert, Paris
Documenta 7, Kassel
"'60-'80," Stedelijk Museum, Amsterdam
"Choix pour aujourd'hui," Centre Georges Pompidou, Paris
"Zeitgeist," Martin-Gropius-Bau, Berlin

**Bibliography**
Groot, Paul : "The spirit of Documenta 7," *Flash Art,* Milano, n. 108, Summer
Rogozinski, Luciana : "Jannis Kounellis," *Artforum,* New York, March
*Catalogues :* Stedelijk Van

Abbemuseum, Eindhoven. CAPC, Bordeaux. Kassel. Stedlijk Museum, Amsterdam. Centre Georges Pompidou, Paris, Martin-Gropius-Bau, Berlin.

---

**Kracke, Bernd**
Bremen, West Germany, 1954 ;
lives in Cambridge, Massachusetts

**Screenings**
Anthology Film Archives "Four from CAVS/MIT," New York
"Video in Deutschland 1962-1982," Kolnischer Kunstverein, Cologne
"Slow-scan," Biennale Paris, Musée d'art Moderne de la Ville de Paris, Paris
United States Film and Video Festival, Salt Lake City, Utah

**Bibliography**
*Catalogues :* Kolnischer Kunstverein, Köln. Biennale de Paris

---

**Kudo, Tetsumi**
Aomori, Japan, 1935 ; lives in Paris

**Exhibitions**
UNAC Gallery, Tokyo
Galerie Ban, Osaka
Galerie 16, Kyoto
Galerie Ginza Kaigakan, Tokyo
Galerie Takagi, Nagoya

**Group Exhibitions**
"Où," Galerie Paul Ambroise, Paris
"The 1960's : A Decade of Change in Contemporary Japanese Art," National Museum of Modern Art, Tokyo ; National Museum of Modern Art, Kyoto
"Art Festival — Hommage to Shuzo Takiguchi," Toyama Modern Art Museum, Toyama, Japan

**Bibliography**
Baatsch, Henri-Alexis : catalogue, Galerie Paul Ambroise, Paris
Jouffroy, Alain : catalogue, Galerie Paul Ambroise, Paris
Kudo, Tetsumi : "Awaiting the Visit of President Mitterand," *Mainichi,* Tokyo, April 13
Takiguchi, Shuzo : catalogue, Toyama Modern Art Museum, Toyama
"Expression of Space and/or Space of Expression," *Revue de la pensée d'aujourd'hui,* Tokyo, July
Interview with Kudo, *Bijutsu Techo,* Tokyo, September
*Mainichi,* Tokyo, Feb. 2, Apr. 13
*Komei,* Tokyo, Feb. 7
*Yomiuri,* Osaka, Feb. 27
*Sankei,* Osaka, March 1
*Mainichi,* Kyoto, May 18
*Asahi,* Osaka, May 19
*Mainichi,* Osaka, May 2
*Kyoto,* Kyoto, May 22
*Yomiuri,* Osaka, May 27
*Asahi,* Tokyo, Aug. 14
*Catalogues :* National Art

Museum, Tokyo. Galerie Paul Ambroise, Paris. Toyama Modern Art Museum, Toyama

---

**Kusama, Yayoi**
Matsumoto City, Nagano, Japan, 1929 ; lives in Tokyo

**Exhibitions**
Box Gallery, Nagoya
Fuji TV Gallery, Tokyo

**Group Exhibitions**
"The 1960's: A Decade of Change in Contemporary Japanese Art," The National Museum of Modern Art, Tokyo ; The National Museum of Modern Art, Kyoto

**Bibliography**
Shiraïshi, Kazuko : "Yayoï Kusama," *Bijutsu Techo,* June
Kusama, Yayoi : "I Am Very Happy at this time," *Bijutsu Techo,* Tokyo, April
*Catalogues :* Fuji TV Gallery, Tokyo. The National Museum of Modern Art, Tokyo

---

**Kyung-In, Kim**
Inchun, Korea, 1941

**Group Exhibition**
"11 artists, 11 critics," Seoul Gallery, Seoul

---

**Ladda, Justen Houston**
Grevenbroich, West Germany, 1953 ; lives in New York

**Group Exhibitions**
80 Langton St., San Francisco, California
"New Perspectives," Wave Hill, Bronx, New York
"Natural History," Grace Borgenicht Gallery, New York

**Bibliography**
Alinari, Francesca : "Arte della Frontiera," *Flash Art,* Milano, Aprile
Alinari, Francesca : "Come Usare un Quartiere Furioso," *Domus,* Milano, Aprile
Arnim, Gabriele von : "Kunst in den Slums," *Art,* April
Boetger, Susan, *San Francisco Chronicle,* May
Brooks, Rosetta, *ZG Magazine,* London, Spring
Cook, Scott, "Natural History," catalogue, Grace Borgenicht Gallery, New York
Gambrell, Jenney : "Reviews," *Artforum,* New York, January
Gluech, Grace : "A Critic's Guide to the Outdoor Sculpture Scene," *New York Times,* New York, June
Owens, Craig : "New Perspectives," catalogue, Wave Hill, New York
Rayner, Vivien : "Art : An Unnatural' Natural History," *New York Times,* New York, June
Robinson, Walter : "The Thing in the South Bronx," *Art in America,* New York, March
Schjeldahl, Peter : "Situations," *Village Voice,*

New York, June 15
Silber, Alex : "Die Perspective Liegt im Untergrund," *Basler Allgemeine,* Juni
*Catalogues :* Wave Hill, New York. Grace Borgenicht Gallery, New York

---

**Laib, Wolfgang**
Metzingen, West Germany, 1950 ; lives in Biberach/Riss, West Germany

**Group Exhibitions**
Biennale Venice
Documenta 7, Kassel

**Bibliography**
*Catalogues :* Biennale di Venezia, Electa. Kassel

---

**Larivée, Francine**
Montreal, Canada, 1942 ; lives in Montreal

**Group Exhibition**
"Art et Féminisme," Musée d'Art Contemporain, Montreal

**Bibliography**
*Catalogue :* Musée d'Art Contemporain, Montréal

---

**Lavier, Bertrand**
Châtillon-sur-Seine, France, 1949 ; lives in Aignay le Duc, Gold Coast, France

**Exhibitions**
Galerie Michèle Lachowsky, Anvers
"Bonjour, Monsieur Toroni !," Galerie Media, Neuchâtel, Switzerland

**Group Exhibitions**
"Du cubisme à nos jours," Musée Cantini, Marseille
"1982," CCI, Gand
"Neue Skulptur," Galerie nächst St. Stephan, Vienna
"Leçons de Choses," Kunsthalle, Berne ; Musée Savoisien, Chambéry ; Maison de la Culture, Chalon-sur-Saône
Documenta 7, Kassel
Biennale Sydney
Centre d'art contemporain Buisson Rond, Chambéry

**Bibliography**
Blistène, Bernard : "L'objet dé la peinture," *Flash Art,* February
Bordaz, Jean-Pierre : Cinq pièces faciles de Bertrand Lavier : la peinture et ses énigmes, *Opus International,* Paris, n° 86
Callewaert, Marc : "La peinture absurde de Bertrand Lavier," *Gazet van Antwerpen,* Apr. 1
Nuridsany, Michel : "Lavier, entre l'ironie et l'émotion," *Le Figaro,* Paris, 30 juin
Pohlen, Annelie : "Bertrand Lavier," *Artforum,* New York, October
Strasser, Catherine : "Cinq pièces faciles," *Art Press,* Paris, janvier
Tio Bellido, Ramon ;

"Bertrand Lavier, sculpteur," *Axe Sud,* Toulouse, mars
Vaizey, Marina, *The Sunday Times,* London, June 27
"Wer ist das denn ?," *Art,* n° 9, September
*Catalogues :* Galerie nächst St. Stephan, Wien. Kunsthalle, Bern. Kassel. Musée Cantini, Marseille

---

**Leal, Paulo Roberto**
Rio de Janeiro, Brazil, 1946 ; lives in Rio de Janeiro

**Exhibitions**
"A Casa," Galerie GB, Rio de Janeiro
"In-comunicabile/Inter-comunicabile," Musée d'Art contemporain de l'Université de São Paulo, São Paulo
"XIIIe Salon National d'Art," Musée d'Art moderne, Belo Horizonte

**Bibliography**
Màs, Daniel : "Paulo Roberto Leal e sua Armadura de Papel," *Casa Vogue,* São Paulo
Pontual, Roberto : "Que casa é Essa, a da Arte Brasileira ?," *Modulo,* Rio de Janeiro, n. 70

---

**Le Gac, Jean**
Alès, Gard, France, 1936 ; lives in Paris

**Exhibitions**
Galerie France Morin, Montréal
Galerie Catherine Issert, Saint-Paul-de-Vence, France
"Contemporary Artists from France," Hal Bromm Gallery, New York
Galerie l'A, Liège

**Group Exhibitions**
"Five French artists," John Gibson, New York
"Twelve Contemporary French Artists," Albright-Knox Art Gallery, Buffalo
"Faire semblant," Musée de Grenoble
"Paris 1960-80," Museum des 20. Jahrhunderts, Vienna

**Bibliography**
Clair, Jean & Francblin, Catherine : "Le délassement du peintre Jean Le Gac," Musée de Toulon
Dagbert, Anne : "Trouvez l'artiste," interview, *Art Press,* Paris, n. 52, mai
Jean Le Gac, *Art Press,* Paris, n. 52, mai
Poinsot, Jean-Marc : "Le peintre sans œuvre, un art de musée," catalogue, Musée de Grenoble
*Catalogues :* "Statements New York 82," Association Française d'Action Artistique. Musée de Grenoble, Grenoble. Museum des 20. Jahrhunderts, Wien

---

**Lichtenstein, Roy**
New York 1923, lives in New York

**Exhibitions**
"Roy Lichtenstein 1970-

1980," Fort Worth Art Museum, Fort Worth, Texas ; Museum Ludwig, Cologne ; Orsanmichele, Florence ; Musée des Arts Décoratifs, Paris
"Roy Lichtenstein Tapestries," Mattingly Baker Gallery, Dallas, Texas
"Roy Lichtenstein Woodcuts," Gimpel-Hanover & Andre Emmerich Galerie, Zurich
"Roy Lichtenstein at Colorado State University," Colorado State Univversity, Colorado Parrish Art Museum, Southampton, New York

### Group Exhibitions
"Surrealism : Geometric Abstraction. Prints from the Museum of Modern Art," Art Gallery, California State Univbersity, Northridge, California
"A Benefit Sale for Creative Artists Program Service, Inc.," Seventy Arts Limited, New York
"Classical Works : 1962-1967," Blum Helman, New York
"Janie C. Lee Honoring Leo Castelli," Janie C. Lee Gallery, Houston, Texas
"The West As Art : Changing Perceptions of Western Art in California Collections," Palm Springs Desert Museum, Palm Springs, California
"Faces and Portraits," Galerie Beyler, Basel
"New Paintings : Jasper Johns, Ellsworth Kelly, Roy Lichtenstein, Robert Ryman, Frank Stella, Cy Twombly," Young Hoffman Gallery, Chicago
"Works on Paper," Larry Gagosian Gallery, Los Angeles
"New Work by Gallery Artists," Leo Castelli, New York
"Drawings, Watercolors and Prints," Root Art Center, Hamilton College, Clinton, New York
"Art Materialized : Selections from the Fabric Workshop," The New Gallery for Contemporary Art, Cleveland, Ohio ; The Gibbs Art Gallery, Charleston, South Carolina ; The Hudson River Museum, Yonkers, New York ; USF Art Galleries, Tampa, Florida ; The Art Museum and Galleries, Long Beach, California ; Alberta College of Art Gallery, Calgary, Alberta ; Pensacola Museum of Art, Pensacola, Florida
"Hommage to Leo Castelli," Galerie Bischofberger, Zurich
"Castelli and his Artists : Twenty-five Years," La Jolla Museum of Contemporary Art, La Jolla, California ; Aspen Center for the Visual Arts, Aspen, Colorado ; Leo Castelli Gallery, New York ; Portland Center for the Visual Arts, Portland, Oregon ; Laguna Gloria Art Museum, Austin, Texas
"Casting : A Survey of Cast Metal Sculpture in the 80's,"

Fuller Goldeen Gallery, San Francisco
"'60-'80," Stedelijk Museum, Amsterdam
"A Selection of Prints by Hampton Artists," Alex Rosenberg Gallery, New York
"Woodcuts '82," Landfall Gallery, Chicago
"Block Prints," Whitney Museum of American Art, New York
"In Our Time," Contemporary Arts Museum, Houston
"Chia, Cucchi, Lichtenstein, Twombly," Sperone Westwater Fischer, New York

### Bibliography
Cavaliere, Barbara : "Roy Lichtenstein," Flash Art, Milano, n. 105
Lamarche-Vadel, Bernard : "Roy Lichtenstein, entretien au magnétophone," Artistes, Paris, juin-juillet
Catalogue : The Saint Louis Art Museum, Saint-Louis (Catalogue appears in German and Italian editions).

---

## Lohse, Richard Paul
Zurich 1902, lives in Zurich

### Exhibitions
Galerie Renée Ziegler, Zurich
Kunsthaus, Zurich
Galerie Teufel, Cologne

### Group Exhibitions
"Art concret suisse," musée des Beaux-Arts, Dijon ; musée d'art moderne, Strasbourg ; musée des Beaux-Arts, Dunkerque ; maison de la culture, Chalon-sur-Saône (France)
Documenta 7, Kassel

### Bibliography
Tages Anzeiger Magazin, Zürich, n. 36, 11 September
Lohse, Richard Paul : "Kunst im technologischen Raum," Tages-Anzeiger, Zürich, 2 Oktober
Hollenstein, Roman : "Der Meister der Farbgeometrie," Neue Zürcher Zeitung, Zürich, 11-12 Sept.
Vachtova, Ludmila, catalogue, Galerie Renée Ziegler, Zürich
Catalogues : Galerie Teufel, Köln. Musée des Beaux-Arts, Dijon. Kassel

---

## Long, Richard
Bristol, Great Britain, 1945, lives in Bristol

### Exhibitions
Art & Project, Amsterdam
Galerie Yvon Lambert, Paris
Flow Ace Gallery, Los Angeles
Sperone Westwater Fischer, New York
National Gallery of Canada, Ottawa
Art Agency, Tokyo
CAPC, Bordeaux

### Group Exhibitions
"Aspects of British Art Today," Tokyo Metropolitan Art Museum, Tokyo ; Tochigi Prefectural Museum of Fine Arts, Utsunomiya ; The

National Museum of Art, Osaka ; Fukuoka Art Museum ; Hokkaido Museum of Modern Art, Sapporo
Documenta 7, Kassel
Anthony D'Offay, London
"Choix pour aujourd'hui," Centre Georges Pompidou, Paris

### Bibliography
Bos, Saskia : "Richard Long," Artforum,, New York, Summer
Francblin, Catherine : "Richard Long," Art Press, Paris, n. 58, avril
Prevost, Jean-Marc : "Richard Long," Flash Art, Milano, n. 107, May
Mexico 1979, Van Abbemuseum, Eindhoven
Catalogues : CAPC, Bordeaux. The British Council & Tokyo Metropolitan Art Museum, Tokyo. Kassel. Centre Georges Pompidou, Paris

---

## Longo, Robert
Brooklyn 1953, lives in New York

### Exhibitions
Texas Gallery, Houston
"Sound Distance," The Kitchen, New York

### Group Exhibitions
"Flat and Figurative/20th Century Wall Sculpture," Zabriskie Gallery, New York
"A Few Good Men," Portland Center for the Visual Arts, Portland
"Dynamix," The Contemporary Arts Center, Cincinnati ; The Ohio State University, Colombus ; Allen Memorial Art Museum, Oberlin, Ohio ; The Butler Institute of American Art, Youngstown, Ohio ; The University Art Museum, University of Kentucky, Lexington
"The Human Figure in Contemporary Art," Contemporary Arts Center, New Orleans
"New New York," Florida State University Fine Arts Gallery, Tallahassee
"Eight Artists : The Anxious Edge," The Walker Art Center, Minneapolis
"7 from Metro Pictures," Middendorf/Lane Gallery, Washington D.C.
"Body Language : Current Issue in Figuration," University Art Gallery, San Diego State University
"Focus on the Figure : Twenty Years," The Whitney Museum of American Art, New York
"The New Reliefs," School of Visual Arts Museum, New York
"Documenta 7," Kassel
"Neo-Objective Sculpture," Dart Gallery, Chicago
"Art and the Media," The Renaissance Society, University of Chicago
"Frames of Reference," The Whitney Museum, Downtown Branch, New York

"Painting and Sculpture Today 1982," Indianapolis Museum of Art, Indiana
"Figurative Images : Aspects of Recent Art," Georgia State University Art Gallery
Metro Pictures, New York
"Drawings," Blum Helman Gallery, New York

### Bibliography
Banes, Sally : "The Long and the Short of It," Village Voice, New York, May 18
Bos, Saskia : "Icarus in Het Tijdperk van de Ruimte Vaart," Kunstschrift, Weesp, jan.-feb.
Caroli, Flavio : "Magico Primario," Gruppo Editoriale Fabbri, Milano
Ferrulli, Helen & Yassin, Robert A : catalogue, Indianapolis Museum of Art
Goldberg, RoseLee : "Post-TV Art," Portfolio, New York, vol. IV, n. 4, July-August
Gordon, Kim : "Unresolved Desires : Redefining Masculinity in Some Recent Art," ZG Magazine, London, n. 7
Groot, Paul : "Metro Pictures en Deutsche Angst," Museum Journal, Amsterdam, n. 27/3
Haskell, Barbara : catalogue, The Whitney Museum of Art, New York
Heartney, Eleanor : "Anxiety Show at the Walker : Where is the Faith ?," New Art Examiner, Chicago, June
Hughes, Robert : "Lost Among the Figures," Time Magazine, New York, May 31
Hutton, Jon : "The Anxious Figure," Arts Magazine, London, January
Komac, Denis : catalogue, University Art Gallery, San Diego State University, California
Kontova, Helena : "From Performance to Painting," Flash Art, Milano, February-March
Longo, Robert : "Empire : A Performance Trilogy," Wedge, Ashland, Wisconsin, n. 1, Summer
Lyons, Lisa : catalogue, The Walker Art Center, Minneapolis
Onorato, Ronald J. : "Desperadoes and Madonnas," Art Express, January-February
Ratcliff, Carter : "Contemporary American Art," Flash Art, Milano, Summer
Siegel, Jeanne : "Figuratively Sculpting, P.S.1.," Art Express, March-April
Siegel, Jeanne : "The New Reliefs," Art Magazine, London, April
Upshaw, Reagan : "Figuratively Sculpting, at P.S.1.," Art in America, New York, March
Catalogues : The Renaissance Society of the University of Chicago. Kassel. Indianapolis Museum of Art, Indiana. The Whitney Museum of Art, New York. University Art Gallery, San Diego State University. The Walker Art Center, Minneapolis

## Longobardi, Nino
Naples, Italy, 1953 ; lives in Naples

### Exhibitions
Lucio Amelio, Naples
Galeria Fernando Vijande, Madrid
Galerie Art in Progress, Munich
Galeria Leyendecker, Santa Cruz de Tenerife

### Group Exhibitions
"Futura fett : Herbert Bardenheuer, Nino Longobardi," Galerie Heiner Heppe, Art in Progress, Düsseldorf
"Italian Art Now," Solomon R. Guggenheim Museum, New York
"Avanguardia Transavanguardia," Mura Aureliane, Rome
Biennale Venice

### Bibliography
Bonito Oliva, Achille : catalogue, Mura Aureliane, Roma
Caroli, Flavio : "Magico Primario," F. Fabbri Editori, Milano
Ratcliff, Carter : "On Iconography and Some Italians," Art in America, New York, September
Catalogues : Guggenheim Museum, New York. Galeria Fernando Vijande, Madrid. Mura Aureliane, Roma, Electa. Biennale di Venezia, Electa. Leyendecker, S. Cruz de Tenerife

---

## Lubennikow, Iwan Leonidowitsch
Minsk, USSR, 1951 ; lives in Moscow

### Group Exhibition
"Aspekte Sowjetischer Kunst der Gegenwart," Kolnischer Stadtmuseum, Cologne ; Neue Galerie - Sammlung Ludwig, Aachen

### Bibliography
Catalogues : Museum Ludwig, Köln & Neue Galerie, Aachen

---

## Lüpertz, Markus
Liberec, Czechoslovakia, 1941 ; lives in Berlin and in Karlsruhe, West Germany

### Exhibitions
Galerie Fred Jahn, Münich
Galerie Gillepsie-Laage-Salomon, Paris
Galerie Michael Werner, Cologne
Waddington Gallery, London
Marian Goodman Gallery, New York

### Group Exhibitions
"Avanguardia Transavanguardia," Mura Aureliane, Rome
"La Transavanguardia Tedesca," Galleria Nazionale d'Arte Moderna, Republic of San Marino
Documenta 7, Kassel
"Zeitgeist," Martin-Gropius-

Bau, Berlin
"La rage de peindre," Musée cantonal des Beaux-Arts, Lausanne
"German Drawing of the Sixties," Yale University Art Gallery, New Haven
Galerie Annemarie Verna, Zürich
Galeria Heinrich Ehrhardt, Madrid
Studio Marconi, Milan
"Mythe Drame Tragédie," Musée d'Art et d'Industrie, Saint-Étienne, France

**Bibliography**
Dagbert, Anne : "Markus Lüpertz," *Art Press*, Paris, n. 61, juillet-août
Gachnang, Johannes : "New German Painting," *Flash Art*, Milano, n. 106, February-March
Gohr, Siegfried : "The Situation and the Artists," *Flash Art*, Milano, n. 106, February-March
Gohr, Siegfried : "La peinture en Allemagne : les confusions de la critique," *Art Press*, Paris, n. 57, mars
Groot, Paul : "The Spirit of Documenta 7," *Flash Art*, Milano, n. 108, Summer
Kuspit, Donald B. : "Acts of Aggression : German Painting Today," *Art in America*, New York, September
Morgan, Stuart : "Markus Lüpertz," *Artforum*, New York, April
Simmen, Jeannot L. : "New Painting in Germany," *Flash Art*, Milano, n. 109, November
Skoggard, Ross : "Markus Lüpertz at Marian Goodman," *Art in America*, New York, February
Svestka, J. : "Nein das kann ich nicht, versetzte die Raupe," catalogue, Galerie Michael Werner, Köln
*Catalogues* : Mura Aureliane, Roma, Electa. Galleria Nazionale d'Arte Moderna, Republica di San Marino. Kassel. Martin-Gropius-Bau, Berlin. Musée cantonal des Beaux-Arts, Lausanne. Yale University Art Gallery. Galerie Michael Werner, Köln. Musée d'Art et d'Industrie, Saint-Étienne

---

**Luyten, Mark**
Antwerp, Belgium, 1955 ; lives in Antwerp

**Exhibitions**
Galerie Fabien de Cugnac, Bruxelles
"Vereniging voor het Museum van Hedendaagse Kunst," Gand

**Group Exhibitions**
"Le désir pictural," Galerie Isy Brachot, Bruxelles
"La magie de l'image," Palais des Beaux-Arts, Bruxelles

**Bibliography**
Bex, Flor ; "New Painting in Belgium," *Flash Art*, Milano, n. 109, November
*Catalogues* : Galerie Isy Brachot, Bruxelles. Palais des Beaux-Arts, Bruxelles

**Mc Lean, Bruce**
Glasgow, 1944 ; lives in London

**Exhibition**
Mary Boone Gallery, New York

**Group Exhibitions**
Documenta 7, Kassel
"Vergangenheit-Gegenwart-Zukunft," Württembergischer Kunstverein, Stuttgart
"Zeitgeist," Martin-Gropius-Bau, Berlin
"Thoughts and Action," Laforet Museum, Tokyo ; Tokyo Metropolitan Art Museum, Tokyo

**Bibliography**
*Catalogues* : Kassel. Martin-Gropius-Bau, Berlin. Laforet Museum, Tokyo

---

**Magazzini Criminali**
Tiezzi, Federico : Lucignano, Arezzo, Italy, 1955 ; lives in Tizzano, Florence
D'Amburgo, Marion : Lucignano, Arezzo, Italy, 1956 ; lives in Florence
Lombardi, Sandro : Arezzo, Italy, 1953 ; lives in Florence and Marrakech

**Video Shows**
"Crollo Nervoso," Teatro Comunale, Fermo ; Teatro Comunale, Iesi ; Teatro Trianon, Rome ; "Incontri Cinematografici," Salsomaggiore ; Teatro Nuovo, Naples
"Ebdomero," Teatro Testoni, Bologna ; Teatro Comunale, Alessandria
"Crollo Nervoso," "Oceano Pacifico," "Zone Calde," Galleria Comunale d'Arte Moderna, Bologna
"Oceano Pacifico," "Zone Calde," Teatro Tor di Nona, Rome
"Oceano Pacifico," Teatro Rasi, Ravenna
"Sulla Strada," Teatro Aurora, Scandicci ; Teatro di Porta Romana, Milan ; Teatro Duse, Bologna ; Teatro Variety, Florence ; Teatro Esperia, Forlì ; Teatro Comunale, Ferrare ; Teatro Malibran, Venice
"Progetto Alcantara," Padiglione d'Arte Contemporanea, Milan
"Crollo Nervoso," "Oceano Pacifico," "Ebdomero," Teatro di Rifredi, Florence

**Group Exhibitions**
IIIe Festival International d'Art Vidéo, Locarno, Switzerland
"Iride," Villa Romana, Florence

**Bibliography**
Bartolucci, Fabbri, Pisani & Spinucci, *Paesaggio metropolitano*, Milano
Bartolucci, Giuseppe & Marchese, Claudio, *Teatroltre*, Roma, n. 24
Bolelli, Franco, *Rumori planetari*, Firenze
Bonfiglioli, Landi, Mango & Manzella, *Teatroltre*, Roma, n. 25-26

Godard, Colette "Kerouac à la Biennale de Venise : Mosaïque," *Le Monde*, Paris, 1er juin
Gregori, Maria Grazia : "Il nomadismo senza radici con le cadenze del musical," *L'Unità*, 31 maggio
Klett, Renate : "Die Soufflierte Stimme," *Theater Heute*, n. 1, Berlin, Januar
Manzella, Gianni : "Mucho mucho mucho calor. Sulla strada coi Magazzini Criminali," *Il Manifesto*, 1 giugno
Nierensztein, Susanna : "On the road again," *Lotta Continua*, 6 aprile
Privitera, Pietro : *Scatola scenica*, Roma
Tiezzi, Lombardi, D'Amburgo ; "Verso luoghi e culture calde," *Modo*, n. 54, novembre
Volli, Ugo : "Con Kerouac verso il sud in cerca della tenerezza," *La Repubblica*, 1 giugno
*Catalogues* : Il Patalogo 4, Milano. Schedule d'arte, Firenze

---

**Mainolfi, Luigi**
Avellino, Italy, 1948 ; lives in Turin

**Exhibitions**
Appel und Fertsch, Frankfort
Museo Butti, Viggiù, Italy
Galleria Tucci Russo, Turin

**Group Exhibitions**
Documenta 7, Kassel
Biennale Venice
"Arte Italiana 1960-1982," Hayward Gallery, London ; ICA, London
"Generazioni a confronto," Facoltà di Storia dell'Arte, Università di Roma
"La Sovrana Inattualità," PAC, Milan ; Museum des 20. Jahrhunderts, Vienna
"11 Italienische Künstler," Kunstlerwerkstatten, Munich
"Forma Senza Forma," Galleria Civica d'Arte Moderna, Modena
Biennale Paris
"9 Artisti Italiani," Villa Montalvo, Campi Bisenzio
"Il Primato dell'Artista," Salone del Podestà, Faenza
"Landschaft," Bonner Kunstverein, Bonn
"Descultura," Caltagirone
"Una Generazione Postmoderna," Teatro Falcone, Genoa
"La Storia, Il Mito, La Leggenda," Galleria d'Arte Moderna, Verona

**Bibliography**
*Catalogues* : Kassel. Biennale di Venezia, Electa. Hayward Gallery, London. Biennale de Paris

---

**Mason, Raymond**
Birmingham, Great Britain, 1922 ; lives in Paris

**Exhibitions**
"Raymond Mason, Coloured Sculptures, Bronzes and

Drawings 1952-1982," Serpentine Gallery, London
Museum of Modern Art, Oxford

**Group Exhibitions**
"La Délirante," Centre Georges Pompidou, Paris
"Aftermath-France 1945-54," Barbican Centre, London
"Paris 1960-1980," Museum des 20 Jahrhunderts, Vienna
Biennale Venice
"British Sculpture in the Twentieth Century," Wgitechapel Art Gallery, London

**Bibliography**
Biard, Ida : "Interview with Jean Clair," *Flash Art*, Milano, n. 108, Summer
*Catalogues* : Serpentine Gallery, London. Centre Georges Pompidou, Paris. Barbican Center, London. Biennale di Venezia, Electa. Whitechapel Art Gallery, London

---

**Matta, Roberto**
Santiago du Chile, Chile, 1911 ; lives in Paris

**Exhibitions**
"Garganta-tua," Galeria la Bezuga, Florence, Italy ; Galerie Samy Kinge, Paris
Centre Culturel, Ivry-sur-Seine, France
„Odisseano," Palazzo Reale, Naples
"Hommage à Matta," Espace latino-américain, Paris
Tarquinia, Italy
Rose Art Museum, Massachusetts
"What is the Object of the Mind," Galerie R. Onnasch, Berlin
"Las flores saben el sol," Lima, Peru

**Group Exhibitions**
"L'Amérique Latine à Paris," Grand-Palais, Paris
"Aftermath-France 1945-54," Barbican Centre, London
"Revolutionary Figurations : From Cezanne to Present," Bridgestone Museum, Tokyo
"Le Père Duchesne," Centre Georges Pompidou, Paris

**Bibliography**
Faye, Jean-Pierre : catalogue, Galleria La Bezuga, Firenze
*Catalogues* : Galleria La Bezuga, Firenze. Grand-Palais, Paris. Barbican Center, London. Bridgestone Museum, Tokyo. Centre Georges Pompidou, Paris

---

**Merz, Mario**
Milan, Italy, 1925 ; lives in Turin

**Exhibitions**
Sperone Westwater Fischer,

New York
Museum Folkwang, Essen
Staatsgalerie, Stuttgart
Kestner-Gesellschaft, Hanover
Ace Gallery, Los Angeles
Galleria d'Arte Moderna, Bologna

**Group Exhibitions**
Documenta 7, Kassel
"Vergangenheit, Gegenwart, Zukunft," Württembergischer Kunstverein, Stuttgart
"'60-'80, Stedelijk Museum, Amsterdam
"Die Handzeichnung der Gegenwart II," Graphische Sammlung, Staatsgalerie, Stuttgart
"Works on Paper," Museum of Modern Art, New York
"Zeitgeist," Berlin
"Arte Italiana, 1960-1982," Hayward Gallery, London
"Avanguardia Transavanguardia," Rome
"Kiefer, Kounellis, Merz," Christian Stein, Turin
"Collection du musée d'art contemporain de Gand," Palais des Beaux-Arts, Brussels
"Arte Povera Antiform," CAPC, Bordeaux
"Choix pour aujourd'hui," Centre Georges Pompidou, Paris

**Bibliography**
Bargiacchi, Enzo : "Mario Merz-Gallerie Stein e Tucci Russo, Torino," *Segno*, Pescara, n. 24, gennaio
Groot, Paul : "The Spirit of Documenta 7," *Flash Art*, Milano, n. 108, Summer
Grüterich, Marlis : "Italienische Identität oder reiche arme Kunst," *Kunst-Bulletin*, Bern, n. 2, Februar
Haenlein, Carl : "Bemerkungen zum Iglumotiv bei Mario Merz," catalogue, Kestner-Gesellschaft Hannover
Kontova, Helena : "From Performance to Painting," *Flash Art*, Milano, n. 106, February-March
Liebmann, Lisa : "Mario Merz," *Artforum*, New York, Summer
Zdenek, Felix : "Die Kraft der Phantasie," catalogue, Museum Folkwang, Essen
*Catalogues* : Kassel. Stedelijk Museum, Amsterdam. Martin-Gropius-Bau, Berlin. Arts Council of Great Britain, London. Kestner-Gesellschaft Hannover. Museum Folkwang, Essen. Mura Aureliane, Roma, Electa. Palais des Beaux-Arts, Bruxelles. CAPC, Bordeaux. Centre Georges Pompidou, Paris

---

**Messager, Annette**
Berck-sur-mer, France, 1943 ; lives in Paris

**Exhibition**
Artists spaces, New York

**Group Exhibitions**
"Art d'aujourd'hui et érotisme," Kunstverein, Bonn
"Façons de peindre," Maison de la Culture, Chalon-sur-Saône ; Musée des Beaux-Arts, Genève ; Musée de Chambéry
"Statement," Holly Solomon Gallery, New York
"De Matisse à nos jours," Musée des Beaux-Arts, Lille

**Bibliography**
Besson, Christian ; catalogue "Façons de peindre"
Groot, Paul, *Museumjournaal*, sept
Hahn, Otto, catalogue, "Statements"
Moufarrese, Nicolas, *New York Native*, april
Schjeldahl, Peter, *Village Voice*, March
*Catalogues :* Statements New York 82, Association Française d'Action Artistique. Maison de la culture Chalon-sur-Saône

---

**Middendorf, Helmut**
Dinklage, West Germany, 1953 ;
lives in Berlin

**Exhibitions**
Galerie Yvon Lambert, Paris
Galerie Albert Baronian, Brussels
Studio d'Arte Cannaviello, Milan
Galerie Buchmann, St. Gallen

**Group Exhibitions**
"Im Westen nichts Neues," Centre d'art contemporain, Geneve ; Neue Galerie, Sammlung Ludwig, Aachen
"Zehn Künstler aus Deutschland," Museum Folkwang, Essen
"Gefühl und Härte," Kulturhuset Stockholm ; Kunstverein, Münich
"Spiegelbilder," Kunstverein, Hanover
"In virtù del possesso delle mani," Museo Gibellina, Sicily
"Berlin-das malerische Klima einer Stadt," Musée Cantonal des Beaux-Arts, Lausanne
Bonlow Gallery, New York
"Zeitgeist," Martin-Gropius-Bau, Berlin

**Bibliography**
"Deutsche Kunst, hier-heute," *Kunstforum International*, Mainz, n. 47
Faust, Wolfgang Max & de Vries, Gerd : "Hunger nach Bildern," Köln
Kuspit, Donald B. : "Acts of aggression : German Painting Today," *Art in America*, New York, September
Renard, Delphine : "Helmut Middendorf," *Art Press*, Paris, n. 64, novembre
*Catalogues :* Kunstmuseum, Luzern ; Centre d'art contemporain, Genève ; Neue Galerie, Sammlung Ludwig, Aachen. Museum Folkwang, Essen.

Kunstverein, München.
Musée Cantonal des Beaux-Arts, Lausanne

---

**Mogami, Hisayuki**
Yokosuka, Japan, 1936 ; lives in Japan

**Group Exhibitions**
"The 1960's : A Decade of Change in Contemporary Japanese Art," The National Museum of Modern Art, Tokyo ; The National Museum of Modern Art, Kyoto
"Japan '70," Institute for Cultural Development, Seoul, Korea

**Bibliography**
*Catalogues :* The National Museum of Modern Art, Tokyo. Institute for Cultural Development, Seoul

---

**Monory, Jacques**
Paris 1934 ; lives in Paris

**Exhibitions**
Musée de la Chartreuse, Douai
Maison de la Culture, Nevers
Musée des Beaux-Arts, Pau

**Group Exhibitions**
"Aléa," ARC, Musée d'Art moderne de la ville de Paris
"Sigma," CAPC, Bordeaux
"European Pavilion : Movements in Contemporary European Art," Seoul Gallery, Seoul, Korea
"Revolutionary Figurations : From Cezanne to Present," Bridgestone Museum, Tokyo
"L'univers d'Aimé Maeght," Fondation Maeght, Saint-Paul-de-Vence
"New Figurations in France," Seoul Gallery, Seoul, Korea

**Bibliography**
Bailly, Jean-Christophe : *Les peintres cinéastes*, CNRS, Paris
Lyotard, Jean-François, extrait de *Derrière le Miroir* n. 244, catalogue SIGMA, Bordeaux
*Catalogues :* ARC, Paris. CAPC, Bordeaux. Seoul Gallery, Seoul. Bridgestone Museum, Tokyo

**Films/Vidéo**
Brown, David Carr & Lyotard, Jean-François : *Instances et cinéma*
Labarthe, André : *Cinéma cinéma n° 3*, Antenne II, Paris

---

**Monro, Nicholas**
London 1936 ; lives in Berkshire, Great Britain

**Group Exhibition**
"British Sculpture in the Twentieth Century," Whitechapel Art Gallery, London

**Bibliography**
The Whitechapel Art Gallery, London

---

**Moore, Henry**
Castleford, Great Britain, 1898 ; lives in Hertfordshire

**Exhibitions**
"Primitivism in Modern Sculpture : Gauguin to Moore," Art Gallery of Ontario, Toronto
Auckland City Art Gallery : Traveling exhibition in New Zealand
"Henry Moore Graphics," Traveling exibition in Spain, 12 cities including : Malaga, Granada, Santander, Bilbao Wintraub, U.S.A.
Christies Contemporary Art, New York
Colorado Springs Fine Art Center
Harlow Playhouse Gallery
Tasend Gallery, La Jolla, California
Durham Light Infantry Museum
Fischer Fine Art, London
Palazzo Ancaiana, Spoleto
Galleria Communale, Forte dei Marmi
Hoam Art Museum, Seoul
Horace Richter Gallery, Tel-Aviv ; Tel Aviv University Museum of Modern Art, Mexico
Monterrey Museum
Rex Irwin Gallery, Sydney
Henry Moore Centre for the Study of Sculpture, Leeds City Art Gallery, Leeds
Galerie Beyeler, Basel
Geolfrith Gallery, Sunderland
Louisiana, Humlebaek

---

**Morley, Malcolm**
London 1931 ; lives in New York

**Exhibitions**
Kunsthalle, Basel ;
Whitechapel Art Gallery, London

**Group Exhibition**
Zeitgeist, Martin-Gropius-Bau, Berlin

**Bibliography**
*Catalogue :* Martin-Gropius-Bau, Berlin

---

**Müller, Felix**
Eggersriet, Switzerland, 1955 ; lives in St.Gallen

**Group Exhibitions**
Kunsthalle, Basel
Galerie Nouvelles Images, The Hague
Galerie Farideh Cadot, Paris
CH-OST, Kunstverein, St.Gallen
Galerie-Provisorium, Chur, Switzerland

**Bibliography**
Frey, Patrick, *Tages Anzeiger*, Zürich, 26 Febr.
Jehle, Werner : "Die Neuen Wilden," *Tages Anzeiger magazin*, Zürich, n. 11
Prerost, Irene, *Weltwoche*, Zürich, n. 12, 24 März
Schnell, Urs, *Berner Zeitung*, Bern, 6 März
Stahlberger, Peter, *Tages Anzeiger*, Zürich, 9 Juli
Wildermuth, Armin, *Aspekt Schweiz*, St.Gallen
Zoller, Jörg, *Sonntagzeitung*, 28 Febr.
*Catalogues :* Kunsthalle, Basel. Galerie Nouvelles

Images, Den Haag.
Kunstverein, St.Gallen

---

**Nantel, Lise**
Montreal, Canada, 1944 ; lives in Montreal

**Group Exhibitions**
"Art et Féminisme," Musée d'Art Contemporain, Montreal
"Colloque international sur la recherche et l'enseignement relatifs aux femmes," Université Concordia

**Bibliography**
Corriveau, Marie-Josée : "Une exposition qui dérange et questionne le pouvoir," *Presse-Libre*, juin
Tourangeau, Jean : "Art et Féminisme," *La Presse*, Montréal
*Catalogue :* Musée d'Art Contemporain, Montréal

---

**Narimanbekow, Togrul Fanuandritsch**
Baku, USSR, 1930 ; lives in Baku

**Group Exhibitions**
"Aspekte Sowjetischer Kunst der Gegenwart," Kölnischer Stadtmuseum, Cologne ; Neue Galerie-Sammlung Ludwig, Aachen

**Bibliography**
*Catalogue :* Museum Ludwig, Köln & Neue Galerie, Aachen

---

**Nash, David**
Surrey, Great Britain, 1945 ; lives in Blaenau Ffestiniog, Wales

**Exhibitions**
"Sculpture and drawings," Kilkenny Art Gallery, Ireland
"Stoves and Hearths," David Grob Gallery, London

**Group Exhibitions**
"Makers Eye," Crafts Council Gallery, London
"Aspects of British Art Today," Tokyo Metropolitan Art Museum, Tokyo ; Tochigi Prefectural Museum of Fine Arts, Utsunomiya ; The National Museum of Art, Osaka ; Fukuoka Art Museum, Fukuoka ; Hokkaido Museum of Modern Art, Sapporo
"Wood Quarry," Rijksmuseum Kröller-Müller, Otterlo, Holland
"Presence of Nature," Carlisle Museum
Yorkshire Sculpture Park
"Two Views of Nature," Elise Meyer Gallery, New York

**Bibliography**
*Catalogue :* The British Council & Tokyo Metropolitan Museum of Art, Tokyo

---

**Nauman, Bruce**
Fort Wayne, Indiana, 1941 ; lives in Pecos

**Exhibitions**
Leo Castelli Gallery, New York

Sperone Westwater Fischer Inc., New York

**Group Exhibitions**
"Eight Lithographs," Margo Leavin Gallery, Los Angeles
"Livres d'Artistes," Musée d'Art Contemporain, Montreal
"Amerikanische Zeichnungen der 70er Jahre Lenbachhaus," Stadtische Gallerie, Munich
"Gemini G.E.L. - Group Show," Thomas Babeon Gallery, La Jolla, California
"Arte Povera Antiform," CAPC, Bordeaux
"Works on Paper," Larry Gagosian Gallery, Los Angeles
"Castelli and His Artists : Twenty-five Years," La Jolla Museum of Contemporary Art, La Jolla, California ; Aspen Center for the Visual Arts, Aspen, Colorado ; Leo Castelli Gallery, New York ; Portland Center for the Visual Arts, Portland, Oregon ; Laguna Gloria Art Museum, Austin, Texas
Documenta 7, Kassel
"Casting : A Survey of Cast Metal Sculpture in the Eighties," Fuller Goldeen Gallery, San Francisco
"'60-'80," Stedelijk Museum, Amsterdam
"Postminimalism," The Aldrich Museum, Ridgefield, Connecticut
Max-Ulrich Hetzler Gmbh, Stuttgart

**Bibliography**
*Catalogues :* CAPC, Bordeaux. Kassel. Stedelijk Museum, Amsterdam

---

**Newton, John Edgar**
Birkenhead, Great Britain, 1941 ; lives in Birkenhead

**Group Exhibition**
"Stoffwechsel-K 18", Kassel

**Bibliography**
*Arts Review*, London, July 16
*Textil Kunst*, 3 Sept.
*Catalogue :* K 18, Kassel

---

**Noé, Luis Felipe**
Buenos Aires 1933 ; lives in Paris

**Exhibition**
New York Art School, New York

**Group Exhibitions**
Galerie Bellechasse, Paris
"La Nueva Imagen," Galeria del Buenos Aires, Buenos Aires
"Pintura Fresca," Buenos Aires
"L'Amérique latine à Paris," Grand Palais, Paris
"Congress of Latin American Art," Mexico City
"Biennale del paisaje", Mexico City
Museo d'Arte Moderna, Venice

---

**Nomura, Hitoshi**
Tatsuno, Hyogo Pref., Japan,

1945 ; lives in Takatsuki, Osaka Pref.

**Exhibitions**
Gallery White Art, Tokyo
Gallery 16, Kyoto

**Group Exhibition**
Fifth Triennale India

**Bibliography**
Masuda, Hiroshi : catalogue, Fifth Triennale India
Masuda, Hiroshi : "Space Ordered by Silence and Poetry, Fifth Triennale India," *Yomiuri*, April 2
*Skoal*
*Catalogue :* Fifth Triennale India

---

**Nørgaard, Bjørn**
Copenhagen, Denmark, 1947 ; lives in Copenhagen

**Exhibitions**
"Hætsjj", The Department of Prints and Engravings, The Royal Art Museum, Copenhagen
"Ceramic Works," Gladsaxe Library, Gladsaxe

**Group Exhibitions**
"Arte de '82," Bilbao
"Portrait Bienale," Tuzla, Yugoslavia
Sculpture Center Veksølund, Denmark
"Art Now," The Solomon Guggenheim Museum, New York ; Port of History Museum, Philadelphia
Louisiana, Humlebaek

**Bibliography**
*Arkitektur*, n. 5
*New York Times*, September 17
*The New Republic*, November 8
*Village Voice*, n. 39, September 28
*Catalogues :* The Royal Museum, København. The Solomon Guggenheim Museum, New York. Louisiana, Humlebaek.

---

**Ohlin, Kjell**
Sweden, 1942 ; lives in Uppsala, Sweden

**Exhibition**
"Englund-Kirschenbaum-Ohlin," Moderna Museet, Stockholm

**Bibliography**
Granath, Olle : "3 + 3 = världen utan återvändo," *Moderna Museet*, Stockholm, n. 1

---

**Oldenburg, Claes Thure**
Stockholm, Sweden, 1929 ; lives in New York

**Exhibition**
Dedication of "Hat in Three Stages of Landing," Salinas Community Center, California

**Group Exhibitions**
"20th Century American Art : Highlights from the Permanent Collection," The Whitney Museum of American Art, New York

"Livres d'Artistes," Musée d'Art Contemporain, Montréal
"A Benefit Art Sale for CAPS," Seventy Arts Ltd., New York
"Classical Works : 1962-1967," Blum Helman, New York
"Janie C. Lee Honoring Leo Castelli," Janie C. Lee Gallery, Houston
Documenta 7, Kassel
"The Americans : Collage 1950-82," Contemporary Arts Museum, Houston
"Castelli and His Artists : Twenty-five Years," La Jolla Museum of Contemporary Art, La Jolla, California ; Aspen Center for the Visual Arts, Aspen, Colorado ; Leo Castelli Gallery, New York ; Portland Center for the Visual Arts, Portland, Oregon ; Laguna Gloria Art Museum, Austin, Texas
"The Written Word," Downey Museum of Art, Downey, California
"The Expressionist Image : American Art from Pollock To Today," Sidney Janis Gallery, New York
"Works in Wood," Margo Leavin Gallery, Los Angeles
"Works by Gallery Artists," Leo Castelli Gallery, New York
Group Exhibition, Margo Leavin Gallery, Los Angeles

---

**Olivier, Olivier O.**
Paris 1931 ; lives in Paris

**Group Exhibitions**
Biennale Venice : International Pavilion
"Paris 1960-1980," Museum des 20. Jahrhunderts, Vienna
"Scalp," Salon d'Art, Bruxelles
"Scalp," Liège
"Le Baiser," Galerie Jean Briance, Paris
"La Délirante," Centre Georges Pompidou, Paris
"Choix pour aujourd'hui," Centre Georges Pompidou, Paris

**Bibliography**
*Catalogues :* Biennale di Venezia, Electa. Museum des 20. Jahrhunderts, Wien. Centre Georges Pompidou, Paris

---

**Oppenheim, Dennis**
Electric City, Washington, 1938 ; lives in New York

**Exhibitions**
Marianne Deson Gallery, Chicago
Rijksmuseum Kröller-Müller, Otterlo, Holland
Mario Pieroni, Rome
Mills College Gallery, Oakland, California
Galerie Stampa, Basel
Ikon Gallery, Birmingham
Lewis Johnstone, London
Musée d'Art et d'Histoire, Genèva
Olsen Gallery, New York
Bonlow Gallery, New York
Vancouver Art Gallery, Vancouver
Taub Gallery, Philadelphia

Ohio State University, Columbus, Ohio

**Group Exhibitions**
Wurtembergischer Kunstverein, Stuttgart
"Alea," ARC 2, Musée d'art Moderne de la Ville de Paris, Paris
"Artist and Printmaker : Printmaking as a Collaborative Process," Guild Hall, East Hampton, New York
Fattoria di Celle, Pistoia, Italy
"Avanguardia Transavanguardia," Mura Aureliane, Rome
"Documenta Urbana," Kassel
"Mile of Sculpture," Chicago Sculpture Society, Chicago
"100 Years of California Landscape," Oakland Museum, Oakland, California
"Illegal America," Franklin Furnace, New York
"Currents : A New Mannerism," University of Southern Florida, Tampa, Florida
"Art on the Beach," Creative Time Inc., New York
"Art sans frontières," Galerie Isy Brachot, Bruxelles
"Model Citizens Against Post-Modernism," Express/Network, New York
"Drawings, Models, Sculptures," 14 Sculptors Gallery, New York
"The Monument Redefined," Gowanus Memorial Artyard, Brooklyn, New York
"'60-'80," Stedelijk Museum, Amsterdam

**Bibliography**
Ayers, Robert : "Dennis Oppenheim," *Art Monthly*, London, May
Falcon, S. : "Art on the Beach," *Express*
Gassert, S. : "Review, Stampa Gallery," *Basler Zeitung*, Basel, 9 Juni
Kent, S. : "Mutants, Machines, Make-Believe," *Time-out*, London, May 7-13
Larson, K. : "Apocalypse Now", *New York Magazine*, New York, June 14
Lawson, T. : "Review, Bonlow Gallery," *Artforum*, New York, September
MacManus, I. : "A Sculptor who Plays with Fire," *Guardian*, London, May 12
Metaphor, A.J. : "The Mechanical Obsession," *New Art Examiner*, Chicago, February
Morgan, S. : "Dennis Oppenheim at the Ikon Gallery and Lewis Johnstone," *Artscribe*, London, n. 35, June
Tully, J. : "Rockets Red Glare," *Art World*, New York, Summer
Wheeler, S. : "Review, Deson Gallery," *New Art Examiner*, Chicago, June
"Alors, Oppenheim," *La Suisse*, Genève, 27 mars
"Kröller-Müller Beeldentuin," *Kunstechos*, Otterlo, mars-avril
"La sculpture d'Oppenheim n'ira pas à Parc Bertrand," *La Tribune de Genève*, Genève, 27 mars

"Review, Galleria Pieroni," *Flash Art*, Milano, Summer
"Sculpture with a Short Fuse," *Life Magazine*, New York, October
*Catalogues :* Mura Aureliane, Roma, Electa. Stedelijk Museum, Amsterdam. Hirshhorn Museum and Sculpture Garden, Smithsonian Institution, Washington. The Chicago Sculpture Society, Chicago. Exit Art Press, New York. Documenta Urbana, Kassel. ARC 2, Musée d'Art Moderne de la Ville de Paris.

---

**Orr, Eric**
Covington, Kentucky, 1939 ; lives in Venice, California

**Exhibitions**
Neil G. Ovsey Gallery, Los Angeles
Taylor Gallery, Taos, New Mexico

**Group Exhibitions**
Documenta 7, Kassel
"Art as Alchemy," California State University, Dominguez Hills, California

**Bibliography**
Mc Eviley, Thomas : "Eric Orr," *Artforum*, June
*Catalogue :* Kassel

---

**Otero, Alejandro**
El Manteco, Venezuela, 1921 ; lives in Caracas

**Group Exhibitions**
Biennale Venice

**Bibliography**
*Catalogue :* Biennale di Venezia, Electa

---

**Paik, Nam June**
Seoul, Korea, 1932 ; lives in Dusseldorf, W. Germany and New York

**Exhibitions**
Whitney Museum of American Art, New York
Galerie Watari, Tokyo
"Tricolor Vidéo de Nam June Paik," Centre Georges Pompidou, Paris

**Group Exhibition**
Kölnischer Kunstverein, Cologne

**Bibliography**
Ancona, Victor : "Videomania at the Whitney : Replay of Nam June Paik's retrospective," *Videography*, October
Denison, D.C. : "Video Art's Guru," *The New York Times Magazine*, New York, April
Drukker, Leendert : "Nam June Paik : Video Pioneer Upsets Reality," *Popular Photography*, August
Gardner, Paul : "Tuning in to Nam June Paik," *Artnews*, May
Gelmis, Joseph : "Painting with Light and Video," *Newsday*, June 10
Gever, Martha : "Pomp and

Circumstances : The Coronation of Nam June Paik," *Afterimage*, October
Glueck, Grace : "Art : Nam June Paik has Show at Whitney," *The New York Times*, New York, May 7
Hoberman, J. : "Paik's Peak," *Village Voice*, New York, May 25
Hughes, Robert : "Electronic Finger Painting," *Time Magazine*, May 17
Kurtz, Bruce : "The Zen Master of Video," *Portfolio*, May-June
Kurtz, Bruce : "Paikvision," *Artforum*, New York, October
Larson, Kay : "Nam June Paik's Zen Video," *New York Magazine*, New York, May 24
Ratcliff, Carter : "Video Art : Paik's Peak," *Saturday Review*, May
Sterritt, David : "What does Video Art Look Like ? Sometimes it can be a Sculpture," *The Christian Science Monitor*, May 17
Sturken, Marita : "Video Guru," *American Film*, May
Wooster, Ann-Sargent : "Nam June Paik : Granddaddy of Video Art," *Museum Magazine*, May-June
*Catalogues :* The Whitney Museum of American Art, New York. Kölnischer Kunstverein, Köln.

---

**Paladino, Mimmo**
Paduli, Benevento, Italy, 1948 ; lives in Milan and Southern Italy

**Exhibitions**
Galerie Buchmann, St.Gall
Waddington Galleries, London
Von der Heydt Museum, Wuppertal ; Städische Galerie, Erlangen
Schellmann & Klüser, Munich
Marian Goodman Gallery, New York
Nicholas Logsdail Lisson Gallery, London
Galerie 121, Antwerp
Galerie Tanit, Munich
Franco Toselli, Milan
Galerie Munro, Hamburg
Manheimer Kunstverein, Manheim ; Louisiana, Humlebaek

**Group Exhibitions**
Documenta 7, Kassel
"Avanguardia Transavanguardia," Mura Aureliane, Rome
"Neue Skulptur," Galerie nächst St.Stephan, Vienna
"Zeitgeist," Martin-Gropius-Bau, Berlin
"Arte Italiana 1960-1982," Hayward Gallery, London ; ICA, London
Biennale Sydney, Sydney
"Transavanguardia Internazionale," Galleria civica, Modena

**Bibliography**
Ammann, Jean-Christophe : "Paladino : Diamonds and Secret Cards," *Flash Art*, Milano, n. 109, November
Bröder, F.J. : "Bilder der

190

Seele," *Bayerischen Staatszeitung,* München, 13 August
Bröder, F.J.: "Paladinos apokalyptische Visionen," *Donau Kurier,* 10 August
Bröder, F.J.: "Reaktion auf heillose Zeitläufte," *Main-Echo,* 21 August
Collier, Caroline : "Mimmo Paladino," *Flash Art,* Milano, n. 108, Summer
Fenn, Walter : "Die weisse Maske des Todes," *Nüremberg Nachriten,* 14-15 August
Groot, Paul : "Mimmo Paladino," *Flash Art,* Milano, n. 107, May
Groot, Paul : "The Spirit of Documenta 7," *Flash Art,* Milano, n. 108, Summer
Puyplat, Liza : "Von Leidenschaft und Verwundbarkeit," *Erlanger Nachriten,* 7-8 August
Schlagheck, Irma : "Ohne Grenzen," *Nürnberger Zeitung,* 23 August
Trini, Tommaso : "Mimmo Paladino, la langue Mozart," *Art Press,* Paris, n. 55, janvier
Wiese, Klaus Martin : "Wie Gesichter zu Masken erstarren," *Abendzeitung-8 Uhr Blatt,* 14-15 September
Wildermuth, Armin : "Mimmo Paladino," *Flash Art,* Milano, n. 109, November
*Catalogues :* Kassel. Mura Aureliane, Roma, Electa. Galerie nächst St. Stephan, Wien. Martin-Gropius-Bau, Berlin. Arts Council of Great Britain, Hayward Gallery, London. Von der Heydt Museum, Wuppertal ; Städtische Galerie, Erlangen

___

**Paolini, Giulio**
Genoa, Italy, 1940 ; lives in Turin

**Exhibitions**
"La caduta di Icaro," Padiglione d'Arte Contemporanea di Milano, Milan
Kunsthalle Bielefeld, Bielefeld ; Von der Heydt Museum, Wuppertal ; Neuer Berliner Kunstverein, Berlin
"Mnemosine/Nonsense," Marilena Bonomo, Bari ; Françoise Lambert, Milan
Raum für Kunst, Hamburg
"Une introduction à l'œuvre de Giulio Paolini, 1960-70," Le Nouveau Musée, Lyon-Villeurbanne
"Scene di conversazione," The Japan Foundation, Laforet Museum, Tokyo
Galerie Yvon Lambert, Paris

**Group Exhibitions**
"Generazioni a confronto," Istituto di Storia dell'Arte, Università di Roma, Rome
"A Selection of the Acquisitions," Tate Gallery, London
"'60-'80," Stedelijk Museum, Amsterdam
"Mise en scène," Kunsthalle Bern, Bern
"Avanguardia

Transavanguardia," Mura Aureliane, Rome
"Vergangenheit-Gegenwart-Zukunft," Kunstverein, Stuttgart
Documenta 7, Kassel
"Spelt from Sibyl's Leaves/Explorations in Italian Art," Power Gallery, University of Sydney, Sydney
"Grafik aus den siebziger Jahren/Neuerwerbungen der Grafischen Sammlung," Kunsthalle Bielefeld
"Choix pour aujourd'hui," Centre Georges Pompidou, Paris
"Arte Italiana 1960-82," Hayward Gallery, London ; ICA, London
"Cento anni di arte italiana," Museum of Modern Western Art, Tokyo
"Thoughts and Action," Laforet Museum, Tokyo ; Tokyo Metropolitan Art Museum, Tokyo

**Bibliography**
Altamira, A. : "Salotto metafisico di Paolini al "Pac," *Il Giornale nuovo,* Milano, 15 gennaio
Bandini, M. : "Carta d'identità per l'arte d'oggi," *Avanti !,* Roma, 15 luglio
Briganti, G. : "Canta il cigno sotto le mura,," *La Repubblica,* Roma, 13 maggio
Brok, B. : "Paolini," *Besucherschule Documenta 7,* Kassel
Busche, E. : "Kunst aus Kunst," *Die Zeit,* Berlin, 20 August
Caroli, F. : "E Icaro cadde nel colore," *Corriere della Sera,* Milano, 17 gennaio
D'Elia, A. : "L'artista si concede la pausa di memoria," *La Gazzetta del Mezzogiorno,* Bari, 23 aprile
De Marchis, G. : "L'arte in Italia dopo la seconda guerra mondiale," *Storia dell'arte italiana, vol. 7 : Il Novecento,* Torino
Denizot, R. & Paolini, G. : *De bouche à oreille,* Yvon Lambert ed., Paris
Di Genova, G. : *Narcissus,* Centro Di, Firenze
Franz, E. & Faust, W.M. : *G. Paolini, Del bello intelligibile,* Kunsthalle Bielefeld, Bielefeld
Gatt, G. : "L'identità dell'arte è irraggiungibile," *Avanti,* Roma, 14 gennaio
Meneguzzo, M. : "Giulio Paolini," *Flash Art,* Milano, febbr.
Müller, C. : "Kunst im Kopf," *Westdeutsche Zeitung,* Wuppertal, 15 mai
Sayagues Areco, M. : "Paolini o la busca de Averroes/Un texto más para Babel," *Opinar,* Montevideo, n. 61-62
Spiazzi, L. : "L'enigma in cocci," *Brescia oggi,* 23 gennaio
Vattimo, G. : "Le tele tagliate e la Luna," *La Stampa,* Torino, 29 agosto
Vincitorio, F. : "Kassel, sconfitti i pittori selvaggi," *La Stampa,* Torino, 13 luglio
"Giulio Paolini/Lo sguardo

della Medusa," *Domus,* Milano, n. 624
"Paul Maenz and the Young Germans," *Domus,* Milano, n. 624
"Giulio Paolini e Gerhard Richter," *Terzo Occhio,* Milano, marzo
"Nove tele per far cadere Icaro," *Lotta Continua,* Milano, 30 gennaio
*Catalogues :* The Tate Gallery, London. Stedelijk Museum, Amsterdam. Mura Aureliane, Roma, Electa. Kunstverein, Stuttgart. Kassel. Power Gallery, University of Sydney. Kunsthalle Bielefeld. Centre Georges Pompidou, Paris. Raum für Kunst, Hamburg

___

**Pardi, Gianfranco**
Milan, Italy, 1933 ; lives in Milan

**Exhibitions**
Galleria Plurima, Turin

**Group Exhibition**
"Arte Italiana 1960-1982," Hayward Gallery, London ; ICA, London

**Bibliography**
*Catalogue :* Hayward Gallery, London

___

**Parr, Mike**
Sydney, Australia, 1945 ; lives in Sydney

**Group Exhibitions**
"Eureka (Exclamation Mark) : Artists from Australia," Institute of Contemporary Art, London
"Vision in Disbelief," Fourth Biennale of Sydney, Art Gallery of New South Wales, Sydney
"Act III" (Performance Festival), Canberra
"The Temple of the Winds," N-Space, Melbourne

**Bibliography**
Paroissien, Leon, *Australian Art Review,* Essays by Borlase, Nancy & Muphy, Bernice
Underhill, Nancy D. ; Taylor, Paul & Waterlow, Nick : catalogue, ICA, London
*Catalogue :* ICA, London. Sydney.

___

**Partos, Paul**
Bratislava, Czechoslovakia, 1943 ; lives in Melbourne, Australia

**Group Exhibition**
"Australian Perspecta 1981," Sydney

___

**Penck, A.R. (Ralf Winkler)**
Dresden, E.Germany, 1939 ; lives in Cologne, W.Germany

**Exhibitions**
Ileana Sonnabend Gallery, New York
Gillespie-Laage-Salomon, Paris
Galleria Lucio Amelio, Naples
Galleria Toselli, Milan
Studio d'Arte Cannaviello, Milan

Waddington Galleries, London
Bruna Soletti, Milan
Michael Werner, Cologne
Young Hoffman Gallery, Chicago

**Group Exhibitions**
"German Drawing of the Sixties," Yale University Art Gallery, New Haven
Young Hoffman Gallery, Chicago
Annemarie Verna, Zurich
"Avanguardia Transavanguardia," Mura Aureliane, Rome
Documenta 7, Kassel
Galeria Heinrich Ehrhardt, Madrid
Studio Marconi, Milan
"Mythe Drame Tragédie," Musée d'Art et d'Industrie, Saint-Étienne
"Choix pour aujourd'hui," Centre Georges Pompidou, Paris
"Zeitgeist," Berlin
"La transavanguardia tedesca," Galleria Nazionale d'Arte Moderna, San Marino
Biennale Sydney, Sydney
"New York oh Paper 2," Museum of Modern Art, New York

**Bibliography**
Gohr, Siegfried : "The Situation and the Artists," *Flash Art,* Milano, n. 106, February-March
Gohr, Siegfried : "La peinture en Allemagne : les confusions de la critique," *Art Press,* Paris, n. 57, mars
Kontova, Helena : "A.R. Penck," *Flash Art,* Milano, n. 107, May
Kuspit, Donald B. : "A.R. Penck at Sonnabend," *Art in America,* New York, February
Kuspit, Donald B. : "Acts of Aggression : German Painting Today," *Art in America,* New York, September
Lawson, Thomas : "A.R. Penck," *Artforum,* New York, March
Prevost, Jean-Marc : "A.R. Penck," *Flash Art,* Milano, n. 107, May
Schwerfel, Heinz Peter : "A.R. Penck," *Art Press,* Paris, n. 57, mars
*Catalogues :* Galerie Gillespie-Laage-Salomon, Paris. Yale University Art Gallery, New Haven. Mura Aureliane, Roma, Electa. Kassel. Musée d'Art et d'Industrie, Saint-Étienne. Centre Georges Pompidou, Paris. Martin-Gropius-Bau, Berlin. Galleria Nazionale d'Arte Moderna, Repubblica di San Marino. Waddington Galleries, London. Museum of Modern Art, New York

___

**Penone, Giuseppe**
Garessio, Italy, 1947 ; lives in Garessio and in Turin

**Exhibitions**
Salvatore Ala, New York
Konrad Fischer, Zurich

**Group Exhibitions**
Documenta 7, Kassel

"Italian Art Now," Solomon R. Guggenheim Museum, New York
"Choix pour aujourd'hui," Centre Georges Pompidou, Paris

**Bibliography**
*Catalogues :* Kassel. Guggenheim Museum, New York. Centre Georges Pompidou, Paris.

___

**Pignon-Ernest, Ernest**
Nice, Alpes Maritimes, 1942 ; lives in Paris

**Works in situ**
Intervention/images, "Concert baroque," Uzeste, France
Dessin mural, Musée de Martigues, France
Intervention/images, Martigues, France

**Group Exhibitions**
"Art actuel en France," ICC, Anvers ; musée des Beaux-Arts, Chartres
"Dessins français contemporains," Musée Seita, Paris ; Knoxville, Tennessee
Biennale d'Échirolles, France
"Affiches de peintres pour le théâtre," Palais de Chaillot, Paris
"Art socio-critique," Festival de La Rochelle, France
"Dessin 2," Ancien Couvent royal, Saint-Maximin, France
Sélection française, Biennale Alexandria, Égypta
"Des Murs en France," réalisation d'un mur peint à Hyères

**Bibliography**
Faucher, Michel : "Ernest Pignon-Ernest," *Arts Magazine,* January
Humblot, C. & Briot, Marie-Odile : *La peau des murs,* reedition, Paris
Poggi, François : "Attention un regard peut en cacher un autre," *Le Gai Pied,* Paris, juin
*Catalogues :* ICC, Anvers. Musée des Beaux-Arts, Chartres. "Des Murs en France," Association pour le Développement de l'Environnement Artistique & ministère de la Culture

___

**Pistoletto, Michelangelo**
Biella, Italy, 1933 ; lives in Turin

**Exhibitions**
"La mano, la spalla, la testa," Galleria Pieroni, Rome
"La porta obliqua e il tempio a dondolo," Galleria Toselli, Milan
Galerie Tanit, Munich

**Group Exhibitions**
"Generazioni a confronto," Istituto di Storia dell'Arte Medievale e Moderna, Università di Roma, Rome
"Avanguardia Transavanguardia," Mura Aureliane, Rome
"Spiegelbilder," Kunstverein, Hanover
"Accardi, Oppenheim, Pistoletto," Galleria Mario

Pieroni, Rome
"Arte Italiana 1960-1982,"
Hayward Gallery, London ;
ICA, London.
Villa Celle, Pistoia, Italy
Documenta 7, Kassel

**Bibliography**
Bonito Oliva, Achille :
"L'incidente di Pistoletto,"
*Segno,* n. 27, luglio-agosto
Corà, Bruno : catalogue,
Galleria Pieroni, Roma
Corà, Bruno, *Flash Art,* Milano,
n. 108, estate
Izzo, Arcangelo : "Michangelo
Pistoletto : una mano per
l'arte," *LapisArte,* anno III, n. 6
*Catalogues* : Galleria Pieroni,
Roma. Mura Aureliane, Roma,
Electa. Hayward Gallery,
London. Kunstverein,
Hannover. Kassel

---

**Poirier, Anne & Patrick**
Anne : Marseille 1942
Patrick : Nantes 1942
live in Paris

**Exhibitions**
Ileana Sonnabend, New York
Massimo Valssecchi, Milan
Galleria G7, Bologna

**Group Exhibitions**
"Paris 1960-1980," Museum
des 20 Jahrhunderts, Vienna
"Vergangenheit-Gegenwart-
Zukunft," Württembergischer
Kunstverein; Stuttgart
Fattoria di Celle, Pistoia
"Collection du musée d'art
contemporain de Gand,"
Palais des Beaux-Arts,
Bruxelles
Kunsthalle, Berlin

**Bibliography**
*Catalogues* : Statements New
York 82, Association Française
d'Action Artistique. Museum
des 20 Jahrhunderts, Wien.
Museum van Hedendaagse
Kunst, Gent

---

**Poivret, Jean-Luc**
Paris 1950 ; lives in Paris

**Exhibitions**
Galerie Françoise Palluel, Paris
Chez Ben, Nice
Kunsthalle, Berne
"Grand Boulevard," Bourges
Galerie Lucien Durand, Paris

**Group Exhibitions**
"Ateliers 81/82," ARC2 Musée
d'Art Moderne de la Ville de
Paris
"Livres d'artistes," Musée,
Rouen
"Un nouvel éclectisme,"
Atelier 4, Sens
Salon de Montrouge, Hauts de
Seine
Tours-Multiple, Tours
Galerie Transform, Paris

**Bibliography**
Chalumeau, J.L., *Arts,* Paris,
n. 58, mars
Godart, Lionel & Tio Bellido,
Ramon : catalogue, Musée
d'Art Moderne de la Ville de
Paris
Goldcymer, Gaya, *Art Press,*

Paris, n. 57, mars
Hahn, Otto, *L'Express,* Paris,
octobre
Joppolo, Giovanni : catalogue,
Chez Ben, Nice
Martin, Jean-Hubert & Tio
Bellido, Ramon : catalogue,
Kunsthalle, Berne
Parent, Béatrice, *Art Press,*
Paris, n. 64, novembre
Poinsot, Jean-Marc : "New
Painting in France," *Flash Art,*
Paris, juin
Rimsky Korsakoff, F., *Canal,*
janvier
*Axe Sud,* Toulouse, juillet
*Telerama,* Paris, novembre
*Le Figaro,* Paris, 3 novembre
*Catalogues* : Chez Ben, Nice.
Kunsthalle Bern. Musée d'Art
Moderne de la Ville de Paris,
Paris. Galerie Françoise
Palluel, Paris

---

**Pommereulle, Daniel**
Sceaux, France, 1937 ; lives in
Paris

**Group Exhibitions**
"Revolutionary Figurations :
From Cezanne to Present",
Bridgestone Museum, Tokyo
"Des Murs en France," Mural
in Anthony, France
"Aléa," ARC ,Paris
"New Figurations in France,"
Seoul Gallery ; Korea
"European Pavilion :
Movements in Contemporary
European Art,"
Seoul Gallery, Korea

**Bibliography**
*Catalogues* : Bridgestone
Museum, Tokyo. "Des Murs
en France," A.D.E.A.
Musée d'Art Moderne de la
Ville de Paris, Paris. Seoul
Gallery, Seoul

---

**Pope, Nicholas**
Sydney, Australia, 1949 ; lives
in Ledbury, Herefordshire,
Great Britain

**Group Exhibitions**
"British Sculpture in the
Twentieth Century,"
Whitechapel Art Gallery,
London
Waddington Galleries, London

**Bibliography**
*Catalogue* : Whitechapel Art
Gallery, London

---

**Portillos, Alfredo**
Buenos Aires, Argentina,
1928 ; lives in Buenos Aires

**Group Exhibitions**
Centro de Arte y
Comunicación (CAYC),
Buenos Aires
Galería del Retiro, Buenos
Aires

**Bibliography**
*Catalogue* : CAYC, Buenos
Aires

---

**Pozzati, Concetto**
Vò di Padova, Padova, Italy ;
lives in Bologna

**Group Exhibitions**
"Arte Italiana 1960-1982,"
Hayward Gallery, London ;
ICA, London
Biennale Venice
"Officine & Ateliers," Casa del
Mantegna, Mantoua
Galleria De'Foscherari, Bologna
Galleria Due Torri, Bologna

**Bibliography**
Calvesi, Maurizio : catalogue,
Casa del Mantegna, Provincia
di Mantova
Caroli, Flavio & Marchiori,
Giuseppe : "Microcronache
dell' immenso," Galleria Due
Torri, Bologna
Pozzati, Concetto : *Quasi
tutto Licini, Parliamo di Mario
Pozzati,* Bologna
*Catalogues* : Hayward Gallery,
London. Biennale di Venezia,
Electa. Casa del Mantegna,
Provincia di Mantova. Galleria
Due Torri, Bologna

---

**Raetz, Markus**
Büren an der Aare,
Switzerland 1941 ; lives in
Berne and Berlin

**Exhibitions**
Galerie Farideh Cadot, Paris
Daadgalerie, Berlin
Kunsthalle, Basel

**Group Exhibitions**
"Momentbild," Kestner
Gesellschaft, Hanover
Documenta 7, Kassel
"Heiter bis aggressiv,"
Museum Bellerive, Zurich
"Le dessin suisse 1970-
1980," Musée Rath, Geneva
"'60-'80," Stedelijk Museum,
Amsterdam
"Amsterdam 60/80," Museum
Fodor, Amsterdam
"Choix pour aujourd'hui,"
Centre Georges Pompidou,
Paris

**Bibliography**
Blistène, Bernard : "Markus
Raetz," *Flash Art,* Milano,
n. 106, February-March
Gassert, Siegmar, *Basler
Zeitung,* Basel, 4-10
Girard, Xavier : "Markus
Raetz," *Artforum,* New York,
May
Heller, Martin : "Fragen an
die Wahrnehmung im
Räumlichen," *Basler
Volksblatt,* Basel, 4-10
Lamarche-Vadel, Bernard :
"Entretien avec Markus
Raetz," *Artistes,* Paris, n. 1,
juin-juillet
Thürer, Georg : "Markus
Raetz in der Kunsthalle Basel,"
*Volksstimme Sissach,* 12-10
Vogel, Matthias : "Markus
Raetz im Spiegel der
schweizerischen Kunstkritik,"
*Zeitschrift für schweizerische
Archäologie und
Kunstgeschichte,* Zürich, Bd.
39, Heft 2
Wechsler, Max :
"Manifestation einer
notwendigen Lebenspoesie,"
*Vaterland,* 8-10
Zoller, Jörg : "Ausstellung
des Berner Künstlers Markus
Raetz in der Kunsthalle Basel,"

*Berner Zeitung,* 27-10
*Catalogues* : Kunsthalle,
Basel. Kassel. Stedelijk
Museum, Amsterdam. Centre
Georges Pompidou

---

**Raveel, Roger**
Machelen aan de Leie,
Belgium, 1921
lives in Machelen aan de Leie

**Exhibitions**
"De hoop en de wanhoop van
de hedendaagse kunstenaar,"
Galerie Baronian-Lambert, Gent
"Werken op papier 1956-
1960," Vereniging voor het
Museum van Hedendaagse
Kunst te Gent, Gent
Galerie William Wouters,
Oosteeklo
"Raveel en de Mundial,"
Paleis voor Schone Kunsten,
Brussels
"Raveel en de Mundial,"
Osterriethuis, Antwerp
"Een plastisch dagboek van
een verblijf te Marnac 1981,"
Museum van Deinze en
Leiestreek, Deinze
De Nieuwe Tijd, St.-Niklaas
Galerie Forty-One, Antwerp

**Group Exhibitions**
"Zeefdruk in Vlaanderen,"
International Exlibriscentrum,
St.-Niklaas
"Kunst in de Metro," Brussels
"Fifty One Club," Centrum
voor Kunst en Kultuur, St.-
Pietersabdij, Gent
"Arteder," Bilbao
"'60-'80," Stedelijk Museum,
Amsterdam
Printshop, Amsterdam
"10 x 3 tekeningen," Galerie
William Wouters, Oosteeklo
"Het picturaal verlangen,"
Galerie Isy Brachot, Brussels
"Verzameling Museum van
Hedendaagse Kunst Gent,"
Palais des Beaux-Arts,
Brussels
"Aanwinsten Provinciaal
Museum Moderne Kunst
1979-1982," Hallen, Ypres
"Vier schilders van de Nieuwe
Visie," Cultureel Centrum,
Venlo
"Taal en Teken," Stadhuis,
Mortsel
"Keuze van Tekeningen,"
Delta, Bruxelles
"Groepstentoonstelling,"
Stichting Veranneman,
Kruishoutem
"Hedendaagse Kunst,"
Stedelijke Feestzaal,
Nieuwpoort ; De Singel,
Antwerp
"L'art belge depuis 1945,"
Musée des Beaux-Arts André
Malraux, Le Havre
"Vier schilders van de Nieuwe
Visie," Gemeentehuis, Heerlen

**Bibliography**
Bekkers, L. : "Roger Raveel,"
catalogue, Kunst in de Metro,
Brussel
Claus H., Gedicht : "Taal en
Teken," catalogue, Stadhuis,
Mortsel
De Dauw & Van Durme, V. :
"Roger Raveel," catalogue,
Paleis voor Schone Kunsten,
Brussel

Jooris, R. : "Roger Raveel :
Werken op papier 1956-1960,"
catalogue, Museum van
Hedendaagse Kunst, Gent
Raveel, R. : catalogue, Kunst
in de Metro, Brussel
Raveel, R. : "De Nieuw
Visie," catalogue, Cultureel
Centrum, Venlo
Sizoo, Hans : "New Painting
in Holland," *Flash Art,* Milano,
n. 107, May
Van den Bussche, W. : "Het
Provinciaal Museum voor
Moderne Kunst te Ieper,"
*Openbaar Kunstbezit,*
Antwerpen
Van Mulders, W. : "Het
Picturaal Verlangen,"
catalogue, Galerie Isy Brachot,
Brussel
*Catalogues* : "Kunst in de
Metro," Brussel. Stedelijk
Museum, Amsterdam. Paleis
voor Schone Kunsten, Brussel.
Stadhuis, Mortsel. Cultureel
Centrum, Venlo. Openbaar
Kunstbezit, Antwerpen.
Galerie Isy Brachot, Bruxelles

---

**Raysse, Martial**
Golfe Juan, Alpes Maritimes,
1936 ; lives in Paris

**Exhibitions**
"Statement One," Sidney
Janis Gallery, New York
Musée Picasso, Antibes

**Group Exhibitions**
"Paris 1960-1980," Museum
des 20. Jahrhunderts, Vienna
"Les Nouveaux Réalistes,"
Musées de Nice, Nice
Biennale Venice
"New Figurations in France,"
Seoul Gallery, Korea
Louisiana, Humlebæk
"Revolutionary Figurations,"
Bridgestone Museum,
Foundation Ishibashi, Tokyo

**Bibliography**
Biard, Ida : "Interview with
Jean Clair," *Flash Art,* Milano,
n. 108, Summer
Bréerette, Geneviève :
"Martial Raysse à Antibes,
Antipolis ou la joie de vivre,"
*Le Monde,* Paris,
mardi 21 septembre
Cabanne, Pierre : "La
Biennale de Venise," *Le
Matin,* Paris, vendredi 2 juillet
Giraudy, Danièle : catalogue,
Musée Picasso, Antibes
Restany, Pierre : "Le nouveau
réalisme," *Flash Art,* Milano,
n. 105, December 1981-
January 1982
*Arts, PTT,* janvier
*Catalogues* : Statements New
York 82, Association Française
d'Action Artistique. Musée
Picasso, Antibes. Museum
des 20. Jahrhunderts, Wien.
Louisiana, Humlebæk.
Musées de Nice, Nice.
Bridgestone Museum, Tokyo

---

**Rebeyrolle, Paul**
Eymoutiers, Haute-Vienne,
France, 1926 ; lives in
Boudreville, Aube, France

**Exhibitions**
Galerie Editart, Geneva

Centre d'Art Contemporain, Hospice Saint-Louis, Avignon
Galerie d'Art Contemporain, Limoges
Galerie Maeght, Zurich

**Group Exhibitions**
FIAC, Paris
"Images pour la Pologne," Fondation des arts graphiques et plastiques, Paris

**Bibliography**
Bouisset, Maïten : "Les évasions manquées," *Le Matin*, Paris, 31 juillet
Distel, Alain : "Rebeyrolle," *Le Nouvel Observateur*, Paris, 7 août
Ferrier, Jean-Louis : "Toiles de violence," *Le Point*, Paris, 25-31 octobre
Figuière, J. : "Les évasions manquées de Rebeyrolle," *Vaucluse Matin*, 15 juillet
Heliot, Armelle : "Rebeyrolle, peintre des désespoirs," *Le Quotidien de Paris*, 9 août
Rivière, Jean-Loup, *Libération*, Paris, 9 août

---

**Rivers, Larry**
New York 1925 ; lives in New York and Long Island

**Exhibitions**
Kestner-Gesellschaft, Hanover : Kunstverein München, Munich ; Kunsthalle, Tübingen ; Staatliche Kunsthalle, Berlin
Marlborough Gallery, London
Studio Marconi, Milan
Marlborough Gallery, New York
Tower Gallery, Southampton, Long Island
Gloria Luria Gallery, Bay Harbor Islands, Florida

**Bibliography**
Belting, H. : "Larry Rivers und Die Historie in der Modernen Kunst," *Art International*, Lugano, January
"Larry, Rivers : Joseph H. Hirshhorn, 1899-1981," *Art in America*, New York, January
Winter, P. : "Bilder, Skulpturen un Zeichnungen 1950-1980," *Kunstwerk 34*, Stuttgart, n. 2
"Ein neuer Historismus ? von der Gegenwart der vergangen in der Jungsten Kunst Phanomene und Symptome," *Kunstwerk 34*, Stuttgart, n. 3
*Catalogue* : Marlborough Gallery, New York

---

**Rohling, Gerd**
Krefeld, West Germany, 1946 ; Berlin

**Group Exhibitions**
Old World, New York
The Clocktower, New York
"Gefühl und Härte," Kunstverein, Munich ; Kulturhuset, Stockholm
Studio Exhibition P.S.1, New York
Dada Montage Konzept, Berlinische Galerie, Berlin
Kunst, Kutscherhaus, Berlin
Galleria Peccolo, Livourne, Italia
"Kunst wird Material,"

Nationalgalerie, Berlin
"Sieben," Kutscherhaus, Berlin

**Bibliography**
Blase, Christoph : "Neue Kunst aus Berlin," *Art*, Oktober
Köcher, Helga : "Brief aus New York," *Das Kunstwerk*, I
Matts, B. : "Gefühl und Härte, Stockholm," *Flash Art*, Milano, Summer
Ohff, Heinz, *Tagesspiegel*, 23-5 ; 19-10
Winter, Peter : "Miniaturistische Kunst," *Das Kunstwerk*, III
"3 Deutsche Maler," *II Tirrenia*, Oktober
*Catalogues* : Kunstverein, München. Kulturhuset, Stockholm. Berlinische Galerie, Berlin. Galleria Peccolo, Livorno. Nationalgalerie, Berlin. Kutscherhaus, Berlin

---

**Rösel, Karel**
Prague, Czechoslovakia, 1947 ; lives in Cologne, W.Germany

**Exhibitions**
"Hobby 82," Galerie Eric Fabre, Paris

**Group Exhibitions**
"Ich bin nur eine Idee," Kunstverein Köln, Cologne
"Versöhnung mit der Polizei," Exhibition in Police Station, Cologne
"Auf dem 4.Blick," Kunstverein Brühl, Brühl
"Die neue Künstlergruppe die wilde Malerei," Klapperhof 33, Cologne
"Les Lumières de la ville," Galerie Eric Fabre, Paris

**Bibliography**
Sauerbier, S.D. : "Die neue Malerei und ihre Kritik," *Kunstforum*, Mainz, n. 48, Februar-März
*Catalogues* : Kunstverein, Köln. Galerie Eric Fabre, Paris

---

**Rosz, Martin**
East Prussia 1940 ; lives in W.Germany

**Group Exhibitions**
"Gefühl & Härte,"
Kulturhuset, Stockholm ; Kunstverein, Munich
"Vergangenheit-Gegenwart-Zukunft," Württembergischer Kunstverein, Stuttgart

**Bibliography**
Kunstverein, München

---

**Rousse, Georges**
Paris 1947 ; lives in Paris

**Exhibition**
Bibliothèque Nationale, Paris

**Group Exhibitions**
Biennale Paris
Galerie Farideh Cadot, Paris
"L'Air du Temps, Figuration libre en France," Galerie d'Art Contemporain des Musées de Nice, Nice

**Bibliography**
*Art Press*, Paris, n. 58, avril
*Artistes*, Paris, n. 11, juin-juillet
*Le Figaro*, Paris, 6 octobre
*Catalogues* : Biennale de Paris. Galerie d'Art Contemporain des Musées de Nice, Nice

---

**Rowe, Nellie Mae**
Fayette County, U.S.A., 1900 ; lives in Vinings, Georgia

**Group Exhibition**
"Black Folk Art in America 1930-1980," Corcoran Gallery of Art, Washington ; J.B. Speed Museum, Louisville, Kentucky ; The Brooklyn Museum, Brooklyn, New York

**Bibliography**
*Catalogue* : Corcoran Gallery of Art & University Press of Mississippi, Jackson

---

**Rückriem, Ulrich**
Düsseldorf, W.Germany ; lives in Cologne

**Exhibitions**
Galerie Nordenhake, Malmo, Sweden
Konrad Fischer, Dusseldorf

**Group Exhibitions**
Norman Mackenzie Art Gallery, University of Regina, Regina, Canada
Documenta 7, Kassel
Villa Celle, Pistoia, Italy
"Choix pour aujourd'hui," Centre Georges Pompidou, Paris

**Bibliography**
*Catalogues* : Kassel. Centre Georges Pompidou, Paris

---

**Ruscha, Edward**
Omaha, Nebraska, 1937 ; lives in Los Angeles

**Exhibitions**
"The Works of Edward Ruscha," San Francisco Museum of Art, San Francisco ; Whitney Museum of American Art, New York ; San Antonio Museum of Contemporary Art, San Antonio, Texas ; Los Angeles County Museum of Art, California ; Vancouver Art Gallery, Canada
"The Works of Ed Ruscha," Flow Ace Gallery, Los Angeles
"Edward Ruscha Drawings," Castelli Graphics, New York
Bernard Jacobson Ltd, London
Jacoson-Hochman Gallery, New York

**Group Exhibitions**
"Artists' Photographs," Crown Point Gallery, New York
"Painting," Metro Pictures, New York
"Livres d'artistes," Musée d'Art Contemporain, Montreal
"Drawings/New Directions," Summit Art Center, Summit, New Jersey

"Works on Paper," Larry Gagosian Gallery, Los Angeles
"New Work by Gallery Artists," Leo Castelli Gallery, New York
Documenta 7, Kassel
"Target III in Sequence," Museum of Fine Arts, Houston, Texas
"Postminimalism," The Aldrich Museum, Ridgefield, Connecticut
"Castelli and his artists : Twenty-five Years," La Jolla Museum of Contemporary Art, La Jolla, California ; Aspen Center for the Visual Arts, Aspen, Colorado ; Leo Castelli Gallery, New York ; Portland Center for the Visual Arts, Portland, Oregon ; Laguna Gloria Art Museum, Austin, Texas
Galerie Jacques Girard, Toulouse

**Bibliography**
Deak, Edit, *Artforum*, New York, October
Failing, Patricia : "Ed Ruscha, Young Artist : Dead Serious About Being Nonsensical," *Artnews*, New York, April
Larson, Kay : "Billboards Against the Sunset," *New York Magazine*, New York, July 26
Raynor, Vivien : "Art : The Spell of Ruscha's Words," *The New York Times*, New York, July 16
Rickey, Carrie : "Ed Ruscha, Geographer," *Art in America*, New York, October
Schjeldahl, Peter : *Arts and Architecture*, v. 1, n. 3
Stevens, Mark : "Pop Goes Los Angeles," *Newsweek*, New York, August 23
Tarshis, Jerome : "Ruscha in Retrospect," *Portfolio*, New York, March-April
*Catalogue* : San Francisco Museum of Modern Art, San Francisco, & Hudson Hills Press, New York

---

**Ruthenbeck, Reiner**
Velbert 1937 ; lives in Dusseldorf, W.Germany

**Group Exhibition**
Documenta 7, Kassel

**Bibliography**
*Catalogue* : Kassel

---

**Salle, David**
Norman, Oklahoma 1952 ; lives in New York

**Exhibitions**
Mario Diacono, Rome
Mary Boone/Leo Castelli, New York

**Group Exhibitions**
"Art and Amonie," Josef Gallery, New York
"Series and Editions," The New York Public Library, New York
"Focus on the Figure : Twenty Years," The Whitney Museum of American Art, New York

"The Anxious Edge," Walker Art Center, Minneapolis
"Figurative Images : Aspects of Recent Art," Georgia State University, Atlanta
"Body Language," University Art Gallery, San Diego State University
"Castelli and His Artists," Museum of Contemporary Art, La Jolla, California
"Art and the Media," Renaissance Society, Chicago
"74th American Exhibition," Art Institute of Chicago, Chicago
Documenta 7, Kassel
Biennale Venice
"Avanguardia Transavanguardia," Mura Aureliane, Rome
"The Pressure to Paint," Marlborough Gallery, New York
"Transavanguardia," Galleria Civica, Modena
"Homo Sapiens," The Aldrich Museum, Ridgefield, Connecticut
Bruno Bischofberger, Zurich
Anthony D'Offay, London
"Fast," Alexander Milliken Gallery, New York
"The Americans : Collage 1950-1982," Contemporary Arts Museum, Houston
"Zeitgeist," Martin-Gropius-Bau, Berlin

**Bibliography**
Agnese, Maria Luisa & Carbonne, Fabrizio : "Ve lo do io Artista," *Panorama*, Milano, 22 maggio
Anderson, Ali : "Editor's Choice," *Portfolio*, New York, September
Bargert, Albrecht : "Neue Kunst oder nur eine neue Masche ?," *Ambiente*, Offenburg, February
Bonito Oliva, Achille : "Avanguardia Transavanguardia," Milano
Brewster, Todd : "Boone Means Business," *Life Magazine*, New York, May
Brooks, Rosetta : "The Art Machine : Editorial," *ZG Magazine*, London, n. 3
Caroli, Flavio : *Magico Primario*, Milano, Gruppo Editoriale Fabbri, 1982
Castle, Ted : "A Bouquet of Mistakes," *Flash Art*, Milano, Summer
de Coppet, Laura : "Leo Castelli," *Interview*, New York, February
DeAk, Edit & Cortez, Diego : "Baby Talk," *Flash Art*, Milano, May
DeAk, Edit : "Staling Art," *Artforum*, New York, September
Diehl, Carol : "Galleries : As Time Goes By," *Art and Auction*, London, May
Doherty, M. Stephen : "Hype Returns to the Art World," *American Artist*, July
Feaver, William : "A Bad Case of Hype," *Observer Review/Arts*, London, 11 July
Frackman, Noel & Kaufmann, Ruth : "Documenta 7 : The Dialogue and a Few Asides," *Arts Magazine*, New York,

October
Fox, Catherine : "The Art of Equivocation," *The Atlanta Journal and Constitution,* Atlanta, April 10
Gendel, Milton : "Report from Venice," *Art in America,* New York, September
Glueck, Grace : "Emoting over the Figure," *The New York Times,* May 30
Goldberg, RoseLee : "Post-TV Art," *Portfolio Magazine,* New York, July-August
Greenspan, Stuart : "Americans Abroad," *Art and Auction,* October
Groot, Paul : "The Spirit of Documenta," *Flash Art,* Milano, Summer
Haden-Guest, Anthony : "The New Queen of the Art Scene," *New York Magazine,* New York, April 19
Haime, Nora : "Color, Versatilidad y Figuration," *Harper's Bazaar,* New York, January
Haime Nora : "25 Anos de Exito : Leo Castelli," *Harper's Bazaar,* New York, September
Hunter, Sam : "Post Modern Painting," *Portfolio Magazine,* New York, January-February
Kirshner, Judith Russi : "74th American Exhibition," *Artforum,* New York, October
Kontova, Helena : "From Performance to Painting," *Flash Art,* Milano, n. 106, February-March
Kosuth, Joseph : "Portraits... Necrophilia Mon Amour," *Artforum,* New York, May
Kuspit, Donald B. : "David Salle at Boone and Castelli," *Art in America,* New York, Summer
Kutner, Janet : "Voices from the 1980's Cutting Edge," *Dallas Morning News,* September 15
Larsen, Kay : "David Salle," *New York Magazine,* New York, March 29
Liebmann, Lisa : "David Salle," *Artforum,* New York, Summer
Lowe, Ron : "FWAM Exhibit Jolts Viewers into the 80's," *The Fort Worth Star Telegram,* Fort Worth, September 12
Salle, David : "David Salle, New York 1981," *Domus,* Milano, February
Schjeldahl, Peter : "South of the Border," *The Village Voice,* New York, June 29
Schjeldahl, Peter : "King Curator," *The Village Voice,* New York, July 20
Schjeldahl, Peter : "David Salle's Objects of Disaffection," *The Village Voice,* March 23
Secrest, Meryle : "Leo Castelli : Dealing in Myth," *Art News,* New York, Summer
Silverthorne, Jeannie : "The Pressure to Paint," *Artforum,* New York, October
Smith, Roberta : "Group Flex," *The Village Voice,*

Moufarrege, Nicholas : "The Eye of the Beholder," *New York Native,* New York, April 12
Paker, William : "Expressionism is Back in Fashion," *Times,* July 6
Paley, Maggie : "Mary Boone : A Confident Vision," *Saavy Magazine,* New York, June
Peters, Lisa : "David Salle," *Print Collector's Newsletter,* New York, January-February
Pincus-Witten, Robert : "Gary Stephan : The Brief Against Matisse," *Arts Magazine,* New York, March
Pincus-Witten, Robert : "David Salle : Holiday Glassware," *Arts Magazine,* New York, April
Plagens, Peter : "Issues and Commentary : Mixed Doubles," *Art in America,* New York, March
Ratcliff, Carter : "David Salle," *Interview,* New York, February
Ratcliff, Carter : "An Attack on Painting," *Saturday Review,* New York, February
Ratcliff, Carter : "Contemporary American Art," *Flash Art,* Milano, Summer
Ratcliff, Carter : "David Salle's Aquatints," *Print Collector's Newsletter,* New York, September-October
Reed, Susan : "The Metoric Rise of Mary Boone," *Saturday Review,* New York, May
Reichard, Steven : "David Salle," *Inperformance,* September
Robins, Corinne : "Ten Months of Rush-Hour Figuration," *Arts Magazine,* New York, September
Russell, John : "In the Arts : Crictics' Choices," *The New York Times,* New York, July 11
Russell, John : "Art : David Salle," *The New York Times,* New York, March 19
New York, June 22
Smith, Roberta : "Mass Productions," *The Village Voice,* New York, March 23
Stevens, Mark : "The Revival of Realism," *Newsweek Magazine,* New York, June 7
Tompkins, Calvin : "The Art World," *The New Yorker,* New York, June 7
Tucker, Maria : "An Iconography of Recent Figurative Painting," *Artforum,* New York, Summer
Unger, Craig : "Attitude," *New York Magazine,* New York, July 26
Wallace, Joan & Donahue, Geralyn ; "You wish you were Closer to You," *ZG Magazine,* London, n. 7
Winter, Simon Vaughan : "Rubbing Our Noses in It," *The Art Magazine,* London, Winter
Yoskowitz, Robert : "David Salle at Mary Boone," *Arts Magazine,* New York, September
*Catalogues :* Mura Aureliane,

Roma, Electa. Martin-Gropius-Bau, Berlin. Kassel. Biennale di Venezia, Electa

**Salomé**
Karlsruhe, W.Germany, 1954 ; lives in Berlin

**Exhibitions**
Galerie Bischofberger, Zurich
Galerie Zwirner, Cologne

**Group Exhibitions**
Documenta 7, Kassel
"10 Junge Künstler aus Deutschland," Museum Folkwang, Essen
"Zwölf Künstler aus Deutschland," Kunsthalle, Basel
Biennale de Sydney
"Gefühl und Härte," Kunstverein München, Munich ; Kulturhuset, Stockholm
"La rage de peindre," Musée Cantonal des Beaux-Arts, Lausanne
Museum Boymans-van Beuningen, Rotterdam
Robert Miller, New York
"Zeitgeist," Berlin
Bonlow Gallery, New York

**Bibliography**
Casademont, Joan : "Salomé," *Artforum,* New York, March
Faust, Wolfgang Max & Vries, Gerd de : *Hunger nach Bildern,* Köln
Schwerfel, Heinz Peter : "Salomé Wild Boy," *Art Press,* Paris, n. 59, mai
Skoggard, Ross : "Salomé at Annina Nosei," *Art in America,* New York, February
"Deutsche Kunst," hier-heute," *Kunstforum,* n. 47
*Catalogues :* Kassel. Museum Folkwang, Essen. Kunstverein, München. Musée Cantonal des Beaux-Arts, Lausanne. Martin-Gropius-Bau, Berlin

**Salvadori, Remo**
Cerreto Guidi, Florence, Italy 1947 ; lives in Milan

**Exhibitions**
Galleria Salvatore Ala, Milan
Salvatore Ala Gallery, New York

**Group Exhibitions**
Biennale Venice
Documenta 7, Kassel
Biennale Paris

**Bibliography**
Corà, Bruno, *A.E.I.U.O.,* gennaio-luglio
*Domus,* Milano, n. 631, 632
*Arts Magazine,* New York, October
*Modo,* November
*Catalogues :* Biennale di Venezia, Electa. Kassel. Biennale de Paris

**Sánchez, Juan Félix**
San Rafael de Mucuchíes, Venezuela, 1900 ; lives in the valley of El Potrero, Venezuela

**Exhibitions**
"Lo Espiritual en el Arte," Juan Félix Sánchez, Museo de Arte Contemporáneo, Caracas

**Bibliography**
Comerlati, Mara : "Cuatro años para revelar un gran artesano," *El Nacional,* Caracas, 30 de enero
*Catalogue :* Museo de Arte Contemporáneo, Caracas

**Saunders, Joyan**
Coob's Arm, Newfoundland, Canada, 1954 ; lives in La Jolla, California

**Group Exhibitions**
"Festival of Festivals," 7th International Film Festival, Toronto, Ontario
"Festival 82" (Video Inn), Robson Square Media Center, Vancouver, British Columbia
"Semaine de la Video Féministe Québecoise," Cinéma Parallèle, Montreal, Quebec
"New Canadian Photography," Center for Canadian Photography, Toronto, Ontario
"Art et Féminisme," Musée d'Art Contemporain, Montreal, Quebec

**Bibliography**
Bentley Mays, John : Review of "New Canadian Photography," *Globe and Mail,* Toronto, September 17
*Catalogues :* Center for Canadian Photography, Toronto. Musée d'Art Contemporain, Montréal

**Schapiro, Miriam**
Toronto, Canada, 1923 ; lives in New York

**Exhibitions**
Hodges Taylor Gallery, Charlotte, North Carolina
Axiom Gallery, New South Wales, Australia
"Invitation and Presentation," Barbara Gladstone Gallery, New York
"The Heartist Series," David Heath Gallery, Atlanta
Douglas Drake Gallery, Kansas City
Yares Gallery, Scottsdale, Arizona
"Miriam Schapiro : A Retrospective, 1953-1980," traveling exhibition organized by Wooster College Art Museum, Wooster, Ohio

**Group Exhibitions**
"The Americans : Collage 1950-1982," Contemporary Arts Museum, Houston
Sydney Biennale, Sydney
"Nature as Image and Metaphor," Judith Christian Gallery, New York
"Women's Art, Miles Apart," Aaron Berman Gallery, New York ; Valencia Community College, Orlando, Florida

**Bibliography**
Avgikos, Jan : "The Decorative Politic, Interview

with Miriam Schapiro," *Art Papers,* November-December
Frank, Elizabeth : "Miriam Schapiro - Formal Sentiments," *Art in America,* New York, May
Glueck, Grace : "Review," *The New York Times,* November 26
*Feminism and Art History - Questioning the Litany,* Harper and Row, New York
*Ornamentalism,* Clarkson N. Potter, New York
*American Women Artists,* Avon
*American Artists on Art from 1940-1980,* Harper and Row, New York
*Catalogue :* Fourth Biennale of Sydney

**Schnabel, Julian**
New York, 1951 ; lives in New York

**Exhibitions**
Stedelijk Museum, Amsterdam
"Drawings," Bruno Bischofberger, Zurich
"Recent Drawings," Margo Leavin Gallery, Los Angeles
"Matrix/Julian Schnabel," University Art Museum, Berkeley, California
Tate Gallery, London

**Group Exhibitions**
"Issues New Allegory," Institute of Contemporary Art, Boston
"Group Show," Mary Boone Gallery, New York
"Focus on the Figure : Ten Years," Whitney Museum, New York
"74th American Exhibition," Art Institute of Chicago, Chicago
"Works on Paper," Larry Gagosian Gallery, Los Angeles
"New Work by Gallery Artists," Leo Castelli Gallery, New York
"Hommage to Leo Castelli," Galerie Bischofberger, Zurich
"Chia, Clemente, Kiefer, Salle, Schnabel : New Paintings," Anthony D'Offay, London
"The Pressure to Paint," Marlborough Gallery, New York
"The Americans : Collage 1950-82," Contemporary Arts Museum, Houston
"'60-'80," Stedelijk Museum, Amsterdam
"Homosapiens : The Many Images," The Aldrich Museum of Contemporary Art, Ridgefield, Connecticut
"Castelli and his artists : Twenty-five years," La Jolla Museum of Contemporary Art, La Jolla, California ; Aspen Center for the Visual Arts, Aspen, Colorado ; Leo Castelli Gallery, New York ; Portland Center for the Visual Arts, Portland, Oregon ; Laguna Gloria Art Museum, Austin, Texas
"Zeitgeist," Martin-Gropius-Bau, Berlin

**Bibliography**
Curiger, Bice : "Robert Moskowitz, Susan Rothenberg and Julian

Schnabel," *Flash Art,* Milano, n. 106, February-March
DeAk, Edit & Cortez, Diego : "Baby Talk," *Flash Art,* Milano, n. 107, May
Groot, Paul : "Julian Schnabel," *Flash Art,* Milano, n. 107, May
Ratcliff, Carter : "Contemporary American Art," *Flash Art,* Milano, n. 108, Summer
Ricard, René : "Sur Julian Schnabel," *Art Press,* Paris, n. 60, juin
*Catalogues :* Stedelijk Museum, Amsterdam. Martin-Gropius-Bau, Berlin

**Segal, George**
New York 1924 ; lives in New Jersey

**Exhibitions**
Sidney Janis Gallery, New York
Contemporary Sculpture Center, Tokyo
Seibu Museum of Art, Tokyo
Takanawa Museum of Art, Karuizawa

**Group Exhibitions**
"Real, Really Real & Super Real," San Antonio Museum, Texas
"Exhibition of Work by Newly Elected Members and Recipients of Honors & Awards," American Academy of Arts & Letters, New York .
"Contemporary Realism since 1960," Pennsylvania Academy of Fine Arts, Virginia Museum, Oakland Museum
"Flat and Figurative : 20th Century Wall Sculpture," Zabriskie Gallery, New York

**Serra, Richard**
San Francisco, California, 1939 ; lives in New York

**Exhibitions**
"Metal Wall Drawings," Gemini G.E.L., Los Angeles
"Model for the St. Louis Project and Large-Scale Drawings," Leo Castelli, New York
"Marilyn Monroe-Greta Garbo," Leo Castelli, New York
The St.Louis Art Museum, St.Louis, Missouri
"Richard Serra Drawings," Carol Taylor Art, Dallas, Texas

**Group Exhibitions**
Akira Ikeda Gallery, Tokyo, Nagoya
"Arte Povera Antiform," CAPC, Bordeaux
"Johns, Kelly, Serra : New York," Blum Helman Gallery, New York
Documenta 7, Kassel
"Castelli and His Artists : Twenty-five Years," Aspen Center for the Visual Arts ; Traveling exhibition
"'60-'80," Stedelijk Museum, Amsterdam
"Correspondences : 5 Architects, 5 Sculptors," Palacio de las Alhajas, Madrid
Leo Castelli, New York
Margo Leavin Gallery, Los Angeles

Gallery Klaus Nordenhake, Malmö, Sweden
Galerie m, Bochum, W.Germany
"Kunst wird Material," Nationalgalerie, Berlin
Villa Celle, Pistoia

**Bibliography**
Serra, Richard : "Notes from Sight Point Road," *Perspecta 19, The Yale Architectural Journal,* Cambridge and London
*Catalogues :* Kassel. Stedelijk Museum, Amsterdam. CAPC, Bordeaux

**Seung-taek, Lee**
Go Won Ham Nam, Korea, 1932 ; lives in Seoul

**Exhibition**
Galerie Kwan Hun, Seoul, Korea

**Sherman, Cindy**
Glen Ridge, New Jersey, 1954 ; lives in New York

**Exhibitions**
Metro Pictures, New York
Galerie Chantal Crousel, Paris
Stedelijk Museum, Amsterdam
Déjà vu, Dijon, France
Larry Gagosian, Los Angeles
Carl Solway, Cincinnati

**Group Exhibitions**
Biennale Venice
Documenta 7, Kassel
"Staged/Photo Events," Rotterdamse Kunstichting, Rotterdam ; Neue Galerie, Aachen

**Bibliography**
Gambrell, Jamey : "Cindy Sherman, Metro Pictures," *Artforum,* New York, February
Ratcliff, Carter : "Contemporary American Art," *Flash Art,* Milano, n. 108, Summer
Rhodes, Richard : "Cindy Sherman, Film Stills," *Parachute,* Montréal, Automne
Ristorcelli, Jacques & Pouvreau, Paul : catalogue, Rotterdamse Kunststichting
Schjeldahl, Peter : "Shermanettes," *Art in America,* March
"Les Auto-portraits de Cindy Sherman," *Les Cahiers du Cinéma,* Paris, Février
*Catalogues :* Stedelijk Museum, Amsterdam. Biennale di Venezia, Electa. Kassel

**Shinohara, Ushio**
Tokyo 1933 ; lives in New York

**Group Exhibitions**
"The 1960's : A Decade of Change in Contemporary Japanese Art,"The National Museum of Modern Art, Tokyo ; The National Museum of Modern Art, Kyoto

**Bibliography**
*Catalogue :* The National Museum of Modern Art, Tokyo

**Simonds, Charles**
New York 1945 ; lives in New York

**Exhibitions**
"Charles Simonds," Museum of Contemporary Art, Chicago ; Los Angeles County Museum of Art ; Fort Worth Art Museum ; Contemporary Arts Museum, Houston

**Group Exhibition**
Betty Parsons Gallery, New York

**Bibliography**
Russi Kirshner, Judith : "Charles Simonds, Museum of Contemporary Art," *Artforum,* New York, May
*Catalogue :* Museum of Contemporary Art, Chicago

**Smits, Kees**
Kortgene, The Netherlands, 1945 ; lives in Amsterdam

**Exhibition**
Galerie van Krimpen, Amsterdam

**Group Exhibitions**
"Amsterdam '60-'80," Museum Fodor, Amsterdam
"Junge Kunst aus den Niederlanden," Kunstmuseum Basel
"Jonge Kunst uit Nederland," Gemeentemuseum, 's-Gravenhage
"Zomeropstelling," Stedelijk Museum, Amsterdam

**Bibliography**
Groot, Paul : "Galerie," *NRC-Handelsblad,* Rotterdam, 6-8
Heynen, Pieter : "Expositie tekeningen," *Volkskrant,* Amsterdam, 10-8
Sizoo, Hans : "New Dutch Painting," *Flash Art,* Milano, April
*Catalogues :* Museum Fodor, Amsterdam. Kunsthalle, Basel

**Slot, John van't**
Rotterdam, The Netherlands, 1949 ; lives in Rotterdam

**Exhibitions**
Galerie Swart, Amsterdam
Galerie 121, Antwerp

**Group Exhibitions**
Biennale Sydney, Art Gallery of New South Wales, Sydney
"Contemporary Art from the Netherlands," Museum of Contemporary Art, Chicago
"Grand Hotel," Centro d'Arte Contemporanea, Syracuse, Italy
The Living Art Museum, Reykjavik
"Junge Kunst aus den Niederlanden," Kunsthalle Basel, Basel

**Bibliography**
Peters, Philip : "John van't Slot," *Contemporary Art from the Netherlands,* Amsterdam
*Catalogue :* Kunsthalle, Basel

**Spagnulo, Giuseppe**
Tarente, Italy, 1936 ; lives in Milan

**Exhibitions**
Städtische Galerie im Lenbachhaus, Munich
Galleria Tero, Milan

**Group Exhibitions**
"11 Italienische Künstler in München," Kunstlerwerkstätten, Munich
"Spelt from Sibyl's leaves : Exploration in Italian Art," Power Gallery, University of Sydney ; University Art Museum, University of Queensland, Brisbane, Australia
"La Sovrana inattualità," Pavillon d'Art Contemporain, Milan ; Vienna, Austria
"Arte Italiana, 1960-1982," Hayward Gallery, London ; ICA, London

**Bibliography**
Caroli, Flavio, *Corriere della Sera,* Milano
Fenn, Walter : "Das Gewicht der Haut," *Nürnberger Nachriichten,* München
Gliewe, Bert in *Abend Zeitung,* München
Hegewisch, Katharina : "Die wassen des Achille," *Frankfurter Algemeine Zeitung*
Pinelli, Antonio, *Il Messagero,* Article on London exhibition
Schmidt, Doris in *Süddeutsche Zeitung,* München
Spadoni, Claudio : "Scultura ancora viva," *Il Resto del Carlino,* 23 marzo
*Catalogues :* Städtische Galerie im Lenbachaus, München. Kunstlerwerkstätten, München. Power Gallery, University of Sydney. Hayward Gallery, London

**Staccioli, Mauro**
Volterra, Italy, 1937 ; lives in Milan

**Exhibition**
Galleria Panta Arte, Como, Italy

**Group Exhibitions**
IIe Festival international de Arte Viva, Almada, Portugal
"Arte Italiana 1960-1982," Hayward Gallery, London ; ICA, London
Städtische Galeria, Regensburg, W.Germany
Villa Celle, Pistoia, Italy

**Bibliography**
Agnese, Maria Luisa & Carbone, Fabrizio, *Panorama,* Milano, 24-5.
Bargiacchi, Enzo : "Art Spaces in the Hill," *Domus,* Milano, Nov.
Bargiacchi, Enzo : "Arte contemporanea : nasce un'isola fra Prato e Pistoia," *La Città,* Firenze, 18-6
Barilli, Renato, *L'Espresso,* 19 sett.
Boralesi, Antonella, *Panorama,* Milano, 26-7
Bossaglia, Rossana : "Lombardia vent'anni dopo," Assessorato alla Cultura, Pavia

Cabutti, Lucio : "A Londra l'onda azzurra," *Arte-Bolaffi,* Milano, Ottobre
Castellano, Alado : "Il parco delle sculture," *Ville e Giardini,* Dicembre
Caviglioli, Rino : "I mattoni della piramide," *Conquista del lavoro,* Roma, 22-3
Cesana, Eligio & Somaini, Luisa : "30 anni d'arte italiana 1950-80," Musei Civici di Lecco
Corgnati, Martina : "Alla conquista di Londra," *Montenapoleone,* Milano, Ottobre
Guarracino, Vincenzo : "Tre domande a Staccioli," *La voce di Como,* Marzo
Guarracino, Vincenzo : "Staccioli, l'intelligenza della mano," *Il punto-stampa,* Como, aprile
Hanske, Horst, *Die Woche,* 13-5
Kelber, Ulrich : "Kultur," *Mittelbayerische Zeitung,* 19-5
Lely, Caterina, *Quest'arte,* Pescara, Marzo-Aprile
Loers, Veit, catalogue, Stadische Galerie Regensburg
Nicolin, Pier Luigi : "Una solitudine interrotta, " *Gran Bazar,* Gibellina, novembre
Paloscia, Tommaso, *La Nazione,* Firenze, 9-6 •
Pampameo, Rosella, *Vogue pelle,* Milano, febbraio
Perazzi, Mario, *Il mondo,* Milano, 20-9
Pozzi, Gianni : "Dal degrado al recupero," *Paese sera,* Roma, 12-6
Quintavalle, Carlo Arturo, *Panorama,* Milano, 23-8
Reichardt, Jasia, *Bolding Design*
Rosci, Marco : "Scultori d'oggi fra le clarisse," *La Stampa,* Torino, 7-10
Sanesi, Roberto, catalogue
"Scultura oggi," Voghera
Trucchi, Lorenza, *Il Giornale Nuovo,* Milano, 29 ottobre
Vincitorio, Francesco, *L'Espresso,* Milano, 6-6
Wiedemann, Christoph : "Zwischen Utopie und Skepsis," *Suddeutsche Zeitung,* N. 127, 5-6 Juni
*Catalogues :* Hayward Gallery, London. Stadische Galerie Regensburg, Ed. Verbag Kretschmer & Groebmann, Frankfurt-Rodelheim.

**Staeck, Klaus**
Dresden 1938 ; lives in Heidelberg, W.Germany

**Group Exhibitions**
Documenta 7, Kassel

**Bibliography**
*Catalogue :* Kassel

**Stella, Frank**
Malden, Massachusetts, 1939 ; lives in New York

**Exhibitions**
Akira Ikeda Gallery, Nagoya, Tokyo, Japan
Knoedler Gallery, London
Galeria Juana de Aizpuru, Seville
Leo Castelli Gallery, New York
Kitakyushu City Museum of Art, Kitakyushu, Japan

**Group Exhibitions**
Knoedler Gallery, London
Young Hoffman, Chicago
"Avanguardia Transavanguardia," Mura Aureliane, Rome
"'60-'80," Stedelijk Museum, Amsterdam
Louisiana, Humlebæk, Denmark
"Zeitgeist," Martin-Gropius-Bau, Berlin

**Bibliography**
Foster, Hal : "Frank Stella at Knoedler," Art in America, New York, February
Catalogues : Mura Aureliane, Roma, Electa. Stedelijk Museum, Amsterdam. Louisiana, Humlebæk. Martin-Gropius-Bau, Berlin

---

**Stimm, Thomas**
Vienna, Austria, 1948 ; lives in Vienna and Waldviertel

**Group Exhibitions**
Arco, Madrid
Art 13, Basel
"Neue Skulptur," Galerie nächst St.Stephan, Vienna
Teilnahme/Premio Lubiam, Mantua, Italy

**Bibliography**
Catalogue : Galerie nächst St.Stephan, Wien

---

**Swennen, Walter**
Forest, Belgium, 1946 ; lives in Brussels

**Exhibitions**
Rue de Flandres, Brussels
Galerie Verelst, Antwerp
Waterpoort, Courtrai, Belgium

**Group Exhibitions**
"Biennale de la critique," Antwerp
"Le désir pictural," Galerie Isy Brachot, Brussels
"La Magie de l'Image," Palais des Beaux-Arts, Brussels

**Bibliography**
Catalogues : Galerie Isy Brachot, Bruxelles. Palais des Beaux-Arts, Bruxelles

---

**Tadini, Emilio**
Milan, 1927 ; lives in Milan

**Exhibition**
Galerie J.L., Ostende

**Group Exhibitions**
"Arte Italiana 1960-1982," Hayward Gallery, London ; ICA, London
"L'Opera Dipinta," La Pilotta, Parma ; Rotonda de la Besana, Milan
Biennale Venice

**Bibliography**
Catalogues : Hayward Gallery, London. Biennale di Venezia, Electa

---

**Takis**
Athens, Greece, 1925 ; lives in Athens and Paris

**Exhibitions**
"Takis : 3 Totems Espace musical," Centre Georges Pompidou, Paris
Galerie Maeght, Paris

**Group Exhibition**
"Choix pour aujourd'hui," Centre Georges Pompidou, Paris

**Bibliography**
Pas, Annemieke van de : "Takis : Voor mij is de sculptuur als een actie in de ruimte," Kunstbleui, Mars
Prevost, Jean-Marc : "Takis," Flash Art, Milano, n. 106, February-March
Rimsky-Korsakoff, Françoise : "Takis," Canal, janvier
Rivais, Yak : "Takis, L'extase du monstre," Les cahiers de la peinture, n. 128, février
Catalogue : Centre Georges Pompidou, Paris

---

**Tannert, Volker**
Ruhr region, W.Germany, 1955 ; lives in Cologne

**Exhibitions**
Galerie Rolf Ricke, Cologne
Galerie Peter Pakesch, Vienna

**Group Exhibitions**
"Zwölf Künstler aus Deutschland," Kunsthalle, Basel ; Museum Boymans-van Beuningen, Rotterdam
"Zeitgeist," Martin-Gropius-Bau, Berlin
Galerie Peter Pakesch, Vienna
Documenta 7, Kassel
Galerie Rolf Ricke, Cologne

**Bibliography**
Ammann, Jean-Christoph : catalogue, Kunsthalle Basel
Gassert, Sigmar, Basler Zeitung, Basel, Nr. 63
Glozer, Laszlo, Süddeutsche Zeitung, Stuttgart, 24 Mai
Hohmeyer, Jürgen, Spiegel, Hamburg, Nr. 22, Mai
Catalogues : Martin-Gropius-Bau, Berlin. Kunsthalle, Basel. Kassel

---

**Tinguely, Jean**
Fribourg, Switzerland, 1925 ; lives in Milly-La-Forêt, France

**Exhibitions**
Kunsthaus, Zurich ; Tate Gallery, London ; Palais des Beaux-Arts, Bruxelles
René Ziegler, Zurich
"Sketches & Sculpture," Anne Berthoud Gallery, London
Galerie Bischofberger, Zurich

**Group Exhibition**
"Le Nouveau Réalisme," Galerie Beaubourg, Paris

**Bibliography**
Curiger, Bice : "Jean Tinguely," Flash Art, Milano, n. 106, February-March
Curiger, Bice : "Jean Tinguely," Art Press, Paris, n. 56, février
Meyer, Franz : "Les deux cultures de Jean Tinguely," Art Press, Paris, n. 62, septembre
Restany, Pierre : "Le Nouveau Réalisme," Flash Art, Milano, n. 105, December 1981-January 1982
Catalogue : Kunsthaus, Zürich

---

**Tolliver, Mose**
Pike Road, Alabama, 1915 ; lives in Montgomery, Alabama

**Group Exhibition**
"Black Folk Art in America 1930-1980," Corcoran Gallery of Art, Washington D.C. ; J.B. Speed Museum, Louisville, Kentucky ; The Brooklyn Museum, Brooklyn, New York

**Bibliography**
Catalogue : Corcoran Gallery of Art, Washington, D.C. & University Press of Mississippi, Jackson

---

**Tongiani, Vito**
Matteria, Fiume, Italy, 1940 ; lives in Turin

**Exhibition**
"Le peintre et son modèle," Galerie Karl Flinker, Paris

**Group Exhibitions**
Biennale Venice
"Giovani pittori e scultori italiani," Rotonda della Besana, Milan

**Bibliography**
Clair, Jean : catalogue, Galerie Karl Flinker, Paris
Catalogues : Galerie Karl Flinker, Paris. Biennale di Venezia, Electa

---

**Tordoir, Narcisse**
Mechelen, Belgium, 1954 ; lives in Antwerp

**Group Exhibitions**
"Le désir pictural," Galerie Isy Brachot, Brussels
"La Magie de l'Image," Palais des Beaux-Arts, Brussels

**Bibliography**
Bex, Flor : "New Painting in Belgium," Flash Art, Milano, n. 109, November
Catalogues : Galerie Isy Brachot, Bruxelles. Palais des Beaux-Arts, Bruxelles

---

**Tousignant, Claude**
Montreal, Canada, 1932, lives in Montreal

**Exhibitions**
"Claude Tousignant : Sculptures," Musée des Beaux-Arts de Montréal
"Une exposition," Galerie Graff, Vancouver, Canada

---

Côté, Martin P. : "Tousignant, faire face à la réalité," Journal de Montréal, Montréal, samedi 16 janvier
Gascon, France : "Tousignant, sculpter pour peindre," Parachute, Montréal, n. 29, décembre
Payant, René : "Nommées Sculptures," Spirale, Montréal, avril
Sabbath, Laurence, The Gazette, Montréal, Saturday, February 6
St-Amand, Diane : "Tousignant ou le langage de l'art," Virus, Montréal, janvier
Toupin, Gilles : "De la peinture à la sculpture," La Presse, Montréal, samedi 23 janvier
Toupin, Gilles, La Presse, Montréal, samedi 9 octobre
Viau, René : "Tousignant : dépasser la peinture," Le Devoir, Montréal, samedi 23 janvier
Viau, René, Le Devoir, samedi 9 octobre
Catalogue : Musée des Beaux-Arts, Montréal

---

**Trakas, George**
Québec 1944 ; lives in New York

**Group Exhibition**
Villa Celle, Pistoia, Italy

**Works in Progress**
"A Piece on the River," Commissioned by the National Oceanic and Atmospheric Administration, Seattle, Washington
Atlanta, Georgia
Amherst, Massachusetts

---

**Traylor, Bill**
Alabama, 1854, died in 1947, Montgomery, Alabama

**Group Exhibition**
"Black Folk Art," Corcoran Gallery of Art, Washington D.C. ; J.B. Speed Museum, Louisville, Kentucky ; The Brooklyn Museum, Brooklyn, New York

---

**Tsuruoka, Masao**
Gun-ma, Japan, 1907 ; died in 1979

**Group Exhibition**
"Japan : The 1950's," Metropolitan Art Museum, Tokyo

**Bibliography**
Catalogue : Metropolitan Art Museum, Tokyo

---

**Twombly, Cy**
Lexington, Virginia, 1929 ; lives in Rome

**Exhibitions**
"Cy Twombly, Works on Paper 1954-1976," Elvehjem Museum of Art, Madison, Wisconsin ; Virginia Museum of Fine Art, Richmond,

Virginia ; Art Gallery of Ontario, Toronto
Kartsen Greve, Cologne
Sperone Westwater Fischer, New York
Haus Lange, Krefeld, W.Germany
Sprovieri Arte Moderna, Rome
Mayor Gallery, London
Galerie Yvon Lambert, Paris

**Group Exhibitions**
"Avanguardia Transavanguardia," Mura Aureliane, Rome
Documenta 7, Kassel
Young Hoffman, Chicago
Galerie Folker Skulima, Berlin
Blum Helman, New York
"Beuys, Rauschenberg, Twombly, Warhol, Sammlung Marx," Nationalgalerie, Berlin ; Städtisches Museum Abteiberg, Mönchengladbach
"Zeitgeist," Martin-Gropius-Bau, Berlin

**Bibliography**
Ballerini, Julia : "Cy Twombly at Sperone Westwater Fischer," Art in America, New York, November
Groot, Paul : "The Spirit of Documenta 7," Flash Art, Milano, n. 108, Summer
Myers, John Bernard : "Marks : Cy Twombly," Artforum, New York, April
Pohlen, Annelie : "Cy Twombly," Flash Art, Milano, n. 105, December 1981-January 1982
Catalogues : Newport Harbor Art Museum, Newport Beach. Mura Aureliane, Roma, Electa. Kassel. Nationalgalerie, Berlin. Martin-Gropius-Bau, Berlin

---

**Uncini, Giuseppe**
Fabriano, Italy, 1929 ; lives in Milan

**Exhibition**
"Dimore," Galleria Arco d'Alibert, Rome

**Group Exhibitions**
"Proposta," Parco Massari, Ferrara
"Expo '82," Bari
"In Chartis," Museo Civico, Spoleto
"Art and Critics : A Selection," Marshall & Field, Chicago
"Arte Italiana 1960-1982," Hayward Gallery, London ; ICA, London
"Costruttivo," Teatro Romano, Tour Fromage, Aoste
"Realtà in equilibrio," Galleria Il Segno, Rome

**Bibliography**
Barilli, Caroli, Sanesi, Fagone, Ballo : catalogue "Arte Italiana 1960-1982," Electa, Milano
Crispolti, Enrico : catalogue "In Chartis '82," Ed. Cartière Miliani, Fabriano
Farina, Franco : catalogue "Proposta," Ed. Museo Palazzo dei Diamanti
Lux, Simonetta : "Giuseppe Uncini," Flash Art, Milano, n. 110

Menna, Filiberto : catalogue "Costruttivo," Ed. Region Autonome vallée d'Aoste
Volpi, Marisa ; catalogue, "Art and Critics : a Selection," Ed. Marshall & Field, Chicago
Zoccoli, Franca : "Il Magico nell'arte contemporanea," *Terzo occhio*, Ed. Bora, Bologna, n. 25, dicembre
*Catalogues* : Parco Massari, Ferrare, Ed. Museo Palazzo dei Diamanti. Museo Civico, Spoleto, Ed ; Cartiere Miliani, Fabriano. Hayward Gallery, London. Marshall & Field, Chicago. Teatro Romano, Aoste, Ed. Région Autonome vallée d'Aoste

---

**Vedova, Emilio**
Venice, Italy, 1919 ; lives in Venice

**Exhibition**
Galerie Neuendorf, Hamburg

**Group Exhibitions**
"Gli Anni trenta : Arte e Cultura in Italia," Milan
"Avanguardia Transavanguardia," Mura Aureliane, Rome
Biennale Venice
Documenta 7, Kassel

**Bibliography**
Groot, Paul : "The Spirit of Documenta 7," *Flash Art*, Milano, n. 108, Summer
*Catalogues* : Milano. Mura Aureliane, Roma, Electa. Biennale di Venezia, Electa

---

**Vega, Jorge de la**
Buenos Aires 1930, died in 1971

---

**Viallat, Claude**
Nîmes, France, 1936, lives in Nîmes

**Exhibitions**
Galerie Wentzel, Cologne
Leo Castelli Gallery, New York
Centre Georges Pompidou, Paris ; Musée des Beaux-Arts, Montréal, Canada
Galerie Athanor, Marseille

**Group Exhibitions**
"Du cubisme à nos jours : collection de dessins contemporains," Musée Cantini, Marseille
"Paris 1960-1980," Museum des 20. Jahrhunderts, Vienna
"The Subject of Painting," Museum of Modern Art, Oxford, G.B.

**Bibliography**
*Catalogues* : Centre Georges Pompidou, Paris. Statements New York 82, Association Française d'Action Artistique. Musée Cantini, Marseille. Museum des 20. Jahrhunderts, Wien

---

**Vilmouth, Jean-Luc**
Lorraine, France, 1952 ; lives in London

**Exhibitions**
Galerie van Krimpen, Amsterdam
Galerie Michèle Lachowsky, Bruxelles
Lisson Gallery, London

**Group Exhibitions**
Biennale Sydney
Biennale Venice
Documenta 7, Kassel
"Leçons de choses," Kunsthalle, Berne ; Musée Savoisien, Chambéry, France ; Châlon-sur-Saône, France
"Préfiguration pour le Centre d'Art Contemporain," Chambéry.
Lisson Gallery, London
"Vol de Nuit," Galerie Eric Fabre, Paris

**Bibliography**
Francis, Mark, *Arts Magazine*, New York
Martin, Jean-Hubert : "Interview," catalogue, Kunsthalle, Bern
Newman, Michael : "New Sculpture in Britain," *Art in America*, New York, Sept.
Schlatter, Christian : catalogue, Galerie Eric Fabre, Paris
*Catalogues* : Biennale di Venezia, Electa. Kassel. Kunsthalle, Bern. Galerie Eric Fabre, Paris

---

**Visch, Henk**
Eindhoven, The Netherlands 1950, lives in Eindhoven

**Exhibition**
The Living Room, Amsterdam

**Group Exhibitions**
The Living Room, Amsterdam
"Junge Kunst aus den Niederlanden," Kunsthalle Basel, The Netherlands
"Den Haag Junge Kunst aus der Niederlanden," Haags Gemeentemuseum, The Hague
Van Reekummuseum, Apeldoorn, The Netherlands
Stedelijk van Abbemuseum, Eindhoven, The Netherlands
"Open Studios," PS1, New York
Museum Fodor, Amsterdam
Verdeelde Beelden, Amsterdam

**Bibliography**
Groot, Paul : "Henk Visch," *NRC/Handelsblad*, Rotterdam, 9-4
Heynen, Pieter : "Expositie toont getekende ruzie tussen kunstenaars," *De Volkskrant*, Amsterdam, 6-10
Houts, Catherine van : "Je kijkt vooruit en je denkt achteruit," *Het Parool*, Amsterdam, 9-7
Ottevanger, Allied : "Prachtige Tijden," *Metropolis M*, n. 5, Utrecht, 1-7
Peters, Philip : "De nieuwe Nederlandse expressionisten," *De Tijd*, n. 423, Amsterdam, 9-7
Visch, Henk : catalogue, Kunsthalle Basel
*Catalogues* : Kunsthalle, Basel. The Living Room, Amsterdam

---

**Warhol, Andy**
Pittsburgh, 1928 ; lives in New York

**Exhibitions**
Leo Castelli Gallery, New York
Galerie Holtmann, Cologne
"Myths," Marianne Deson, Chicago ; Modernism, San Francisco
American Graffiti Gallery, Amsterdam
"Reversals 'Marilyn'," Akira Ikeda Gallery, Tokyo
Galerie Watari, Tokyo
"Fate Presto," Galleria Lucio Amelio, Naples
Galerie Daniel Templon, Paris

**Group Exhibitions**
"Classic works : 1962-67," Blum Helman Gallery, New York
Documenta 7, Cassel
"Zeitgeist," Martin-Gropius-Bau, Berlin
Collection du Musée de Gand, Palais des Beaux-Arts, Bruxelles
"Beuys, Rauschenberg, Twombly, Warhol, Sammlung Marx," NationalGalerie, Berlin ; Städtisches Museum Abteiberg, Mönchengladbach

**Bibliography**
Francblin, Catherine : "Andy Warhol : les dollars de l'art," *Le Quotidien de Paris*, Paris, 19 mars
Kawanaka, N. : "Andy Warhol's Fix-Movies," *Bijutsu techo*, Tokyo, août
Kuspit, Donald B. : "Andy Warhol at Castelli," *Art in America*, New York, March
Nakamura, K. : "Warhol's Syndo-chrome," *Bijutsu techo*, Tokyo, août
Terayama, S. : "Andy Warhol's Crimes," *Bijutsu techo*, Tokyo, août
"Mythological Exhibition," *Bijutsu-techo*, Tokyo, avril
*Catalogues* : Kassel. Martin-Gropius-Bau, Berlin. Palais des Beaux-Arts, Bruxelles. NationalGalerie, Berlin

---

**Whirled Music**
Burwell, Paul : Ruislip, G.B., 1949
Eastley, Max : London, 1944
Beresford, Steve : Wellington, Shropshire, G.B., 1950
Toop, David : Enfield Middlesex, G.B., 1949
live in London

**Performances**
Biennale Paris, Musée d'Art Moderne de la Ville de Paris, Paris
Waterloo Gallery, London
Claxon Festival, Centrum 'T Hoogt, Utrecht, The Netherlands
Ikon Gallery, Birmingham

**Bibliography**
Cook, Richard : "Schemer, Idiot or Genius ?," *New Musical Express*, 24th April
Cook, Richard : "It's Everywhereman," *New Musical Express*, 25th September

*Catalogue* : Biennale de Paris

---

**Woodrow, Bill**
Henley, Great Britain, 1948 ; lives in London

**Exhibitions**
Lisson Gallery, London
Kunstausstellungen, Stuttgart
Galerie Eric Fabre, Paris
St. Paul's Gallery, Leeds
Ray Hughes Gallery, Brisbane, Australia
Galerie 't Venster, Rotterdam
Galerie Michele Lachowsky, Antwerp

**Group Exhibitions**
Biennale Sydney
"The South Bank Show," London
"Neue Skulptur," Galerie nächst St.Stephan, Vienna, Austria
"Leçons de Choses," Kunsthalle, Berne ; Musée d'Art et d'Histoire, Chambéry ; Maison de la Culture, Châlon-sur-Saône
Biennale Venice
"Englische Plastik Heute," Kunstmuseum, Lucerne
Biennale de Paris, Musée d'Art Moderne de la Ville de Paris
"New Sculpture," Fruit Market Gallery, Edinburgh
"Vol de Nuit," Galerie Eric Fabre, Paris
"British Sculpture in the Twentieth Century," Whitechapel Art Gallery, London

**Bibliography**
Collier, Caroline : "Reviews : London, Bill Woodrow, Lisson Gallery," *Flash Art*, Milano, n. 106, February-March
Cuvelier, Pascaline : "Le système anglo-panique des objets," *Libération*, Paris, 4 mai
Einzig, Hetty : "London Reviews : Bill Woodrow, Sculpture," *Arts Review*, London, vol. XXIV, n. 3, January 29
Januszczak, Waldemar : "Bill Woodrow," *The Guardian*, London, January 14
Miller, Sanda : "Bill Woodrow," *Art Press*, Paris, n. 58, avril
Newman, Michael : "Bill Woodrow," *Art Monthly*, London, n. 53, February
Newman, Michael : "Bill Woodrow and the Excavation of the Object," catalogue, Kunstmuseum, Lucerne
Okabe, Aomi : "Reviews : London," *Geijutsu-Sincho*, Japan, April
Roberts, John : "Car Doors and Indians," *ZG*, London, n. 6, April
Vaizey, Marina : "Jokers in the Pack," *Sunday Times*, London, January 31
*Catalogues* : Galerie nächst St.Stephan, Wien. Kunsthalle, Bern. Biennale di Venezia, Electa. Biennale de Paris. Galerie Eric Fabre, Paris. Kunstmuseum, Luzern. Whitechapel Art Gallery, London

---

**Wurm, Erwin**
Bruck/Mur, Austria, 1954 ; lives in Austria

**Exhibition**
Neue Galerie, Graz, Austria

**Group Exhibitions**
Arteda '82, Bilbao
"Buchobjekte," Universitätsbibliothek, Heidelberg
Galerie Verifica 8 + 1, Venice
"Rocca del Comune," Udine, Italy
"Das lebende Museum," Graz ; Salzbourg ; Vienna
"Kunst aus der Steiermark," Pecsis-Galleria, Pecs, Hungary
"Neue Skulptur," Galerie nächst St.Stephan, Vienna
"Kunst aus der Steiermark," Museum Gyöngös, Gyöngös, Hungary
"Buchobjekte," Hessisches Landesmuseum, Darmstadt
"Analyse '82," Stadtmuseum, Graz

**Bibliography**
*Catalogues* : Galerie nächst St.Stephan, Wien. Neue Galerie, Graz. Museum Gyöngös, Gyöngös. Stadtmuseum, Graz

---

**Yamaguchi, Takeo**
Seoul, Korea, 1902 ; lives in Japan

**Group Exhibitions**
"The 1960's : A Decade of Change in Contemporary Japanese Art," The National Museum of Modern Art, Tokyo

**Bibliography**
*Catalogue* : The National Museum of Modern Art, Tokyo ; The National Museum of Modern Art, Kyoto

---

**Yokoo, Tadanori**
Hyōgo, Japan, 1936 ; lives in Tokyo

**Exhibitions**
Nantenshi Gallery, Tokyo
Crafts Museum, Hamburg

**Group Exhibitions**
Musée Central, Tokyo
"The 1960,s : A Decade of Change in Contemporary Japanese Art," The National Museum of Modern Art, Tokyo ; The National Museum of Modern Art, Kyoto

**Bibliography**
Tono, Yoshiaki : Catalogue, Nantenshi Gallery, Tokyo
Yokoo, Tadanori : "Is he mythicizing himself ?" *Bijutsu techo*, Tokyo, april
"Recent works of Tandanori Yokoo," *Bijutsu techo*, Tokyo, September
*Catalogues* : Nantenshi Gallery, Tokyo. The National Museum of Modern Art, Tokyo

---

**Yong-Min, Kim**
Yonsan, Korea, 1943 ; lives in Korea

**Group Exhibition**
"11 Artists, 11 critics," Seoul Gallery, Seoul, Korea

---

**Yoshimura, Masunobu**
Oita, Japan, 1932 ; lives in Japan

**Group Exhibitions**
"The 1960's : A Decade of Change in Contemporary Japanese Art," The National Museum of Modern Art, Tokyo ; The National Museum of Modern Art, Kyoto

**Bibliography**
*Catalogue :* The National Museum of Modern Art, Tokyo

---

**Yuhara, Kazuo**
Tokyo, Japan, 1930 ; lives in Tokyo

**Exhibition**
Prefectural Modern Art Museum, Kanagawa

**Group Exhibitions**
"The 1960,s : A Decade of Change in Contemporary Japanese Art," The National Museum of Modern Art, Tokyo ; The National Museum of Modern Art, Kyoto

**Bibliography**
*Catalogue :* The National Museum of Modern Art, Tokyo

---

**Zorio, Gilberto**
Andorno Micca, Italy, 1944 ; lives in Turin

**Exhibitions**
Galleria Cavellini, Brescia
Galleria Christian Stein, Turin
Pinacoteca Comunale, Ravenna

**Group Exhibitions**
"La sovrana inattualità," Pavillon d'Art Contemporain, Milan ; Vienna
"Arte Povera Antiform," CAPC, Bordeaux
"Italian Art Now," Solomon R. Guggenheim Museum, New York
"11 Italienische Künstler in München," Kunstlerwerkstätten, Munich
"Arte Povera," Galerie Munro, Hamburg
"Halle 6," Kampnagel Fabrik, Hamburg
"Past-Present-Futur," Württembergischer Kunstverein, Stuttgart
Villa Celle, Pistoia
Collection du Musée de Gand, Palais des Beaux-Arts, Brussels
"Spelt from Sibyl's Leaves, exploration in Italian Art," Power Gallery, University of Sydney ; University Art Museum, University of Queensland, Brisbane, Australia
"Idee per la Pace," Commune d'Asti, Italy
"Arte Italiana 1960-1982," Hayward Gallery, London ; ICA, London

**Bibliography**
Apuleio, V. : "Che dolce sapore di nichilismo ?" *Il Messaggero,* 21 Aprile
Ballerini, L. : catalogue, Power Gallery, University of Sydney
Barilli, R. : catalogue, Hayward Gallery, London
Brogi, S. : "Sei scultori coerenti," *Prospettive d'arte,* n. 53, marzo
Caroli, F. : "È inattuale lo scultore di qualità," *Corriere della Sera,* Milano, 10 marzo
Celant, G. : catalogue, CAPC, Bordeaux
Chessa, P. : "Poi l'America disse : appendiamoli al muro !," *L'Europeo,* 10 maggio
Feeser, S. : "Gilberto Zorio, Galerie Appel und Fertsch, Frankfurt," *Das Kunstwerk,* I, XXXV
Gertler, W. : "Guggenheim : Italian Art — An American perspective," *The Ticker,* Baruch College, New York, May 10
Giachetti, R. : "Hurrah per i magnifici sette," *La Repubblica,* 4 maggio
Gualdoni, F. : Catalogue, Padiglione d'Arte Contemporanea, Milano
Hoet, J. : catalogue, Museum Van Hedendaagse Kunst, Gand
Meneguzzo, M. : "La sovrana inattualità," *Segno,* Pescara, marzo-aprile
Osterwold, T. : catalogue, Württembergischer Kunstverein, Stuttgart
Seveso, G. : "Gli scultori inattuali si presentano a Milano," *L'Unità,* 6 aprile
Spadoni, C. : "Scultura ancora viva," *Il Resto del Carlino,* 23 marzo
Veronesi, R. : "La sovrana inattualità, *Invece,* febbraio
Waldmann, D. & Tabak, L. : catalogue, Guggenheim Museum, New York
Wolff, T.F. : "A Frontal Assault on the Art of the Times — Once Again," *Christian Science Monitor,* New York, May 3
Zaccharopoulos, D. : "Gilberto Zorio," *Artistes,* Paris, octobre-novembre
"Al sodo, al sodo amici miei," *Il Tirreno,* 8 aprile
*Catalogues :* Power Gallery, University of Sydney. Hayward Gallery, London. CAPC, Bordeaux. Padiglione d'Arte Contemporanea, Milano. Museum Van Hedendaagse Kunst, Gent. Württembergischer Kunstverein, Stuttgart. Guggenheim Museum, New York

We would like to thank all those artists, galleries and museums who assisted us in the production of these biographical and bibliographical notes for the year 1982.

# Illustrations

**Credits**

Van Abbemuseum, Eindhoven 46, 47
A.D.E.A., Levallois-Perret 96
Galleria Lucio Amelio, Napoli 101-2, 101-3, 111
Shigeo Anzai, Tokyo 24-1, 24-2, 25-1
Art & Communications Counselors, New York 146-1, 146-2 (Whitney Museum of American Art, New York), 146-3 (The Saint-Louis Art Museum, Saint-Louis)
Art Gallery of New South Wales, Sydney 10-1, 11-3, 11-4 ; 11-1 (John Delacour), 11-2 (Jennifer Steele, Aboriginal Artists Agency, Sydney)
BBKB, Amsterdam 75
Berlinische Galerie, Berlin 65
Florent Bex, Antwerpen 66-2, 67-4, 67-5, 69-2, 69-3, 69-4, 82-1, 82-2, 83
Bijutsu Shuppan Design Center, Tokyo 19
Mary Boone Gallery, New York 142-1, 142-2, 143-2
Boymans-van Beuningen, Rotterdam 59-3
Philippe Briet, Caen 30, 31
British Council 23-1, 23-2 ; 23-3 (Richard Davies)
The Brooklyn Museum, New York 144
Galerie Farideh Cadot, Paris 84-3
Susan Caldwell Gallery, New York 154-1 (Joyce David), 154-2, 154-3, 154-4 (D. James Dee)
Leo Castelli Gallery, New York 48-1, 49-1, 49-2, 142-3, 143-1
Mario V. Castelo 130-2
CAPC, Bordeaux 90
CAYC, Buenos-Aires 129
Centre Culturel du Mexique, Paris 134, 135-2, 135-3 ; 135-1 (Julius Shulman, Los Angeles)
Paula Cooper Gallery, New York 155
Galerie Chantal Crousel, Paris 87, 152, 157-2, 157-3, 157-4
Galerie Fabien de Cugnac, Bruxelles 81-1
Hilda Deecke, Münster 61-2
Jean-Luc Dubin, Paris 20-1, 22-4, 42 à 45, 48-2, 48-3, 50-1, 52, 53, 80-1, 80-3, 81-2, 81-3, 93, 94, 95-2, 95-3, 98, 99-3, 99-4, 102-2, 102-3, 102-4, 103-1, 103-3, 103-4, 104, 105, 110-2, 110-3, 112-1, 112-3, 117-3, 121, 124, 125, 156-1
J. Dubout, Paris 112-2, 113
Galerie Durand-Dessert, Paris 95-1
Galerie Eric Fabre, Paris 86
Galerie de France, Paris 91
Galerie Gillepsie-Laage-Salomon 92-2, 92-3 ; 92-1 (André Morain)
Nigel Greenwood Inc., London 119
The Solomon R. Guggenheim Museum, New York 150-1 ; 150-2, 150-3 (Sperone Westwater Fischer, New York)
Gérard Guyot, Paris 58-2, 68-2, 103-2
Helsingin Kaupungin Taidemuseo, Helsinki 32, 33
Henie-Onstad Kunstsenter, Høvikodden 37, 38, 39-1, 39-2 ; 36-1 (Dirk Bakker) ; 36-2 (D. Low), 39-3 (Jamie Parslow)
Ikon Gallery, Birmingham 118-2
Sidney Janis Gallery, New York 21
Key Gallery, Tokyo 20-2
Kunsthalle Basel, Basel 74-3 ; 74-1 (Christian Baur), 74-2 (Arthur Adolf), 78-1 (Christian Baur)
Kunsthalle, Bern 76 (Roland Aellig, Bern), 77-1 (Roland Aellig, Bern)
Kunsthaus, Zürich 73-3
Galerie Yvon Lambert, Paris 85-2
J. Littkemann, Berlin 67-1, 67-2, 69-1
Louisiana, Humlebæk 40-1, 40-2
Galerie Adrien Maeght, Paris 88-1 (Gérard del Sol)
Galerie Maeght, Paris 97-2, 97-3 ; 97-1 (Claude Gaspari)
Marlborough Gallery Inc., New York 147
Metro Pictures, New York 156-2, 157
Musée d'art contemporain, Montréal 136 ; 137-1, 137-2 (Centre de documentation Yvan Boulerice) ; 137-3 (Marc Cramer)
Musée des Beaux-Arts, Montréal 139 (Marilyn Aitken)
Musée de Chambéry 77-2
Musées de Nice 85-3 (Michel di Lorenzo)
Museo de arte contemporáneo, Caracas 132 (Mariano V. de Aldaca), 133 (Marianella de Cruz)
Museum of Contemporary art, Chicago 145-1 (Rudolph Burckhardt) ; 145-2, 145-3 (Tom van Eynde, Chicago)
Museum van Hedendaagse Kunst, Gent 82-3, 83-2
Museum of Modern Art, San Francisco 149
Museum des 20.Jahrhunderts, Wien 70
Nakamura, Tokyo 68-1
Nantenshi Gallery, Tokyo 12, 13
National Gallery of Victoria, Melbourne 10-2
Neue Galerie-Sammlung Ludwig, Aachen 64
Newport Harbor Art Museum, Newport Beach, California 140, 141
Neil G. Ovsey Gallery, Los Angeles 148
Ed. Peterson 118-1
Enzo Ricci, Torino 102-1
Luca Rodriguez 131-3
Scan Shop, Zug 78-2, 78-3
Tony Shafrazi Gallery, New York 151
Marco Scucciari, Rieti 100-1, 100-3, 100-4, 101-1, 106, 107-1, 107-3, 107-4, 107-5, 107-6
Städtische Erlangen 60
Statens Konstmuseer, Stockholm 34, 35
Galerie nächst St. Stephan, Wien 71-1, 71-2 ; 71-3 (Schachinger, Wien)

Tate Gallery Press Office Millbank, London 72, 73-2
Galerie Daniel Templon, Paris 50-2, 51, 85-1
José Augusto Varella/José Roberto Cecato 130-1
Videoart, Locarno 79
Galeria Fernando Vijande, Madrid 115 (J. Pingarron), 122, 123
Villa Celle, Pistoia 107-2 (Aurelio Amendola)
Waddington Gallery, London 120
Galerie Michael Werner, Köln 61-1
The Whitechapel Art Gallery, London 116-2, 116-3 ; 116-1 (Derek Carver) ; 117-1, 117-2, 117-4, 117-5 (Derek Carver)
Whitney Museum of American Art, New York 158-1 (Peter Moore) ; 158-2, 158-3, 159-1, 159-2 (Jock Gill)
Zeitgeist, Berlin 67-3 ; 66-1 (J. Littkemann)
Galerie De Zwarte Panter, Antwerpen 80-2 (Ludo Geysels)

We are grateful to all those authors and publishers who gave us permission to reprint extracts from their newspapers, magazines, catalogues and books.
In particular :
Artforum, New York 148
Art in America, New York 157, 162, 163
Art Monthly, London 118
Art Press, Paris 126
Arts Magazine, New York 156
Bijutsu Techo, Tokyo 21
Cahiers du CRIC, Limoges 87
Corriere della Sera, Milano 108
Daily News Record, Fairchild Publications, Inc., New York 151
Electa Editrice, Milano 103, 164, 165
El País, Madrid 112
Geijutsu Sincho, Tokyo 21
La Presse, Montréal 139
Le Matin, Paris 91
Opus International, Paris 88, 89, 95
Spirale, Montréal 136
The New York Times, New York 145, 155
The Village Voice, New York 143, 147, 154